The Rule, the Bible, and the Council

College Art Association

Monograph on the Fine Arts, LV

Editor, Robert S. Nelson

Diana Gisolfi
Staale Sinding-Larsen

The Rule, the Bible, and the Council

The Library of the
Benedictine Abbey at Praglia

Published by
COLLEGE ART ASSOCIATION
in association with
UNIVERSITY OF WASHINGTON PRESS
SEATTLE AND LONDON 1998

University of Washington Press
PO Box 50096
Seattle, Washington 98145

Library of Congress Cataloguing-in-Publication Data

Gisolfi, Diana

 The rule, the Bible, and the council : the library of the
Benedictine Abbey at Praglia / Diana Gisolfi and Staale
Sinding-Larsen.

 p. cm. — (Monographs on the fine arts : 55)

 Includes bibliographical references (p.) and index.

 ISBN 0-295-97661-8 (University of Washington Press : alk.
paper)

 1. Badia di Praglia—Library. 2. Library decoration—
Italy—Padua Region—History—16th century. 3. Mural
painting and decoration. Italian—Italy—Padua Region. 4.
Mural painting and decoration—16th century—Italy—Padua
Region. 5. Christian art and symbolism—Renaissance,
1450–1600—Italy—Padua Region. 6. Benedictine art—Italy—
Padua Region. 7. Monastic libraries—Italy—Padua Region.
I. Sinding-Larsen, Staale. II. Title. III. Series : Monographs on
the fine arts : 55.

Z810.B33G57 1997

727′.8′094532—dc21 97-34406

 CIP

Contents

LIST OF ILLUSTRATIONS vii

PREFACE xi

I Introduction 1

II The Library Then and Now: Reconstructing
the Cinquecento Room 5
 1 The Library Today 5
 2 The Original Placement of the Wall Paintings 6
 3 Documents Concerning the Library Furnishings 8
 4 The Original Library Furniture and Comparisons
 with Other Libraries 11
 5 The Condition of the Paintings 13
 6 The Dating of the Furnishings and the Paintings 14
 6.1 The Campaign of 1562–64 14
 6.2 Chronology of the Paintings 14
 6.3 A Cycle in the Anteroom Ceiling? 16

III The Benedictine Tradition of Books 19
 1 The Rule, the Bible, and the Fathers 19
 2 Benedictine Library Usage 23

IV The Ceiling and Wall Paintings in the Praglia Library
and Other Benedictine Cycles 27
 1 Praglia 27
 1.1 The Ceiling Paintings 28
 1.2 The Wall Paintings 41
 2 Painted Decorations in Other Benedictine Contexts 47
 3 A Comparison between the Praglia and
 Santa Giustina Programs 54

V The Benedictine Order and the Catholic Reform 59

 1 The Benedictines and the Roman Church
 before Trent 60
 2 Italian Heresies, Deviations, and Debates Leading
 up to Trent 63
 3 Main Issues at Trent 64
 4 Three Benedictine Abbots at Trent 68
 5 Consolidation after Trent 70
 6 The Cassinese Congregation after Trent 71

VI The Texts of the Fathers 73

 1 General Problems of Interpretation 73
 2 A Monastic Setting 75
 3 From Images to Meditation 76
 4 Scanning the Praglia Pictorial Cycle 78
 4.1 Focal Pictures: The Church and Tradition; the
 Holy Spirit and the Virgin 78
 4.2 The Biblical Scenes: God's Chosen, the
 Benedictines, and Their Obligations 83

VII Benedictine Self-Identification in Times of Challenge 88

 1 Benedictine Tradition in a Period of Challenges 88
 1.1 Indispensable Qualities: Approaching Wisdom 88
 1.2 Serving the Lord's School 91
 1.3 Benedictine Self-Identification in Times
 of Challenge 96
 2 Conclusion 98

APPENDIXES

 1 Praglia Documents: Excerpts 100
 2 The Text of Don Vincenzo of Milan: Excerpts 105

NOTES 108

BIBLIOGRAPHY 127

ILLUSTRATIONS 133

INDEX 194

Illustrations

PLATES

I Present-day view of the Library Room at Praglia, from the anteroom

II View of the ceiling of the Library at Praglia, from the entrance

III *Jael and Sisera,* tempera on canvas, 320 × 180 cm. Ceiling of the Library at Praglia

IV *Saints Gregory and Jerome Preaching and Teaching,* tempera on canvas, 320 × 320 cm. Ceiling of the Library at Praglia

FIGURES

1 View of the abbey at Praglia

2 Map of the Cassinese Congregation in 1520 (from Trolese, 1991)

3 Library and church at Praglia, from the north

4 Pozzoserrato, detail of fresco: view of Praglia from the south, ca. 1575. Anteroom of the sacristy, Sta. Giustina, Padua

5 Vincenzo Zabeo-Giovanni Battista Meduna, proposed reconstruction of the monastery showing north Library windows restored, ca. 1824

6 Exterior north wall of the Library at Praglia

7 Interior of the Library at Praglia (see Plate 1)

8 Interior window of the Library at Praglia

9 Exterior of the west wall of the Library at Praglia

10 Staircase in the room below the Library at Praglia

11 Exterior of the anteroom of the Library at Praglia, from the upper cloister

12 Exterior view of the monastery at Praglia, from the southeast

13 Ceiling of the anteroom at Praglia, from the Library

14 Ceiling of the anteroom at Praglia

15 Interior view of the Refectory at Praglia, with Zelotti's wall paintings from the Library on the side walls

16 Tommaso da Modena, fresco decoration with Dominican monk-scholars, 1352. Chapter Hall, S. Nicolò, Treviso

17 View of the library at Cesena

18 Detail of the library benches, Cesena

19 Michelangelo, Laurentian Library, Florence, 1524–34

20 View of the former library room, abbey of Sta. Giustina, Padua, 1461

21 Detail of Figure 20: wall opposite entrance with sinopia of *Madonna and Child with Saints Justine and Benedict*

22 *St. Gregory,* fresco. Entrance to the library room, Sta. Giustina, Padua

23 View of the former library room, S. Bernardino, Verona

24 Detail of Figure 23: wall opposite entrance with fresco by Domenico Morone, *Madonna with Saints and Donors,* ca. 1500

25 Plan of the Library at Praglia today

26 Computer reconstruction of the Praglia Library furnishings in the 16th century, view toward the north

27 Computer reconstruction of the Praglia Library furnishings in the 16th century, view toward the south

28 Chart showing the reconstructed relationship of subjects of the ceiling paintings and the wall paintings in the Library at Praglia

29 Computer reconstruction of the Library at Praglia with paintings scanned in, view toward the north

30 Computer reconstruction of the Library at Praglia with paintings scanned in, view toward the south

31 Battista Zelotti, *Assumption,* ca. 1559, tempera on canvas, arched, 450 × 241 cm. Church of Sta. Maria di Praglia

32 Battista Zelotti, *Allegory of Modesty,* 1557, tempera on canvas, diam. 230 cm. Marciana Library, Venice

33 Battista Zelotti, *Allegory of Study,* 1557, tempera on canvas, diam. 230 cm. Marciana Library, Venice

34 Battista Zelotti, detail of fresco decoration, Room of Sofonisba, Villa Caldogno, ca. 1570

35 Battista Zelotti, detail of fresco decoration, Room of Scipio, Villa Caldogno, ca. 1570

36 Paolo Veronese, decorations of the interior of S. Sebastiano, Venice, showing placement of *Erythraean Sibyl* (hidden by organ shutter) and *Samian Sibyl* below Archangel Gabriel at the entrance to the sanctuary, ca. 1560

37 Paolo Veronese, *Cumaean and Tiburtine Sibyls* below *Virgin Annunciate and Prophet,* ca. 1560. S. Sebastiano, Venice

38 Battista Zelotti, *Jacob and Esau,* tempera on canvas (before 1960 conservation). Refectory, Praglia

39 Battista Zelotti, *Jacob and Esau,* tempera on canvas, ca. 340 × 234 cm (after 1960 conservation). Refectory, Praglia

40 Battista Zelotti, *Prodigal Son,* tempera on canvas (before 1960 conservation). Refectory, Praglia

41 Battista Zelotti, *Prodigal Son,* tempera on canvas, ca. 340 × 229.5 cm (after 1960 conservation). Refectory, Praglia

42 Battista Zelotti, *Moses Breaking the Tablets of the Law,* tempera on canvas (before 1960 conservation). Refectory, Praglia

43 Battista Zelotti, *Moses Breaking the Tablets of the Law,* tempera on canvas, ca. 340 × 242 cm (after 1960 conservation). Refectory, Praglia

44 Battista Zelotti, *Christ Chasing the Money Changers from the Temple,* tempera on canvas (before 1960 conservation). Refectory, Praglia

45 Battista Zelotti, *Christ Chasing the Money Changers from the Temple,* tempera on canvas, ca. 340 × 245 cm (after 1960 conservation). Refectory, Praglia

46 Battista Zelotti, *Solomon and the Queen of Sheba,* tempera on canvas (before 1960 conservation). Refectory, Praglia

47 Battista Zelotti, *Solomon and the Queen of Sheba,* tempera on canvas, ca. 340 × 269 cm (after 1960 conservation). Refectory, Praglia

48 Battista Zelotti, *Jesus Teaching in the Temple,* tempera on canvas (before 1960 conservation). Refectory, Praglia

49 Battista Zelotti, *Jesus Teaching in the Temple,* tempera on canvas, ca. 340 × 268 cm (after 1960 conservation). Refectory, Praglia

50 Battista Zelotti, *Moses on Mount Sinai Receiving the Tablets and the Baby Moses Saved,* tempera on canvas (before 1960 conservation). Refectory, Praglia

51 Battista Zelotti, *Moses on Mount Sinai Receiving the Tablets and the Baby Moses Saved,* tempera on canvas, ca. 340 × 252 cm (after 1960 conservation). Refectory, Praglia

52 Battista Zelotti, *Sermon on the Mount,* tempera on canvas (before 1960 conservation). Refectory, Praglia

53 Battista Zelotti, *Sermon on the Mount,* tempera on canvas, ca. 340 × 250 cm (after 1960 conservation). Refectory, Praglia

54 Battista Zelotti, *Pentecost,* tempera on canvas (before 1960 conservation). Refectory, Praglia

55 Battista Zelotti, *Pentecost,* tempera on canvas, 340 × 240 cm (after 1960 conservation). Refectory, Praglia

56 Battista Zelotti, ceiling of the Library at Praglia (see Plate II)

57 Battista Zelotti, *David and Goliath,* tempera on canvas, oval, 180 × 320 cm. Library at Praglia

58 Battista Zelotti, *Samian Sibyl,* tempera on canvas, 180 × 180 cm. Library at Praglia

59 Battista Zelotti, *Tiburtine Sibyl,* tempera on canvas, 180 × 180 cm. Library at Praglia

60 Battista Zelotti, *Saints Augustine and Ambrose Attacking Heretics,* tempera on canvas, 320 × 320 cm. Library at Praglia (see Plates I and II)

61 Battista Zelotti, *Samson with the Gates of Gaza,* tempera on canvas, oval, 320 × 180 cm. Library at Praglia

62 Battista Zelotti, *Jacob's Ladder,* tempera on canvas, oval, 320 × 180 cm. Library at Praglia

63 Battista Zelotti, *Catholic Religion with the Four Evangelists,* tempera on canvas, octagon, 320 × 320 cm. Library at Praglia

64 Battista Zelotti, *Judith and Holophernes,* tempera on canvas, 320 × 180 cm. Library at Praglia

65 Battista Zelotti, *Jael and Sisera,* tempera on canvas, 320 × 180 cm. Library at Praglia (see Plate III)

66 Battista Zelotti, *Saints Gregory and Jerome Preaching and Teaching,* tempera on canvas, 320 × 320 cm. Library at Praglia

67 Battista Zelotti, *Moses with the Burning Bush and Serpent,* tempera on canvas, oval, 320 × 180 cm. Library at Praglia

68 Battista Zelotti, *Abraham and Isaac,* tempera on canvas, oval, 320 × 180 cm. Library at Praglia

69 Battista Zelotti, *Daniel in the Lions' Den,* tempera on canvas, oval, 180 × 320 cm. Library at Praglia

70 Battista Zelotti, *Erythraean Sibyl,* tempera on canvas, 180 × 180 cm. Library at Praglia

71 Battista Zelotti, *Cumaean Sibyl,* tempera on canvas, 180 × 180 cm. Library at Praglia

72 *Humility Killing Pride, Flanked by Jael and Judith,* from the *Speculum virginum,* MS 72, fol. 31, illumination 20 × 18.4 cm. Walters Art Gallery, Baltimore, Maryland

73 *Tree of Virtues,* from the *Speculum virginum,* MS 72, fol. 26, illumination 21 × 16.2 cm. Walters Art Gallery, Baltimore, Maryland

74 *Temple of Wisdom, with Seven Gifts of the Spirit Collated with Virtues, Beatitudes, the Lord's Prayer, Apostle's Creed, with Inscriptions from Proverbs 9:1 and Isaiah 11:1–3,* from the *Speculum virginum,* MS 72, fol. 104r, illumination 25.4 × 20.4 cm. Walters Art Gallery, Baltimore, Maryland

75 "Tree of Porphyry" (after Sowa)

76 Integrated reconstruction of the 16th-century Library Room at Praglia with furnishings and Zelotti's paintings, view toward the north

77 Integrated reconstruction of the 16th-century Library Room at Praglia with furnishings and Zelotti's paintings, view toward the south

Preface

THE TOPIC OF THIS BOOK is the original arrangement and significance of the pictorial decorations in the Library of the Benedictine monastery at Praglia near Padua. This series of twenty-four paintings on canvas by Battista Zelotti, which we date around 1570, consists of religious allegories and scenes from the Old and New Testaments displayed in various-shaped compartments in the ceiling and large rectangular canvases that were on the walls. D. G. began a stylistic study of the paintings, while S. S.-L. intended a supplement on the iconography of the cycle. As work progressed, the entire project proved less simple and more demanding than anticipated— but also more challenging. An initial campaign resulted in our reconstruction of the sixteenth-century room and its furnishings and revealed that the pictorial program is doctrinal. We realized that we needed to look at the program in relation both to Benedictine traditions and to the extremely complex theological and dogmatic disputes and reassessments in the Roman Church in the fifteenth and sixteenth centuries, especially the debates and statements of the long-lasting Council of Trent. It then became evident that there existed no single reliable account of this multidocumented but also internally conflict-ridden process. The conservative Jesuit scholar Hubert Jedin, in his *History of the Council of Trent,* gives one kind of outlook. S. S.-L., taking this author as a main source, soon came up against challenges to Jedin's somewhat hardened position by authors, including some Benedictines, who were discovered mainly by D. G. Our collaboration in these matters proved especially useful because the intricate situation we were exploring, we found, required considerable negotiation among various sources to describe the intellectual, spiritual, and institutional context to which we believe the Praglia Library program responded.

We are aware, as the reader will be, that our interpretation rests upon a hypothetical reconstruction of the arrangement of the wall paintings. That reconstruction relies primarily on the measurements of the paintings themselves, which constitute pairs—each a thematically related set of Old and New Testament scenes—that are placed in correspondence to the varying widths of wall sections. Secondarily it derives from the observation of visual and motif correspondences among the paintings on the walls and ceiling, guided by a reading of the biblical texts with reference to the Benedictine and Conciliar contexts. We consult the biblical texts themselves, references to them in the *Rule of Saint Benedict* and Saint Gregory's *Life of Saint Benedict,* and sometimes their use in relation to the liturgy of the Divine Office or the Mass. In addition, we often look at the texts in the light of commentary by Church Fathers and later meditative scholars, especially Benedictines of the Cassinese Congregation, and we bring in texts documenting the debates at Trent and our Benedictines' role in the Council. We see the thematic choices as inspired both by the emphatic reaffirmation of sacramental and

monastic traditions in the period of consolidation following the close of Trent and by ancient Benedictine tradition. This further interpretation of the system corroborates our measurement-derived placement of the wall paintings.

Such interpretations are common in cases like the present one; art history abounds with them. In historical disciplines we proceed, ideally, from the most secure and concrete information to more hypothetical arguments, drawn from the fullest basis we can construct. The information we assemble, however, is by its nature incomplete, and it is important to be conscious of the circularity of the argument. Such argumentation, provided the underpinnings are scientifically plausible, remains a complex working hypothesis. Its usefulness should consist in conveying observations, arguments, and information that support the case at hand but which can also be reused in alternative models of interpretation. A good study is one that provides a framework for future scholarship. Developing such perspectives is a matter of theory, and the development of constructive theories must proceed from empirical or "real-world" situations, lest they remain the free-floating abstractions that we encounter often enough. We hope that our findings may prove useful.

In such a complex project, advice and assistance from many quarters are required, and we have been especially fortunate in this respect. First we want to extend our thanks to the monks of Praglia, particularly to Don Basilio Spolverato, O.S.B., for his unforgettable eagerness to help us with problems as well as with technical matters. To stay at Praglia, Don Callisto Carpanese, O.S.B., a prolific author of relevant studies, was most hospitable, as was Don Giuseppe Tamburrino, librarian at the time of our initial campaign. The central site of the Congregation to which Praglia belongs is the monastery of Santa Giustina at nearby Padua, and there we found Don Francesco Trolese, O.S.B., who was extremely helpful and, as the reader will soon discover, is also the author of a series of fundamental contributions on Benedictine tradition. We also wish to thank Corrado Corcioni of Verona for references to monastic source material.

The Praglia cycle contains combinations of themes that we thought were rather uncommon. Colleagues have helped us with many of these, and we extend our thanks to Dr. Dorothy Shepard of Pratt, expert in medieval manuscripts, who helped us follow up (through the Princeton Index of Christian Art) suggestions received from John Scott and Joanne Burnstein at the presentation of this material during the College Art Association's annual meeting in San Antonio in 1995. We also wish to thank Dr. Gary Radke for his initiative and the willingness of the Kress Foundation to fund travel for the San Antonio talk in the session sponsored by the Italian Art Society and chaired by Dr. Kathleen Weil-Garris Brandt. It has been a pleasure to work with Dr. Robert Nelson, editor of the CAA Monograph Series, Virginia Wageman, managing editor; her successor, Elaine Koss; Sharon Herson, copyeditor; and Russell Hassell, designer. We thank them and the two anonymous readers, whose comments on substantive matters and on presentation in our manuscript were most constructive and useful; their advice has helped us to improve numerous points.

In Venice, the Soprintendente, Dr. Giovanna Nepi Sciré, kindly let us have photographs of the prerestoration state of the wall paintings. In the same city, we enjoyed the kindness of the staff of the Biblioteca Marciana and of the Cini Foundation Library. Our warm thanks to Don Floriano of San Giorgio Maggiore, Venice, for the loan of the *Breviarium Monasticum,* a pre–Vatican II Breviary. Elsewhere the staffs of the following institutions aided us immeasurably: the Biblioteca Comunale and the university library at Padua; the Bibliotheca Apostolica Vaticana; the Soprintendenza ai Beni Artistici e Storici di Venezia; the Soprintendenza per i Beni Artistici e Storici del Veneto; and the library at Castelvecchio in Verona. In the United States, we especially thank Margot Karp and Joseph Cahn, the librarians of Pratt Institute in Brooklyn, New York, for continued helpfulness in finding publications that were not easily available; and we were also given ready assistance by the librarian of Fordham University, New York (Rosehill Campus), James McCabe, for which we are very grateful. In Norway the library staff of the Section Library for Architecture, Construction, and Mathematics, of the Norwegian Institute of Technology, as usual, provided efficient and generous assistance.

In our respective countries, we wish to acknowledge the financial support received from the American Philosophical Society, the Norwegian Research Council for Science and the Humanities, the Faculty of Architecture of the Norwegian Institute of Technology, and the support of the Provost's Faculty Development Fund of Pratt Institute for project completion.

The technical help of Terje Moe and Kjetil Hoel of the Norwegian Institute of Technology, and Rachel Moog, graphic designer and Pratt graduate, working with architect Catherine Vardon, was crucial to our development of computer models of our reconstruction of the Library decorations and furnishings. Specific photographic sources are given at the end of this volume. Many photographs are our own, taken on site thanks to the patient hospitality of Don Basilio.

In sending this book off, we think especially of Fiona Veronese Gisolfi Pechukas (1973–1990), who in the fall of 1990 printed most of the photographs of Praglia used here.

I

Introduction

The little carriage followed the crests, at first, of humble little hills, passed
a village, a river, other villages, took a tortuous little vagabond road into the
plain up to the outposts of the Euganeian Hills, turned into the majestic
avenue of plane trees that skirts their deserted flank on the north. Where
this flank faces about to look eastwards and then stretches away to the south,
a broad road parts from the main road and follows it to come up after five
minutes at the misty enclosure of the great abandoned monastery, the battle-
mented tower, the beautiful and mighty sanctuary of the Quattrocento, rest-
ing upon an enormous cube of black rock, from which burst forth here and
there, as if in league with rebellious thought, rebellious living grasses. . . .
When he saw before him the dim enclosing walls and the battlemented
tower of Praglia, he thought that perhaps, who knows, in the silence of the
ancient monastery the divine voice would make itself heard to him.

La carrozzella seguì l'unghia, in principio, di umili collinette, passò un
villaggio, un fiume, altri villaggi, corse una tortuosa stradicciuola vagabonda
nel piano sino agli avamposti degli Euganei, piegò per il viale maestoso di
plantani che ne rade a settentrione il fianco deserto. Dove questo svolta a
guardar il levante e si allontana verso mezzodì, si parte dalla via maestra e
lo segue uno stradone che mette capo dopo cinque minuti alla fosca
cintura del grande monastero abbandonato, alla torre merlata, al bel tempio
possente del Quattrocento, assiso su un enorme dado di pietre nere, onde
irrompe, qua e là, congiurata con le ribellioni del pensiero, la ribellione
dell'erba viva. . . . Quando si vide a fronte la fosca cintura e la torre merlata
di Praglia pensò che forse, chi sa, nel silenzio dell'antico monastero la voce
divina gli si farebbe udire.

—Antonio Fogazzaro, *Piccolo mondo moderno,* 1901[1]

THE BENEDICTINE ABBEY of Santa Maria di Praglia is set at the foot of the
Colli Euganei southwest of Padua, between the tiny village of Teolo and Abano
Terme (Fig. 1). The monastery was founded around 1100,[2] but the buildings
we see today date primarily from the fifteenth century and were decorated mainly dur-
ing the fifteenth and sixteenth centuries.[3] This Renaissance complex is a product of the

reform and renewal of the Benedictine Order in Italy begun under the leadership of Ludovico Barbo from the neighboring abbey of Santa Giustina at Padua. Ludovico was made abbot in 1409 and died in 1443. In 1448 Praglia became the twenty-second monastery to join the rapidly growing "Congregation of Santa Giustina." The continuing expansion of this Benedictine Congregation (called the Cassinese Congregation after 1504) is illustrated in Trolese's map of its membership in 1520 (Fig. 2). The Congregation attracted gifted men and, famous for its renaissance of Benedictine biblical and patristic scholarship, played a significant role in the religious debates of the sixteenth century, including events preceding, surrounding, and during the Council of Trent.

Viewing the buildings of the abbey at Praglia from below the level of the church, the Library Room is seen to the left of the facade, placed parallel to the church (Fig. 3). On the other side of the Library and behind it are cloisters and cells, shown in the view painted by Pozzoserrato in the late sixteenth century (Fig. 4).[4] It is the Library Room with its sixteenth-century furnishings and decorations that is the physical object of our study. Since this room was modified in the eighteenth century, we must first reconstruct its sixteenth-century form, furnishings, and decorative system before turning to the ambiance that produced them and then finally to the analysis and interpretation of the painted program.

The Library and its decorations are not discussed in such standard early sources as Vasari, Ridolfi, and dal Pozzo and have received relatively little attention in scholarly literature. The state of the problem in written texts is as follows. The earliest mention appears in the manuscript of 1639 by Jacopo Filippo Tomasini on Paduan libraries;[5] in 1687 Jean Mabillon, in his survey of monastic riches in Italy, describes Praglia's Library as decorated with paintings and as arranged according to the ancient system.[6] The paintings on the Library ceiling and those on the refectory walls are recorded as Zelotti's in Giovanbattista Rossetti, *Descrizione delle pitture, sculture ed architetture di Padova*, 1776,[7] and the eighteenth-century renovation of the Library is described briefly in the manuscript of Don Benedetto Fiandrini, archivist of Praglia, in 1800.[8] Early twentieth-century guides[9] written at the monastery specify that the paintings now hanging on the lateral walls of the refectory decorated the walls of the Library until 1765. Franca Zava Boccazzi, writing in 1970 on the style of the recently restored ceiling paintings of the Library, suggests a date of 1566.[10] In 1985 she revises this, putting the date back to 1562–64, and offers suggestions concerning the placement of three of the wall paintings and a literary source for the inscriptions of the Sibyls.[11] Some documents concerning the Library exist at Praglia and are referred to, with fragments quoted, by Callisto Carpanese, O.S.B., and Zava Boccazzi.[12]

Battista Zelotti's paintings in fresco and on canvas in the church, refectory, and Library of the abbey at Praglia constitute an important achievement, comparable in size and complexity to that of Paolo Veronese at San Sebastiano in Venice. Born in Verona and trained in Antonio Badile's shop beside Veronese, Zelotti is less well known, in part because his Venetian commissions were fewer and also because his once highly visible facade decorations in Venice, much praised by Boschini and Ridolfi, are gone.[13] While the

great bulk of Zelotti's surviving oeuvre consists of frescoes of mainly secular content for private villas in the Veneto, the work at Praglia stands out for its religious context and subject matter. The dates, meaning, and original placement of Zelotti's paintings in the church at Praglia seem relatively well studied,[14] but major questions remain about each of these factors in the case of the Library and the paintings from the Library that are now in the refectory. The Benedictines of Praglia commissioned works from Zelotti's master, Antonio Badile, his contemporaries Tintoretto, Veronese, and Pozzoserrato, and probably Veronese's son Carletto as well. Tintoretto and Veronese were employed by the Benedictines of San Giorgio Maggiore in Venice, and Veronese by the Benedictines of Santa Giustina in Padua and San Benedetto del Po, all monasteries belonging to the same Congregation.[15] Veronese's first known supper scene was commissioned by the Benedictines of Santi Nazaro e Celso in Verona;[16] perhaps the best surviving painting by Veronese's and Zelotti's master, Badile, is his altarpiece of 1544 in the church of Santi Nazaro e Celso. This network of patronage or reappearance of artists in various abbeys of the Congregation has been compared with the frequent rotation of abbots under the Congregation and is in all probability connected with it.[17]

We shall address the unsettled questions regarding the original appearance of Praglia's Library in the sixteenth century and the dating of the complex through an examination of the physical site, transcription and reevaluation of the documents, analysis of the style of the paintings in comparison with other decorations by Zelotti, and evidence from other monastic libraries. These varied means allow us to offer a reconstruction of the sixteenth-century Library.

In order to consider the iconography of the reconstructed program, we explore the religious context in which the Library was decorated and consider how this may have affected the choice of subject matter. This context is multifaceted, comprising the Benedictine tradition, its own recent revival, and its interface with the Catholic Reform, which is, in itself, a matter of considerable complexity.

In the case of this monastic Library, the subjects chosen for the pictures are all religious and all apparently included in a theologically meaningful pattern; but they are not necessarily determined by any fixed liturgy since this is not a room with an altar. Our Benedictine monastery provides, however, a richly documented and multifarious religious ambiance and thus offers a framework for interpretation. It is a framework that we must piece together from many different factors, so that there is a certain degree of unpredictability to the process. We can draw only selectively on comparative library iconography, since the material is varied and not well studied. Even though there is no specific liturgy for a library, the function of a library in a monastery will necessarily have to be evaluated in the full context of religious life, and here the liturgy of the Divine Office is central. The monks would have known the basic liturgy by heart and would have tended to see whatever biblical or traditional imagery there may have been in the light of that liturgy. It is therefore not surprising that we discover comparative material for the Praglia program in Benedictine pictorial cycles of the period located in other parts of a monastery as well as in the library.

II

The Library Then and Now: Reconstructing the Cinquecento Room

I N THIS CHAPTER we introduce the reader to the physical appearance of the Library and its anteroom today. We show through photographs and documents extant at Praglia the changes that occurred in the eighteenth century. On the bases of these and of original documents preserved at Praglia concerning the sixteenth-century furnishings and the displaced paintings in the refectory at Praglia, we offer a reconstruction of the appearance of the Library when its decoration was completed in the late sixteenth century. According to the arguments we advance here, this would have been around 1570.

1 The Library Today

Today the Library consists of a main room and, as a vestibule between the staircase and this, a smaller southern room, which we shall refer to as the anteroom; in the documents it is called "atrio" (Fig. 25). The anteroom is closely coordinated with the main room due to the installation in the 1960s of shelves and galleries modeled after the eighteenth-century system in the main room. According to the Reverend Basilio Spolverato, O.S.B., who was at the time of the interview acting abbot of Praglia Monastery, the eighteenth-century door now at the outer entrance to the anteroom was moved there from the archway between the anteroom and the main room in 1962−63 (Fig. 13). In the main room, there are now only two pairs of side-wall windows; however, the outlines of two windows are still discernible on the exterior north wall (Fig. 6). The windows of the north wall appear to have had the same width and placement as the two existing arch-shaped north windows on the floor below and have been so visualized in a published elevation drawing of the monastery made at Praglia (Fig. 5).[1] These were walled in during the eighteenth-century renovation to allow for the shelves that fill the walls (Fig. 7).[2] Originally, the two pairs of windows along the lateral walls (Fig. 8) probably were similar to the north wall windows. On the exterior a change in the masonry reveals the filled-in area between the upper and lower sections of the lateral windows, as can be

seen in the photograph of the west wall (Fig. 9). It seems clear that in the eighteenth-century restructuring, the four lateral windows were altered: they were stretched almost to the floor and the ceiling, then subdivided with horizontal sections of masonry to compensate for lost stability and to provide wall space for the upper galleries of the library shelves. The stretching of the side windows must have been intended to compensate for the loss of light that occurred from the filling of the wall behind the galleries and the closing of the north windows. (See chapter III below and appendix 1, document 7.)

Furthermore, the Reverend Callisto Carpanese, O.S.B., informs us about the original access to the Library. The large room underneath the old Library main room is now a library reading room. It has a mid-sixteenth-century fireplace. In this lower room, there is a stair engaged to the east wall (Fig. 10), and this led originally to a lateral entrance into the anteroom (Fig. 11), from which one had access to the old Library. On the exterior the boxlike entrance is still visible (Fig. 12). Carpanese stressed the importance of this access, as it was used also for heating the upper rooms. This means that the present anteroom also originally functioned as an entrance vestibule to the main Library Room, while the sideways access did not affect the eastern wall of the main room, which thus remained perfectly symmetrical to the west wall (Fig. 25).

The ceiling of the main room is intact, with a wooden framework (painted white, with a monochrome rosette pattern) that creates fifteen compartments filled with fifteen paintings by Battista Zelotti (Fig. 56). The ceiling of the anteroom has a sixteenth-century system of unpainted wooden compartments evidently intended for paintings (Fig. 14). Here, however, the ceiling compartments are empty. There seems to be no information or tradition to the effect that they were ever filled with canvases; so that this seems to be a case of uncompleted decoration. It is unlikely, though, that such a compartment system would have been planned without relatively clear ideas about what kind of pictorial representations to install in the various compartments (for further discussion on this point, see II.6.3 below).

2 The Original Placement of the Wall Paintings

In the main room, with (originally) two windows in the north wall (see II.1 above), two windows in each side wall, and the entrance door, there would have been one wall section in the north wall, two sections flanking the door, and three in each lateral wall: nine sections that could accommodate such large paintings as the nine presently in the refectory (Fig. 15). Since the height of each of the nine canvases is close to 340 cm, while the widths vary considerably, we pair the paintings on the basis of their widths, isolating the *Pentecost,* since its symmetrical composition suggests the only solitary position, on the wall opposite the entrance. This exercise produces four pairs of paintings, each containing one scene from the Old Testament and one from the New, with the *Pentecost* alone placed tentatively on the end wall. The measurements given in the chart on the facing page are the widths of each wall painting:

Pentecost (240 cm)

Moses on Sinai Receiving the Tablets (252 cm)	*Sermon on the Mount* (250 cm)
Solomon and the Queen of Sheba (269 cm)	*Christ Teaching in the Temple* (268 cm)
Moses Breaking the Tablets (242 cm)	*Christ Expelling the Money Changers* (245 cm)
Jacob and Esau (234 cm)	*The Prodigal Son* (229.5 cm)

entrance

The pairs of Old and New Testament scenes are clearly connected thematically, suggesting the traditional concordance of Old Testament subjects on one side of the room and related New Testament scenes opposite, as in the Sistine Chapel. There, Old Testament scenes are to the left of the main entrance, and New Testament scenes to the right—and at least one pair is thematically identical: *Moses on Sinai–Sermon on the Mount*. We shall presently offer an argument for a corresponding placement at Praglia. Our pairings argue against Zava Boccazzi's suggestions for the placements of three of the paintings.[3] She had proposed that *Solomon and the Queen of Sheba* belonged on the north wall because it was wider than the rest, but when we measured all nine paintings we found that two paintings, not one, are wider than the rest. This finding suggests that *Christ Teaching in the Temple* was originally opposite *Solomon and the Queen of Sheba* and that this pair occupied the central lateral wall sections of the Library (that is, the widest sections: see Fig. 25, measured plan). Zava Boccazzi had further argued that the two scenes involving Moses flanked the entrance door, since she thought that the grisaille border is intact along the lower edge in these two canvases, and that all the rest must have been tangent to seven original bookcases along the other sections of wall. Her perception, based on the restored state of the canvases, is, however, not correct (see II.5 below and Fig. 42); and it is a mistake, as we shall show, to assume that the original *scaffali* were along the walls (see II.4 below). Instead it seems likely that the narrowest pair of scenes, *Jacob and Esau* and the *Prodigal Son,* occupied the spaces flanking the entrance door, since these are the narrowest of the nine original wall sections of the Library.

In terms of transversal axes across the ceiling, the correspondence between the wall paintings and those of the ceiling cannot have been accurate, except for the middle axis, where the wall paintings with *Solomon and the Queen of Sheba* and with *Christ Teaching in the Temple,* being placed between the windows, would have corresponded axially to the central ceiling octagon and its flanking rectangular frames. Each of the remaining four wall paintings, occupying the wall spaces between the windows and the corners of the room, would have had its middle axis just beyond (as seen from the corners) the line of the closest frame side of the relevant ceiling painting. Thus these four wall paintings would have corresponded to the projection from the *Sibyl* painting (four Sibyls occupy the corner compartments of the ceiling, Pl. I) and the adjacent ceiling painting. This circumstance does not seem to compromise the idea of a programmatic correspondence.

With the help of designer Rachel Moog and architect Catherine Vardon, we have been able to reconstruct the placement of the wall paintings in relation to the ceiling (Figs. 29–30) by having photographs of the wall paintings scanned onto a simple perspective view of the room. For the dimensions of the room, we have relied on Carpanese's plans of the monastery provided by Don Basilio Spolverato (Fig. 25). The placement of the paintings and reconstructed windows at the vertical center of the wall is based on the height of the furnishings, which will be discussed below (II.4).[4]

The large wall paintings covered most of the intervals between the original windows. Our reconstruction (Figs. 29–30) does leave room for a framework, probably in wood, that might have included inscriptions and/or small painted areas, perhaps in monochrome.

3 Documents Concerning the Library Furnishings

An account of our reading of the relevant documents will now be given. The texts are presented in appendix 1 (documents 1–8).

Document 1 is an index referring to document 2, of 1562, and cites "scanzie" for the Library. The term could mean "shelves" as well as "book cases" (Zingarelli Italian dictionary, *s.v.* scansia: "mobile a ripiani usato per contenere libri, carte, oggetti vari; scaffale").

Document 3, from the same index as document 1, refers to document 4 and records the payment of 494 ducati for "the new choir."

Document 2, of 1562, stipulates a contract with carpenters/woodcarvers for 28 lengths of shelf systems based on "the existing drawing on three sheets which these masters have seen and accepted [considerati]," each unit being 3.15 m long and 1.40 m high ("corssi numero vintiotto di longeza de piede noue in circa et di alteza di piú di quatro et vna onza o piu o meno"; for the meaning of the term "corso," cf. "li corssi doue si riponerano li libri"). Now, 1 piede vicentino = ca. 0.35 m; in all: $9 \times 0.35 = 3.15$ m. An oncia is a twelfth of a piede = 2.916666 cm; the term "quattro" must refer to "piede," not to "oncia" ("quatro et vna" would be five and would have been written accordingly). Thus: $35 \times 4 = 140$, which gives a height of a little more than 1.40 m. Document 2 also contains the clause to pay 17 ducati for each unit of shelves and benches: "pagarli ducati disesete [diciasette] pro bancho et corsso" [28 units, see above; $28 \times 17 = 476$ ducati]. Included here are also the decorated side panels of the shelves (facing the aisle) with some "teste" (probably masks): "et li frontoni di nogaro bello et apponerano lauoradi de Intagio iuxta el dito disegno Cum le sue teste manufate a Intagio." These "frontoni" in "beautiful walnut" ("nogara bello") were to be inlaid ("lauoradi de Intagio") after the same drawing. It is not clear what the "teste" may mean; later in the document, we learn that they were to be placed "apresso il muro e porta predicta": near the wall and the above-mentioned door. The description clearly concerns a system of benches and shelves, confirming Mabillon's "antiquo ritu dispositis riferta,"[5] not shelves along the walls as Zava Boccazzi assumed.

The document also stipulates the making of a "pala" (for which, see below)

according to a drawing to which reference is made. In the same document of 1562, the two spellings of "pala" and "palla" are used interchangeably. The price for the "palla" is included in the price of 17 ducati for each unit of the 28 "banchi et corssi," while the "teste" all together are evaluated at the price of one such set, "ala porcion di un bancho," that is, at 17 ducati. The library furniture, the "palla," and the rest (i.e., the "teste") were to be completed within fourteen months.

An important piece of information here is that the "palla," whose price is included in the price for the library furniture, even though it is consistently cited as a separate entity, must have been a modest feature—certainly not the entire ceiling framework as proposed by Zava Boccazzi.[6] We are also informed that the "palla" was to be made after a drawing to be provided by the cellerario. Thus, a drawing (separate from those on three sheets already provided for the "libreria") was to be submitted for the "palla."

Document 4, of 28 March 1564, concerns a payment of 80 ducati and specifies quantities of grain and wine toward completion of the work referred to in document 2, including "banchi et Assetati." The account is not to be settled, however, until the woodcarvers have installed the furnishings and delivered the "palla" (for comments on this, see below), confirming that it is clearly one piece and of particular importance (see above).

Document 6, of 17 April 1569, concerns payments to one of the woodcarvers cited in documents 2 and 4 for four "pale" in the church. Whenever the object "pala" is mentioned in document 6, it is either in the plural or the context shows that more than one is under consideration. The term "pala" in document 6 ("quatro pale delle capele picole"—four "pale" for the four small chapels) must refer to altarpieces for the two side altars flanking the sanctuary and the two transept altars, so that the term is intended here to specify the frames by citing the "pale" that are to receive the frames (see below). In documents 2 and 4, however, the term is always in the singular.

Thus documents 2 and 4, when stipulating payments for the "palla" or "pala," must refer to just one item and certainly not to a whole series of frames or images, since the "corsi" and "banchi" are always in the plural.

In order to clarify the significance of the term "palla"/"pala," let us look at some contemporary documents. We shall see that the "pala" cannot be referring to the ceiling framework. If the extant (cited) documents had concerned the present wooden compartment system of the ceilings of the Library and anteroom (and the hypothetical original wooden wall compartments), one would have expected to find the terms typical for such works in the period in question. In the restoration campaign in the Doge's Palace after the fires of 1574 and 1577,[7] which involved numerous wooden ceiling compartments like those at Praglia, we find the following terms which, with the exception of "banchi," do not appear in the Praglia documents so far available: "modanature," "spaliere di noghera" (for the Sala del Collegio),[8] "sagoma della cornise" and "cartelle," "pilastri,"[9] "partimenti . . . di friso" (for ceiling compartments in wood),[10] "soffittà" (for ceiling decoration); whereas, for all the numerous new painting frames involved in the Palace redecorations, the term "palla" does not, to the best of our knowledge, appear even once. This seems to imply that the term is used for single items, such as the frame of one picture, or

one picture, and not for framework systems like those on the ceilings in the Doge's Palace or in the Praglia Library.

On the other hand, in the Venetian context the term "pala" or "palla" would have been familiar from all the public ceremonies at San Marco in Venice during which the Pala d'Oro was opened up or closed ("palla aperitur . . . ," etc.).[11] In the twelfth-century *Breviarium caeremoniarum* of Melk, there are instructions concerning the "pallae . . . altarium" (i.e., for covering the altar or only the Eucharist).[12] Whenever the term "pala" appears in an unambiguous functional relationship in the Praglia documents, what is involved is evidently an altarpiece. From this usage, the term might easily have been transferred to apply to any image with a religious subject.

The documents in fact would seem to suggest that an original project of 1562–64 might have included just one sacred image for the Library; since the term "pala" may refer to a sacred picture but also to its frame, it is hard to conjecture with confidence about its material composition. The Zelotti cycle on the ceiling (and probably, then, also the paintings on the walls) would seem to have originated in a second project for the Library, not envisaged in our documents and thus dated after 1564 (also never completed, since the ceiling compartments in the anteroom are, and have apparently always been, quite empty).

Document 5, of 1564, concerns the payment of a little more than lire 417 to Zelotti; the document does not specify the work or the terms for its completion, nor indeed does it refer to a more comprehensive stipulation such as a contract. It may therefore relate to just one installment of a larger account or a payment for a relatively limited job. Zava Boccazzi cites this document as concerning Zelotti's painting cycle for the Praglia Library.[13] This conclusion is, however, too hasty; the payment could just as well refer to work elsewhere in the monastery, since we know that the artist was employed over a considerable period of time at Praglia and that he also made paintings for the Praglia church. Thus the presently known sixteenth-century documents do not give any explicit information concerning Zelotti's pictorial cycles for the Library or the corresponding ceiling compartments in wood, or the hypothetical wooden wall compartments. They clearly record an arrangement that provided for a system of benches and shelves set on the floor and one single picture, the "palla," probably envisaged as a focal image at the northern end wall of the main room.[14]

Document 8, dated 1768, records the renewal of the Library furnishings. The ancient arrangement of freestanding benches with shelves had become inadequate especially on account of donations of books, and a system of wall shelves was planned. The original intent was to finance the renovation out of the monastery's own income. At a certain stage, it became clear that sufficient funds for completing the work were not available, and a petition was presented to "his Excellence," most likely the bishop, for financial aid to complete the refurnishing. In the contract with the carpenter, the "marangon," the system roughly as we see it today, including the central table, was envisaged. There is no information concerning masonry work, such as remodeling the windows, which, however, would not have required notable expenses. No information useful

for throwing more light on the original system can be culled from the 1768 document. In fact, to save money, the carpenter was ordered also to make use of the wood material from the old furnishings.

4 The Original Library Furniture and Comparisons with Other Libraries

Closer examination of the cited documents in connection with information from neighboring libraries of the period may help us to formulate some assumptions concerning the original functional setup in the Praglia Library. We noted in the beginning that Jean Mabillon (published 1687 and 1745) informs us that the Library at Praglia was arranged "according to the ancient system" ("bibliotheca libris antiquo ritu dispositis referta").[15] What is meant is that the books were arranged in benches and shelves placed on the floor (and not along the walls) and in two rows transversal to the longitudinal axis of the room—an arrangement still found in the libraries at Cesena and Florence (the Laurenziana) (Figs. 17–19) and originally probably also in the fifteenth-century library in the abbey of Santa Giustina, Padua, and that of San Bernardino, Verona.[16] According to document 8 of 1768 (see appendix 1), for Praglia, a new system of shelves—the present one—was then being installed. This necessitated the removal of the wall paintings, which were placed in the refectory.

According to document 2, of 1562, there were to be 28 lengths of shelf systems, each 3.15 m in length. The Library Room at Praglia is 16.34 m in length and 9.33 m in width. Assuming, on the strength of Mabillon's source (see above), that there were two rows of benches parallel to the length axis, there would have been 14 rows on each side. This would have left a free space across the room of 3.03 m. Thus the situation would have been almost exactly the same as in the library room at Cesena and roughly as at the Laurenziana. At Praglia, the door between the vestibule and the main room is 2.18 m wide. Assuming that the middle aisle took the same width, we would have a remaining 0.85 m for the two side aisles, i.e., 0.425 m for each of them. This, in fact, is the size of the slight side aisles at the Laurenziana: between 0.4318 m and 0.4191 m.

Considering the arrangement in the length direction, we shall have to accommodate 14 sets of "banchi et corssi" in a space 16.34 m long. Therefore we took measurements of the two libraries with original furnishings, Cesena and the Laurenziana, as a basis for comparison. At Cesena, one bench unit, from one front of a reading desk to the front of the next one, measures 1.235 m; it is comprised of a seat of 0.41 m, an interval of 0.28 m, and a desk of 0.54 m (of which 0.37 m makes a broad desk top and 0.17 m accounts for the slope). Multiplying this unit by 14 (13 whole units plus half units at each end—a desk at the front, and an interval and a bench at the back), we obtain 17.29 m: 0.95 m more than the length of the Library Room at Praglia, suggesting that the units at Praglia must have been a bit more slender in proportions. The Laurentian Library units, in fact, are considerably more elegant: the seat measurement of 0.40 m is almost the same as at Cesena (0.41 m) and the interval is 0.25 m, but the desk only 0.39 m. Using

fourteen of the Laurentian units, we obtain 14.56 m; this set would fit into the length of
the Library at Praglia with 1.78 m to spare. Since the main difference in the size of the
units at Cesena and the Laurenziana lies in the considerably deeper desks in the earlier
library at Cesena, our reconstruction of Praglia's system (Figs. 26–27) uses Cesena's seat,
interval, and desk-slope measures of 0.41 m, 0.28 m, and 0.17 m respectively, with a desk-
top measure of 0.28 m. The total desk depth in our reconstruction of 0.45 m (rather
than the 0.54 m total at Cesena) is still deeper than the elegant Laurentian measure of
0.39 m. In addition, we calculate the bench top of the end benches at 0.10 m. Thus, our
reconstructed units for Praglia are 1.14 m; multiplying this times 14, we get 15.96 m,
plus 0.10 m equals 16.06 m. Subtracting this from the 16.34 length of the room at Praglia,
we have 0.28 m as leeway. It seems likely, then, that the Praglia bench-and-desk system
was closer in dimension to the Cesena model than to the Laurentian example, but there
were undoubtedly other, perhaps closer, models of similar systems that are now lost.

The important conclusion to draw is that, contrary to Zava Boccazzi's assump-
tion, the shelves were not on the walls but on the floor, leaving the wall space free for the
paintings that are today in the refectory. The question now must be asked whether suffi-
cient height remains between the library benches and the ceiling to accommodate these
wall paintings. We have already noted that there was sufficient space in the lateral direc-
tion, taking into account the width of the windows. The maximum height of the wall
paintings is 3.43 m *(Sermon on the Mount),* the minimum height 3.38 m *(Solomon and the
Queen of Sheba).* The wall height is 6.2 m. The bench height is a little more than 1.40
m, while in Cesena the benches are 1.275 m high and in the Laurenziana 1.32 m.
Assuming (as we have in our reconstruction) that the base line of the series of wall paint-
ings sits at the top line of the benches, the total height (3.43 m + 1.40 m) is 4.83 m,
while the total height today between the base of the lower windows and the top of the
upper ones is 5.0 m. The maximum and minimum heights of the slightly irregular walls
from floor to ceiling are 6.30 m and 6.10 m. Thus, there would have been sufficient space
also in the vertical direction for the wall paintings.

This exercise demonstrates that a unified system of benches, shelves, and desks,
such as the extant examples at Cesena and Florence, fits quite precisely into the existing
space at Praglia, and confirms that the measurements given in appendix 1, document 2
(1562) conform to Mabillon's report.

A computer reconstruction of the benches within the Library Room, including
the ceiling compartments and the outlines of the wall paintings, has been made for us by
architects Terje Moe and Kjetil Hoel at the Norwegian Institute of Technology, allowing
us to visualize the furnished room according to the above measurements and to view
the room from any angle (Figs. 26–27). As we noted above with regard to Figures 29
and 30, the large wall paintings fill most of the wall area not blocked by the benches,
but since the original framework surrounding windows and paintings is not intact, we do
not know if it consisted only of wooden frames or if it may have included inscriptions,
carvings, or any additional (and necessarily much smaller) painted decorations either on
the wood or on thin strips of canvas.

5 The Condition of the Paintings

The condition of the ceiling paintings appears to be quite good. This appearance con-
forms to the notes in the files of the Soprintendenza del Veneto and to the record of
cleaning and revarnishing by Ferruccio Volpin in 1963. Due to contradictory information
concerning the medium, and difficulty in observation because of protective varnish and
distance, we asked Volpin himself, who stated that the medium is tempera.[17] G. M. Pivetta,
in 1831, reported water damage to the ceiling paintings, specifying the *Daniel in the Lions'
Den* as having suffered recently from rain.[18] This painting (Fig. 69) may have some loss
and reintegration of the surface that is not presently visible from the floor.

 The nine wall paintings of biblical subjects presently hanging in the refectory
do not appear to be as well preserved as the ceiling paintings. The wall pictures were cleaned
by Lorenzo Lazzarin in 1960 at the instance of Vittorio Moschini, then Soprintendente
alle Gallerie di Venezia. Some photographs were published by Francesco Cessi in 1960,
but they did not show the painted borders of the canvases.[19] The borders resemble close-
ly those of the wooden frames on the ceiling of the Library, simply using half instead of
full circles (Figs. 38−56). It is worth noting also that the pattern of the borders is similar
to that used in some of Zelotti's frescoes at the Villa Emo and at the Castello del Cataio.[20]
The canvases do not show the border along the bottom, but in the case of *Moses Breaking
the Tablets* (see Figs. 42-43) there is a horizontal strip of darker paint equivalent in thick-
ness to the border paint; the photograph taken before restoration shows that the lower
border of the canvas was damaged or never extended to its present vertical dimension.[21]
In the paired canvas of *Christ Expelling the Money Changers,* the photograph taken before
restoration shows the lower part of the stretcher exposed (Fig. 44). In *Solomon and the
Queen of Sheba* (Figs. 46−47) the lower border is also missing. In the *Moses on Sinai with
the Birth of Moses* (Figs. 50−51) the lower border appears to be damaged but intact, yet the
pattern of half-circles is not intact; in this case there may have been an earlier restoration
in which the canvas was rebacked or pieced and an approximate continuation of the
border added. In the *Pentecost* (Figs. 54−55), for example, an irregular darkened strip
crosses the bottom of the canvas; there is similar evidence of damage and repair to the
lower border in the *Sermon on the Mount* (Figs. 52−53) and the *Prodigal Son* (Figs. 40−41).

 Unfortunately, there is no written report on the restorations of 1960 to supple-
ment observations gleaned from photographs from the Soprintendenza ai Beni Artistici
e Storici di Venezia published here that record the appearance of the nine canvases before
and after the 1960 cleaning. The "before" photographs show damaged lower borders in
several cases, including the *Pentecost, Solomon and the Queen of Sheba,* the *Sermon on the
Mount,* and *Christ Expelling the Money Changers.* The height of all nine canvases is close to
340 cm, so that this circumstance of some missing lower borders cannot be a case of
cropped canvases; in fact, in some instances the uniformity in height may be due to the
restoration of 1960, since some "before" photographs show the lower border quite gone
(or never there) and the wooden frame fully visible. In fact, there is not a single case in
which the pattern of the top and side border continues along the lower border, only

some cases in which a darkish area corresponds in width to the borders. This, together with the damage to several of the canvases near the lower extremity and evidence of piecing or backing in others, suggests that a wainscoting or molding equal in level to the height of the benches in the Library may have originally covered the lower edges of the pictures (Figs. 26–27).

As we have just noted, contradictory information is given concerning the medium used in these decorations: tempera and oil are both mentioned. According to the records of the Soprintendenza per i Beni Artistici e Storici del Veneto, the wall paintings are all in tempera on canvas (schede 177–186); however, the dimensions of all are given as 320 × 240 cm and we know that this is not correct (see II.2 above). The records of the Soprintendenza say that the ceiling paintings are all in oil on canvas except for the two large square scenes of *Saints Augustine and Ambrose* and *Saints Jerome and Gregory,* which are in tempera on canvas, but Volpin confirmed that the fifteen ceiling paintings are all in tempera. Perhaps the better state of conservation of the ceiling canvases compared with the quite poor condition of the wall paintings documented in 1960 have led to the judgments in the literature and even in the *notizie critiche* at the Soprintendenza that the quality of the wall paintings is inferior to that of the ceiling pictures or that the dating is different.[22] The perceived differences reflect condition; well-preserved parts of the wall paintings closely resemble the ceiling pictures.

6 The Dating of the Furnishings and the Paintings

6.1 *The Campaign of 1562–64*

According to our analysis of the cited documents, none speak of the cycle of paintings, but they refer consistently to one "palla" or "pala." We hypothesize that this refers to the framing of one wall painting, probably placed on the end wall, serving as a focus for the monks' meditation. Our hypothesis is suggested by altarpiece-like frescoed images that still exist on the end walls of the earlier libraries at Santa Giustina in Padua of 1461 and in the Franciscan library at the monastery of San Bernardino in Verona, decorated around 1500. In the former case, the sinopia visible today shows the *Madonna and Child with Saints Justine and Benedict* (Figs. 20–21). In the latter case, the end wall is frescoed with a scene of the *Madonna and Child with Saints and a Donor* against a backdrop of Lake Garda; along the side walls are members of the Franciscan order, standing on illusioned pedestals (Figs. 23–24).[23] A third, more distant case, in an Augustinian library at San Barnaba in Brescia, has Augustinian churchmen along the walls and on the wall opposite the entrance an *Allegory of the Teachings of Saint Augustine,* including a "ship of faith" on stormy waters.[24]

6.2 *Chronology of the Paintings*

We have seen that the documents of 1562–64 concern the building of a system of wooden benches, desks, and "shelves" or *corsii,* and that they also include a "pala." We noted that in the one recorded payment to Zelotti, 417 lire paid to him in 1564, no specification whatever is offered of what kind of work this payment was meant for, nor are we

informed whether it was a full payment or just an installment (see II.3 above and appendix 1). The possibility remains, therefore, that the painted decoration of the library was executed after the benches, shelves, and perhaps an original "palla."

Let us review previous opinions concerning the dating and then study the question in terms of Zelotti's stylistic development. Zava Boccazzi's dating in 1970 of the Library ceiling paintings to 1566 was based on the idea that this cycle belongs after the decorations at the Villa Emo (for which she accepted Pallucchini's dating of 1565) and prepares for the decorations at Cataio of the early seventies. She also implied that during the period of the early sixties Zelotti was busy at the Monte di Pietà in Vicenza (1558−63) and at Brugine (ca. 1560) and La Malcontenta (ca. 1561), although she assigned the refectory paintings to ca. 1562.[25] In 1985, Zava Boccazzi modified her opinion and argued that the payment to Zelotti in 1564 is for paintings in the Library; she assumed that the "palla" meant the wooden framework of the ceiling and stated that the pictorial decoration of the library was "progettato e subito avviato nel 1562"; Brugnoli Meloncelli in 1992 simply summarized her argument.[26] (On the word "palla," see our discussion of document 6, II.3 above). In 1968 Pallucchini had briefly addressed the question of chronology, mentioning that Zelotti was active at Praglia in the period 1559−64 and suggesting that the canvases now in the Refectory might have been done after the ceiling pieces.[27]

The style of Zelotti's paintings for the ceiling and the walls of the Library suggests that they were executed at some distance from the *Assumption* in the church of Praglia, documented as of 1559 (Fig. 31),[28] and also well after the contemporary organ shutters for the same Santa Maria di Praglia, now in the Museo Civico in Padua.[29] In these canvases, Zelotti's forms are still close to those we see in his two surviving *tondi* of 1557 on the Marciana Library ceiling: carefully modeled with relatively small brushstrokes, draped with rather close-fitting cloth articulated in smooth, repetitive, sometimes "watery" folds (Figs. 32−33). Nor do the Library paintings seem contemporary with the two altarpieces done by Zelotti for the Duomo of Vicenza, the *Miraculous Draught of Fishes* and the *Conversion of Saint Paul,* presumably put in place by 1562, which still are stylistically close to the organ shutters from Praglia.[30] The pictures for the Library at Praglia resemble more the altarpieces by Zelotti now at San Rocco in Vicenza and thought to date from the end of the sixties or the seventies: the forms are grander with fuller proportions, and the draperies are looser, more boldly rendered with more generous folds.[31] In fact, the *Pentecost* in San Rocco is essentially the same composition as the *Pentecost* at Praglia, somewhat calmed by the arched shape of the canvas and more closed pose of the Virgin.[32]

The examples of dated canvases in Zelotti's oeuvre, however, are few, so we shall have to consider comparison with fresco decorations as well. Key points in the chronology of Zelotti's decorative cycles are: the Villa Godi from the mid-fifties (here we accept Crosato's dating);[33] the Villa Emo from ca. 1565 (here we concur with Pallucchini's dating);[34] the Villa Caldogno, dated 1570 on its facade, yet the frescoes seem to just precede this;[35] and the rich complex of frescoes at the Castello del Cataio dated 1570−73.[36] Limiting our comparisons to these rather secure examples, the somewhat grander, bolder, and looser style of the works on canvas for the Library at Praglia compares most close-

ly with that of the frescoes by Zelotti in the Villa Caldogno. Even though Zelotti's fres-
coes in the *stanze* at Caldogno are somewhat damaged, we can see the similarity of such
a scene as *Virtue and Vice* from the Stanza di Scipio at Caldogno (Fig. 35) to *Christ
Expelling the Money Changers* at Praglia (Fig. 45). The gestures of the fallen figures, the
very small heads and simplified features of the two females, the relatively large folds of
drapery are all very close. We might also compare the damaged scene of *Sofonisba Receives
the Poison* at Caldogno (Fig. 34) with that of *Solomon and the Queen of Sheba* (Fig. 47) at
Praglia: the extremely elongated proportions, coiffures, and costumes of the women are
close, and the left hand of the poison bearer is constructed precisely like that of the
repoussoir figure in *Solomon and the Queen of Sheba*. The stylistic evidence, then, seems to
support Zava Boccazzi's earlier argument: that the Praglia ceiling was executed after the
Villa Emo decorations, begun ca. 1565, and close to the complex at nearby Cataio, begun
in 1570. There is, however, no stylistic difference between the ceiling and wall paintings
for the Library, and there is every reason to assume that they were executed as part of the
same campaign, at the end of the sixties or the beginning of the seventies. In subsequent
chapters we shall show that wall and ceiling paintings are programmatically connected
throughout and that they must have been commissioned as one.

6.3 A Cycle in the Anteroom Ceiling?
We have noted above that in the anteroom ("atrio") the ceiling has a clearly sixteenth-
century wooden framework. This structure creates nine compartments, the central one
being a large oval (Fig. 14). The compartments are empty, letting us see the wooden
boards in the ceiling. Certainly such a framework would not have been built unless some
plan had been devised for filling up the system with paintings. (It is likely that there was
some plan for the walls as well, but for this we have no evidence whatever, not even a
framework or an opportunity to look closely for clues, since the walls of the anteroom are
now covered with shelves matching those of the Library.) It is remarkable that in the
extant painting decorations of the Praglia Library, there is not a single reference to Saint
Benedict himself, and it is tempting to conjecture that the anteroom ceiling was intend-
ed for a cycle concerning him. In the more modest fifteenth-century library at Santa
Giustina, Padua, Saint Gregory is represented in the lunette in the hall over the entrance,
and Saint Benedict is represented beside the Virgin on the wall opposite the entrance
(Figs. 21–22).

On the basis of Saint Gregory's second book of *Dialogues,* which tells the life of
Saint Benedict, and probably developed in illustrated manuscripts of it, some fifty events
from the life, death, and glory of the saint have been identified and used in later cycles in
various media, such as the fifteenth-century frescoes in the cloister of Santa Giustina at
Padua and the engravings in the Rome 1579 edition of his life.[37] T. E. Cooper has expli-
cated at length their use in the choir stall carvings completed in 1598 at San Giorgio
Maggiore in Venice, also a member of the Cassinese Congregation.[38] In our case, it quite
obviously does not make sense to try to guess from these lengthy catalogues what par-
ticular scenes might have been chosen for the nine compartments in the Praglia ante-

room. But the Roman Breviary and the Benedictine Breviary provide a much more restricted selection, and here, in fact, in the reading for 21 March (Saint Benedict's day), we find exactly eight stories, as follows (all of which are represented in the above cycles): *Lectio* IV: 1. Transfer from Rome to Subiaco ("in altissimam speluncam"). 2. Receives Romanus. 3. Tempted by the devil, covers himself in spiny shrubs. 4. Jealous monks try to poison him, but the cup is broken at the sign of the cross. *Lectio* V: 5. Builds twelve monasteries. 6. Transfer to Cassino, where he destroys the altar with Apollo's image; builds there a chapel for Saint Martin and an "aedicula" for Saint John. 7. King Totila submits to Saint Benedict, who predicts his life and death. *Lectio* VI: 8. Saint Benedict's death and assumption. The latter event is depicted, in the Breviary reading, as a true assumption and glorification, including also the road to heaven (as in the eleventh-century *Codex Benedictus,* see below), a scene very suitable for a centerpiece in the ceiling.[39] The scenes mentioned in the Breviary are represented as follows in the 1579 engraved edition of the Life of Benedict: 1 and 2 are in figure 4; 3 is in figure 8; 4 is in figure 9; 5 is in figure 12, which shows only six of the twelve monasteries he built; 6 is in figure 18; 7 is in figure 25. The death and assumption of Saint Benedict, number 8 in our list from the Breviary, take up three engravings: figure 47 shows the death; figure 48 shows the road to heaven, as in the earliest illustrated Life of Benedict at the Vatican (mentioned above), and figure 50 shows his glory in heaven with the Trinity.

Since the anteroom ceiling has nine compartments, including the large central oval compartment, it seems plausible to conjecture that the eight surrounding compartments were taken up by the eight stories as recorded in the Breviary, while the central compartment showed the assumption or "glory" of Saint Benedict—thus set apart from his death and burial. The examples in the engraved edition of 1579 show that the events around Benedict's death might be separated in illustrations. Perhaps an ordinary "glory" representation, with the saint hovering in the air surrounded by angels, like that of Saint Bruno at the Certosa di Galluzzo (Florence), is not as likely as the "road to heaven" in the case of Saint Benedict, for the pictorial tradition, attested as far back as around the year 1070, in the so-called *Codex Benedictus,* follows Saint Gregory's *Dialogue II,* chapter 37, in which a road of light leads up to heaven, a sign of his ascent (fol. 80r). In the same codex, the subject is repeated in the Life of Saint Mauro (fol. 140v), and here we also see the "homunculus"-shaped soul of Saint Benedict being led up the road by an angel (lectures for the feast of Saint Mauro).[40] We might offer a further speculation, based purely on what is *not* in the extant decorations of the Praglia Library (but would have had precedents in the monastic library decorations at San Bernardino in Verona and San Barnaba at Brescia), that the intent may have been to decorate the walls of the anteroom with learned Benedictines, from Gregory the Great to Ludovico Barbo.

Did the Benedictines at Praglia associate Jacob's ladder as referred to in the *Rule* (see below) with this image of the path of light on which Saint Benedict's soul, helped by an angel, is ascending upon his death? In *Paradise,* canto 22, Dante meets Saint Benedict, and the context, set out in canto 21 (28–42), is, in Peter Hawkins's terms, one of "valuation of the contemplative life over the active": "I saw the color of gold on which a sun-

III

The Benedictine Tradition of Books

HAVING DECIDED ON OUR PROPOSAL for a reconstruction of the Library furniture and the original placement of the wall paintings now in the refectory, we should be ready to tackle the issues of pictorial content and program unity with regard to the ceiling and the wall paintings. At this time in the sixteenth century, however, no fixed traditions seem to have existed specifically for library decorations; nor was there any particular ritual function like a liturgy for library use to direct our interpretations. We must, therefore, have recourse to more general evidence regarding book and library usage in Benedictine and other monastic contexts, both in Italy and abroad. We have found very little directly pertinent material concerning Praglia itself. On the other hand, we shall show that not only reading and library traditions, but also—and specifically—the rule for the Benedictine Order (Saint Benedict's *Rule*), focus very strongly on the role of reading and literary studies, forcefully enough, in fact, to make a case for seeing a library as a place worthy of great attention to pictorial messages. There is an enormous modern literature on the role of reading in the medieval and post-medieval period; we limit our references to what has seemed to us to be of closest relevance.

1 The Rule, the Bible, and the Fathers

The Benedictine Order's traditions concerning reading, books, and even monastic library usage were initiated by the founder in the sixth century, developed during the Middle Ages, and renewed by Ludovico Barbo.

From the beginning, reading was fundamental to Benedictine monastic life. Saint Benedict (480–547) established the first monasteries himself and, evidently drawing upon wisdom gathered in his experience as abbot, wrote his brief *Rule,* arranged in seventy-three paragraph-long chapters. After the Bible, this was the most important book in a Benedictine monastery and was virtually memorized by the brothers. In fact, Saint Benedict in his Prologue refers to the monastery as "a school for monks," and we shall return to this subject in chapter VI. Most of the *Rule* was copied from the earlier so-called *Regula Magistri*.[1] In various chapters, the *Rule* prescribes reading as a basic activity, placing the Scriptures first, but also specifying the writings of the Fathers of the Church. The last chapter of the *Rule* is worth quoting in full:

The reason why we have written this rule is that, by observing it in monasteries, we can show we have some degree of virtue and the beginning of monastic life. But for anyone hastening on to the perfection of monastic life, there are the teachings of the Holy Fathers, the observance of which will lead him to the very heights of perfection. What page, what passage of the inspired books of the Old and New Testaments is not the truest of guides for human life? What book of the holy catholic Fathers does not resoundingly summon us along the true way to reach the Creator? Then, besides the Conferences of the Fathers, their Institutes and their Lives, there is also the rule of our holy father Basil. For observant and obedient monks, all these are nothing less than tools for the cultivation of virtues; but for us, they make us blush for shame at being so slothful, so unobservant, so negligent. Are you hastening toward your heavenly home? Then with Christ's help, keep this little rule that we have written for beginners. After that, you can set out for the loftier summits of the teaching and virtues we mentioned above, and under God's protection you will reach them. Amen.[2]

One other basic early source for Benedictines is the second book of the *Dialogues* of the Benedictine pope Saint Gregory the Great (590–604), which tells of Benedict's life, including a series of miracles. It says that Benedict founded twelve monasteries, the chief one being at Monte Cassino, at the site of a temple to Apollo. Sometimes the *Rule* and *Dialogue II* were printed together, or copied together, indicating their joint importance in a Benedictine monastery.[3] It is useful, for further reference, to note the provisions of the *Rule* concerning reading.

Chapter 4 is titled "Quae sunt instrumenta bonorum operum" (What are the tools of [our] Good Works). Among the tools given are "lectiones sanctas libenter audire, orationi frequenter incumbere" (to listen readily to holy reading, to devote yourself often to prayer), indicating that these are actions of good works, that is to desire and enjoy reading or listening to the reading of sacred texts and to busy oneself often with prayer.[4] In ranking among the "tools for good works" of chapter 4, the linked tools of reading and prayer are placed with other tools that Benedict considered key, mainly consisting of paraphrases of the Ten Commandments and of the Sermon on the Mount.

Chapter 38 specifies that reading will always accompany the meals of the brothers and that one reader is to be assigned to do the readings for the period of a week, starting on Sundays. He is to ask the others to pray "that God may shield him from the spirit of vanity," but "brothers will read and sing, not according to their rank, but according to their ability to benefit their hearers." The others are to be silent during the meal, and the reader "is to receive some diluted wine before he begins to read."

In chapter 42, Benedict says that on days when there are two meals, someone should read after supper from the Conferences or the Lives of the Fathers. Also, "On fast days there is to be a short interval between Vespers and the reading of the Conferences . . .

then let four or five pages be read, or as many as time permits. This reading period will allow for all to come together. . . ."

In chapter 47 Benedict, speaking of those leading the psalms or refrains, again stresses: "None should presume to read or sing unless he is able to benefit the hearers; let this be done with humility, seriousness and reverence, and at the abbot's bidding."

In chapter 48 there is a discussion of the schedule for manual labor and its variations according to season. In all versions of the daily schedule a period of reading is specified.

> From Easter to the first of October, they will spend their mornings after
> Prime till about the fourth hour at whatever work needs to be done. From
> the fourth hour until the time of Sext, they will devote themselves to reading.
> . . . From the first of October to the beginning of Lent, the brothers ought to
> devote themselves to reading until the end of the second hour. . . . Then after
> their meal they will devote themselves to their reading or to the psalms.

The most reading time is specified for Lent, and it is here, still in chapter 48, that Benedict speaks of a library:

> During the days of Lent, they should be free in the morning to read until
> the third hour, after which they will work at their assigned tasks until the
> end of the tenth hour. During this time of Lent each one is to receive a
> book from the library, and is to read the whole of it straight through. These
> books are to be distributed at the beginning of Lent.

The importance of reading is stressed:

> Above all, one or two seniors must surely be deputed to make the rounds
> of the monastery while the brothers are reading. . . . On Sunday all are to
> be engaged in reading except those who have been assigned various duties.
> If anyone is so remiss and indolent that he is unwilling or unable to study
> or to read, he is to be given some work in order that he may not be idle.

Benedict's *Rule* establishes the fundamental importance of reading in monastic life and provides for its incorporation in the fabric of the daily rituals. Biblical readings and writings by the Church Fathers are specified. In Smalley's summary: "Following Cassian the founders of Western monasticism incorporated *lectio divina* or *lectio sacra* into their rules. St. Benedict allotted two hours on weekdays, three in Lent, to private reading; on Sundays it replaced manual work. The books of the Bible were to be distributed to the brothers for reading during Lent."[5]

In the Benedictine tradition reading is not only connected with Scripture, called "lectio Biblica" and ranked a tool for good works, it is also advocated as a means to meditation.[6] Barbo articulates the connection in his *Metodo di pregare e di meditare,* published in 1443, as we shall see in chapter VI.

There is a very long-standing and richly developed monastic tradition behind these notions concerning study, learning, and wisdom. In the Prologue to his *Rule,* Saint Benedict equates the monastery with a school: "Therefore we intend to establish a school for the Lord's service."[7] Even though Benedict, in adapting from the so-called *Regula Magistri* for his *Rule,* left out most of the other references to terms related to teaching *(magister, magisterium, disciplina, disciplus),* the concept lived on very actively through later monastic tradition, including the Benedictine. The true "magister" is Christ, who is teaching from his *cathedra crucis,* where Christ is the "exemplary book" from which to learn. But later tradition attributes to Saint Benedict the corresponding attitude, if not explicit formulations in the same terms.[8] The monastery, wrote the author of the medieval text *De fructibus carnis et spiritus,* is a school of heavenly teachings for the holy monks.[9] At the same time, the monk's life of prayer and his participation in the liturgy, especially in the Mass and the Divine Office, was conceived of as one dedicated to reading *(lectio)* and meditation.[10] Penco develops this theme in a section appropriately named "Prayer, divine reading, [the] Scripture and monastic life."[11] Divine reading *(lectio divina)* was intimately connected with meditation *(meditatio),* prayer *(oratio)* and contemplation *(contemplatio).* Penco, in a section concerning "Liturgical prayer and private prayer," comments: "The totality of all these spiritual attitudes . . . led to the rise of a devotional literature inspired by the Bible and by the liturgy. . . ." This also led to historical interests in the Benedictine Order, for example, concerning the Hebrew cult, something we have witnessed in the decorations of the library of San Giovanni Evangelista at Parma (see chapters II and VI).[12] As Penco notes, "The conversance . . . with God's Law and the importance of 'divine reading' as a fundamental element of monastic spirituality contribute to enhancing . . . the biblical aspect of prayer, liturgical as well as private. The encounter between devotion and literature . . . was of great consequence for the further development of monastic spirituality."[13] In fact, Saint Benedict instituted Psalter recitation for the entire week. This preoccupation with "divine reading" was intended to activate the internal life of the monks: "What is expressed by our voice, dwells in our heart." This formulation of Saint Augustine's was rephrased by Saint Benedict: "Our minds are in harmony with our voices" (*Rule,* 19:7).[14]

It is evident from the *Rule* that the Benedictine tradition of biblical and patristic scholarship was initiated by Benedict himself. We also know that a strong revival of scholarship coupled with monastic reform had occurred in the Benedictine Order in Italy, led by Ludovico Barbo, abbot of the monastery of Santa Giustina of Padua during the fifteenth century. Recent scholarship, particularly that of Padre Trolese of Santa Giustina, has documented this movement.[15] The renewal of scholarship and reform spirit of the fifteenth century attracted many gifted men to the order and also donations of entire private libraries to the monasteries.

As Santa Giustina was at the center of the collection of Benedictine monasteries that joined the Congregation of Santa Giustina, including Praglia (from 1448, and the Congregation was called "Cassinese" after Saint Benedict's own monastery of Montecassino joined in 1504), it is useful that one of the few inventories that survived Napoleon's massive

disruption of monastic holdings is that of Santa Giustina in the fifteenth century.[16] Scanning the 1337 titles catalogued in 1453, we see a continuation of Benedict's emphasis on the Scriptures, the Fathers, and the *Rule*. There are many editions of the Bible and of parts of the Bible, and of the Breviary (often marked "portatile"), many writings of the Fathers of the Church, both Greek and Latin, as well as many editions of the *Lives of the Fathers,* many copies of the *Rule of Saint Benedict* and also of Saint Gregory's *Dialogue II* with the Life of Saint Benedict, and a few editions of other monastic rules, including that of Basil; some texts by Thomas Aquinas, writings of Saints Bernard and Bonaventura, some Greek and Latin authors such as Aristotle, Plotinus, Pliny, and Virgil; Dante and Petrarch; some grammars, books of Greek vocabulary, and medical books. Religious titles dominate strongly and include (besides those just mentioned) several copies of the *Meditations of Saint Augustine* and of the *Imitation of Christ*. The inventory is in Latin, and most of the books are in Latin; many are in Greek, and only a few are "in volgare."

2 Benedictine Library Usage

Following the principles established by Saint Benedict in his *Rule,* and briefly noted above, the Benedictine Order further developed routines for annual reading among the monks that included "edificational" books in addition to those on dogmatics and liturgy.[17]

Albers's series of *Consuetudines monasticae* (begun in 1905) and the more recent one, *Corpus consuetudinum monasticarum,* both of which cover the periods from the tenth until the fourteenth century and concern pre–book printing centuries, contain much information on Benedictine library practice. The "circle" was annual; each monk had to account for his reading of the texts handed out to him the previous year. The exchange took place at Lent, in a rite starting with the proper liturgical reading and a sermon by the abbot.[18] *Consuetudo* XII gives further details in "De tempore Quadragesimae": at the *feria secunda* the books to be read during the coming year are placed on a carpet or cloth in the Chapter house, and before the distribution, Saint Benedict's "De observatione Quadragesimae" is recited.[19]

In the *Consuetudo* II (thirteenth century) there is a special paragraph on consultation books, and these are distinguished from books for everyday (liturgical) use and books for the instruction and edification of the brethren. The situation envisaged here does not seem to involve a reading room, and books were usually lent out to the monks separately.[20] According to the *Consuetudo* for Stift Melk (late fourteenth century), books were lent out to people outside the monastery, too, with the provision of a signed receipt or other qualification.[21]

In addition to these various categories of books and book uses, there is one particular category that deserves attention here, the "processionals." These books contain litanies and texts (Gloria, psalms, etc.) provided with musical notes. These books are usually small and produced in a number of copies. One or two brethren would sing from each of them during the processions from the church and in the cloister. At Santa Maria degli Angeli, Assisi, six

identical processionals are preserved, while an earlier example from San Marco, Venice, is in the Biblioteca Correr, and a fifteenth-century one, originally from the Benedictine monastery of San Giovanni Evangelista at Parma, is extant in the abbey of Sant'Andrea della Castagna (Genoa).[22] Since Praglia belonged to the same Congregation as the Parma monastery, the monks there probably used processionals similar to the one now at Sant' Andrea della Castagna. It consists of one sheet with a litany and thirty-eight sheets with the musical texts, all of parchment (24 × 17 cm). It contains a prayer to Saint Benedict. After the initial litany are "short litanies to be sung [going] through the cloister."[23] The chapters come as follows: "In the feast of the Purification of the Virgin, at the procession"; "On Palm Sunday, at the procession"; a rubric for this (see below); a rubric for Good Friday; sung texts for the same day; a litany, and a long rubric for funerary processions (where there is reference to "this abbey of San Giovanni Evangelista at Parma"); sung texts for this rite; two sheets with later additions; another (original) litany including "The holy father Benedict."

There are several factors connected with sixteenth-century conditions that render a comparison with "medieval" conditions somewhat precarious; these may be listed as follows:

1. Since the fourteenth century, at least, there occurred an activation of a general "book culture"—also in terms of large private collections.[24]

2. The new printing technique brought about increased book production.

3. Intensification of publication exchange was caused by "religious" (in a wide sense of the term) debates preceding and during the Reformation and the Catholic Reform. Gerolamo Aleandro, papal nuncio to the emperor in Germany, complained in 1537 that so far there was no serious opposition to the Lutheran publications that were flooding the market.[25] It has been affirmed that "only towards the end of the century did the [Roman] Church grasp the real role of the printing press as a propaganda means."[26]

4. A systematization of archives and libraries followed in the wake of the Council of Trent.

Nevertheless, it is convenient to have in mind some of the principal features in the monastic library tradition of earlier centuries. The practice established then was continued into our period.[27]

In ecclesiastic and monastic contexts, we may distinguish the following kinds of library functions. First, there is the collection for regular use during the canonical hours and during the year in the liturgy and paraliturgical rites: the service library. Second, we have the less well-defined category of "religious" texts for annual circulation among the monks according to fixed rules (see below): a circulation library. Third, there is the collection (to the extent that it existed) of literature for special consultation in the sense of a modern library: a consultation library, for using inside or, occasionally, on loan to external readers. The literature concerning "medieval" monastic libraries seems not to discuss these important distinctions. Since the service and circulation collections were subjected

to fixed liturgical and ritual rubrics or to local practice based on the actual monastic rule, it is not surprising that we find better documentation for these and only rare evidence for a consultation library.

The regular circulation was annual and hence not so frequent as to demand topographical proximity between the library and the rest of the monastery with its church. At Praglia, therefore, the sixteenth-century Library could very well have served this function in addition to that of being a general consultation library. Previously, in many cases the monks would have had to bring their "annual" books to their cells. The "armarii," or cupboards that constituted the "library," may have been placed somewhere in the monastery, while special books and documents, as well as tools for book production and binding, were kept in a cupboard in the church itself; this was apparently the case in the twelfth century at Fruttuaria in Piedmont and at Saint Blasius in Schwarzwald.[28] Proper reading rooms ("Studienbibliotheken"), as well as *scriptoria,* are attested for a number of monasteries within what is loosely styled the "Gothic period," i.e., in Germany after the middle of the fourteenth century, "corresponding to the heightened requirements of the activities of scholastic science."[29] Not surprisingly, one of the first printing presses in Italy was at the Benedictine monastery at Subiaco.[30] The arrival of the printed book certainly caused a rapid increase in the book collections and must have caused storage problems and motivated the construction of monastic libraries. With a reading room in the monastery, external persons, who would previously have had to take away books they wanted, could now be expected to consult them in the reading room. Furthermore, having a proper reading room must have been considered a matter of prestige for the monastery—a display of the learning for which it wanted to be known.

Since a ritual reading was held during meals in the refectory of the Benedictine monastery, there are particular provisions for the keeping of books dedicated to this use.[31] When the wall paintings from the Praglia Library were removed and installed in the refectory, this amounted to a liturgically meaningful "storage." The refectory had its proper liturgy, which the reading room of a library does not possess. Books were read as a part of the refectory rites (according to the *Rule,* chapter 38, cited above), so that one might say that the two spatial units were functionally interconnected. In terms of the regularized monastic life of Praglia, the paintings could function in the refectory.

We do not possess a complete inventory for the Praglia Library during this period, but a small selection of manuscripts noted by Tomasini in 1639 includes liturgical books (missal, hymnals), biblical texts of the Evangelists and Saint Paul, commentary on the Apocalypse, the sermons of Saint Gregory, Saint Bonaventura's *Apologia,* the Life of Saint Jerome, grammar and rhetoric books, and Saint Benedict's *Rule.*[32] Only Sanudo's similarly selective list of manuscripts remains for the lost library of the monastery of San Giorgio Maggiore in Venice, where a library room inaugurated in 1478 had evidently been funded by Cosimo de' Medici after his sojourn there with the Benedictines in 1433.[33] The thirty titles given by Tomasini for Praglia suggest a range of material comparable to that discussed above, which is documented in the surviving inventory of 1453 for the library of Santa Giustina at 1,337 volumes.[34]

Since the library room built at Santa Giustina in 1461 exists and we know its dimensions are somewhat smaller than those of the Library at Praglia, it is likely that the capacity of the Praglia Library as originally furnished was at least comparable to that of Santa Giustina, perhaps around fifteen hundred volumes.[35] When the larger Laurentian Library opened in 1571, nearly three thousand volumes were chained to the shelves;[36] and the Laurentian Library had twenty-four benches and shelves in each row as opposed to fourteen in each row at Praglia, as we have reconstructed it. This evidence provides only an approximate idea of the capacity of the Praglia Library as originally furnished, partly because we do not know from the inventory of Santa Giustina whether some of the listed books were stored outside the library. In the much earlier case of an inventory of 1362 from San Giorgio Maggiore in Venice, fifty-eight manuscripts are itemized, and it is added that about twelve other books are in a cupboard in the sacristy.[37]

Two gifts of private libraries from young monks entering Praglia augmented the collection in the fifteenth century and may have spurred the building of the Library Room. Both came shortly after Praglia joined the Congregation of Santa Giustina in 1448. The first gift of codices in 1456 was from the monk Michele Selvatico, a Venetian. The second was a gift of one thousand gold ducats from an entering monk, Paolo Fexi, two hundred of which were dedicated to the Library. Carpanese believes that at this time the library was housed in one of the big rooms on the ground floor of the *chiostro doppio,* and that the Library Room was built in the sixteenth century.[38]

In this chapter, we have taken stock of the more important issues concerning Benedictine library usage as a background for understanding the functioning of the Praglia Library, and we have also brought together the available information regarding collections here and in certain other relevant cases. We have seen that use of books in a Benedictine monastery extended beyond what we might today consider typical for a library. The crucial question is the religious and spiritual role of such a library, and to this subject we shall return in chapter VI.

Our knowledge about library conditions and use specifically at Praglia is scarce, to say the least. In this period Praglia, like all other Benedictine establishments in the Cassinese Congregation, followed the letter and presumably the spirit of the *Rule of Saint Benedict.* At the same time, usages concerning reading and circulation of books were codified in many Benedictine monasteries in Europe, and records of their usages tended to circulate and spread among the various congregations and monasteries. Therefore, we assume that the general tendencies culled from the above-cited documents prevailed at Praglia as well. Such "bookish" attitudes would have prepared the monks at Praglia for alertness to literary messages in the pictorial arts. In this regard it is not irrelevant to point out that most manuscripts and early printed codices were illustrated. We shall return to this matter, too, in chapter VI. We do expect the monks—and also the unidentified ecclesiastical authorities ultimately responsible for the decorations in this specific place— to have been active behind, and also in following up, a decoration program of their Library that conveyed messages which they considered important.

IV

The Ceiling and Wall Paintings in the Praglia Library and Other Benedictine Cycles

CONSIDERING THE EXPERIENCE from pictorial decorations in many churches and chapels, one would assume that the monks at Praglia were used to perceiving a close coherence between themes represented in the various parts of a decoration in which distinct wall or vault sections were spatially connected. So, on the one hand, a unified idea should be predicted also in the series of wall and ceiling paintings being studied here, and a focus might be on the Virgin Mary, to whom the monastery and the church were dedicated. This is exactly what we are proposing: to look at the images with reference to the biblical texts and also to the Breviary, Saint Benedict's *Rule,* and Saint Gregory's *Dialogue II* with the *Life of Saint Benedict.* Support is then sought from other relevant cases, especially the Benedictine cycles at Santa Giustina at Padua and Madonna del Monte at Cesena. On the other hand, it is hard to identify a specific library iconography, since the monastery as a whole was considered a place of meditation and study. Indeed, even the super-articulate Benedictine library decoration at Parma (1580–90) offers just a few, quite generic, points of affinity, and there are even fewer in secular libraries like the Marciana at Venice. Far more useful for Praglia are the ideas that circulated inside and outside the Benedictine order and also those connected with the Council of Trent, as we shall see in chapter v. At first sight, the pictorial program at Praglia seems to be doctrinal in principle rather than narrative.

1 Praglia

In the case of the monastic Library of Praglia, in which the subjects chosen are all religious and all apparently included in a theologically systematic manner, the program must have been developed by one or several people well versed in the matter. Zava Boccazzi associates Abbot Placido da Marostica with decisions concerning the painting program, but his periods of service as abbot do not fit with our dating of ca. 1570.[1] We have found no documentation to help solve this question, but a subsequent documented case in the Congregation of Santa Giustina supports assumptions we make based on the circum-

stances. Whoever might have worked out the program would have had to submit it to authorities at various levels, so that the end product would have been a joint affair. If our dating of the painting cycle close to 1570 is correct, the abbot at Praglia would have been Eusebio da Brescia. Under the Congregation of Santa Giustina (the Cassinese Congregation), however, abbots often served only for a year. This means that any project would have required the cooperation of the leaders and scholars of the community and would not have depended on one abbot.[2] For example, in the well-documented case of Longhena's library for the Benedictines of San Giorgio Maggiore in Venice, construction of the room began under Abbot Squadron in 1654 and the library was completed only under Abbot Sopercio in 1671; the paintings (ca. 1662–64) were executed by Giovanni Coli and Filippo Gherardi at the time of Abbot Codanino, and the walnut shelves by Franz Pauc and his assistants were built and carved between 1665 and 1671. From the contemporary account of iconographical considerations by Padre Marco Valle concerning the San Giorgio library, we learn about the quite elaborate planning concerning the content of paintings and their placement in relation to each other and to the library user.[3] The sequence of abbots at Praglia around 1570 is as follows: Giuliano Carena da Piacenza (1569 only); Eusebio da Brescia (1570–71); Damiano da Novara (1572–73); Placido da Marostica (1574, evidently very briefly); Celso Guglielmi da Venezia (1574–80). This represents only part of the complexity, since others in the monastery and in the Congregation, perhaps those known particularly for their biblical and theological learning, would probably have been consulted. We shall return to this matter in our final chapter, when we pull together the threads of our argument.

1.1 *The Ceiling Paintings*

Here we give basic narrative contents concerning biblical references for the ceiling paintings, and we consider how Zelotti presents the subjects in terms of composition, color, and other elements of style. We leave further interpretation for chapter VI. For the English translation of the scriptural quotations we use Knox, who based his translation of the Bible on the Vulgate in the light of the original Hebrew and Greek. We reason that this is as close as we can get to what the Cassinese Benedictines would have been most familiar with, since in our next chapter we see that their representatives at Trent advocated the Vulgate revised in the light of the Hebrew and Greek for the authoritative translation. In several cases the biblical story is too complex and rich in connotations to be really classified according to some specific notion of what the "facts" are; this difficulty applies to biblical iconography in general, unless it belongs to a liturgical context. Because the monks of Praglia, and other users too, would have been familiar with the liturgy, biblical texts used for the program would have been considered also for their liturgical use, whenever they were so used; therefore, we cite liturgical usage whenever it applies. In this case we refer not just to the Mass liturgy but also to the Breviary (revised by Pius V in 1570), since a monastery functions in terms of the daily times for prayer: Lauds, Prime, Terce, Sext, None, Vespers, Compline, and in Benedict's *Rule* also Vigils,[4] making eight times for prayer in the Benedictine monastery. This Divine Office is continually referred

to in the *Rule* as the Work of God, and although Saint Benedict provides a flexible program with variables to be left up to each community or abbot, he insists that all one hundred fifty psalms be read in the course of any week.[5] There is naturally no ruling concerning Mass liturgy in the *Rule,* since this is not a competence of a monastic order.

There are fifteen ceiling paintings in a wooden frame system that forms fifteen compartments; these are bisymetrically arranged as a center set with ovals at the ends, an octagon in the middle, and squares in between, with flanking pairs respectively of squares, ovals, and rectangles (Figs. 29–30, 56; Pl. ii). The dimensions of the canvases are all variants of 180 cm and 320 cm. Between the entrance and the north wall, then, are five groups of three paintings, which we shall refer to as groups one to five. We begin our description with the middle painting in each group first, continue with the left-hand one, and end with the right-hand one (Fig. 28).

Group 1, the closest above as one enters the main room of the Library, features *David and Goliath* in the central oval (1 Sam.[= 1 Kings] 17:4ff.; Fig. 57). The Philistines collected their forces and so did the Israelites under Saul. A gigantic and armored champion named Goliath came out from the Philistine camp for forty days running and challenged the Israelites to battle. Among the Israelites, a young man called David was tending the sheep while his elder brothers fought the Philistines under Saul. One day, when Goliath appeared again, and frightened the Israelites, David was present, and he asked: "What reward is there for saving Israel's honor, by overcoming the Philistines? What, shall an uncircumcised Philistine defy the armies of the living God?" (1 Kings 17:26). Wanting to fight Goliath and being discouraged by his own party, he insisted, saying, among other things: "I used to feed my father's flock, and if lion or bear came and carried off one of my rams, I would go in pursuit. . . . Lion or bear I would slay them, and this uncircumcised Philistine shall have no better lot than theirs. . . . The Lord . . . who protected me from lion and bear, will protect me against this Philistine" (1 Kings 17:34–37). Facing Goliath with a sling in his hand, David challenged the giant with (among others) these words: "thou comest with sword and spear and shield to meet me, meet thee I will, in the name of the Lord of Hosts; in the name of that God who fights for the armies of Israel . . . and this day the Lord will give me mastery; I will strike thee down and cut off thy head. I will feed bird and beast with the corpses of Philistine warriors; prove to all who stand about us that the Lord sends victory without the help of sword or spear" (1 Kings 17:45–47). Then David killed Goliath with his sling and cut off his head. According to a victory song (1 Kings 18:7), ten thousand Philistines died in the aftermath.

In the Praglia Library, the oval with *David and Goliath* is directly overhead as one enters (Fig. 29). Zelotti's depiction (Fig. 57) takes this placement into account. The figures are sharply foreshortened, the powerful form of Goliath crumpled forward as the small David behind raises his sword to sever the giant's head. Clearly Zelotti was familiar with Titian's ceiling painting of the same theme, dated 1542, then in Santo Spirito in Venice and now in the sacristy at the Salute. We are not sure of the original appearance of the sky in Titian's work, since during cleaning at the Laboratorio San Gregorio in Venice the Soprintendenza discovered that the sky, lost through water damage, had been repainted in

the seventeenth century.⁶ Battista Zelotti's solution is, in any case, highly effective. David rises ready to strike, his hands forming the apex of a pyramid over Goliath; the triangular white cloud behind him echoes and emphasizes his outline, while the light coming from above illuminates his serene face and blesses the beheading.

To the left of *David and Goliath* is the *Samian Sibyl,* and to the right is the *Tiburtine Sibyl* (Figs. 58–59). In the opposite corners, there are, on the left, the *Erythraean Sibyl,* and, on the right, the *Cumaean Sibyl* (Figs. 70–71). Zava Boccazzi traced the inscriptions that accompany the Sibyls to a fifteenth-century treatise by a Dominican, Filippo Barbieri, referring to two versions in the Biblioteca Marciana, Venice, one of 1481 and one printed after 1500, seemingly in 1546.⁷ We quote them in our notes below. The version of 1481 is hard to read, because the inscriptions are placed on rolling scrolls where parts of the lettering are hidden. The Praglia inscriptions are closer to the shortened inscriptions of the later version but do not correspond exactly. They may, therefore, derive from another source or another version, or they may have been intentionally modified. The traditional role of the Sibyls in a Christian context is as representatives of the pagan world who announce the coming of Christ. In Veronese's contemporary decoration of the church of San Sebastiano in Venice, the same four Sibyls, identified by their names without further inscriptions, are frescoed below the arch framing the choir area on which Paolo painted the Annunciation (Figs. 36–37).

Let us cite the texts accompanying the four Sibyls together at this point, giving the inscriptions from the two versions of Barbieri at the Biblioteca Marciana, Venice, in notes. This will both document the variations in the inscriptions and allow us to compare the inscriptions at Praglia to see whether they offer a basis for deciding on which sides to locate, respectively, the wall pictures from the Old and the New Testaments. On the left side near the entrance is the Samian Sibyl: "Ecce veniet dives et nascetur de paupercula et bestiae terrae adorabunt eum";⁸ and near the end wall at the left is the Erythraean Sibyl: "In ultima aetate humiliabitur proles divina unietur humanitati divinitas."⁹ On the right-hand side near the entrance is the Tiburtine Sibyl: "Nascetur Christus in Bethlehem o felix illa mater cuius ubera illum lactabunt";¹⁰ and then the Cumaean Sibyl is next to the north end wall: "Magnus ab integro seculorum nascetur ordo iam reddit et virgo redeunt saturnia regna iam nova progenies coelo demittitur alto."¹¹ Clearly, all these texts refer to the incarnation, the birth of Christ and its effects, but it is on the right side, in the inscription held up by the Cumaean Sibyl, that we are told explicitly about Christ being born in Bethlehem, and born of a virgin, and about the coming of a new, "Saturnian," age. It would be surprising if this inscription had been placed on the side chosen for the Old Testament scenes rather than those of the New Testament. This allows us to conclude that the wall paintings were originally arranged as shown in our reconstruction, that is, with the Old Testament series on the left and the New Testament series on the right—as seen from the entrance. This is the arrangement, again as viewed from the entrance, both on the walls of the Sistine Chapel and at the main altar of San Giorgio Maggiore in Venice, with Tintoretto's *Manna* on the left and his *Last Supper* on the right.

Narrative series in the naves of churches often started near the sanctuary and

ended near the entrance wall in cases involving two narrative series, as in the lower and upper churches at Assisi or in the Sistine Chapel in the Vatican. In the Madonna del Monte at Cesena and at Pomposa the series start and end near the altar (see pp. 51–52). Thus there is no fixed rule for this.[12] Nor is there a fixed rule with regard to vantage point. In the Cappella di San Zeno (817–24) in Santa Prassede, Rome, and, to take a much later example, in the ceiling of the Madonna dei Miracoli (early sixteenth century) in Venice, the pictures are seen correctly from the altar, while in most cases they are clearly meant, as in the Praglia Library, to be seen from the entrance.

Now we return to our description of the ceiling paintings of Group 1. The *Samian Sibyl* (Fig. 58) to the left of *David and Goliath* (Fig. 57) appears to share the "sky line" of David's cloud (Fig. 56); perched in her corner, she turns toward the David scene and gazes upward toward the light source, forming the "lost profile" so typical of Zelotti's figures. She rests the tablet of her inscription lightly on her left thigh, supporting it with her left hand while her right hand gestures to her own breast. Opposite, the *Tiburtine Sibyl* (Fig. 59), backed by the same bank of clouds, sits turning to the right, tipping her tablet forward for us to read. Her bright vermilion dress is emphasized by the pink mantle that surrounds it, balancing the orange ocher and green earth tones of the *Samian Sibyl*. Thus draperies of each Sibyl pick up colors from the central oval with David's pink tunic and Goliath's drape of red ocher. In this first trio of paintings, we see Zelotti's sensitivity to site, including the dramatic foreshortening and the continuity of the illusion of sky across the three canvases, and his balancing of color and form. Less expected, perhaps, is the clarity with which he presents David's act as just.

Group 2 has in the central position a square canvas with *Saints Ambrose and Augustine* attacking some people with a hammer and a whip (Fig. 60); the traditional, and evidently correct, interpretation is that the people are heretics. Augustine combated Manichaean teachings and the Pelagian heresy, which held that humans can save themselves, while Ambrose attacked the Arians, who denied the Trinity. The Breviary reading for Augustine's feast, 28 August, says that he started a violent campaign against the Manichaean heresy and confuted the teachings of Fortunatus. The Breviary reading for 7 December, the Feast of Saint Ambrose, says that as bishop, he fervently defended Catholic teachings and converted many Arians and other heretics to the truths of the faith.[13]

The composition of *Ambrose and Augustine Attacking Heretics* is appropriately forceful. Zelotti seems to take into account its position with respect to the visitor, just following the David and Goliath above the entrance (Pls. I–II, Fig. 56). The scene is again rather sharply foreshortened, the architectural setting seen from a low viewpoint and the figures arranged so that victors and the defeated recall depictions of *Virtue Overcoming Vice* in earlier ceiling paintings by both Zelotti and Veronese (for example, Veronese's canvas in the Sala dei Tre Capi, Doge's Palace, Venice, 1554, and Zelotti's roughly contemporary picture now in the Pinacoteca Civica, Bologna). The figural grouping forms a pyramid that seems to amplify the smaller pyramid of the preceding grouping of *David and Goliath* (Fig. 29). Looming into the foreground, the older bishop Ambrose (340?–397) raises—to the top center of the canvas—a tripartite whip symbol-

ic of the Trinity, and the younger Augustine (354–430) brandishes a hammer against a man whom he holds forcefully by the scruff of the neck. It is notable that Ambrose also holds his nearer victim, by the left arm, and that this heretic, fallen like the famous ancient statues of Gauls (used earlier by Veronese in the San Sebastiano sacristy ceiling) holds in his right hand a book (Fig. 60). This is a detail to which we shall return. All in all, this large painting is impressive; Zelotti again lets the light come from directly above—to illuminate the impassive face of Ambrose, to shine on the bishops' mitres, and to glimmer on the three bands of the lofty scourge. As in the scene with David, the viewer is clearly being told that the violence is just, and the composition as a whole, in its bright color and equilibrium of forms, is serene. The Mass for Saint Augustine's day (August 28) takes the Epistle from 2 Timothy 4:1–8, including:

> Preach the word: be instant in season, out of season: reprove, entreat, rebuke in all patience and doctrine. For there shall be a time when they will not endure sound doctrine, but according to their own desires they will heap to themselves teachers, having itching ears, and will indeed turn away their hearing from the truth, but will be turned into fables. But be thou vigilant, labor in all things, do the work of an evangelist, fulfill thy ministry. . . . I have fought the good fight, I have kept the faith. . . . there is laid up for me a crown of justice. . . .

The Alleluia for the same Mass uses Psalm 88, verse 21, connecting Augustine with David: "I have found David my servant: with my holy oil I have anointed him. Alleluia."[14]

To the left of *Saints Augustine and Ambrose* is *Samson with the Gates of Gaza* (Fig. 61). This text is not used in the Roman liturgy, but there is an implied reference to Samson in Benedict's *Rule*.[15] The gist of the story is that Samson, a judge of Israel, while spending the night at Gaza in company with a prostitute and surrounded by the Philistines, makes an escape by removing the city gates of Gaza (Judges 16:1–3). The book of Judges is largely a story of Israel's fight against the Philistines: "Then, once again, the sons of Israel defied the Lord, and for forty years he left them at the mercy of the Philistines" (Judges 13:1). A man sent to rescue them was born and given the name of Samson: "no razor must come near his head. And he shall strike the first blow to deliver Israel from the power of the Philistines . . ." (Judges 13:5).[16] Zelotti's depiction of Samson, in an oval frame, simply shows the strong man carrying the gate (Fig. 61). The angle of view matches that of the adjacent *Ambrose and Augustine* (Fig. 60); and Samson moves toward their space, easily carrying his large gate, which resembles a big wooden door, blue sky and puffy white clouds behind him.

To the right of *Saints Ambrose and Augustine* is the oval with *Jacob's Ladder* (Gen. 28:12–20; Fig. 62). We cite the biblical text at length, because it seems to say something quite different from what Saint Benedict's *Rule* and its commentators say about it.

> He dreamed that he saw a ladder, standing on the earth, with its top reaching up into heaven, a stairway for the angels of God to go up and come

down (with angels ascending and descending). Over this ladder the Lord himself leaned down and spoke to Jacob, I am the Lord, he said, the God of thy father Abraham and the God of Isaac; this ground on which thou liest sleeping is my gift to thee and thy posterity. Thy race shall be countless as the dust of the earth; to west and east, to north and south thou shalt overflow thy frontiers, till all the families on earth find a blessing in thee, and in this race of thine. I myself will watch over thee wherever thou goest, and bring thee back to this land again; before I have done with thee, all my promises to thee shall be fulfilled. When he awoke from his dream Jacob said to himself, Why, this is the Lord's dwelling-place, and I slept here unaware of it! And he shuddered; What a fearsome place this is! he said. This can be nothing other than the house of God; this is the gate of Heaven. So it was that, when he rose in the morning, Jacob took the stone which had been his pillow, set it up there as a monument [sacred pillar], and poured oil upon it; and he called the place Bethel, the house of God.[17]

In the *Rule of Saint Benedict,* chapter 7, however, the scene is explicated as an example of humility, with twelve steps of humility spelled out, leading finally to "that perfect love of God which casts out fear (1 John 4:18). Through this love, all that he once performed with dread, he will now begin to observe without effort, as though naturally, from habit, no longer out of fear of hell, but out of love for Christ, good habit and delight in virtue."[18] There are twelve rungs on the ladder in Zelotti's painting at Praglia. There is, however, no contradiction between this interpretation in the *Rule* and the rather proud biblical story; this becomes clear from the way Saint Benedict presents his conception of humility. It also is so in Saint Gregory's words in his *Dialogue II:*

> All this reflects God's boundless wisdom and love. By granting these men the spirit of prophecy, He raises their minds high above the world, and by withdrawing it again He safeguards their humility. When the spirit of prophecy is with them they learn what they are by God's mercy. When the spirit leaves them they discover what they are of themselves.[19]

The *Rule,* chapter 7, "On Humility," starts by quoting Luke 14:11 (or 18:14): "Whoever exalts himself shall be humbled, and whoever humbles himself shall be exalted." The *Rule* goes on to state:

> Accordingly, brothers, if we want to reach the highest summit of humility, if we desire to attain speedily that exaltation in heaven to which we climb by humility of this present life, then by our ascending actions we must set up that ladder on which Jacob in a dream saw angels descending and ascending [Gen. 28:12]. Without doubt, this descent and ascent can signify only that we descend by exaltation and ascend by humility.[20]

There are twelve levels of humility corresponding to the twelve rungs of the ladder, and they are spelled out in the *Rule* and in the commentaries. Also in the chapter on the election of an abbot (chapter 64), Saint Benedict uses Jacob as a model of moderation: "he should be discerning and moderate, bearing in mind the discretion of holy Jacob, who said, 'If I drive my flocks too hard, they will all die in a single day' [Gen. 33:13]."[21]

It is worth noting that Benedict borrowed most of chapter 7, "On Humility," from an even earlier rule, the so-called *Regula magistri,* while changing the text at one important point.[22] The earlier *Regula* spent a long paragraph on the eschatological goal of the ascent up the ladder (meeting God). Saint Benedict initially mentions this but suppresses the corresponding treatment as given by the "Master" and, as Pricoco explains, reinterprets the issue: "Benedict places at the summit of the ladder Charity, discarding the topic of the ultimate end, and instead shows his preference for a different perspective: to see the spiritual way of the monks as an earthly concern and pragmatically working within the monastery."[23] The earlier rule had also stressed the purely monastic and "disciplinary" significance of the monk's ascent up the ladder: "scala . . . nostra est vita in saeculo" (the ladder is our life on earth), and the ascent is identified as the true condition of the monk: "humilitas vel disciplina" (humility or obedience to the rule).[24] At any rate, the famous ladder became the subject of a vast interpretative literature; we cite examples from relevant medieval writings in order to convey a notion of the thematic range.

Smaragdus, in his ninth-century *Commentary on the Rule,* gives a very extensive treatment of the significance of Jacob's ladder and its twelve rungs, distinguishing between various aspects of humility.[25] Martène's (died 1739) *Commentary on Saint Benedict's Rule* is a compendium citing numerous earlier authors of such comments, among them Smaragdus.[26] Much space is dedicated to Jacob's dream and his ladder in the various comments; for the sake of brevity we shall give the references summarily as far they seem to be in interpretative agreement. There are twelve levels of humility, corresponding to the twelve rungs of the ladder, and the ladder refers to the actions of humans, in the words of Smaragdus, "exaltatione descendere, et humilitate ascendere": meaning that humans seek heaven in humility. The rungs of the ladder signify both body and soul (Smaragdus and others),[27] and also the various degrees or levels of humility. It is stressed (by Smaragdus, among others) that "the ladder represents our earthly life which, because our heart is filled with humility, the Lord raises this life up to heaven."[28] After having elucidated all twelve levels of humility, Smaragdus sums up by saying: "When the monk has ascended all these degrees of humility, he directly obtains divine charity. . . ."[29] Bernhard of Montecassino,[30] for one, introduces the term "good works" in this context: "Divine calling (vocation) took hold of those who ascended" *(Divina evocatio ascendendos inseruit)* states the *Rule.* Bernhard's comment here, written in the thirteenth century, is: "Divine calling means election, that God chooses those whom, by virtue of the fruits of good works, in his grace he leads to glory."[31] In the commentaries, this ascending via humility is linked with the overcoming of evil and of the devil, but there are other, less commonly shared, interpretations, as well. Hildemar's ninth-century commentary, for example, interprets the ladder as Holy Scripture and says that "Jacob is a personification of the monks."[32]

In addition to interpretations of the *Rule,* the interpretations of Saint Benedict and John Cassian of Jacob's dream as an allegory of step-by-step moral perfection had literary offspring, including the *Scala Paradisi* by the seventh-century abbot of Mount Sinai, John Climacus. A Latin translation of this text is known from 1294, from which a revised edition was published in Venice in 1531 and reprinted repeatedly.[33]

Medieval illuminations visualizing Jacob's ladder were likely to have been familiar to the scholarly Benedictine(s) who devised the Praglia program. Examples appear in various contexts, including, not unexpectedly, manuscripts of the Rule of Saint Benedict. Many of the illustrations show ascending and descending angels, on a ladder that leads directly to heaven with God at the top. The *Speculum virginum* manuscripts usually include an allegorical ladder with God at the top, a dragon at the bottom, and figures of Virtues and Vices battling on the rungs. In some late medieval examples, the ladder is conflated with the cross.[34] We shall come back to the ideas expressed in these images in chapters VI and VII.

Zelotti's representation of *Jacob's Ladder* (Fig. 62) is particularly lyrical, suggesting that he may have been aware of its special importance. Set in the oval to the right of *Augustine and Ambrose* (Fig. 60), the composition consciously answers that of *Samson with the Gates of Gaza* (Fig. 61) on the other side of the heresy-fighting Fathers. The pairing of Jacob with Samson may derive at one level from Jacob's statement upon waking, quoted above, that "this [place or ladder] is the gate of Heaven." The strong form of the sleeping Jacob resembles that of Samson; the ladder rising diagonally to the right is traversed by a very graceful ascending angel, who turns to look upward at another angel who, stepping downward, gestures toward the first. The yellow light emanating from the clouds behind them indicates divine presence, while the blue sky at Jacob's level below the billowing cloud denotes the earthly atmosphere. In this way Zelotti illustrates the biblical story of Jacob's dream and some ideas of the Benedictine readings given above, most clearly chapter 7 of the *Rule.*

Group 3 has at the center the octagonal ceiling centerpiece, a representation of *Catholic Religion* or the *Church* (Fig. 63), a female holding the cross, denoting the sacrifice of Christ, and the Eucharistic chalice, symbolic of its continual reenactment, accompanied by the four Evangelists, embodying the Scriptures that tell the life of Christ.[35] The life of Saint Benedict as told in Saint Gregory's *Dialogues* contains several stories to show the power of the Eucharistic host.[36] When this female figure is labeled "Faith," it is quite obvious, because of the cross and the chalice, that it is the operative and hence liturgically active faith, and not the human property intended by the northern reformers. We quote again the Prologue to the *Rule:* "Clothed then with faith and the performance of good works, let us set out on this way, with the gospel for our guide, that we may deserve to see him who has called us to his kingdom."[37] The Mass sacrifice was seen in the light of the concept of "good works" and through them also Justification. It is characteristic for the sixteenth century that these ideas even penetrate State iconography. The notion of "good works" was sufficiently urgent to make it a subject in a theological program (on a Veronese drawing) for Veronese's paintings in the Anticollegio of the Doge's Palace in

Venice. One of the inscriptions, in a series with some very sophisticated Latin forms and clearly written by an expert in theology but not used for the final version on the Anticollegio ceiling, reads: "RELLIGIO EX OPERIBUS VERA DIGNOSCITUR" (True religion is recognized by [our] works/deeds).[38] The inscription in fact refers to three themes: Justification, the Mass as a sacrifice (referred to pictorially in Veronese's central painting in the adjoining Sala del Collegio), and the divine basis of power (an appropriate reminder in the context of a government palace).

In Zelotti's octagonal canvas (Fig. 63, Pls. I–II), Catholic Religion is a forceful figure, seated as if enthroned, seen from below; she holds her large cross in her left hand, placing it vertically at her side; the chalice is held in her outstretched right hand, and her gaze rests upon it. The four Evangelists sit more casually in the clouds below her, the right-hand pair also looking at the chalice, the left-hand pair seeming to chat; their books are quite prominently displayed, at the center and in the foreground of the composition. The figure of Catholic Religion is clothed in white, illumined by a burst of bright light in the cloud that frames her; the Evangelists wear earthy tones, greens and rusts.

On the left of Catholic Religion is the rectangular canvas of *Judith and Holophernes* (Judith 13, passim; Fig. 64). The story is that the beautiful widow Judith, invited into the tent of Holophernes, freed the people of Bethulia from the siege of the Assyrians by pretending betrayal of her own people, enticing Holophernes to drink too much, and slaying him. His severed head is presented—amidst recitals reminiscent of the "Song of Deborah" (see below)—as the confirmation of God's support of Israel's people and as an act of worship to God. In Judith 8:29 the heroine is praised for her wisdom and for speaking the truth. There is an implied reference to Judith in the *Rule of Saint Benedict* as a model of chastity: Judith's chastity is cited in the Bible as reason for her victory.[39]

Zelotti's composition (Pl. II, Fig. 64) shows the frequently depicted moment when Judith, her task achieved with the help of prayer, deposits the head in the sack held by the waiting servant. Judith at the left still holds the scimitar of her victim, and the tent behind the women indicates that they are about to return to the city with their prize. Again, light from above, falling on Judith's lovely impassive face, her arms, and the hands that hold scimitar and head, indicates divine benediction of the violent act. Here the light breaks through the gray clouds at upper left to illuminate Judith's fair hair and skin, set off, in accordance with the biblical account, by her alluring attire. The pale blue of the opening in the clouds is echoed in the blue of Judith's underskirt; her bodice is white and overskirt a warm rose, probably made of vermilion and lead white. Judith's bright attire, together with the white and gold headpiece and scarf of her helpful servant, is in contrast to the darker tones used for the tent (earth green) and the dark hair of Holophernes. As a whole, the composition takes into account its position to the left of *Catholic Religion* and is oriented toward it (Fig. 56, Pl. I). In Judith's report to the Israelites (Judith 13:19), she exclaims: "Look upon this head. . . . he lay . . . in drunken sleep, when the Lord smote him, and by the hand of a woman." In her hymn of victory, she exults: "What power divine crushes the enemy, but the Lord's great name?" (Judith 16:3).

On the right of *Catholic Religion* is *Jael with Sisera and Barak* (Judges 4–5; Fig. 65,

Pl. III). The Israelites "would defy the Lord yet again"; and they were submitted for twenty years to the king of Canaan, whose troops were commanded by Sisera.

> At this time Israel was ruled by a prophetess called Deborah. . . . the people of Israel had recourse to her. . . . And now she summoned Barac . . . and gave him a message from the Lord God of Israel: Go and muster an army on mount Thabor of ten thousand warriors. . . . Then I will lure Sisara . . . into the valley . . . with his chariots and all his forces, and give thee mastery over them (Judges 4:4–7). . . . Bestir thyself Deborah said to Barac; now it is that the Lord means to put Sisara in thy power; thou hast the Lord himself for thy leader (Judges 4:14).

Jael completed Barak's defeat of Sisera's forces (based on the inspired instructions of Deborah); pretending hospitality by giving milk to Sisera who had fled the slaughter on foot, she then killed him by driving a tent peg through his temple as he slept. This is the story leading up to the triumph of the judge Deborah, representative of the people of Israel, God's chosen people, and the real focus is on the "Song of Deborah" that follows (Judges 5). The song is a victory hymn, ending with the words: "So perish all thy enemies, Lord; and may all those who love thee shine out glorious as the sun's rising!" (Judges 5:31).

The rectangular painting of *Jael* (Fig. 65, Pl. III) on the right side of *Catholic Religion,* is composed with the placement in mind and nicely balances the *Judith* composition with which it is paired (Fig. 56, Pls. I–II). Barak, pursuing Sisera, enters Jael's dwelling from the right, his pose answering the figure of Judith on the opposite side of *Catholic Religion.* Barak's stride indicates his haste, and his gestures show his surprise as the crouching Jael at the left looks up at him and lifts the sheet to reveal her handiwork, the tent peg driven "through his [Sisera's] brain into the ground beneath" (Judges 4:21). The light settles particularly on Jael's face, neck, and her left arm holding the sheet, and glimmers on the tent peg. She is clad in pink, white, and gold, and Sisera's fate is emphasized by his red shirt and his lifeless arm that falls into the foreground. Barak wears ocher, and his flowing mantle is bright green, possibly malachite. The setting, with an ionic column suggesting a house more than the biblically dictated tent, is a more neutral gray.

Group 4 has in the middle *Saints Jerome and Gregory Preaching and Teaching* (making, with *Saints Augustine and Ambrose* of Group 2, the full set of the four Latin Fathers of the Church). Jerome holds a book, richly bound and set prominently against the sky, probably the Vulgate that he translated. Gregory makes a rhetorical gesture, as both face the public from an elevated platform (Fig. 66, Pl. IV). The raised platform is at the left, making a diagonal composition from upper left to lower right. Saint Jerome was known as a great biblical scholar and also as a teacher of children. In a Benedictine context, Saint Gregory the Great is especially important, since he was a Benedictine who became a justly famous pope, and because book two of his *Dialogues* provides the main source for Saint Benedict's life and works. (Gregory's *Dialogue II,* in fact, provides the text for all the various cycles, in monumental paintings as well as in prints, concerning the founder of

the Order.) Zelotti again employs light and color with sensitivity to his subject matter. Pope Gregory in the foreground is clothed in white, with a gold and white tiara and a gold mantle lined with blue. This sunny array is set against Jerome's vermilion cape; the Fathers preach and teach from a dais beneath a canopy that creates a shadowed area at upper left, so that the sky with billowing clouds opens brightly to their right, allowing light to fall on their listeners. In the left foreground, a child draped in pale pink holds a long thin cross, while in the right foreground a female *repoussoir* figure, also wearing pink, kneels in rapt attention to the words of wisdom coming from the Fathers, as her child clings to her. Both figures serve to emphasize the low viewpoint of the beholder and to bring him (the monk using the Library) into the vision.

To the left of *Saints Jerome and Gregory* is *Moses with the Burning Bush and Serpent* (Exod. 3–4; Fig. 67), an often-cited manifestation of divine presence and sanctification of a particular site. Speaking to Moses from the bush that burned but was not consumed, God said: "Do not come nearer; rather take the shoes from thy feet, thou art standing on holy ground. Then he said, I am the God your father worshipped, the God of Abraham, and Isaac, and Jacob" (Exod. 3:5–6). Again, the concern is from God to help his Chosen:

> I have not been blind, the Lord told him, to the oppression which my peo-
> ple endures in Egypt. . . . I know what their sufferings are, and I have come
> down to rescue them from the power of the Egyptians; to take them away
> into a fruitful land and large, a land that is all milk and honey. . . . thou art
> to lead my people, the sons of Israel, away out of Egypt. At this Moses said
> to God, Ah, who am I, that I should lead. . . . I will be with you, God said
> to him. . . . when thou hast brought my people out of Egypt, thou wilt find
> thyself offering sacrifice to God on this mountain. But Moses still pleaded
> with God . . . (Exod. 3:7–13).

Moses feared people would not believe him and kept asking for proofs; finally the Lord said:

> What is that in thy hand? . . . A staff, he said. So the Lord bade him cast it
> on the ground, and when he did so it turned into a serpent. . . . Now put
> out thy hand, the Lord said, and catch it by the tail. He did so, and it turned
> to a staff in his hand. And the word came to him, Will they still doubt that
> the Lord God of their fathers, Abraham, Isaac and Jacob has appeared to
> thee? (Exod. 4:2–5).

Nonetheless, God gave two more signs to the demanding Moses!

In the oval canvas (Fig. 67, Pl. ii) to the left of *Saints Jerome and Gregory,* Zelotti depicts Moses, at left center, already holding the staff as its head turns into a serpent and the green bush, at the right, spews flames that seem to speak and that, in turn, put forth gray smoke; the mountain setting is suggested by the boulders on which Moses stands and

by the low viewpoint. The colors are bright, Moses' mantle is vermilion, his other garments white and purple; the sky below the smoke, an opaque blue (perhaps azurite mixed with lead white). Light issues from the flickering flames to shine on the parts of Moses that face the bush. The mouthlike shaping of the flames and Moses' animated pose together evoke a sense of the prolonged argument between Moses and God reported in Exodus, as Moses keeps demanding proofs of God's power to convince his people that he should lead them out of Egypt.

On the right of *Saints Jerome and Gregory* is *Abraham and Isaac* (Gen. 22; Fig. 68); the event takes place "in terra visionis" (Gen. 22:2), again a manifestation of divinity on a sanctified site and also the arch-example of obedience to God.[40] We shall see below that Abraham's story was cited as an example of the first, human-specific, category of good works. The main point is one of testing faith: "After this, God would put Abraham to the test"; and God commanded Abraham to sacrifice his only son, Isaac. After Abraham had made good his willingness to do this,

> Once more the angel of the Lord called to Abraham from out of heaven;
> and he said, This message the Lord has for thee: I have taken an oath by
> my own name to reward thee for this act of thine, when thou wast ready
> to give up thy only son for my sake. More and more I will bless thee, more
> and more will I give increase to thy posterity, till they are countless as the
> stars in heaven, or the sand by the seashore; thy children shall storm the
> gates of their enemies; all the races of the world shall find a blessing
> through thy posterity, for this readiness of thine to do my bidding.

Again the same story: either after correcting their errors or after having stood the test, the Chosen People prevail through the word of their God. We note that Abraham is adjacent to the *Cumaean Sibyl,* who prophesies a great one coming from a virgin birth.

Zelotti's oval of *Abraham and Isaac* (Fig. 68, Pls. I–II) tells the familiar story with clarity. In the right foreground on a primitive altar is the small figure of Isaac, his hair grasped by the left hand of Abraham; the looming figure of Abraham is seen from below, as he turns to his right to see that the angel, in a shining cloud at upper left, has stopped his sword. The ram, which will be substituted for Isaac, after God has seen Abraham's willingness to obey this extreme instruction, appears at lower left. Light from above falls particularly on the face of the intended victim, as he turns toward the viewer. But the overpowering figure is Abraham himself, and it is he who wears flowing colorful garments, red tunic and green mantle.

Group 5 is located over the north wall where *Daniel in the Lions' Den* (Dan. 6:16; Fig. 69) is flanked by the *Erythraean Sibyl* and the *Cumaean Sibyl*. Daniel was put in the lions' den by the Persian king because he was faithful to his own religion, and he was saved by his faith:[41] "out of the pit they brought him, unscathed from head to foot; such reward they have that trust in God" (Dan. 6:23). "Then Darius sent out a proclamation to all the world, without distinction of nation, race or language, wishing them well, and

enjoining this decree upon them, that all the subjects of his empire should hold the God of Daniel in awe and reverence" (Dan. 6:25–26). We note the relevance of the notion of sending forth good news in every language in this episode to the miraculous ability received by the apostles at Pentecost to be understood in all tongues and thus to spread the Gospel. Zelotti's painting of Pentecost was, if our reconstruction is correct, placed on the end wall, just beneath the *Daniel* (Fig. 29). A hymn about the living God, a savior, a worker of signs and wonders, follows (Dan. 6:26–27).

In the oval of *Daniel in the Lions' Den* at the north end of the ceiling (Figs. 69, 29, 56; Pl. II), Daniel is seen from below, kneeling, opening his arms to heaven and looking upward in an attitude of supplication similar to the ritual gesture of the priest at Mass. Light pours down on him abundantly from above, indicating that his trust in his God has met with favor. Daniel's rose tunic is the only bright color; his mantle is earth green, and the stony lions' pit and the two unmoving lions to either side of Daniel are brown. This restraint serves to emphasize the figure of Daniel, himself bathed in light of divine origin, effectively telling the story of his salvation through his faith.

Daniel's oval is flanked by the two square canvases of the *Erythraean Sibyl* to the left and the *Cumaean Sibyl* to the right. The *Erythraean Sibyl* (Fig. 70) is seated, turning her legs toward Daniel while she gazes to the left. She holds a sword in her right hand and her tablet, held by her left hand, rests on her knee. She is clothed in black and white, a Benedictine nun's habit. In fact, she is dressed exactly as is Saint Benedict's sister Saint Scholastica in medieval and Renaissance representations.[42] The Erythraean Sibyl is represented holding a sword and dressed like a nun in the printed illustrations of both the 1481 and the 1546 version of the Barbieri treatise.[43] Her appearance in Zelotti's painting and in the book illustrations is rather stern. This is in keeping with her admonition, quoted above, "In ultima aetate humiliabitur. . . ." It is striking that a figure the Praglia monks must have associated with Saint Scholastica is placed in the reading room and that her text refers explicitly to a paramount Benedictine virtue: humility. Furthermore, it would have been awkward to have this figure in the reading room without having Saint Benedict himself represented somewhere in the Library area; so the case seems to support our hypothesis concerning an intended cycle from the life of Saint Benedict in the Library anteroom.

The *Cumaean Sibyl* (Fig. 71) at the north end of the ceiling on the right also turns her body toward Daniel but gazes away, in this case to the right. Her inscription, about the reign of Saturn quoted above, is lettered on the book she holds up in her right hand. Her left hand rests a second open book on her left thigh. In holding a book, she corresponds to the illustrations of her counterparts in Barbieri.[44] She is dressed in iridescent gold and rose, probably composed of lakes and ochers, and her blond hair is uncovered, so that she appears more youthful and less stern than the Erythraean Sibyl.

Seen individually, the fifteen subjects of the ceiling canvases in the Library at Praglia are readily identifiable. It is clear, just from our descriptive review of content and form, that they have been chosen and arranged with care. Battista Zelotti displays considerable skill in representing the selected subjects, and his compositions reveal sensitiv-

ity both to meaning and to placement within the cycle. He uses color and especially light, as well as figural poses, to articulate content. In each painting, figures are foreshortened to take into account the position of the library user below. It is evident that the foreshortening addresses the visitor as he (a Benedictine monk usually) enters at the south end and moves toward the north end, or studies facing north (Pls. i–ii, Figs. 26, 29, 76). The pictures are not easily read from the other direction (Figs. 27, 30, 77).

1.2 *The Wall Paintings*

Basing our interpretation here again on a "straight" reading of the biblical texts, and with the reservations already expressed attached to such a procedure, we now offer short descriptions of the wall paintings. We remind the reader of the poorer condition of the wall paintings discussed in chapter ii and of the arrangement as we have reconstructed it, shown in the diagram and visualizations (Figs. 26–30). Moving from the south entrance toward the north end wall one sees: *Jacob and Esau* to the left and the *Prodigal Son* to the right of the door on the south wall; on the left (west) wall, *Moses Breaking the Tablets of the Law, Solomon and the Queen of Sheba, Moses on Sinai Receiving the Tablets;* on the right-hand wall, *Christ Expelling the Money Changers, Christ Teaching in the Temple, Sermon on the Mount;* and finally, on the north wall, the *Pentecost.*

Again we proceed group by group, starting from the entrance wall and considering each pair of paintings, left and right, in turn.

The first subject is *Jacob and Esau* (Figs. 38–39). The older son Esau married a Hittite woman (Gen. 26:34f.), which means implicitly that he sought alliances outside his own tribe; and the younger Jacob, helped by his mother Rebecca, cheats blind old Isaac over the blessing, depriving Esau of it; the blessing stands in spite of the treachery (Gen. 27). That is, the blessing sets a distinction among people: "a curse on those who curse, a blessing on those who bless thee!" (Gen. 27:29). In spite of his own dismay, Isaac refuses to change the blessing, so that this is a ritual affirmation of an absolute authority bestowed by God and hence immutable.

Zelotti's painting of the story of Jacob and Esau might be more correctly titled *Isaac Blessing Jacob.* The canvas has suffered considerable losses of original pigment (Fig. 38), particularly in the left foreground. Nonetheless, the composition is legible, and reintegration of the surface with in-painting has made the losses less distracting (Fig. 39). Jacob kneels by the bed as the blind Isaac blesses him, guided by Rebecca; the disinherited Esau is seen in the background view at the right, returning from the hunt. Even in its damaged condition the painting shows Zelotti's use of rose on Isaac and orange on the bedcover, together with light falling from upper left on Isaac's hand, to emphasize the blessing.

The following quotation from the *Dialogues* of Saint Gregory addresses themes of delegated power from God that we find in the paired paintings of *Jacob and Esau* and the *Prodigal Son*:

> PETER: Is it not extraordinary that souls already judged at God's invisible
> tribunal could be pardoned by a man who was still living in the mortal

flesh, however holy and revered he may have been? GREGORY: What of Peter the Apostle? Was he not still living in the flesh when he heard the words, "Whatever thou shalt bind on earth shall be bound in heaven, and whatever thou shalt loose on earth shall be loosed in heaven [Matt. 16:19]." All those who govern the Church in matters of faith and morals exercise the same power of binding and loosing that he received. In fact, the Creator's very purpose in coming down from heaven to earth was to impart to earthly man this heavenly power.[45]

To the right of the entrance is the parable of the *Prodigal Son* (Luke 15:11−32; Figs. 40−41). The sinner is separated from God and by repentance may be forgiven and welcomed back: "Father, I have sinned against heaven and before thee; I am not worthy, now, to be called thy son . . ." (Luke 15:18−19); the father, to the son who did not go astray, "thy brother here was dead, and has come to life again; was lost, and is found" (Luke 15:32); the confession is a means to return to grace. Forgiveness is a central theme both in the *Rule of Saint Benedict* (Prologue: "As the Apostle says, 'Do you not know that the patience of God is leading you to repent' (Romans 2:4). And indeed the Lord assures us of his love: 'I do not wish the death of the sinner, but that he turn back to me and live'" (Ezekiel 33:11) and in Saint Gregory's *Dialogues* (the story of Saint Peter just quoted).[46]

The story of the *Prodigal Son* (Fig. 41), like the *Isaac Blessing,* is told with simplicity and clarity; this is evident despite considerable paint loss (Fig. 40). In the foreground, the father bends down to embrace the son, who kneels in an attitude of asking forgiveness. The house from which the father comes to welcome the son resembles the rusticated bottom floor of a Vicenza palazzo designed by Palladio, such as the Palazzo Thiene or the Palazzo Porto, which were certainly familiar to Zelotti. Apparently the figures in the doorway are arranging the feast, just ordered by the father, and the figure behind is the elder son inquiring of a member of the household what is the cause of the merrymaking. Light falls in particular on the shoulders of father and son as they embrace.

On the left (west) wall again is *Moses Breaking the Tablets of the Law* (Exodus 32:1−35; Figs. 42−43). Moses walks up to Sinai once more; his people went astray, worshipping the golden calf, and provoked Moses' righteous anger at the idolatry; and they were heavily punished for it. "Rally to my side, all that will take the Lord's part. Then the whole tribe of Levi gathered round them [Moses and Aaron]" (Exodus 32:26). He instructed them to kill the less loyal people, and three thousand died.[47]

Zelotti's painting tells the story with characteristic clarity (Figs. 42−43). Moses and Joshua in the left foreground are on their way down Mount Sinai; below to the right the crowd of Israelites surrounds the golden calf set upon an altar.

Josue said to Moses, I hear the cry of battle in the camp. No, he said, it is the sound of singing. . . . Then they drew near and he saw the calf standing there and the dancing. And so angry was he that he threw down the tablets

he held, and broke them against the spurs of the mountain; then he took
the calf they had made and threw it on the fire and beat it into dust
(Exodus 32:17–20).

In the painting, Moses in the foreground is about to break the tablets; he is also shown in
the background beating the calf. Except for Moses' white tunic and pink mantle, the
foreground area is dark, while the scene with the interrupted worship of the golden calf
is bright. Aaron, whom Moses confronts for allowing idolatry, must be the bearded figure
in red at the other side of the altar.

Corresponding to this painting on the right-hand wall, there was, according to
our reconstruction, *Christ Expelling the Money Changers from the Temple* (Mark 11:15–17;
Figs. 44–45), a story of Christ's righteous anger at profit-taking in the Temple of the
Lord. Returning to Jerusalem toward the end of his ministry,

Jesus went into the temple, and began driving out those who sold and
bought in the temple, and overthrew the tables of the bankers, and the
chairs of the pigeon-sellers; nor would he allow anyone to carry his wares
through the temple. And this was the admonition he gave them, Is it not
written, My house shall be known among all the nations for a house of
prayer? Whereas you have made it into a den of thieves.

God's house should not be corrupted.

Zelotti's depiction of the event (Fig. 45) is dramatic. Christ rushes forward with
his left arm drawn back brandishing a branch, while the moneylender in the foreground
shields his face with one arm and holds his table with the other. A column on a pedestal
at the extreme right and the step on which the money changer cowers identify the loca-
tion as the porch of the Temple. The light from above picks up particularly Christ's face,
arm, and knee, the arms of the money changer, and the woman who draws back at the
left. Two other merchants behind move away from the centrifugal force of Christ; in the
photograph taken before the picture was reintegrated in 1960 (Fig. 44), we see that a
crate seeming to hold pigeons is held aloft at the left, while the merchant running to
the right seems to hold a lamb. Two figures watch from the balcony behind Christ, per-
haps the priests and scribes whose displeasure is reported in the following verse (Mark
11:18). Christ wears the traditional rose tunic and blue mantle, and the woman wears
ocher and white; the other areas are brown, gray, and varied neutral tones. Again, light and
color highlight the action.

To the left, at the center of the west wall, the visitor would have seen *Solomon
and the Queen of Sheba* (3 Kings [1 Kings] 10:1–13; Figs. 46–47). The episode is confir-
mation of Solomon's famous wisdom: he answers all of the questions posed by the
Queen of Sheba, including the most abstruse. But there is more to this story; as it turns
out, Solomon's wisdom was flawed. For Solomon married many foreign women
(11:1–13):

It was of such races that the Lord had warned Israel, you must not mate
with them, or let them mate with your daughters; no question but they
will beguile your hearts into the worship of their own gods. Hotly he loved
and close he clung to them; seven hundred wives, each with queen's rights,
and three hundred concubines besides; what marvel they beguiled his
heart? So, an old man now, he was enticed by women into the worship of
alien gods, and his heart was not true to the Lord his own God, like his
father David's before him. Solomon built shrines to other gods, so the Lord
was angry. "I will not scruple to tear the kingdom from thy grasp, and give
it to one of thy own servants. Only for love of thy father David, I will not
do it in thy life-time; it is thy son that shall lose his kingdom. Nor will I
take away the whole of it; one tribe he shall have left to him, for the sake
of my servant David, and Jerusalem, my chosen city."

Thus the story issues a warning to anyone who goes astray from the true faith.

This wide painting suffered very heavy damage, and the best-preserved figures are
the incidental ones in the foreground. It seems, however, that the queen was splendidly
dressed in gold, that deep red, blues, and gold were generously used, and that Zelotti effec-
tively suggested the exchange of rich gifts told of in the Bible as well as the dialogue that so
impressed the queen with Solomon's wisdom. It would be difficult to say which, if any, of
the peripheral female figures is intended to represent the thousand wives and concubines.

Corresponding to this, on the right-hand wall, would have been *Christ Teaching in
the Temple* (Luke 2:41–52; Figs. 48–49). After three days the twelve-year-old Christ is
found in the Temple surrounded by the teachers, amazing them with his wisdom, "lis-
tening to them and asking them questions; and all who heard him were in amazement at
his quick understanding and at the answers he gave." "Could you not tell that I must
needs be in the place which belongs to my father?" (Luke 2:46–49), was his response
when Mary and Joseph found him. This is the biblical story in which Christ's wisdom is
first revealed. It may be significant that both Solomon and Christ ask and answer ques-
tions, and both display their wisdom in the Temple.

The wide canvas of *Christ Teaching* was at the center of the east wall and has also
been severely damaged (Figs. 48–49) so that the painting is merely a legible shadow of
its original form. It seems that the colors chosen were more subdued than those in the
Solomon and the Queen of Sheba opposite. The composition is rather standard: Christ teach-
es from a pedestal, surrounded by the rabbis. The figure in the left foreground raising his
index finger seems to ask a question that Jesus is about to answer; the three rabbis on the
right, one of whom holds a thick book, and a few behind them speak to each other,
apparently expressing amazement at the child's wisdom. The columns and step signify the
Temple setting, while the figures listening at far left must represent Mary and Joseph.[48]

The farthest painting on the left-hand (west) wall was the *Baby Moses Saved and
Moses on Sinai Receiving the Tablets of the Law* (Exodus 2:1–10; Figs. 50–51). The Jews are in
Egypt; newborn boys are to be killed; Moses is chosen and saved by Pharaoh's daughter,

who, thus, acts against her own father's will and—implicitly—in the service of God's plan. The Ten Commandments represent the Old Law. Only Moses and Aaron are allowed to the summit of Sinai to see God (Exodus 19:20–25). But in the event it seems that only Moses goes to the summit:

> All the people stood watching while the thunder rolled and lightning
> flashed, while the trumpet sounded and the mountain wreathed in smoke,
> terrified and awestricken so that they kept their distance. . . . So the people
> stood their ground far off, while Moses went up into the darkness where
> God was (Exodus 20:18–21, immediately after the Ten Commandments
> [Exodus 20:1–17]).

In Zelotti's depiction (Figs. 50–51) Moses in the basket is shown in the foreground at the right, and Moses receiving the tablets of the law is at the upper left. There was considerable paint loss along the lower border of the painting, but the key area at upper left appears to be well preserved. There Zelotti evokes the drama described in Exodus: lightning seems to flash from the billowing clouds of smoke so that the tablets received from the clouds by the kneeling Moses come as if they are thunderbolts. This dramatic lighting affects the lower part of the picture as well, and the figures there seem to hear the thunder. The three barely legible figures in the middle ground at the left must represent the people whom Moses, following God's instruction (Exodus 19:9–15), told to listen from below but not touch the mountain. In the foreground is the child Moses in his basket. The woman who nurses him must be his mother, and the female figure standing above her may be Moses' sister, according to Exodus 2:7–9. After the Pharaoh's daughter had found the child in the basket, "the boy's sister asked, Wouldst thou have me go and fetch one of the Hebrew women to nurse the child for thee? Go by all means, she said; and the girl went and fetched her mother. Take this boy, the Pharaoh's daughter said, and nurse him for me. . . ." So, although the subject is usually given as the birth of Moses, it seems more likely that this is the moment represented. In any case, Moses' role in receiving the tablets on Sinai and his early rescue from slaughter are connected in this painting.

Paired with the Sinai painting, the *Sermon on the Mount* (Matthew 5; Figs. 52–53) on the opposite wall would have represented the New Law. Matthew 5 is cited several times in Saint Benedict's *Rule*. Here are eloquent statements of the message of Christ's more positive New Law, offered to his apostles shortly after he had chosen them. Yet, in view of the stress on being on the right or wrong side in several of the other paintings listed so far, the following text perhaps is especially relevant:

> Blessed are you, when men revile you, and persecute you, and speak all
> manner of evil against you falsely, because of me. Be glad and lighthearted,
> for a rich reward awaits you in heaven; so it was they persecuted the
> prophets who went before you (5:11–12).

Chapter 4 of Saint Benedict's *Rule,* "The Tools of Good Works," includes several para-phrases from the Sermon on the Mount and a quick summary of the old command-ments and as well as the instructions to read Scripture and pray, noted in chapter III.

Zelotti's *Sermon on the Mount* (Figs. 52–53) is in striking contrast to the dramatic picture opposite, except that Christ, like the adult Moses, is shown high on a mountain. There Jesus sits in peaceful discourse with a group of his followers who listen intently; in the foreground we see a crowd of listeners, including a *repoussoir* figure of a woman with a child seated at the right and two men apparently discussing the sermon at left. The entire composition is bathed in an even light. The palette is correspondingly light, chiefly rose, pale blues, and moss greens. Altogether Zelotti evokes an atmosphere of acceptance and peace appropriate to the content of the Sermon on the Mount.

Because the Holy Spirit is traditionally used as a focusing point in comparable pictorial series and particularly because all learning is referable back to the inspiration (in a literal sense) of the Holy Spirit, the scene of the *Pentecost* (Acts 1–2; Figs. 54–55) is placed on the end (north) wall. The only reference in the *Rule* to the Pentecost account in the Acts, and a very oblique one at that, is the use of the word "perseverantes" in the Prologue; this, in the modern official versions of the *Rule,* is taken to refer to Acts 2:42, "Erant autem perseverantes in doctrina apostolorum et communicatione fractionis panis et orationibus." This provides us with a typical example of "quotes" in the *Rule* (and other general religious texts). Quite obviously, such quotes cannot be referred to explic-itly in pictures, yet the idea of being continually occupied with the doctrines of the apostles is certainly fundamental in a monastery and in the library of a scholarly order.

In addition to the strategic placement of *Pentecost* as a focal point, suggesting the continual inspiration of the wisdom of the Holy Spirit, we note the strategic placement on the central lateral walls of two other themes concerning wisdom, Solomon on the left and the young Christ Preaching on the right. Valle's contemporary account of the sev-enteenth-century decoration of Longhena's library at San Giorgio Maggiore in Venice stresses the placement of the pictures, which are classical allegories, to give a message concerning the divine source of wisdom.[49] Another motivation for the placement of *Pentecost* is the fact that the Virgin is a central figure in depictions of Pentecost and that Praglia was dedicated to her. Pentecost represents, of course, the first appearance of the Holy Spirit, sent after the Ascension of Christ to guide his followers and provide wisdom. Various important themes are at play here: the universality of the Church, inspiration by the Holy Spirit, the teaching of all nations. The Galileans are speaking, heard by each listener in his own tongue. Acts 2 also describes awe, inspiration, and common property in the early Church, a model for the monastery.

Zelotti's painting, like his painting of *Pentecost* now at San Rocco in Vicenza, is symmetrically arranged. The Holy Spirit at top center appears as a dove in a sunlike shining light from which the tongues of fire issue. Mary is seated directly under the Dove at the physical center of the picture, her hands clasped in a gesture of prayer or inter-cession. The apostles surround her, six to the left and six to the right, since, at the time of Pentecost, Mathias had just been elected to replace Judas (Acts 1:24–26). Acts 2 begins:

> When the day of Pentecost came round, while they were all gathered
> together in unity of purpose, all at once a sound came from heaven like that
> of strong wind blowing, and filled the whole house where they were sitting.
> Then appeared to them what seemed to be tongues of fire, which parted
> and came to rest on each of them; and they were filled with Holy Spirit, and
> began to speak in strange languages, as the Spirit gave utterance to each.

The warm colors, flickering flames, radiating light, and excited postures in Zelotti's painting visualize the passage effectively. The presence of the Virgin in the Acts supports the notion of her as intercessor. Also, she is traditionally associated with the Church and thus lines up with the Religion figure in the center of the ceiling. The Virgin (Madonna with the Child) also serves as a focal point on the end wall of the library room of 1461 at Santa Giustina, Padua (Figs. 20–21), and again in the Franciscans' library room in San Bernardino, Verona (see Figs. 23–24 and discussion below).

The dedication to the Virgin Mary of the "Abbazia di Santa Maria di Praglia," as well as the central position of the Pentecost in the history of salvation and its special significance in contexts of study, learning, and wisdom, powerfully support our original placement (based on measurements of the wall series and the symmetrical composition of Zelotti's painting) of the *Pentecost* painting on the end wall of the Library Room. Thus it would have functioned as a focal point for the program—and for the study activities taking place in the Library. Although no liturgical rites were celebrated in library rooms, the monks and many lay persons, too, would have been familiar with the basic themes in the liturgy of the Mass and of the hours of the Divine Office and the feasts of the liturgical year. They would, upon seeing the *Pentecost* painting, have been reminded of the Pentecost liturgy as well as of Scripture and writings of the Church Fathers concerning the Holy Spirit. We shall return in chapter VI to the Pentecost liturgy and associated knowledge that the image would have called forth.

Zelotti's Old and New Testament scenes on the walls, although in poor condition, still can be seen to display the same sensitivity to subject matter and to physical placement that have been observed in his ceiling paintings. In the pairings, he tends to use composition, light, and color to highlight the similarities and differences in the scenes, thus clarifying the lesson for the library user. There is throughout a faithfulness to the biblical texts that is not unexpected in a Benedictine commission.

Having described the ceiling and wall paintings in terms of their biblical and other textual references, we should be able to come up with some working hypothesis about the whole program to further our investigation. Yet, in order to acquire a more substantial basis for this, we shall (after a brief excursus on the Marciana Library) review some earlier pictorial series in Benedictine contexts.

2 Painted Decorations in Other Benedictine Contexts

Pictorial library programs, whether Benedictine or not, that predate the one at Praglia include the Piccolomini Library in Siena Cathedral and—if the room really did serve as

a library—the Stanza della Segnatura in the Vatican. The thematic affinities between Praglia and these examples are, however, of too generic a character to be useful here.[50]

A few observations on the Biblioteca Marciana in Venice may be relevant before considering Benedictine examples, since this library is geographically close to Praglia, the decorations are roughly contemporary, and because Zelotti worked there, as one of the seven artists commissioned to paint three tondi each in 1556–57.[51] The decorations are not in their original state, since there was damage to some ceiling tondi (one of Zelotti's was replaced), and the wall decorations, after a move to the Doge's Palace, were reinstalled in 1929, incorporating some canvases that were not part of the original decoration. In addition, the vestibule, with Titian's *Divine Wisdom* of 1559 on the ceiling, housed the academy for young Venetian patricians in the late sixteenth century, but the original wall decorations were removed when the space was converted to a sculpture gallery for the Grimani collection in 1591–96.[52]

A relatively detailed description of the seemingly elaborate program is provided by Zorzi, who refers to Ivanoff and acknowledges that it has not been fully deciphered.[53] Zorzi suggests a role for Procurators Vettor Grimani and Antonio Capello as authors of the program, since Sansovino mentions them as occupied with the building of the library; he refers to the sculptural decoration of the exterior and the stuccos and frescoes of the staircase, as well as the canvases of the vestibule and reading room. Following a Platonic reading, after Ivanoff, of the exterior decorations, Zorzi associates the subjects of the staircase (also from the mid-1550s) with the contemplative life and those of the reading room ceiling with the active life; he suggests that the active life receives the greater emphasis here because it will be the calling of most of the young patricians, even if Divina Sapienza reigns over the vestibule-classroom since "All cognition, also according to the Renaissance vision, is unified in God, who is supreme unifier of [all] knowledge." Probably the newly founded "Accademia Veneziana" or "della Fama" had some say in the programming,[54] and the contents of Bessarion's distinguished library may also have been taken into account.

A review of the subjects of the ceiling tondi suggests, in fact, a progression from divinely inspired virtues, near the entrance, to the pursuit of all kinds of arts and sciences and practical virtues, to (in the last trio) the occupations open to the student in this academy: political, military, ecclesiastical. Due to the employment of nine different painters, the execution of the ceiling decoration was rapid, but it lacks the unity of viewpoint and foreshortening that is so effective in Zelotti's later ceiling in the Praglia Library. In Ivanoff's words, "Nel Salone della Libreria, le soluzioni prospettiche vengono frazionate"; the perspective is "fragmented" since some of the artists used more acute foreshortening than others. The "philosophers" of the original wall decorations, some of whom are in situ,[55] are seen in the tradition of representations of great men, depicted in libraries as models for students since Pliny, and Ivanoff associates them with Raphael's Stanza della Segnatura and with Armenini's later comments on library decorations.[56] We shall return to the question of possible relevance for the Praglia problems in chapter VII.

The Benedictine library decoration closest to Praglia in terms of date is the one

at San Giovanni Evangelista at Parma. This is an extremely "learned" program with inscriptions in several ancient languages and groups of doctrinal displays. We shall postpone discussion of this, because there is, or rather was, another painting cycle predating Praglia that in many aspects is closer to it.

The comparison with other Benedictine cycles not belonging to library contexts is more relevant than it might seem at a first glance, while it is hard to identify a typical "library iconography" that predates Praglia other than recurring representations of "wise people" of some sort and some virtues and/or allegories of various arts and/or sciences, all of which occur in other contexts as well. The library function in a Benedictine monastery should not be isolated, since the entire life of any Benedictine monastery was largely devoted to study. This is clear, as seen in chapter III, from the *Rule* itself.

With some justification, especially with reference to the reading routines recorded in chapter III, it may be said that the entire monastery was a reading room: the choir of the church, the single cells, even the refectory. It was more the increased size of the book collections and the technicalities of handling them responsibly, as well as greater external demand, that made specifically appointed reading rooms desirable, and these often in areas where reading and storage could be united spatially. In its turn, this also became a matter of prestige. This process in itself does not seem to provide a particularly relevant basis for any typical library iconography. Nevertheless, in both monastic and secular libraries for which some information is available, there seems, not unexpectedly, to be an accent upon wisdom and scholarship, either of secular or religious tradition, or both.[57] Armenini's comments were published in the 1580s, after Praglia's Library decoration was complete, so his contrast of ancient library decorations depicting maps or great men with a vision that unites the "lume della Santa Fede nostra" (the light of our Holy Faith) with study of the good arts may reflect Praglia's program and others. His prescription for library decoration includes a representation of a beautiful lady as the Holy Church, the Seven Deadly Sins, Virtues, Liberal Arts, and holy men.

Nor is it surprising to find greatly different combinations of themes and motifs from the Old and New Testaments, since Scripture is considered a source of riches to be revealed and meditated on, in a pictorial program as well as in a sermon. In Hans Küng's words, dogmatic definitions

> express the truth infallibly, . . . [but] because they are finite statements
> which never express absolutely everything, they never wholly exhaust the
> fullness of truth. That is why dogmatic formulations are not at all incapable
> of being refined and perfected, just as the Church cannot be tied to any
> particular short-lived philosophical system. . . . As Saint Thomas had said,
> quoting Isidore, "An article [of faith] is a perception of divine truth which
> tends toward that truth. . . ."[58]

Within the Benedictine Order, then, it would not make sense to look only for library prototypes with which to compare the Praglia program. All the extant monastic

pictorial cycles, whether they are in a library or not, may be equally relevant and should be compared on the same level: at Subiaco (walls and vaults in the monastery cave system, with numerous scenes from the life of Saint Benedict); at Pomposa (church and refectory); at Parma (library at San Giovanni Evangelista), at Padua (former library and cloister of Santa Giustina); at Cesena (the nave of Santa Maria del Monte); at Praglia itself (Library); also the image cycle, partly based on the *Speculum humanae salvationis,* on the sixteenth-century choir stalls of the church of Santa Giustina at Padua;[59] and so on—right up to later cycles like Vassilacchi's in the nave of the Benedictine church of San Pietro at Perugia. In the mid-fifteenth-century library room at Santa Giustina, Padua (for the cloister cycle there, see below), there is still a *Virgin and Child with Saints Justine and Benedict* on the end wall, while *Saint Gregory the Great* is represented in the lunette on the external wall above the entrance (Figs. 20–22). Cycles from other monastic or conventual sites should also be studied, since learning and the use of books are important for all of them; we noted this in connection with the Dominicans at Treviso. A closer study should be undertaken of great cycles that combine scenes from both Testaments and a saint's life, like the one in the upper church of San Francesco at Assisi. Often scholarship has provided no more than surveys;[60] or else the interpretation has been flawed by basically mistaken evaluation of the context.[61] The outcome of this situation is that it would be premature to attempt an overall survey of "religious cycles" for Italy; no clear criteria are available for delimiting this material as a whole or even larger chunks of it. For our task, this means we have to work our way from Praglia outwards, trying to postulate useful hypotheses during the process.

What about the issue of a "library iconography" or a monastic library iconography? Only at Parma can one speak of such an accentuation on formal learning and study that could be thought of as proper library iconography; but even here, this is a matter of emphasis, not of essence. The same should apply to the more recent but equally "studious" Order of the Dominicans. It is the walls of their chapter hall at San Nicolò at Treviso, not their library, that are covered with a series of frescoes (by Tommaso da Modena) representing famous Dominicans seated at their study desks, reading and writing (Fig. 16). San Nicolò, like most important Dominican convents, also had a library, in fact, "una ricca biblioteca,"[62] as usual consisting partly of private donations, among them one of two hundred codices given by a Dominican, Fallione da Vazzola, in 1347.

The Franciscans in Verona, too, had a library with pictorial decorations. Here the fresco decorations from about 1500 are well preserved, but the original furnishings are gone (Figs. 23–24). (In chapter II we noted that since the walls are completely decorated, we can assume that the original furnishings were freestanding—in an arrangement similar to the one we can still see in the Biblioteca Malatestiana at Cesena, Figs. 17–18). In this case of a true library room, it is hard to discern any special "library iconography." The decorations by Domenico Morone fill the walls in an illusionistic game. Along the side and entrance walls are pairs of members of the order, each pair standing on an illusioned pedestal that appears to project into the room (not seated at their desks, like the Dominicans at Treviso, Fig. 16).[63] On the wall opposite the entrance is painted a shallow stagelike setting divided into three parts by simple columns; at the center is the

group of the Virgin and Child with saints and donors on either side, and a "backdrop" view of Lake Garda (Fig. 24). Monk-scholars do appear in frescoes along the walls in the earlier library at San Giovanni di Verdara, belonging to non-Cassinese Benedictines in Padua, in a damaged cycle that requires further study.[64]

We shall now briefly survey some of the Benedictine cycles just mentioned without regard to whether the context is a library, as at Parma, a church, as at Pomposa, or a cloister, as at Padua.

The fresco cycle of Pomposa (Ferrara) covers the nave walls and is dated around 1350.[65] The frescoes are distributed over three tiers on each wall. The uppermost tier—beginning to the right of the altar (as one faces it) and ending up opposite its starting point—has scenes from the Old Testament: Adam and Eve, Cain and Abel, Noah (and the Ark), Abraham, Isaac with Esau and Jacob, Jacob's Dream, Joseph's Dream (with his brothers) and his story, Jacob and Benjamin, and a couple of scenes difficult to identify, then the Exodus of the Jewish People, Moses with the Tablets of the Law, the Ark of the Covenant, Joshua Stops the Sun, Daniel in the Lions' Den, Elijah on the Fiery Chariot, a battle.

The middle tiers—running the same course as the Old Testament series—show scenes from the New Testament (but without one-to-one numerical correspondence): Annunciation and Visitation, Birth of Christ, Adoration of the Magi, Massacre of the Innocents, Presentation in the Temple, Baptism of Christ, Wedding at Cana, Resuscitation of Jairus's Daughter, Resuscitation of the Naim Widow's Son, Resurrection of Lazarus, Entry into Jerusalem, Last Supper, Prayer in Gethsemane and Arrest of Jesus, Crucifixion, Deposition in the Tomb, the Angel and the Women at the Tomb, *Noli me tangere,* Incredulity of Thomas, Ascension, Pentecost.

The lowest tiers have scenes from the Apocalypse. The main apse has Christ in Glory with various saints, and on the entrance wall is a combination of Glory and Last Judgment.[66] Also on the entrance wall, to the right of the door as one walks in, is an almost life-sized representation of Saint Benedict; in addition, a scene from his life is painted in the refectory, where it is next to a depiction of the Last Supper.

To the best of our knowledge, no serious investigation of the program of the Pomposa cycle exists, and we rely on our impressions in saying that this is a biblical-encyclopedic series following traditional patterns of biblical typology. The cycle is a contribution to a Benedictine tradition of comprehensive pictorial decorations, but this is all we can conclude about it at present. It is important to note, with Cynthia Hahn, that the source behind an iconographical tradition concerning saints' lives need not always be literary: existing series, in prints or otherwise, may establish patterns on their own: "Although it has been claimed that visual narrative cannot tell a story without the text or memory of one [the reference is to Oleg Grabar], hagiographic stories virtually do so."[67]

The late-fifteenth-century fresco series in the Chiostro Grande at Santa Giustina, Padua, is very close to Praglia both administratively and geographically. (As noted above, Santa Giustina was the monastery from which the "Congregation of Santa Giustina" took its name and to which both Praglia and Parma belonged.) The fresco series in the Chiostro Grande depicted stories

dictated by monks, the Abbot Girolamo da Pavia and Girolamo Lippi or Cattaneo da Padova, assisted by Prospero da Treviso, Angelo Mossiolo da Brescia and Guglielmo da Pontremoli . . . four themes or rather historical levels, . . . with the Life of Saint Benedict dominating, as it was told by Saint Gregory the Great; thereupon the life of the Order. . . ; all this against the double background . . . with biblical medallions from the Old and the New Testaments . . . [our translation from Billanovich].[68]

The thematic structure of the pictorial series in the Chiostro Grande at Santa Giustina is presented here, following the manuscript description in Girolamo da Potenza's *Elucidario*.[69] There were nine sets, each consisting of a scene from the Old Testament, a scene from the New Testament, a scene from the Life of Saint Benedict, and allegorically connected classical motifs with inscriptions. Each set is separated by a grisaille pilaster with grotesques, some of which include sacrificial allegories, and a variety of scenes (apparently copies from ancient sources). A list of parallel scenes from the Old and New Testaments is given below. One of the uses of the cloister was for regular processions whose liturgy was supported by small books called "processionals," starting with "short litanies to be performed in the cloister": *Letanie breuiores fiende per claustrum*.[70] Scanning the Santa Giustina cycle and comparing it with the Praglia Library cycle reveal some similarities and cases of correspondence, but the general system is definitely different (see pp. 56–57).

In contrast, the pictorial program in the nave of the Benedictine church of Santa Maria del Monte just outside Cesena (Forlì), another large program never studied carefully, merits a closer look in our context. This monastery also belonged, from 1453 on, to the Congregation of Santa Giustina.[71] The decorative system of the entrance wall and the main walls of the nave is shown in the chart below.

Distribution of Subjects in the Nave of Santa Maria del Monte, Cesena

ENTRANCE WALL

Circumcision of Christ	Moses with Law	Adoration of Magi
Sibyl	NAVE	Presentation in Temple
Adoration of Child with Passion Instruments		Sibyl
Prophet		Flight into Egypt
Visitation		Prophet
Sibyl		Christ and Doctors in Temple
Annunciation		Sibyl
Prophet		Wedding at Cana
Betrothal		Prophet
Sibyl		Pentecost
Virgin at Temple		Sibyl
not extant		Dormition of Virgin
Birth of Virgin		not extant

At Cesena, the narratives are all taken from the New Testament and concentrate on the life, death, and presence at the Pentecost of the Virgin Mary, which is natural since the church is dedicated to the Virgin. Prophets and Sibyls have accompanying inscriptions, many of which are today no longer extant or readable; they seem to provide the usual typological comments on the historical events. The following Sibyl inscriptions are partly decipherable:

> left wall seen from entrance
> 1. INVISIBILI VERBI CYMAIA <S>IBYL
> 2. ΑΝθΗΣΕΙ ΔΑΝθΟΣ ΚΑθΑΡΟΝ (with omicron instead of omega)
> (he increases the treasury of the pure ones ?)
> 3. TO L (?) <O FE>LIX ILLA MATER CV<IVS> VBE<RA> ILL<VM>
> <L>AC<TABVNT> (. . . glorious that mother whose breasts
> gave him milk)
>
> right-hand wall seen from entrance
> 1. VASan . . . VIRGIN
> 2. IL . . . MATREM EIVS ERITREA *[sic?]* STATERA CV<M?>
> (his mother . . . scales . . . ?)
> 3. Not readable.

We shall leave it to others to study these inscriptions in their proper context; for us it is sufficient that they do seem to make the normal points concerning the coming of Christ as the son of a virgin, while word for word only the Tiburtine inscription, i.e., the one with the "ubera," corresponds to the example at Praglia.

This case presents the familiar elements of Sibyls, Moses with the Law, Christ in the Temple, and Pentecost in another combination apparently determined by the Marian context. Again we find no "typical" background tradition against which to see the Praglia program, beyond the general tendencies within liturgical and ecclesiological iconographies attestable within the Roman Church and any special monastic or mendicant order.

That the cited cycles represent a rich variation in repertory as well as a lack of any consistent thematic correspondence from one cycle to another provides a strong argument against trying to set up broad typologies for monastic iconography in general and Benedictine iconography in particular. This is even more evident when the library decorations at San Giovanni Evangelista at Parma are examined.

The Benedictine library at Parma has been fairly carefully described in a work started by Bruno Adorni and Maria Luisa Madonna and published in 1979 in the volume on San Giovanni Evangelista.[72] The cycle was started in 1573 under the supervision, and perhaps even under the direction, of Stefano da Novara, who had been elected abbot at San Giovanni in 1571; he also had participated at the Council of Trent. It may be worth noting that Stefano Cataneo da Novara was abbot at Praglia in 1538–40, and that Damiano da Novara became abbot of Praglia in 1572. This again illustrates the practice of brief tenures in the Congregation and indicates that the rotating abbots knew each other.

The Parma library program is extremely rich in pictures, single figures, symbols, emblems ("hieroglyphica," etc.), and numerous inscriptions in Hebrew, Syriac, Greek, and Latin; the inscriptions are mentioned but not transcribed or discussed in the cited publication by Madonna. The subtitle of Madonna's article seems more than justified: "Theatrum mundi e theatrum sapientiae." As is the case with programs of this richness, a number of issues remain to be studied. Since the present authors cannot undertake this job, which would be of monographic dimensions, we can look at whether the scenes from the Old Testament and the New Testament and strictly biblical figures bear any similarity to features in the Praglia program. The Parma program appears to be a composite product in which strands from several sources are intertwined; religious and "worldly," and so at different levels. The impression one gains from a survey in situ and from Madonna's account is that of a "total" picture of the universe in terms of scholarship and one in which Christianity, guided by the Council of Trent, is the life-giver.

Over the northern entrance is the Dove of the Holy Spirit, and over the southern door is the Crucifix, in both cases with inscriptions in Hebrew, Greek, and Latin. Over the main door, the Dove of the Holy Spirit is in a halo of light, accompanied by the figures of the seven-armed candelabrum and a bowl with flames (a common image in connection with the Holy Spirit), and by the inscriptions "SPIRITUS VERITATIS DOCEBIT VOS OMNEM VERITATEM" ("The spirit of truth teaches you the whole truth" [John 16:13]); and "CAELI APERUIT ET PLUIT ILLIS MANNA" ("Heaven opened and manna rained on them" [Psalm 77:23–24]). There are also two related inscriptions in Hebrew (with an unidentified reference to "burning" or "fire")[73] and Greek (a slightly edited version of 1 Corinthians 2:10: (ΗΜΙΝ Ο ΘΕΟΣ ΑΠΕΚΛΥΦΕΝ ΔΙΑ ΤΟΥ ΠΝΕΥΜΑΤΟΣ ΑΥΤΟΥ). The two biblical languages and that of the Church are thus represented, probably envisaged as a learned image of the synthesis of the two Testaments and the Tradition of the Church, a fundamental issue in the history of the Roman Church.[74] These quotations belong to the textual basis for the traditional teaching concerning the guidance and bestowal of wisdom and understanding on all levels and under all circumstances (the Church, the church councils, universities, daily life) in the Christian world and need no further comment here. The role of the Holy Spirit in contexts of learning and study is normal and is to be considered an extension of its function as—quite literally—the divine "inspirator" of the world, most particularly the world of learning. The Holy Spirit is represented at one end of the room axis, in the same position that the Holy Spirit at Pentecost occupied at Praglia (according to our reconstruction and argument).

Generally speaking, the Parma program does not present any striking similarity to the one at Praglia, aside from the focus on the Holy Spirit, which is almost a matter-of-course for churches as well as monastic libraries (and other places of study, like universities).

3 A Comparison between the Praglia and Santa Giustina Programs

As proposed above, there seem to be certain affinities between the Praglia cycle and the earlier one in the main cloister at Santa Giustina in Padua, which would seem natural because Praglia belonged to the Congregation of Santa Giustina and was geographically

very close to it. We have mentioned already that the cloister cycle served as an illustration to the regular processions being performed there. The paintings, executed in tempera, are gone in great part and the remaining fragments are seriously damaged, but their subjects and arrangement are known from Girolamo da Potenza's *Elucidario* described above.[75]

This is the most extensive recorded monumental pictorial series on the life of Saint Benedict and at the same time the one that most elaborately develops the narrative in parallel Old Testament and New Testament subjects, as well as classical and allegorical subjects. The closeness of Praglia to Santa Giustina in terms of monastic administration and ideology, and geography, might have made the Paduan series especially relevant for whoever planned the new Library decorations at Praglia.

The Paduan fresco cycle consisted of forty-eight groups, each except one containing one Old Testament story, an allegorical representation, occasionally in the guise of a biblical character or symbol, the titulus of a pope or another important personage issuing from the Benedictine Order, a New Testament story, and a scene from Saint Benedict's life with a titulus explaining it. In addition, there were allegories and grotesqueries on the pilasters dividing one group from another. Besides important narrative scenes from the lives of Moses (Sinai, etc.) and Christ (Baptism, etc.), there are a number of miracles by Christ and quotations of his sayings. The latter might be taken to mean that it was left to the painter to find a way of illustrating them, which would mean that the *Elucidario* was a program for decorations and not a description of a finished one; however, information under No. 9bis shows that the document is in fact a description of an existing series: here, Girolamo da Potenza refers to the "last painting by Parentino—which was left unfinished because of his death." The series of famous Benedictines reminds one of the cycle of famous Dominicans in Tommaso da Modena's frescoes in the chapter house of San Domenico at Treviso or the Franciscans in the library at San Bernardino, Verona.

In the first group at Santa Giustina the accent is upon writing, with Esdras "scriba velox in lege Moysi" (1 Esdr. 7:6), Saint Gregory the Great writing "with four pupils of Saint Benedict," the Evangelist Luke "writing the Acts of the Apostles," and an inscription citing Saint Gregory's Life of Saint Benedict (his *Dialogue II*). It is evident that the Santa Giustina program is thematically determined by the Saint Benedict series. In every group, the Old and New Testament scenes and the inscriptions form a "background" or prototype to events in the founder's life and death, as we have already noted with regard to the first group focused on writing. A few more examples may be cited. When the monk Florentius (or Florenzio), distinguished by his "fraude ò malignità," gives poisoned bread to Saint Benedict hoping to kill him (No. 14), the latter's raven carries off the poisoned bread. Similarly, Samson, breaking the gates, deludes the Philistines and leaves Gaza, and Christ removes falsehood by upsetting the moneylenders' tables in the Temple. When Saint Benedict removes the false idols (No. 18), then the Altar of Bethel is destroyed, and Christ drives out the "buyers and sellers from the Temple." In No. 20, Saint Benedict drives away demons, and so do David with Saul and Christ with the obsessed. When King Totila prostrates himself before Saint Benedict (No. 25), this is seen in the light of the queen of Sheba's meeting with Solomon and Jews encountering Christ and the apostles.

Saint Benedict's appearance to sleeping monks (No. 30) is compared to Joseph's dream in the Old Testament and Joseph's dream of the appearing angel in the New Testament. Saint Benedict's death (No. 41) is typologically connected with Elijah's ascension in his fiery chariot and the Assumption of the Virgin.[76]

At Praglia there cannot have been any kind of linear correspondence between the biblical stories and a possible cycle of Saint Benedict's life, as the anteroom and not the main room would have provided the only available place for it, unless we imagine very small scenes in the framework for the wall paintings. There may have been smaller scenes or allegories on frames enclosing the wall paintings. The space available for pictorial decoration in the cloister of Santa Giustina is so much more extensive than that in the Praglia Library that parallelism in thematic arrangement at Praglia—at any rate parallel stories as at Santa Giustina—can hardly be expected.

We have noted that the choice of scenes from the Old and New Testaments in the Praglia Library, while calling to mind some passages from the *Rule,* does not seem to correspond to any pattern of references either in the *Rule* or in the available pre-sixteenth-century Commentaries on the *Rule.* Let us see, therefore, whether perhaps the choice of subjects and the specific correspondences in the Padua cycle may yield a clue for the Praglia program.

With reference to the *Elucidario,* cited above, we concentrate on the biblical scenes that correspond to those at Praglia and skip the Saint Benedict stories, since they mainly follow the course given in Saint Gregory's *Dialogue II.* This will help elucidate the context in which the Praglia themes occurred at Santa Giustina. We limit ourselves here to recording similarities and correspondences in order to develop a working hypothesis as a basis for further work, and we leave the attempt at deeper interpretation to chapter VI.

We give the Praglia scenes with emphasis, using the same titles for them as above. Instead of giving a lengthy prose description, we prefer to tabulate the contents as briefly as possible. The Praglia biblical scenes are in italics and, whenever a scene is present also in Santa Giustina, the biblical subject with which it is connected there is marked with an arrow (→).

ENTRANCE WALL (at Praglia)

Jacob and Esau (Genesis 27)
Not represented at Santa Giustina

Prodigal son (Luke 15:11–32)
Not represented at Santa Giustina

GROUP I (at Praglia)

David and Goliath (1 Samuel 17:4ff.)
Not represented at Santa Giustina. But there are two other scenes with David: weeping over the death of Saul, "his enemy"; David playing the harp ("cetra") and driving an evil spirit from Saul (1 Kings 16)[77]

GROUP 2

Moses breaking the law tablets (Exodus 32:1–35)
Santa Giustina → Christ tempted by the devil

Samson carrying the gates of Gaza (Judges 16:3ff.)
Santa Giustina → Christ, after the procession up to the Temple, overturn-
ing the moneylenders' tables ("Christo condotto nel monte per precipi-
tarlo"; see chapter VI); connected in an accompanying allegory with Saint
Benedict's story: Judith with the head of Holophernes

Jacob's ladder (Genesis 28:12)
Not represented at Santa Giustina

Christ driving the moneylenders from the temple (Mark 11:15–17)
Santa Giustina → Samson with the gates of Gaza (see above)

GROUP 3

Solomon and the Queen of Sheba (1 Kings [3 Kings]:10ff.)
Santa Giustina → Adoration of the magi

Judith with the head of Holophernes (Judith 13, passim)
Santa Giustina → Samson with the gates of Gaza (see above)

Jael who drives the tent peg into Sisera's temple (Judges 4–5)
Not represented at Santa Giustina

Christ teaching in the temple (Luke 2:41–52)
Santa Giustina → Solomon's judgment

GROUP 4

Birth of Moses and Moses on Sinai (Exodus 2:1–10)
Santa Giustina (both scenes): 1. Birth: Pharaoh's daughter finding
Moses → Purification of the Virgin presentation of Christ; 2. Sinai: Moses
descending with the tablets → Sermon on the Mount

Moses by the burning bush and the serpent (Exodus 3:2, 4)
Santa Giustina → A miracle of Christ: healing of the blind

Abraham's sacrifice (Genesis 22)
Santa Giustina → Nativity of Christ

Sermon on the Mount (Matthew 5)
Santa Giustina → Moses descending from Sinai with the law tablets (see above)

GROUP 5

Daniel in the lions' den (Daniel 6:16)
Santa Giustina → Christ calling "Come to me all ye. . . ."

NORTH WALL

Pentecost (Acts 1–2)
Not represented at Santa Giustina

As a working hypothesis derived from the above analysis of the Praglia cycle and its comparison with the other cycles, especially with the one at Santa Giustina, we suggest the following:

1. The Praglia pictorial program as we have reconstructed it is not narrative but seems to have a decidedly doctrinal message (moral, dogmatic, or otherwise).

2. There is a marked accentuation on subjects having to do with the Chosen People's conflicts with unbelievers (mostly Philistines).

3. A number of subjects and even some subject combinations found at Santa Giustina are repeated. These include Moses on Sinai and the Sermon on the Mount as well as two scenes devoted to Christ in the Temple, overthrowing the tables of the moneylenders and chasing them from the Temple, which may allude to issues of reform. But the Praglia program introduces two biblical scenes not found at Santa Giustina, and these bring in a combative attitude (David and Goliath, Jael and Sisera). The Praglia cycle was not, as was the Santa Giustina cycle, developed to parallel scenes following the life of Saint Benedict. This left the field open for a clearer emphasis on matters of doctrine and morals.

4. Some themes concern Catholic Tradition with a focus on learning and instruction. The Pentecost at Praglia and the Dove at Parma bring in the theme of Divine Wisdom.

The "combative" themes that stress victories of the Chosen People over their enemies and the concomitant emphasis on issues of instruction suggest a relationship to the dogmatic and doctrinal situation preceding the Reformation and developing through the period of the Council of Trent. The inclusion of the heresy-combating Saints Ambrose and Augustine supports this impression. In order to test this hypothesis, we shall have to study the position and role of the Benedictine Order, especially the "Cassinese" Congregation of Santa Giustina to which Praglia belonged, in relation to doctrinal and other perspectives in the mentioned period. This will be the task for the next chapter.

V

The Benedictine Order and the Catholic Reform

W E H A V E A R G U E D that the pictorial cycle at Praglia, taken in its totality, is a doctrinal document displaying a strongly combative quality and stressing matters of instruction. Here we support our hypothesis that this is related to the religious crisis of the period with evidence distilled from the complex primary and secondary literature concerning the Catholic Reform in the fifteenth and sixteenth centuries and the role played by the Benedictine Order. We consciously avoid the misleading term "Counter Reformation," since the reform preceded the northern reformers' appearance on the scene, and because it is more consistent to regard the northern reformers as an offspring of the Catholic Reform than the other way around.[1] It has rightly been stated that "the firewood for the Reformation was piled up long before Luther"—and Luther, Hans Küng reminds us, referred steadily back to late medieval theologians,[2] so it is a great mistake to consider the initiative of Luther as the "origin" of Catholic Church reform.

The Roman Church did indeed take Luther's statements as a cue to reaffirming her own Tradition, and she also felt the necessity of defending her positions. Long before, Cardinal Nicolaus Cusanus, in 1459, worked out a project for a *Reformatio generalis,* and Pope Pius II followed the trend in his Reform program.[3] The whole process, running over several decades after the initiative for a general council (later at Trent), was complicated and full of internal contradictions, and also packed with "Protestant-like" references to Saint Paul and the Greek Fathers. It may easily misrepresent the process if we adopt "a nice little slogan that sticks in the mind," as Ayn Rand would say. We have noted that the Benedictines themselves started their specific "reform" in the early fifteenth century; we shall explore this point further now, as well as connections of the Benedictine reform with widespread reform efforts in the Church. To conclude the present chapter, we extract from this intricate history certain tendencies in the Catholic Reform as a whole and in Benedictine attitudes that may be expressed in the pictorial cycle at Praglia: orthodoxy in basic theology and ecclesiology; combativeness with regard to heretics and other wayward people; a proud and firm conception of the Benedictine Order's specific and historical norms, values, scholarship, teachings, and traditions.

1 The Benedictines and the Roman Church before Trent

In this section, we consider Benedictine traditions of theology and scholarship in relation to those of the Roman Church in general prior to the Council of Trent. The renewal of the Order's traditional attitudes and mores effected under the fifteenth-century reform led by Ludovico Barbo also instituted administrative restructuring, including the annual terms for abbots mentioned above.[4] Although abbots often served for more than a year, terms remained brief (usually one to three years) in the Cassinese Congregation during the sixteenth century; frequently the same abbot would serve in sequence as head of several different monasteries in the Congregation. This mobility contributed, along with Barbo's institution of a Chapter-General of the Order, to the unity of the Congregation.

The devastation of the Black Plague in the fourteenth century affected monasteries and convents as well as cities. Loss of people, scholarly work, and discipline was the result. Even earlier, however, the monasteries had strayed from their founders' intentions. Hawkins has brought attention to the speech of Saint Benedict in Dante's *Paradise* which expresses sadness at the wayward state of his monasteries: "e la regola mia rimasa è per danno de le carte."[5] Ludovico Barbo's "observant" reform could also be called a Renaissance of the Benedictine Order in Italy, since the central idea was to go back to the early Christian origins of the Order and a strict adherence to the *Rule* of its founder. The success of Barbo's reform at Santa Giustina led to the growth of the Congregation, which reached seventy associated monasteries by 1520. It has also been noted that Santa Giustina's location in the university town of Padua was a factor in the rapid growth of the reform congregation, since university students were attracted to the scholarly atmosphere of the renewed monasteries, and scholarly monks from the Order were associated with the University of Padua.[6] It is important to recognize that this reform and renaissance did not occur in isolation, but in connection with various simultaneous efforts at reform within the Church. In fact, the "commenda" of Santa Giustina had been ceded to Barbo under the papacy of Gregory XII, a Venetian, by Cardinal Antonio Correr through the suggestion of his cousin, the Venetian Cardinal Gabriele Condulmer, who later became the ascetic, reform-minded Pope Eugene IV. Condulmer served as the protector of the Order in the Curia, and the Order maintained a "stanza" in Rome.[7] It was Eugene IV who appointed Don Cipriano Rinaldini d'Este, the abbot who brought the abbey of Praglia into the Congregation in 1448.[8] Possibly—since the standard of learning among Italian churchmen must have been relatively high—the Roman Church was alerted to the problem of reform also by the sad experiences during the Council of Florence, under Eugene IV, when the Romans repeatedly were made aware of a deficient theological preparation among their Greek counterparts and the consequent difficulties of reaching any doctrinal formulations whatever.[9]

Barbo's congregation of reformed Benedictine monasteries was first called the Congregazione di Santa Giustina and after 1505, when Benedict's own monastery of Montecassino joined, the Cassinese Congregation. The abbey of Praglia was the twenty-second to join, in 1448.[10] The general picture of the renewed scholarship of the

Benedictines of the reformed congregation needs articulation here, and for this purpose we are fortunate to profit from Barry Collett's penetrating study, *Italian Benedictine Scholars and the Reformation: The Congregation of Santa Giustina of Padua.*[11] His presentation of the teachings of Benedictine scholars in the fifteenth and sixteenth centuries provides us with an important analysis, assessing the theological and doctrinal background, against which we hope to develop a better understanding of the Praglia pictorial program.

The "Cassinese tradition"[12] focused on the study of the Bible, especially Pauline epistles, and the Fathers, especially the Greeks. A strong accent was placed on the notion of God's love[13] and on the idea that man is unable to fulfill the law and save himself without divine help; salvation is a gift, a "beneficio di Cristo."[14] After a chapter entitled "The Propagation of Monastic Doctrines during Years of Crisis 1540–43,"[15] Collett discusses the writings of the Benedictine scholar Benedetto da Mantova and his concept of the "Beneficio di Cristo":[16] faith and the bestowal of the ability to do good works. On the eve of the Council of Trent, in 1543, Benedetto da Mantova brought out a small book, *Il Beneficio di Cristo* (On Christ's Charity), initially approved by prominent clergy and widely distributed. Silvio Tramontin has called it a Cinquecento "best-seller," popular in convent, court, and modest home alike.[17] It was subsequently (1556) placed on the Index, despite the fact that it contained no straightforwardly heretical statements, and, according to Jesuit scholar Hubert Jedin, it was suppressed so efficiently that today copies are extremely hard to come by.[18] Tramontin relates the ideas of the *Beneficio* to those of Gasparo Contarini, to whom we shall return shortly.[19]

According to Collett,

> The furor that arose over the publication of *Il Beneficio di Cristo* in 1543, and the work's swift suppression, must have alarmed the Congregation, for in the spring of 1544 the Chapter-General renewed the *ordinatio* of 1528 against "the Lutheran heresy," ordering that cells be searched and a strict watch be kept for "libri suspecti." It was necessary to be on guard in the uncertain religious climate after the *Beneficio*. There had been denunciations and public burnings. . . . The fact was that the monks could no longer preach their doctrines with the old confidence, for the divisions had hardened and those who sought to reconcile the antagonistic ideologies of western Christendom were now facing a new intolerance.[20]

Collett gives a detailed account of the "attempts to clarify and to apply the Order's traditional teachings to the Reformation debates."[21] Under the heading "Monastic Teachings Clarified," he uses the writings of the Benedictine Luciano degli Ottoni, who was based at Mantua, for a more detailed rendering of the principal ideas.[22] Ottoni was well known to Contarini, Pole, and other Italian proponents of reform. In 1545 Ottoni was chosen as one of three abbots representing the Cassinese Congregation at Trent. After his death in 1552 his edition of Saint John Chrysostom (1538) was placed on the Tridentine Index in 1554 and on the Index of Pope Paul IV in 1559.

Ottoni's theology, in common with that of other Benedictine writers, consisted in a synthesis of the doctrine of the reconciliation of man to God through grace and the doctrine of man's restoration to perfection through faith and works. His sources were mainly biblical and patristic (but not scholastic), dominated by the Epistles of Saint Paul as these were interpreted by Saint John Chrysostom and the other Antiochene Fathers (Diodorus of Tarsus, Theodore of Mopsuestia, Theodorete of Cyprus). Greek theology played an important role for the Benedictine tradition.[23] So did the Greek Fathers, and especially Chrysostom, for Franciscan tradition.[24]

At this point, let us quote Collett at some length.

> Ottoni's book, published in Brescia in 1538, was a translation from Greek into Latin of John Chrysostom's commentary on St. Paul's letter to the Romans. An edition of this work in the original Greek had been published at Verona by [Bishop] Matteo Giberti in 1529, at the same time that Erasmus was editing several other works by Chrysostom. These publications were welcomed by Christian humanists who regarded highly the Greek Father's eloquent moral theology, in which they saw inspiration for church reformers and an antidote to scholasticism. Erasmus praised Chrysostom's emphasis upon charity, his labours "in the service of Christian piety," and his "evangelical philosophy."[25]

In the Roman West, following Saint Augustine, there was a strong accent on the antithesis between grace and works; and in the face of this tradition, Ottoni, for one, had to defend John Chrysostom against the allegation that he diminished the role of grace and exaggerated the notion of free will. According to Ottoni, man is impotent to merit his own salvation, and he refers to Saint Paul, rejecting the "Pelagian" ideas of salvation only through works. With regard to Praglia, we shall return to the question of "works." For Ottoni obedience and good works "flow naturally from living faith."[26] "In practice, restoration was to be carried out through the exercise of faith and works. Again Ottoni followed Paul and Chrysostom closely in his description of the new life...."[27]

Collett writes that Ottoni

> used Chrysostom's distinction between misguided Christians who, like the Israelites, obeyed the Law out of fear and self-interest and true Christians who obey out of faith and love for their Father: "The Law was given to them: grace and truth was procured for us. We accepted the Law in our heart: they on tablets of stone ... we submit to the Law of faith and keep it willingly and freely: they unwillingly obeyed the Law in terror. They with fear and compulsion ... we with love and faith...."[28]

This idea, also expressed by Isidoro Chiari and Benedetto da Mantova, amplifies the basic concept of obedience and good works proceeding from faith expressed in Benedict's *Rule,* which may also go back to Chrysostom.

2 Italian Heresies, Deviations, and Debates Leading up to Trent

Let us face the Italian heretics first, then the black sheep within the fold along with the "gray" ones. Delio Cantimori has given a long account of this subject, and there is substantial recent literature, so here we can restrict our attention to just a few cases or types of cases.[29] Heretical groups were particularly numerous and active after the 1520s in and around the cities of Milan, Venice, Padua, Vicenza, and also to some extent Ferrara, Modena, and Parma.

Attitudes that Hubert Jedin labels "Evangelismus," and which were focused on the problem of faith,[30] were quite widely represented, and a section of his second volume bears the title "Kryptolutheraner auf dem Konzil?" After the Inquisition started, a significant number of booksellers and printers were caught printing and distributing Lutheran and related publications;[31] and also a number of people of different categories were caught possessing similar printed matter. At the same time there was a large production of anti-Lutheran texts in Italy.[32] This situation, as we have just seen above, affected the Cassinese Congregation; Lutheran-focused interests in the Order caused the Chapter-General of 1528 to forbid monks to possess Lutheran books and to discuss Lutheran doctrines.[33] A notorious heretic among the members of the Roman Church was the Benedictine monk Giorgio Siculo, who had left the cloisters and gathered a following at the Collegio di Spagna.[34] He operated at Bologna during the sessions in that city (1547–48) of the Council that later moved to Trent, and he promulgated apocalyptic ideas, telling the Council that Christ himself would speak through his, Giorgio Siculo's, mouth after the conclusion of the Council; and thus all the sin of the world would be obliterated.

We have already mentioned the distinguished Benedictine Gregorio Cortese, who was abbot of Praglia in 1537. He was made a cardinal in 1542, an event celebrated by his reform-minded friends Pole, Contarini, Gonzaga, and Giberti, Pole attributing his election to the "working of the Spirit."[35] He was a prominent member of an ideologically significant group within the Church supported by Pope Paul III that included Cardinals Gasparo Contarini,[36] Reginald Pole, Giacomo Sadoleto, Giovanni Morone (formerly bishop of Modena), and Bishop Matteo Giberti of Verona.[37] These men were attracted by Augustinian ideas especially focused on the role of faith, an emphasis shared with some Cassinese scholars of the time.[38] According to Jedin, they "enthusiastically" adopted Johann Gropper's *Enchiridion,* of 1537, in Jedin's words a "compilation of the truths of the Christian faith, a doctrine on justification, that completely ignored Scholasticism and focused on Augustine; in the center stood Faith."[39] The slogan Justification through Faith "spread all over Europe in the 1530s," and Jedin explains this, saying that Gropper's *Enchiridion* "did not place itself at the level of polemics but rather propagated a positive doctrine of justification based on Augustine (and John Duns Scotus) instead of on the scholastic doctrine of Justification."[40] Gropper also took a personal stand on the crucial question of the Eucharistic species[41] and partly also on the issue of "good works," making their efficiency dependent on a "special faith" not acceptable to Roman tradition.[42] The book was generally rejected by the Church (according to Jedin) and was later relegated to the *Index*

librorum prohibitorum (especially on account of Gropper's treatment of the issue of Justification); and Johann Eck accused it of propagating "semi-Lutheran" ideas.[43]

In 1558, when Paul IV had published an *Index* of forbidden books that was so "literal" as to put Erasmus in a category with Luther and forbid all Protestant books including editions of the Bible and the Fathers, thus "depriving the Catholic scholars of their scientific tools" (Jedin), controversy over this categorization ensued, and a revision was started in 1560 (initially it came to nothing).[44] Elizabeth Gleason reports that Contarini was among those who pointed out the foolishness of suppressing information.[45] With such a searchlight aimed at any book collection, a motivation may be identified for the initiative for displaying orthodoxy in a prestigious library like the one at Praglia.

Finally, even among the authorities of the Roman Church there were prominent members who adopted attitudes concerning faith and justification that showed marked affinities to Luther's teachings, so that Jedin can speak of "diese entsetzliche Verwirrung auf doktrinellem Gebiet" (this terrible confusion in the field of doctrines).[46]

The point of this story about heretics and more or less "Augustinian" but loyal members of the Church seems to be that the latter set were attracted by some of the same central ideas that attracted the Lutherans and thought they could fight them with their own weapons, or thought that the Lutherans were misinterpreting Paul and Augustine. Our cursory look at some of the key issues in scholarship and activities of the 1520s to 1540s illustrates the intensity of the debates of the period. We might say that this grew from internal reform movements of the fifteenth century, of which Barbo's was an important case, and that the debates intensified after Luther's break with Rome, as the stakes became higher and charges of heresy (sometimes well-founded and sometimes politically motivated) darted about like arrows.

3 Main Issues at Trent

At this point we have to consider those issues under debate at the Council of Trent that were probably of special relevance to the Benedictine Order's basic conception of itself and its role in Tradition and in the Catholic Reform movement of the sixteenth century. Leaving aside many topics of ecclesiastical discipline and administration, we may nevertheless feel fairly safe in identifying six general areas that most, or even all, historians would agree were of particular and crucial importance: (1) the Mass as a sacrifice; (2) Justification as dependent on "good works" as well as on faith; (3) the fundamental importance of Tradition as well as Scripture; (4) the status and role of the saints in general and the Virgin Mary specifically; (5) the teaching role of the Church; and finally (6) disciplinary reform (against slackness, corruption, etc.).

Because of earlier neglect and in the face of the Protestant challenge, the dogmas and doctrines concerning the sacrifice of the Mass stood in need of being reaffirmed in conformity with Roman tradition. The Council of Trent's pronouncements on this sacra-

ment did not bring any novel teachings, but they did accentuate specific features in the Tradition, especially the notion of the Mass as a sacrifice and a good work.[47] According to Francis Clark, theologians from the thirteenth to the sixteenth century tended to neglect the idea of "the connection between the Eucharistic liturgy and the heavenly intercession of the eternal high priest" [Christ]; they certainly did not reject the idea, however, for it is expressed with utmost clarity and emphasis in the Mass ritual itself (the prayers *Unde et memores, Supplices te rogamus, Suscipe Sancta Trinitas*).[48] In allegorical illustration—that is to say, in pictorial representations—the concept of the heavenly high priest (Christ who offers and is offered) is visualized by accentuating either the live, glorified Christ as "celebrant" or Christ as the immolated victim. The clerics at the Council of Trent, taking up again old material, now insisted on the distinction between the bloody sacrifice *(sacrificium cruentum)* of Christ and reiterated in the Mass, and the nonbloody sacrifice on the model of Melchizedek *(sacrificium incruentum)*. They also, on 6 August 1552, discussed the Mass sacrifice in terms of a "good work," an *opus bonum,* a subject treated at length by Johannes Eck.[49] The continuity of concepts regarding "good works" is clear when we recall that Saint Benedict called the Divine Office the Work of God.[50] Prayer, in various forms, was called a good work or the work of God from early Christian times and had a special relevance in monastic contexts.

An important issue at Trent—and one that also appears to have played a role for the pictorial program at Praglia—was the Sacrament of Penance. The Sacrament of Penance—*sacramentum paenitentiae*—was codified at Trent in Session XIV, 1551, and connected with that of Extreme Unction.[51] The chapter headings give an idea of the scope: (1) On the Necessity and Institution of the Sacrament of Penance; (2) On the Difference between the Sacraments of Penance and Baptism; (3) On the Substance and Fruits of this Sacrament; (4) On Contrition; (5) On Confession; (6) On the Teaching and Administration of this Sacrament; and Absolution; (7) On "Reservations" (in cases of extreme transgressions); (8) On the Necessity of Atonement and Its Fruits; and (9) On the Works/Deeds of Atonement. This last chapter, with reference to Canon 13, speaks of works of atonement in a context relevant to the "good works" we have noted elsewhere in the present publication.[52]

The Council of Trent, in its pronouncement on Justification, stressed the necessity for the Christian, in a state of membership in Christ (a reference that implicitly focuses on the Eucharist), of practicing the three theological virtues *(fides, spes, charitas)* in combination with (good) works: "for faith without [good] works is futile."[53] The celebration of the Mass and participation in the Eucharist was itself considered the paramount, not to say the concluding "good work," in the debates of 1562 at Trent and in Johannes Eck's writings (and elsewhere).[54]

The notion of "good works," of which participation in the Eucharistic sacrifice becomes a core issue, was stressed by Johannes Eck and at Trent, and was fundamental also for another of the main issues at Trent: Justification. The theologian Hans Küng points out that historically Justification, which is entirely Pauline in origin, "became a burning issue only with the Reformation,"[55] and he quotes the Jesuit scholar Karl Rahner: "Whereas in

scholastic manuals justification used to be treated as a footnote to the theology of grace and sacraments, . . . it now becomes—following the lead of the Reformers—a complete and independent doctrinal treatise. And it is because of the Reformers too that biblical terminology is used extensively in place of scholastic."[56] The Council's decree on Justification was issued in January 1547, but the debate went on long after that date. For example, Cardinal Roberto Bellarmini wrote, in the 1580s and 1590s, what corresponded, in the Milan 1721 edition, to more than one hundred fifty folio pages on Justification in his *De controversiis christianae fidei.*

Justification is the process by which man attains the state of grace and is adopted as a child of God. While we should be aware that the issue is too complex for there to be any one firmly "objective" evaluation of it,[57] the principal clauses may be described in the following terms, taken from Hans Küng's book *Justification* (which, although to some extent polemical and focused on Karl Barth's justification theology, provides a good summary):

> Man . . . was created good; he was justified through God's actions. He
> would not have needed any particular, redeeming, reconciling justification;
> he stood in covenant with his gracious God and was destined for salvation.
> But man himself forfeited this salvation; he broke the covenant in the
> insanity of his sin. If he is justified despite this, and yet as sinner, it is only
> because God has stood by His covenant, notwithstanding the sins of men.[58]

Justification is granted to humans solely through Christ, provided that person believes in God and desires to be reborn in him through the sacraments. Faith alone is inefficient if not coupled with active charity and what is defined as "good works,"[59] among these the participation in the Mass sacrifice.

To sum up, Christian life is seen not as a set of "good" qualities but as a process of good works; Trent stressed the necessity of "good works" to achieve Justification.[60] This means that Sacrifice and Justification were intimately connected, as stressed repeatedly at Trent,[61] a linkage especially provocative in the eyes of the Protestant reformers. In Clark's formulation:

> The Reformation hostility to the sacrifice of the altar is found to be con-
> nected, in a coherent pattern, with the basic Reformation doctrines of
> grace, of justification, of the Church and the sacraments, and ultimately to
> Christology. . . . The Catholic conception of Christian dogma is aptly
> described as "incarnational." . . . By sanctifying grace men are regenerated
> and ennobled inwardly. . . . Not only Christ's holiness and his merits but
> also his *powers* of sanctification are communicated to his hierarchical
> Church. Fallen mankind is not only saved by Christ's atonement, but is also
> raised up to co-operate in Christ's priestly mission of dispensing that salva-
> tion to all succeeding generations. . . . Endowed with Christ's priesthood,
> the Church through her ministers has the function of mediating to all men

the fruits of Christ's all-sufficient work of salvation. This is the "work," the *opus operatum,* of the sacramental system. . . . It was this fundamental conception of Catholicism that was challenged by the Reformation. Religion for the Reformers was the personal encounter of the individual spirit with divine mercy shown in Christ. When they formulated and passionately proclaimed the gospel of justification by faith alone it was, implicitly, the whole "incarnational" ethos of Catholicism they were rejecting. . . . The fundamental difference which divides the Catholic conception of God's dealings with men from the Protestant may be described as a theology of *mediation* and *participation.* In Catholic thought, Christ's manhood, and the Church which is his fullness, and the sacraments which are his actions, form a hierarchy of created means by which the God-man communicates to men his saving activity. There is therefore a "descending" and an "ascending" mediation. . . .[62]

Some of the commentaries to the *Rule of Saint Benedict* appear to have exactly this "descending and ascending" in mind when talking about Jacob's ladder (see chapter IV above). Clark continues: "In this economy of mediation through the Church, the Mass is a principal instrument of Christ's saving action. Through its Eucharistic counterpart the sacrifice of the cross is made available for all men in all succeeding ages."[63]

In introducing the subjects of the Mass sacrifice and Justification, we mentioned four other "main issues" at the Council of Trent: the fundamental importance of Tradition as well as Scripture within the Roman Church; the status and role of the saints in general and the Virgin Mary specifically; the teaching role of the Church (which is intimately related to Tradition); and disciplinary reform.

"Tradition," too, is a term under continual debate, so that we should employ the most basic interpretation of it (which no one would dispute) and take this to be the normal attitude attributable to the Benedictines of Praglia. Tradition, then, would be the sum of what is stated in the Bible and written by the Fathers of the Church and practiced by the Church.[64] In this connection it is important to note that in the case of the Benedictines, the *Rule of Saint Benedict* would be regarded as an important feature in their particular version of the Tradition, since the *Rule* is concerned not only with literary materials but also with practice and works.

With regard to the role of the saints, it is noteworthy that the decrees about them are pronounced on the occasion of a discussion of the cult of images; this again attests to the action-focused, "operative" concern for fundamental issues in the Roman Church, a feature that requires of us a functional approach as well as the literary one. In addition to reaffirming the status of the saints and their veneration, the Council of Trent sanctioned the use of images for this purpose and reaffirmed the traditional Latin conception of the cult of images: that the veneration of a sacred image does not refer to the material image itself but to the "prototype" portrayed therein *(refertur ad prototypa).* In the following section, the Council advised bishops of their obligation to instruct and strengthen the faith-

ful through the "expression in pictures or other likenesses of the stories of the mysteries of our redemption" as sacred images remind people of Christ's "benefices" and conduct is shaped by the "salutary example" of the saints.[65]

Concerning the teaching role of the Church, the decree on the role of images is one of many specific provisions. Others deal with the teaching of Scripture and the writing of a catechism. In one of its sessions, the Council issued a decree, supported (as we shall see below) by Cassinese representatives, obliging cathedrals and monasteries to institute readings of the Bible. Already at the fourth session, in April 1546, the setting up of a catechism was mentioned and a draft followed eight days later. The eventual outcome was *The Catechism of the Council of Trent for Parish Priests Issued by the Order of Pope Pius V;* the writing, however, began only in 1562, with publication in December 1566.[66]

Matters of disciplinary reform affecting monasteries were also addressed in a series of decrees at Session xxv in December 1563. Elements of fifteenth-century reforms in individual Orders (such as fidelity to Orders' rules) were adopted as general guidelines; and, as part of a reinforcement of centralized control, bishops (subjected to residence requirements at an earlier Council session) were assigned some responsibility for overseeing and visiting monasteries in their dioceses.[67]

4 Three Benedictine Abbots at Trent

In early June of 1545, the Cassinese Congregation met at the abbey of San Benedetto of Mantua and elected three abbots to represent the Congregation at the Council.[68] Isidoro Chiari, abbot at Cesena (appointed bishop of Foligno in 1547), Luciano degli Ottoni, abbot of Santa Maria di Pomposa near Ferrara, and Chrysostomo Calvini, abbot of Santissima Trinità at Gaeta (made archbishop of Ragusa in 1560) were all distinguished as biblical scholars and were well known among learned clerics. Isidoro was a friend of Gregorio Cortese, and Luciano (as seen above) knew Contarini, Giberti, and Sadoleto. In general, the views they expressed were those of thoughtful scholars and men of faith well-grounded in the traditional Benedictine study of the Bible and the Fathers of the Church, and their preference was to bypass Scholastic formulations in addressing the issues at hand.[69] Due to episcopal concern, the Council, after some debate, determined that the three abbots should share one vote.[70] It should be noted that the Council of Trent, unlike some earlier Church councils, was dominated by bishops. Giuseppe Alberigo observes that there were few abbots at the Council, and that "among all the Italian bishops ... there were in this period extremely few who had degrees ['dottori'] in theology, or rather in philosophy; the very few who did have a degree, were almost all doctors in canonical law or in the 'classico *utroque jure.*'"[71] Therefore, the dogmatic discourse was held in juridical terms.[72]

Let us return to the three Benedictine abbots at Trent. Ottoni circulated a letter on free will, described by the very conservative Angelo Massarelli, about to become secretary to the Council, as "ineptissimum" and not free from heresy.[73] Three "errors" were

identified by the "influential Spanish Dominican," Fra Domingo de Soto. The first was that the fire of Hell was not necessarily a material fire ("ignis corporeus"). The second was that infants dying without baptism suffered no punishment ("pena"). "This teaching was a corollary of his denial that Adam's guilt was inherited and the newborn were guilty and liable to punishment. . . . The third error, that 'our good works are the reason why God predestines us,' was de Soto's version of Ottoni's belief that the term 'predestination' simply referred to God's foreknowledge of man's good works and ultimate destiny."[74] De Soto, thus, would have accused Ottoni of espousing Pelagian ideas. Ottoni also delivered speeches during the debates on Justification in October 1546, advancing arguments concerning faith and the certitude of grace that were described by Massarelli as "argumenta Lutheranorum."[75] Thus Ottoni, speaking for the Cassinese Congregation, was attacked by de Soto for emphasizing works too much and by Massarelli for emphasizing faith too much! We add that de Soto was a Spaniard and that the conservative Spanish element was increasingly represented at the Council.[76] In 1563, the bishop of Segovia (Spain) accused the opposing faction at the Council of taking inefficient measures that did not remedy "the major part of illnesses in the Church," rather inviting even more abuse: in this way, "the Philistines won the day": *vicerunt Philistiim.*[77]

In the debates on the issue of Scripture and Tradition, Secretary Massarelli's notes indicate that the Cassinese abbots opposed the formula *pari pietatis affectu* ultimately adopted by the Council, and that they agreed with the majority that no attempt should be made to list the "Traditiones." They agreed on setting up the Vulgate version of the Bible as authoritative, providing it should be corrected from Hebrew and Greek texts, a task later assigned, as we shall see, to the Congregation. The abbots, Isidoro Chiari in particular, also favored compulsory lectures on Scripture in all monasteries and cathedrals, a provision that was eventually adopted despite Inquisitor de Soto's opposition.[78]

On Justification, Isidoro spoke for the abbots, expressing the view that theological argument had become too intellectual and complicated—on matters that had been understood by fishermen! According to Isidoro, Scripture says that man is justified by Faith "live with works" *(quae operatur per charitatem)* and that man must assent to God's grace by his own free will. Saint Paul's denunciation of works, he said, in opposition to the Lutheran view, refers merely to works of the Old Law, such as circumcision, not works of Christian charity.[79] In a later session on Justification, however, Luciano degli Ottoni expressed some ideas further from the final formulations of the Council. He argued that sin is accompanied by at least some loss of faith, and concerning the issue of certitude of grace adhered to by Lutherans, he first distinguished between one's belief in one's justification (which might be sincere but incorrect) and knowledge of it (which is not possible), but he later came close to a Lutheran idea of certitude. He publicly recanted this position and the connection of sin with loss of faith, and in subsequent debates appears to have been more cautious.[80] Nonetheless both Ottoni and Chrysostomo Calvini took notable part in the session that continued in Bologna in 1547–48, and both were promoted to the select company of "Prelate-Theologians" at the Council. Continuing representation of the Congregation is indicated by the fact that two members from Ferrara were present at Trent in 1563, name-

ly Eustachio Cordes, whom we shall meet later on, and Agostino Locus.[81]

The case of the former Benedictine monk Giorgio Siculo, executed for heresy at Ferrara in May 1551, was spoken of above. This calamity cannot have passed unnoted at nearby Praglia, and should have been more than sufficient to put the Benedictine Order—or, at least, its image—in an embarrassing position. But there is more, since Luciano degli Ottoni had supported Siculo (he was "ihm wohlwollend," according to Jedin), while reassuring the nervous duke of Ferrara that he was "a pure visionary but completely uneducated."[82] According to Jedin, Ottoni was considered, in the more conservative evaluation, as a "crypto-Lutheran": "a typical representative of Italian Evangelism."[83] Jedin seems more in agreement with Massarelli's criticism of Ottoni as "crypto-Lutheran." Collett's more recent interpretation is that the Benedictines referred to their ancient scholarly tradition in hopes of resolving the existing problems, saying that the Congregation as represented by its chosen representatives at the sessions of 1545–47 at Trent entered "into open theological conflict in the cause of reconciliation."[84] Concerning Ottoni, Collett notes: "Nevertheless his tract was an exposition of the traditional teachings of the Congregation."[85] The gist of these traditional teachings is that good works and faith are both necessary and interactive, that is, good works are inspired by faith and, in turn, perfect the practitioner's faith. Tommaso Leccisotti stresses the close connections of the Congregation with the papacy at the time of the Congregation's early development as a model of monastic reform, and the continuing reliance of the Church on Benedictine theology and scholarship during and after Trent.[86]

5 Consolidation after Trent

The complex issues addressed at Trent did not immediately disappear, and implementation of the reforms of Trent went on for a long period following the conclusion of the Council in 1563. Local documents, quite apart from those issued by popes, bishops, and councils, attest to this. The ceremony master of San Marco, Venice, in 1564, complained that people did not bother to come to church for the indulgences anymore, because the new teachings from the North had undermined their faith in them.[87] The same document records, for 1563, a rubric called "Jn missa & processione pro eresum estirpacione," a Mass and procession for the uprooting of heresy, and also a ceremony to celebrate "la resa d'ugonoti heretici da franza in franza," the surrender of the heretical French Huguenots in France. And a big procession was arranged by the Church of San Marco for the conclusion of the Council of Trent, as attested by the same document.

The continuing need to eradicate heresy is attested by specific cases like the trial of Matteo and Alessandro degli Avogari at Verona in 1567, shortly after the close of the Council of Trent. The Roman tradition concerning the role of the Virgin Mary in relation to the Church was rejected by some heretics; a standard argument, also with Luther himself, was that prayer should go directly to God and to Christ, not through the saints, among them the Virgin Mary. In the trial at Verona the accused explains that he has told

his children to recite a prayer to Christ and skip the *Ave Maria* because the "Ave Maria is just a salutation, while prayer is addressed to Christ." He is then accused of holding that "it is not necessary to pray to the Virgin Mary Mother of Christ, and that the [her] intercession is ineffective [*vana*], and not necessary." The accused confirms this and explains that this is his attitude toward "all the saints."[88]

In 1564 and 1566 Bishop Alvise Pisani of Padua (bishop since he was six years of age!) called two diocesan synods for the promulgation and implementation of the decrees of the Council of Trent. Numerous pastoral visits to monasteries are recorded between 1543 and 1570, and an apostolic visit of 1564 is recorded by Alberigo, who also cites the active presence at Padua of the Jesuits and their efforts to spread the teaching of the catechism.[89]

The Jesuit Cardinal Roberto Bellarmini published in 1586−93 a very extensive work, *Disputationes de controversiis Christianae fidei,* collecting all the Catholic theological and historical arguments against the Protestants. Here he classifies three kinds of "opera" in his chapter XXIII, book III, "De romano pontifice."[90] Using Saint Paul in support of orthodox theology (turning the Pauline "man is not justified by his works, but by his faith" to orthodoxy's advantage), Bellarmini lists the following three types of works. The first belongs to human nature and causes glorification among men but not with God—a concept taken from Romans, chapter 4, in which Saint Paul applies the notion to the case of Abraham (quoted by Bellarmini). Abraham is represented in the Praglia ceiling (see chapters IV, VI, and VII therein).

The second type of works "proceed from faith and from God's grace and predispose [man] for reconciliation with God and remittal from sin" *(ad peccatorum remissionem),* such as prayer, almsgiving, fasting, *dolor de peccatis,* etc.

The third category consists of works that proceed from "man already justified and from the Holy Spirit dwelling in the hearts of men": namely "faith, hope, charity, penance, the sacraments, . . . which [all of them] like media or instruments, through God's disposition, make Christ's merit valid for us" *(ipso Deo praecipue operante, Christi nobis meritum applicatur).* In his book on Purgatory,[91] Bellarmini sums up the Roman view by stating that our works are rendered valid exclusively through Christ's blood *(tota virtus operum & satisfactionis nostrae à Christi sanguine pendet).* In his books on the sacraments,[92] Bellarmini stresses that good works emanating from human virtue do not constitute a sacrifice: *non sunt sacrificia propriè dicta.* An impression of the importance attributed to the issue of good works and to the various uses of the term "opus, opera," may be gained from the fact that in his fourth volume Bellarmini lists thirty-nine entries under the heading "Opus bonum, & satisfactorium"; and in his books on grace and justification,[93] fifty-three entries on "opus, opera."

6 The Cassinese Congregation after Trent

Thus the reaffirmation at Trent and in the debates preceding this synod would lend further accentuation and support to a life already stipulated in the *Rule,* a life dedicated to

"good works": to humble participation in Christ's benefice, which provides opportunity for salvation, the salvation continually consummated in the participation in the Mass sacrifice.

In Collett's view, the Order had developed a tradition based on the Greek Fathers and Saint Paul, and it was precisely this tradition that was played down at the Council of Trent. In Collett's words:

> Suddenly the monks found that the pattern of salvation which they had expounded with increasing determination and skill was now barely acceptable in the Catholic world: in turn this can only have shaken confidence in the biblical and patristic exegesis from which they had drawn their doctrine of salvation. In these circumstances it is hardly surprising that there was a tendency for the monks to concentrate upon inward and personal features of the old pattern of salvation, especially "love" and "good works." These two emphases, which are clearly recognizable as two elements of the earlier doctrine of "faith," were perfectly acceptable in the climate of Roman Catholic spirituality after Trent provided they were not pushed to extremes as Siculo had done.[94]

Collett sees, in the Codex 584, a collection of writings of the 1550s produced at the monastery of Montecassino, and in some of the other writings of Benedictines of the Cassinese Congregation during this decade and the 1560s, a movement away from the Benedictine tradition of careful scriptural and patristic scholarship in favor of a stronger emphasis on obedience and piety.[95]

Leccisotti stresses the continuing erudition, fidelity, connections, and orthodoxy of the Cassinese Congregation.[96] He documents two commissions assigned to the Congregation after the close of Trent that would appear intended to utilize their experience in patristic scholarship in implementing the Catholic Reform: a decree of a Diet of 1566 concerning the commission for the Cassinese Congregation to carry out an annotated revision of the Vulgate; a new edition of the works of the Church Fathers Jerome, Saint John Chrysostom, and Theophilus "to oppose the forces of the Protestants who sought to distort the texts of the Fathers."[97]

Opposition to "distorting the texts of the Fathers": this gives a perfect cue to the gist not only of the Reform itself but also—as we see it—of the pictorial program at Praglia. To those zealous readers of the authorized texts, the Benedictine monks, their painted decorations must have looked exactly like an illustration of that formulation in the specific way this Order had chosen to interpret it.

VI

The Texts of the Fathers

I N C H A P T E R I V we undertook a reading of the ceiling and wall paintings on the bases of the biblical text and other text references (mainly the *Rule of Saint Benedict*). Then we compared this with other extant or recorded painting cycles, primarily the one in the cloister of Santa Giustina at Padua. From the evidence and observations presented so far, we offered a rough working hypothesis that led us to investigate the Benedictine Order's self-image—especially with regard to the Cassinese Congregation—in relation to doctrinal debates before and during the Council of Trent. Now we want to bring together the various strands so as to focus on the pictorial program of the Praglia Library as we have ventured to reconstruct it.

1 General Problems of Interpretation

In addition to the more general difficulties regarding the interpretation of pictorial cycles as such (a subject we mentioned in chapter IV.2), there are several major problems attached to attempts at interpreting the choice of biblical stories for the Library ceiling and walls.

While the identification of the individual subjects in the wall and ceiling paintings of the Praglia Library is straightforward, we have not been able to identify one particular literary source for the specific choice of subjects and themes and their correspondences—except to a certain extent in the descriptions of the fresco cycle in the cloister of Santa Giustina at Padua. The sources abound in biblical references, but not all of them are equally relevant. One would want to believe that in a pictorial program focused on long-range perspectives, incident-related references did not determine the chosen scenes. For example, in the tussles over the contested Council of Basel in 1440, Eugene IV issued a bull entitled *Moyses vir Dei,* which, according to Gill's summary, claimed that "as Moses bade the people leave the company of Korah, Dathan and Abiram, so we must warn the faithful to flee the company of the men of Basel, who are nothing but a collection of reprobates."[1] Once such an incident as this had passed, any pictorial reference to it would lose its meaning.

The second problem concerns the authorship—or better—the question of authority behind the pictorial program. In this book we take it for granted that a relatively complex program like that of the Praglia Library was set up by experts on theolo-

gy and the teachings of the Church, not by the artist. Experiences from several great pictorial campaigns support this view. Concerning the fifteenth-century paintings in the Sistine Chapel in the Vatican, Ettlinger makes the point in the following terms. He cites a document by Leonardo Bruni,

> a document, albeit drawn up some fifty years earlier, which gives us some indication of the collaboration between an artist and his scholarly adviser: Leonardo Bruni's famous letter to the Committee of the Arte di Calimala in charge of the commission for the third door of the Baptistery [in Florence]. Bruni . . . justified his choice of twenty scenes from the Old Testament by saying that they should answer two requirements: they should be *illustri* and *significanti,* explaining the first as an aesthetic and the second as an icono- graphic category. In other words, he wished to suggest the representation of incidents which would not only make fine pictures but were at the same time of significant content. Referring to the latter demand he added: "But I should like to be at hand for the artist who has to design them, so that I can make him understand the significance of each story." This would imply learned control down to details. . . . We can be sure that control of a similar kind was exercised in the Sistine Chapel, and there would have been noth- ing unusual in this even in the late Quattrocento . . . the didactic purpose of almost every detail is made so plain, that there can have been little or no room for any fancy work on the part of the painters. For the moment we are only concerned with establishing the fact that there must also have been an artistic "master-plan," for any visitor to the Chapel is at once struck by the unity and homogeneity of the paintings. There is a cohesion not only of theme, but also in composition and style. . . .[2]

Furthermore, we have at least two cases of expert programming by Benedictines in the context of the Cassinese Congregation. A distinguished Benedictine, Eustachio Cordes, was the author of the program for the pictorial series of the choir stall in the church of Santa Giustina at Padua, which were based in part on the *Speculum humanae sal- vationis.*[3] Cordes, abbot for a period, served as a representative at the Council of Trent; he also was named secretary for the papal commission for the revision of the Vulgate, by Pius V in 1569.[4] The other Benedictine case of expert programming is provided by Vasillacchi's paintings for the Benedictine church of San Pietro at Perugia in 1592. The contract stipulated that the artist should paint the life of Saint Benedict "in conformity with the design thus drawn up by the Reverend Father Don Arnaldo, monk of this Congregation, presently in the monastery of San Giorgio Maggiore in Venice, with all the figures as it is planned."[5]

Another case we may cite here in which written contemporary documents make it abundantly clear that programs were devised by experts and not by the painters, how- ever much some art historians want to "restore the role of the artist," is the decoration

campaign in the Doge's Palace, Venice, after the fires of 1574 and 1577. All the program texts, including one for an inscription on a drawing by Paolo Veronese, are complex and presuppose a high level in learning as well as in intellectual programming.[6]

The third problem is that we are dealing with Christian iconography in a room, the Praglia Library, that has functions related to the rituals of monastic life but does not have the strictly liturgical functions of a church or chapel, for which there is a fixed set of texts and traditions that would form a basis for iconography.

The fourth problem is that controversies over orthodoxy versus heresy or deviations, such as those attested in the writings and carefully reported for the Benedictine Order by Collett, Evennett, Trolese, and others, are communicated with reference to doctrinal and dogmatic statements mainly in the abstract. In contrast, a pictorial iconography depends on scenes, events, and figures that are visualizable. One can refer verbally to "justification," "salvation," and so on, but one cannot do so pictorially without having recourse to something that can be seen—a question of showing rather than saying, to apply Wittgenstein's distinction. In regard to this we try to take account of relevant pictorial traditions as exemplified in medieval manuscript illuminations. In addition to this issue, we must acknowledge some uncertainty concerning the role of emotional attitudes that are not always easy to grasp or document. In the midst of the more or less "rational" theological debates of the sixteenth century, we should not overlook the presence of a mystical tradition within the Roman Church. The matter is not simple, for as Yves Congar, O.P., rightly noted, there are two senses to this term: first, the orthodox and canonical approach of the Fathers of the Church, as an absorption of the mysteries of salvation through *lectio divina* regarding Scripture, the lives of the saints, and practicing the liturgy; and second, the mysticism of supernatural union with divinity in earthly life.[7] Martin Grabmann, in his classic history of Catholic theology, characterizes the Benedictine tradition in the twelfth century in terms of the "theoretical mysticism of the Middle Ages." He cites Saint Anselm of Canterbury's letters, meditations, and prayers and, among others, "the mystical conception of Holy Scripture" in Rupert von Deutz's works.[8] Another example is the Paris-based Peter the Chanter (died 1197), who wrote *De oratione et speciebus illius,* a Part of his *De penitentia et partibus eius.*[9]

This made for openness toward the *devotio moderna* and writings such as Thomas à Kempis's *Imitatio Christi,* apparently well known in the Cassinese Congregation.[10] In the thought of Bernhard of Clairvaux (and not only here), love is connected with membership of the Community of the Holy and man's unity with the saints: "the unity of the Church [is] rooted in love which enables the faithful on earth to share in the merits of the heavenly saints."[11]

2 A Monastic Setting

The Praglia Library provides aspects that are helpful for an analysis venture, too. The *Rule of Saint Benedict,* the well-documented history of the Congregation, and the writings of the Benedictines themselves all provide a fairly rich documentation of the context for the pic-

torial program. The brothers in a venerable and scholarly order are members of the Church and are closely connected with Rome as well. The Divine Office and the Mass and the reading of Scripture and the Fathers are in the fabric of their lives. Here, the life according to the *Rule* consisted in a clearly defined set of activities: prayer, reading, meditation, participation in the Divine Office, and all sorts of appropriate works. They prayed directly individually as well as together; in the *Rule* prayer is the work of God. Barbo's writings on prayer and meditation give us some insights into the situation during the Renaissance.

The *Rule of Saint Benedict* very strongly supports the view that a book collection and the use of it, directly or indirectly, is an important feature of monastic life and, by implication, of any Christian's life. This life is considered "holistically" (to use a modern term), so that the contemplative and studious activity is one with the "good works" of any Christian, and these are ultimately focused on salvation, and hence related to participation in the Sacrifice of the Mass.

The virtue of reading, as we have seen (chapter II), is strongly advocated, in fact, imposed, in Saint Benedict's *Rule,* as a basis for meditation.[12] The Benedictines of the Cassinese Congregation of the sixteenth century had a guide for their prayers and meditations, namely in their great reformer Ludovico Barbo's *Ad monachos S. Iustinae de Padua modus meditandi et orandi . . .* (1443), a book that may have reflected and must have set the scene for Benedictine attitudes toward prayer and meditation not only in ritualized situations, but also in daily patterns of behavior and spiritual attitude (even though Barbo was certainly not the first to produce a treatise on prayer and meditation).[13]

3 From Images to Meditation

Barbo's book offers insight as to the function of religious pictures in a monastic setting. Barbo defines three levels of prayer: the first consists of reciting or reading; the second is meditation described in terms of figures and events of a type that will naturally conjure up visual concepts, many of which are, in fact, standard subject matter in pictorial representations; the third stage of prayer is contemplation, which cannot be taught *(neminem docendum),* but which proceeds from meditation.

At the second stage of prayer, meditation, Barbo says, "we do not express ourselves in words, but with the heart, the mind and with feelings. In fact, when God's works and the order and beauty of what he has created are being presented to our mind, then it scrutinizes and dwells on them, enjoys and becomes carried away by God's love. . . ."[14] Barbo conjures up images of the beauty of Creation: God "created and adorned the sky with stars, the sun and the moon, the earth he embellished with flowers, fruits and innumerable species of animals . . ."—references of a type we find in non-Christian religions, too.[15] Barbo furthermore gives numerous examples of events and figures for consideration and focus in meditation. "Meditate and imagine you are descending into Limbo with your Most glorious Jesus, and are seeing the fullest splendor emanating from him. You also will see Adam, Eve, Abraham, Isaac, Jacob, Moses, David, . . ."[16] and, "After this, imagine you are seeing the

selfsame Lord Jesus being led [away] in fetters. . . ."[17] Barbo speaks of "seeing" these figures and events. The role of visualization, mentally or directly, in human perception and knowledge acquisition has always been taken more or less for granted; in our days solid scientific foundations have been construed for this assumption. In the Roman Church, there was a long-standing tradition of awareness of the cognitive role of images and the role of mental imagery for inspiration, learning, and knowledge acquisition.[18] This was reaffirmed by the Council of Trent.[19] The pictures themselves were seen as an important means for bolstering orthodox faith and practice and as a weapon in the fight against heresies. In chapter v we discussed the statement, issued at Session xxv of the Council of Trent in December 1563, which instructed bishops to use pictorial and other visual arts concerning the mysteries of salvation for the teaching and spiritual gain of the people and also in order to show the love and miracles of the saints as models for them. The statement concludes by saying that anyone who teaches to the contrary shall be anathema.[20]

The Praglia monks, and probably others as well, used their Library for literary studies. Would they have been interested in paintings on the ceiling above them and on the walls around them? "User histories" that might answer a question like this one are almost never directly accessible in the sources. We know, however, that the Church in the sixteenth century made a major point of advocating and actively using images in the traditional sense of this term: paintings, frescoes, sculptures, accessories (like crosses, chalices) with figures and decorative elements on altars, walls, vaults, and cupolas, carried in processions, and so on. In the context of a library as well as that of the liturgy, illustrations in scrolls and codices ("books") were normally used for accentuating and explaining major themes and points in the texts. The earliest manuscript Life of Saint Benedict according to Saint Gregory the Great, the so-called *Codex Benedictus,* today in the Vatican Library, is dated around 1070; it is lavishly illustrated (see below), and so are many of the later printed editions.

The great Benedictine reformer of the Cassinese Congregation in the early fifteenth century, Ludovico Barbo, in Padua, advised those who studied his "method of prayer and meditation" to think in terms of images. Certain rites were focused on images: the washing of the feet of a Christ image in Rome on Maundy Thursday (a rite suppressed by Pius V around 1570); and carrying in procession and chanting before a Virgin image in San Marco, Venice, during the *Salve Regina* liturgy.[21] Images of the saints and of sacred history could be effective by virtue of a mechanism by which, in Hahn's words, concerning "access to the heavenly: one must perceive and learn through the senses . . . one remakes one's perceptions and one's soul in accordance with those models and follows an already prepared path to salvation. Such saintly psychopomps might equally be texts or images, icons or narratives."[22] In monastic settings, sacred images could play a role in terms of internal pastoral care and with repercussions far beyond the immediate surroundings.[23] Here, they also might bring about a connection between public liturgy and private devotion, as in Hedeman's example: "The gesture in the Cleveland panel [Jean de Beaumetz's (?) *Calvary with a Carthusian Monk*] in particular forges a link between the private devotion and public celebration of Carthusian liturgy—a link that, whether intended by the artist or not, would nonetheless have been inferred by the Carthusians."[24]

The case of a Benedictine monastery commissioning iconographic prototypes and seeing to their distribution through prints is attested for Einsiedeln.[25] Cardinal Roberto Bellarmini, writing in the 1580s and 1590s, said nothing new when he stated that everything we know, either with our senses or with our spirit, is known through images. And of images, there are two kinds: perpetual images, like a cross in wood or metal; and transient images, like making the sign of the cross.[26] Bellarmini offers a synopsis of the traditional paradox: "It is usual to depict those who are absent, because one doesn't see them; God, however, is present, but we don't see him, and therefore we depict him, as if he were absent," and these pictures do not represent God but are there "in order to lead mankind into some understanding of God through analogical comparison."[27] So our modern concept of "mental images" is not so modern after all, as we learn also by consulting the image-relevant vocabularies in patristic texts, such as the writings of Saint Ambrose, which were surely well known at Praglia.[28]

Even graphic models, in our sense of the term, were in use since antiquity. In the Aristotelian tradition, strong at the University of Padua, the "Tree of Porphyry" was used to illustrate the interrelations (and distinctions) between matter and spirit, living and nonliving, and so on (Fig. 75): a graphic picture of a true "mental image." As J. F. Sowa put it, "Porphyry arranged Aristotle's categories in the world's first semantic net," and our Figure 75, taken from Sowa, shows it "as it was usually drawn by the Scholastic logicians in the middle ages."[29] This "tree" shows a procession of central terms right through its middle axis, with lateral branches along the axis containing terminological extensions. Conversance with a plan like this would probably have prepared the monks for capturing the idea behind the rather similar system of arrangement in the Praglia ceiling, with its dominant series of paintings along the middle axis and lateral pictorial "extensions" and comments.[30]

4 Scanning the Praglia Pictorial Cycle

The Praglia program, when compared with what is known about other pictorial cycles in the fifteenth and sixteenth centuries, and even earlier (Assisi, for example), offers an especially complex and rich collection of biblical scenes that do not follow a narrative course. The twenty-one biblical scenes were clearly selected for doctrinal and ideological motifs that were brought to the viewer's attention by the three allegorical scenes at the center of the ceiling and by the arrangement. Key themes that emerge are considered below.

4.1 *Focal Pictures: The Church and Tradition; the Holy Spirit and the Virgin*
The Library decoration at Praglia has two interdependent foci: the Holy Spirit as the source of wisdom, inspiration, and illumination on the end wall, and the Church as an all-embracing institution and dispenser of the sacraments at the center of the ceiling (Figs. 29, 55, 63; Pl. II).

A fundamental theme in the theological debates of the sixteenth century con-

cerned transubstantiation,[31] the conversion of bread and wine into the body and blood of Christ in the consecration of the Mass, and hence the instrumentality of the Eucharist in perpetuating Christ's redemptive sacrifice. At the same time, Trent stressed that "faith alone" *(sola fide)* was not sufficient preparation for receiving the Eucharist; the Sacrament of Penance was required to confess works that were not good.[32] In the center of the Praglia Library ceiling, the female personification of the Catholic Religion dominates the picture, accompanied by the Evangelists (Fig. 63). She is holding the cross and the chalice, with unambiguous reference to the Eucharist and the sacrificial celebration of Mass, the recently reemphasized instrument for salvation. Trent had affirmed in 1547 that whoever denies the necessity of the "sacraments of the New Law" and says that only faith is necessary for Justification will be anathema.[33] The explication of the Mass as *opus bonum* had been formulated at Trent, after lengthy debates, in August 1562, and this must have been known also at Praglia during the planning of the ceiling program.[34]

The figure of the Church with the cross and chalice amounts to more than the direct reference to the sacrifice and the Eucharist, and, by normal association, to the other sacraments as well. The institutional character of this allegory should not be overlooked. No sacrament can be made to work without the institutional structure. The sacrifice in the sacrament of the Eucharist is offered for the Church as a whole: "Für diese Kirche wird das Opfer dargebracht," in Jungmann's words, reflecting the words in the Offertory of the Mass.[35] At Session XXI, 16 July 1562, "The Council [of Trent] declares that the Church has always possessed the authority/power to affirm or modify, in her dispensation of the sacraments, while respecting their substance, whatever she judges to be most useful for the faithful or for the (dispensation of the) sacraments themselves, according to differences in time, place and general conditions."[36] In order to increase and intensify human participation in the Eucharist and enjoyment of the fruits thereof, the Council, at the next session, 17 September 1562, expressed the desire that people take communion frequently, preferably at every Mass.[37]

The octagonal painting in the center of the ceiling of the Praglia Library (Fig. 63) is an image of the (Roman) Church with its key sacrament and Scripture symbolized by the Evangelists. Via the adjacent canvases of the Fathers defending and teaching the faith (Figs. 60, 66; Pl. II), the Church is associated with its Tradition, a term that embraces liturgical practice.[38] The Church herself, represented as a *Religio Catholica* figure, turns a pure "Faith"—a self-sufficient entity for Luther while accentuated within a Catholic framework by the Augustinian tradition—into an operative *Religio Catholica* complete with the signs of Christ's Sacrifice and the "good work," the Mass, which Catholic dogma required for the fulfillment of Faith. The importance of the female personification of Catholic Religion in the center of the Praglia ceiling should not be undervalued (Fig. 63). Her cross and the chalice displaying the sacrificial character of the Eucharist amount to a statement against Luther's heresy, a theme which equaled that of Justification as the fundamental dogmatic issue of the Council of Trent. At the same time *Religio* is accompanied by the four Evangelists, reflecting the reaffirmation at Trent of the importance of the Scriptures, as well as Benedict's emphasis on the "Gospels as our guide." Thus the

central canvas embodies the idea of Catholic Religion based on Scripture, while its basis in Tradition as well is symbolized by the presence of the Fathers in the adjacent canvases (Figs. 60, 66). Saint Benedict stressed the reading of the Scriptures and of the Fathers of the Church, and Trent's formulation was that the Catholic Religion is based on both Scripture and Tradition.[39]

Saint Gregory's *Dialogue II,* chapter 1, reports how in the beginning Saint Benedict isolated himself from the life of the Church, yet later he feels himself bound to the Church in the interrelated meanings of this term and to her Tradition. In the *Rule* Benedict pays allegiance to "our Holy Father Basilius," to the Church Fathers, and instructs his monks to read the Lives and Conferences of the Fathers.[40] He specifies such readings as part of the Divine Office at night, known as Vigils: "Besides the inspired books of the Old and New Testaments, the works read at Vigils should include explanations of Scripture by reputable and orthodox catholic Fathers."[41] In the sixth century Benedict is stressing the need to read Scripture with guidance from Catholic Fathers. This point, well known to any monk at Praglia is emphasized in the arrangement of the three central ceiling canvases at Praglia and would have been perceived by those who entered (Figs. 29, 56; Pls. I–II). Visitors who entered the newly decorated Library around 1570 would not have missed the implied criticism of the Protestants. A fundamental issue here is obedience within the *conversatio:* a key term meaning monastic life within the context of the Church.[42]

At Trent it was declared that not only Faith, but also participation in the Church and preparation through the Sacrament of Penance, were required to render the Sacrament of the Eucharist efficacious to a person.[43] The concept of Penance plays an important role in Saint Benedict's *Rule,* and in Saint Gregory's *Dialogue II* on the Life of Saint Benedict there are stories concerning both the power of the host and Peter's power to forgive sin.[44] It should probably be seen as a sign both of Benedictine tradition as laid down in the *Rule,* and of the period just after the conclusion of the Council of Trent, when a Benedictine, Vincenzo of Milan, in May of 1568 completed a treatise, in which the Sacrament of Penance was accentuated in a peculiar manner—and all the way with focus on the Holy Spirit (see appendix 2). In his *De maximis Christi beneficiis pia gratiarum actio* (A thanksgiving for the greatest benefices granted us by Christ), Don Vincenzo offers a number of paragraphs, each with a thanksgiving for a specific "benefice": Christ's Incarnation, Baptism, and so on, up to his suffering and death, and then his sending of the Holy Spirit. From the Pentecost theme he goes straight on to thank Christ for the Sacrament of Penance. He does this by stressing the power *(potestas)* with which Christ has endowed the Roman Church for the administration of this sacrament. Citing the story of Christ giving the keys to Saint Peter *(translatio legis),* Don Vincenzo elaborates the concept that whatever is bound or unbound by the Church headed by Peter, the same will occur in heaven. From there he goes on to paraphrase the passage, receive the Holy Spirit for the remission of sins; thus the theme of Penance is linked with the preceding theme, the Pentecost. Whereupon follows another paragraph in which the subject is "the Book" written inside and outside: an image of Christ but apparently also specifically the "Word," with refer-

ence to Holy Scripture.[45] The book is written outside "in a literal sense," inside with an "allegorical" meaning accessible to "spiritual intelligence," a meaning Christ "conveyed to the blind and dark world through the Holy Spirit." After this, there is a paragraph about Christ's Second Coming and Judgment, and finally about the light prepared for "his chosen" *(tuis electis)*.[46] This treatise, written almost exactly at the time of the Praglia program, focuses on some of the most important themes in this program and may attest to a general concern within the Congregation.

The other focus for the Library Room, the *Pentecost,* is on the guidance of the Holy Spirit and of the Church, the central agency through which the Spirit works. From an ecclesiological point of view, the entire Praglia cycle, with Pentecost representing the inspiration to the entire process, is focused on and preparing for salvation made possible by Christ's sacrifice, in which the individual participates through the Eucharist, as illustrated in the center of the ceiling. One of the Canons on Justification at Trent (Session VI, January 1547) is dedicated to the indispensable action of the Holy Spirit in order to achieve Justification.[47]

Furthermore, the end focus in the Praglia Library (Fig. 29) was on the Virgin Mary. Mary was also a focal point in the earlier library at Santa Giustina (Figs. 20–21). Crucial to the Lutheran and Evangelist controversy, Mary is represented as the central figure in the *Pentecost* (Fig. 55) on the end wall of the Library. The Tradition of the Catholic Church, represented by the four Fathers of the Latin Church in the large ceiling paintings on axis with *Pentecost* (Figs. 28, 29, 60, 66), was an equally hotly contested concept from the Lutheran point of view. At the same time it should be kept in mind that the Catholic Reform, and for that matter Tradition itself, also stressed the knowledge of Scripture. The emphasis on both Testaments in the Praglia program is, of course, in conformity with Roman policy and continues long traditions in Christian writing and imagery. The focus on the Virgin in the Library is also appropriate for a monastery where the church was dedicated to Mary. We have noted that the Pentecost was favored in cycles dedicated to the Virgin, such as the one in the church at Cesena.

Readings in the Missal and Breviary for Pentecost[48] strike all the themes that are combined in the pictorial decoration of the Praglia Library. In the hymn *Beata nobis gaudia,* the fourth strophe places the accent on remission by the law (Breviary, Pentecost Sunday).[49] In Psalms 47(48), 67(68), and 103(104), the notion of meeting God face to face occurs repeatedly (with a specific reference to Mount Sinai and hence to Moses in 67). Naturally also the Virgin Mary is markedly present. Another central theme is the relation to the non-Christian peoples and their conversion—as in the hymn *Iam Christus astra ascenderat,* with verses about the Greeks, Latins, and "barbarians" calling the spirit (Breviary, Pentecost Sunday),[50] while the Jews are unbelievers.[51] The idea of the Church against the heretics is also present: for example, in the same hymn[52] Peter, with his signs, comes forth and announces how the unbelievers convey false teachings; the Prophet Joel [cf. Joel 2:28–32] is testimony of this. In Psalm 47(48), God is breaking the ships of "Tharsis," representative of the forces of the kings assembled against the Lord, while Psalm 103(104) expresses the following hope: let the sinners be consumed out of the

earth, and let the wicked cease to exist.[53] There are also several readings concerning the conversion of pagans and Jews.[54] Furthermore, the teaching role of the Holy Spirit is emphasized.[55] Readings from the sermons of Saint Augustine in the Breviary stress the concept of good works: It behooves you that you hate your own work in yourself and love God's work in yourself.[56] One of these sermons also contrasts God's wisdom with human wisdom found in philosophical tracts and books.[57] The Missal's first prophecy for the Vigils draws on Genesis 22:1–19, with the sacrifice of Abraham, while the second prophecy, from Exodus 14, is about Moses.

Thus there are two subjects we might emphasize. The subject concerning negation of and conversion to Christianity fits in with our general interpretation of the cycle. The other subject is brought out in the hymn *Iam Christus astra ascenderat, reversus unde venerat:* Christ ascends to heaven, returning whence he came and reminding us that the coming of the Holy Spirit follows Christ's Ascension. This invites a new consideration concerning the Pentecost, emanating, as it were, from the end wall of the reading room.

Alone among the paintings in the Praglia Library, only the *Pentecost* represents a day, that is, a specific feast in the ecclesiastical year; there are no representations of the Nativity, the Epiphany, the Purification (for which the Benedictine Breviary adds Psalms 47, 84, and 98 to the normal series), Easter, the Ascension of Christ, or the Assumption of the Virgin. This sets the *Pentecost* apart from the rest and provides a strong additional argument in favor of our placing it separately, on the end wall.

Saint Basil, who was held in special regard in Benedictine tradition and whose works were compulsory reading according to Saint Benedict's *Rule,* wrote in his *Treatise on the Holy Spirit* about the "eighth day." Referring to Psalms and to the Prophet Joel, the eighth day is "the Lord's day" pointing to the future, the eternal "holy Sunday honored by the Resurrection of Christ." A number of Church Fathers, Greek as well as Latin, elaborate the concept, involving a play on the number 50 (literally *pentekoston:* number of days between Passover and the Descent of the Holy Spirit): a jubilee every fifty years, etcetera. The focus is constantly on Christ, the great absent at the event.[58] The number 50 is also linked with the doctrine of the resurrection of the dead: "The entire period of fifty days is reminder for us of the resurrection awaiting us in eternity," wrote Saint Basil concerning the Pentecost. He and many others enter into numerical calculations (multiplying 7 by 7 for days and weeks and adding 1 to get 50), which are reminders that monastic life—even more than external ecclesiastical life—was constantly addressed to numbered time-stretches such as the canonical hours and the subdivisions of the year, the number of Sundays of this or that season. In Daniélou's analysis, "For Basil, as for Athanasios [Gregory of Naziance, too], the Pentecost is a figure of the Resurrection." And Saint Augustine writes:

> The Pentecost day has a very special [mystérieuse, in Danliélou's translation] meaning, for seven times seven is forty-nine, and adding the point of departure, which is the eighth day, and which is also the first [day], we have [the number of] fifty: these fifty days are celebrated after the Resurrection

[Easter] of our Savior. . . . Therefore [at that time] we cease our fasting and pray in an upright position, in memory of the Resurrection, and we chant the Alleluia. . . .

This tradition decidedly supports our placement and the role of the *Pentecost* as a focal image for the entire Praglia cycle. It also relates the entire series to the concept of liturgical time and the period of the *ecclesiastical year* and in this manner accentuates the significance of the monastery's rhythms of life. A similar concept of time, along with the focus on the "eighth day," is to be found in much later authors, such as Cardinal Nicolaus Cusanus (1401–64).[59]

These focal pictures, concerned as they are with the Holy Spirit, the personification of Catholic Religion complete with the sacramental chalice, Tradition represented by the adjacent Fathers, and the Mother of the Church at Pentecost, reaffirm the tradition and the orthodoxy of the Praglia monastery. A closer examination of the other scenes may further elucidate this subject.

4.2 *The Biblical Scenes: God's Chosen, the Benedictines, and Their Obligations*

The subjects of the six paintings directly on axis, five along the middle of the ceiling and one (originally, in our reconstruction) on the end wall, indicate a course from the entrance to the end wall, and they may be treated as one coherent group (Figs. 28, 29, 56; Pl. II). Starting near the entrance, the sequence of themes is:

> David killing Goliath, or David overcoming the Philistine;
> Saints Augustine and Ambrose banishing the heretics;
> Catholic Church or Religion with the gifts of Christ (the Eucharist),
> accompanied by the four Evangelists;
> Saints Gregory and Jerome preaching and teaching the New Law;
> Daniel in the lions' den, being comforted and saved by God;
> The Holy Spirit (Pentecost) and the intercession of the Virgin Mary.

In many cases, programs like this one may be read inversely, or in both directions, thus starting from the inspiration of the Holy Spirit and ending with God giving power to his chosen people (David killing Goliath).[60]

Here, however, the foreshortening in the pictures indicates a reading designed for a user who enters at the south and looks or moves toward the north or sits facing the *Pentecost* at the north end (see chapter IV above). The design indicates the progression that best fits the content as well, from themes of penitence and abolition of wrong to affirmation of Catholic Religion supported by Divine Wisdom to teaching (accompanied by models of virtue all along and continually inspired by the Holy Spirit) to Salvation.

Beginning from the entrance, the first painting in the central axis series is *David and Goliath* (Fig. 57): that is, defeating a Philistine. Perhaps this introductory scene was

intended to connote the long text in 3 Kings 11:38 (= 1 Kings),[61] a text that, along with 3 Kings 14:8 (= 1 Kings) ("David in toto corde suo secutus est Domino" [David, who kept my commands and followed me with his whole heart]), was cited by Bellarmini in his book on Justification.[62] Comparing the Catholics' relations to the Protestants with that of the Israelites toward the Philistines would probably have come naturally and would surely not have been a novelty. We have noted that a Spanish bishop blamed his opponents at the Council of Trent by calling them "Philistines" (see p. 69). On the occasion of the maneuvers to start the Council "of Trent" in 1537, Girolamo Aleandro, papal nuncio to the emperor in Germany, commented on this event, evoking the image of Saul defeating the Philistine kings: Saul "contra Philisteorum reges," under the heading "Oportet obedire magis Deo quam hominibus" (Obey God rather than men; Acts 5:29).[63] Next to the *David and Goliath* at Praglia is *Saints Ambrose and Augustine Attacking Heretics,* so the implication should be clear enough (Figs. 56, 57, 60; Pl. II).

In our examination of the paintings in chapter IV, we noted several cases of confrontation between the Chosen People (often having failed but repented) and their enemies, usually Philistines. It is remarkable that the only biblical scenes at Praglia that we do not find in the earlier program in the cloister of Santa Giustina are those of Esau and Jacob, the Prodigal Son, and the two particularly aggressive stories of the Chosen People killing their enemy: David and Goliath and Jael and Sisera (Pl. III).

In chapter IV we saw that the ovals of *Samson with the Gates of Gaza* and *Jacob's Ladder* (Figs. 61, 62; Pls. I–II), which flank the square picture of the militant Church Fathers (Fig. 60), also have combative connotations and refer to victories of the Chosen People. On the walls below the heresy-fighting Fathers and the flanking ovals of Samson and Jacob (Figs. 29, 76) are the only aggressive subjects among wall paintings, the pair of *Moses Breaking the Tablets and Hammering the Golden Calf* and *Christ Expelling the Money Changers from the Temple* (Figs. 42–45), a somewhat complex combination.

The pictures with Christ upturning the money changers' tables in the Temple and Samson at Gaza belong to the same group and should probably be read in parallel (Figs. 28–29, 45, 61, 76). In the Santa Giustina cloister, the scene with Samson carrying the gates of Gaza was combined with one that Girolamo da Potenza describes ambiguously: "Christo condotto nel monte per precipitarlo," and then: "La figura è di Sansone, quando fu posto prigione da li filistei nella città di Gaza, di mezza notte rotte le porte di essa città le portò seco. Il figurato è Christo condotto sopra il monte da Giudei," with the noun "buggia" ("bugia" in modern Italian: cheating) added. Since Christ in the Gospels ascended mountains at various times but just once was "led there" (by the Devil, not by the Jews) and since he did not overturn *(precipitare)* any mountain, the word "monte" would seem to refer not to a mountain but to a moneylender's bank (also called "monte" in Italian). According to Matthew 21, Christ was accompanied in procession—thus "condotto da ebrei"—up to the Temple, where he upset the tables of the money changers, which are represented by the overturned table in the foreground of Zelotti's painting (Figs. 44–45). The earlier program in the nearby cloister at Santa Giustina offers a precedent for this unusual combination. There, according to Girolamo da Potenza, the Saint

Benedict scene (No. 14 in the cycle, the poisoning of his bread, a case of betrayal by one of his own people) was accompanied by a smaller scene from the Old Testament, namely Judith with the head of Holophernes. Showing Samson carrying the gates of Gaza might have seemed the best way to identify him, rather than showing his downfall via Delilah's tricks. At the same time, as we noted in reviewing the biblical texts in chapter IV, the Gates may have been chosen in parallel with Jacob's dream and his waking remark, "This is the Gate of Heaven." The scenes of *Samson* and *Christ Expelling the Money Changers* involved trickery on the part of Israel's enemies and the overthrow of corruption. The scene of Christ upturning the table of the moneylenders in the Temple may refer both to monastic reform and to the Council of Trent's reform of financial corruption within the Church. It is important to remember that reformers within the Roman Church agreed with Protestant critics on some matters of practice and had addressed such matters in the fifteenth century in local and monastic contexts. The Cassinese Congregation certainly knew its own history and was conscious and proud of its role in setting a model for reforming monastic Orders, as well as of its formal participation at Trent through both voting abbots and consulting theologians.

Adjacent to *Samson* and *Jacob* on the ceiling are, respectively, *Judith and Holophernes* and *Jael with Sisera,* both stories of deceit and murder. *Jael with Sisera* (Fig. 65, Pl. III) is, compared with *Judith and Holophernes* (Fig. 64), a relatively unusual subject in Italian pictorial programs, yet the pairing of Jael with Judith is found in medieval manuscripts of the *Speculum virginum* in which the two Old Testament heroines are shown with their victims on either side of the female personification of Humility, who kills a male personification of Pride (Fig. 72).[64] These figure combinations would probably have been well known to the Praglia monks and whoever drew up the program for their Library decorations, since the medieval illustrated texts of the *Speculum virginum* and the *Speculum humanae salvationis* are attested in most monastic libraries and because the latter provided the textual basis for the sixteenth-century pictorial series of the choir stalls of Santa Giustina at Padua.[65] In the *Speculum humanae salvationis,* distributed in the original Latin version and in translation, Judith as well as Jael (with Sisera) are prefigurations of the Virgin Mary;[66] there we also find the Sibyls.[67]

At Praglia the rectangular canvases with Judith and Jael each having killed an enemy of the Chosen People are flanking the female figure of Catholic Religion (Figs. 28–29, 56, 63–65, 76). The grouping of subjects just reviewed lends a particularly combative atmosphere to the southern part of the Praglia program, the paintings viewed as one first enters. In our analysis of these images in chapter IV, we observed that in each scene of violence as painted by Zelotti for his Benedictine patrons, the executioner or administrator, whether David, Ambrose, Augustine, or Judith, appears impassive and calm as if sure of the justice of his or her act (Figs. 57, 60, 64). Only Moses as he destroys the golden calf and Christ as he banishes the money changers show anger in their expressions and gestures (Figs. 42–45). Each perpetrator is illuminated with light from above, indicating divine benediction.

On the walls at either side of the entrance, however, and close to the ceiling pictures of *David and Goliath* and *Ambrose and Augustine,* were, on the left, *Jacob and Esau,* and

on the right, the *Prodigal Son* (Figs. 38–41). The Esau and Jacob story concerns a blessing from God that stands in spite of shortcomings on the part of the blessed Chosen, a blessing that set Jacob's descendants apart from other people, clearly a reference to the ministry of the Church which remains valid regardless of shortcomings in the individuals consecrated as priests. It stresses the value of a ritual (Isaac's blessing) as an affirmation of immutable decrees by God. The story of the Prodigal Son is paired with that of Jacob and Esau; both stories deal with a father and his sons, and in each, favor seems to fall on the less deserving son. Thus the importance of repentance and forgiveness, and also the power of instituted or canonical ritual were displayed just at the entrance to the Library, placed as prologue to the more "combative" scenes. We should remember that the pictures on the entrance wall would have been seen by the user as he left the Library, presumably after a period of study, reading, and meditation (Figs. 27, 30, 77). They may thus have been intended also as a reminder of the continual need for reconciliation with one's brothers, taught in Jesus' story of the Prodigal Son and in Benedict's *Rule*.[68] In the Christian context, the New Testament scene supersedes the Old; in this pictorial pairing the monks would surely have seen the peaceful resolution of the Prodigal Son story as superior to the deceitful means and remaining anger in the story of Esau. The power of ritual applies to both subjects since the Prodigal Son is the model of the repentant sinner who is forgiven by God through the ritual of the Sacrament of Penance.

Thus, the two scenes with *Jacob and Esau* and the *Prodigal Son* (Figs. 38–41), which in our reconstruction were installed on the entrance wall (Figs. 27–30, 77), seem to set the more "combative" scenes in their correct perspective: in an axial reading of the program, connections are indicated between themes of authority and penance and those of abolishing heresy and corrupt practices. The latter are referred to in the only aggressive wall paintings, *Moses Breaking the Tablets* and *Christ Expelling the Money Changers* below *Ambrose and Augustine*. As we have just said in reference to the Eucharist in the central octagon, the Council of Trent had just reaffirmed and reemphasized the importance of the Sacrament of Penance, and had stressed the necessity of confession as preparatory to participation in the Eucharist. Since frequent communion was recommended at Trent, the Sacrament of Penance was accorded new emphasis. It appears likely, then, that the story of the Prodigal Son was selected by the programmers to refer to this new emphasis as well as to Benedict's instructions concerning confession and penitence among monks and the fundamental Christian principle of forgiveness taught by Christ in the "Our Father." As Trent stressed the need for Penance before receiving the Eucharist, the monk, or any visitor entering the Library, might view the themes of immutable divine authority and reconciliation/penance flanking the door on the back wall under the Samian and Tiburtine Sibyls (Figs. 58–59), who announce the Savior, as a prologue to the themes concerning overcoming enemies, wrong thinking, and corruption.

The placement of the biblical heroines Judith and Jael (Figs. 28, 64–65; Pls. I–III) at the center of the ceiling, flanking the female personification of Catholic Religion, is certainly significant and seems to reinforce the female imagery of the two focal points (Religion and Mary at Pentecost). Like their nearby male counterparts Samson and

David, Judith and Jael clearly function as leaders saving the Chosen People from enemies who would destroy them.[69] The choice of the victorious female figures of Judith and Jael to occupy the rectangles next to the triumphant Religion or Ecclesia (Fig. 63) suggests that they (females who by violence saved their people from enemies) are meant to be seen as prototypes for the militant stance taken by the Catholic Church to save the people from heretical enemies. That this central trio of ceiling pictures is accompanied by the wall paintings of *Solomon and the Queen of Sheba in the Temple* (Figs. 28, 46–47, 76) on the left and *Christ Teaching in the Temple* (Figs. 48–49) on the right suggests that the planners intended to show that the Church has a role in conveying wisdom, whose ultimate source is divine. Wisdom, like the Church, is feminine in the Bible.[70]

On the far side of Ecclesia, the next large ceiling painting in our axial progression, the Church Fathers *Saints Jerome and Gregory Preaching and Teaching* (Fig. 66, Pl. IV), explicitly emphasizes the teaching role of the Church. Here the program seems to turn from the combative themes to the more positive themes, from defeating enemies to teaching truth, and these themes are connected in the central image affirming the Church's role. Already in April 1546, in Session IV, the Council of Trent had confirmed the traditional claim that the Church herself and no one else had the right to interpret the Bible, which is to be achieved in conformity with the "unison accord of the Fathers."[71] Zelotti's depiction aptly uses sunlight as a metaphor for the spiritual illumination of the listeners who avidly follow the instruction of the learned Fathers (Pl. IV).

On the walls below *Saints Jerome and Gregory* are represented the means for this teaching, which Benedict included among tools for good works (*Rule*, chapter 4): the Ten Commandments in *Moses on Sinai Receiving the Tablets of the Law* and the *Sermon on the Mount* (Figs. 50–53). We recall the passage quoted in chapter V citing Ottoni's use of Chrysostom's emphasis that true Christians are those who obey the Law out of faith and love for the Father as opposed to those who "like the Israelites obeyed only out of fear and self-interest." These representations of the Old Law and the New Law are at the north end of the lateral walls of the Library, near the Pentecost (Figs. 29, 76). The placement in our reconstruction is again reinforced by recalling that originally Pentecost was the Jewish celebration of Moses receiving the tablets on Sinai fifty days after Passover and that the appearance of the Holy Spirit occurs on this solemn feast, which marks the beginning of the Church. Thus the Old Law and the New Law which perfects it are connected at Pentecost.[72] The oval scenes adjacent to *Jerome and Gregory, Moses with the Burning Bush and Serpent* and *Abraham and Isaac* (Figs. 67–68), give lessons of testing faith and of prudence and of obedience to divine instruction to which we shall return below. Finally, our south to north progression leads to an image of salvation, illustrated by Daniel, who in Zelotti's oval, placed directly over the *Pentecost,* kneels among peaceful lions, his hope realized, and raises his arms to thank his God (Fig. 69). Daniel is flanked by the *Erythraean Sibyl* and the *Cumaean Sibyl* (Figs. 70–71) who speak of the "ultimate age" and the "Saturnian reign."

VII

Benedictine Self-Identification in Times of Challenge

1 Benedictine Tradition in a Period of Challenges

In a pictorial program executed within a few years of the conclusion of the Council of Trent, the Order would certainly have wanted to follow up the developments within the Church and demonstrate that their tradition was in keeping with Roman orthodoxy. This may be seen as participating in the ongoing consolidation within the Church after Trent. It may be characteristic that, in Venice in 1594, an edition of the *Rule of Saint Benedict* was printed together with the decrees of Trent: *Regola in italiano per le monache con aggiunta delli Decreti del Sacro Concilio di Trento. Et di alcune Bolle Ponteficie spettanti à Monache.*[1]

It would simplify the whole issue unduly, however, to place all our focus on the "combative" theme and its relation to contemporary conflicts. The Benedictine Order had a long and articulate tradition that does not allow us to attribute such a black-and-white attitude to them. The "Philistine" theme, and hence also the notion of being on the "right side," is noteworthy in the paintings toward the south end of the Praglia Library, but it is embedded in and associated with a number of other more positive themes, which we shall try to sort out below. It is worth recalling here the very affirmative message of the paintings themselves, in which even the most violent acts are shown as positive, endowed with bright color bathed in heavenly light (Pls. I–IV).

In our examination of the paintings and their biblical background, we recorded themes that may conveniently be studied on different levels. One might be labeled indispensable qualities in the Benedictine Order: moral requirements set down in the *Rule* that stress qualities such as humility and obedience. Another level would be the complex problem of relating the pictorial program to the self-identification of the Praglia monastery and the Congregation in the times of trouble before and during, and in the period of consolidation just following, the Council of Trent.

1.1 Indispensable Qualities: Approaching Wisdom
A basic notion—not to say the basic claim—in the Old Testament is that the people of

Israel are Chosen. Most of the Old Testament events depicted in the Library express this notion or at least imply it very clearly. Moses' experience with the burning bush is a statement of this: the Lord has seen the miseries of the Israelites and will save them. The end product of this is that the people shall worship God "on this mountain." In a monastic context, this might be read in the terms of the *Rule* and mean that those who are received into the Order have been accepted into a specially dedicated place and have corresponding obligations, among them obedience and humility. Also, they have been called to serve God in that place; in fact, under the Congregation of Santa Giustina, novices, before profession, had to earn favorable votes of two-thirds of the monks.[2] Without its being stated as such in the *Rule,* there is an underlying theme to the effect that a monastery is a sacred place that puts particular demands and responsibilities on the monks. Therefore the biblical evocations of the holiness of a site must have had a particular appeal; and such a place, a place for worship, is depicted in the scene where God appears to Moses in the burning bush (Fig. 67). Jacob's dream and Abraham's sacrifice also present sacred sites, in the latter case a "land of seeing [God]." Jesus demanded respect for a holy place, and the monks and other users of the Praglia Library would have seen him upturning the tables of the money changers in the Temple (Fig. 45).

The Chosen People of the Old Testament lived under the Ancient Law, and the Benedictines, living under the new disposition as practiced in a Christian Order, also were bound by laws and rules. The monks and other users of the Praglia Library would have found well-known, almost trite, examples of laws to be followed, in the cases of Moses and Solomon, and would have seen dreadful consequences of not submitting to them (Moses breaking the tablets). At the same time the monks were very conscious of living not under the Ancient Law but under the New Law, as exemplified by the young Christ teaching the elders in the Temple and the beatitudes of the Sermon on the Mount. The superseding of the Old Law by the New did not mean abrogation of the Ten Commandments, whose importance had just been reaffirmed at Trent; rather it moved beyond these prohibitions to the more affirmative spirit of the Gospels. This was familiar stuff to any monk at Praglia, and it is spelled out at length in Benedict's *Rule,* not just in his paraphrasing of both the Ten Commandments and the Sermon on the Mount as "tools for good works," but in his teaching of the spirit of the New Testament, urging his monks to advance in humility so that obedience becomes joyous rather than burdensome.

While scenes from both the Old Testament and the New Testament appear in the Library at Praglia, it is the Church founded at Pentecost that makes operative the interaction between the two worlds transmitted in the two book collections. This was a central fact for any Christian and was stressed in any ecclesiastic or monastic context, in this case through the agency of the three axial paintings in the ceiling. The four Latin Fathers combating heresy and teaching undergird the centerpiece where we behold the personification of the Catholic Church herself (Figs. 28, 56, 60, 63, 66; Pls. II, IV).

There are several events from the Old Testament that were considered exemplars of obedience, the most dramatic one undoubtedly being Abraham's willingness to sacrifice Isaac (Fig. 68). Related to this theme is the idea of the Chosen People gone astray, punished

(*Moses Breaking the Tablets of the Law,* for example, Fig. 43). In the New Testament the accent is upon forgiveness, illustrated by the story of the *Prodigal Son* (Fig. 41).

Jacob's Dream, with the famous ladder to heaven (Fig. 62), treated at length in chapter IV, also concerned the promise of a great future to the Chosen People, and the biblical account sounds (for us, at least) far from modest. The use of Jacob's ladder as an image of ascent in various salvation connotations goes back to the Fathers, among them Pseudo-Augustine, in a text believed to have been written by Saint Augustine himself; in *De cataclysmo ad catechumenos,* the ladder is identified with the cross.[3] Saint Benedict follows this tradition (in chapter 7 of his *Rule*), saying that true ascent is conditioned by true humility. Several commentators on the *Rule,* closely following the *Rule* itself, state that the ladder, or the climbing up and down it, represents the monks' life;[4] whereas for Hildemar the ladder is Scripture and Jacob a personification of the monks. Jacob is also referred to in the *Rule* as a model for the monastic virtue of moderation.[5] The overlapping of themes is clear when we recall Cahn's discussion of John Climacus's *Scala Paradisi* and the Romanesque manuscript illumination from Verona cited in chapter IV in which the vertical member of Christ's cross is overlaid with a ladder, and an illustration from the *Speculum virginum* in which a more abstracted cross is also a ladder.[6] The *Scala Paradisi* was probably familiar to the monks who designed the Praglia program, since the inventory of the library of Santa Giustina records two copies of the manuscript.[7] So must the concept of the *Scala perfectionis* have been, based as it was on Patristic writings, among them works by Saint Augustine.[8] There also was a tradition for representing Philosophy by a ladder, a tradition active as late as the early seventeenth century (Cesare Ripa).[9] The conflation of images of ladder and cross makes sense since the stated purpose of both Christ's sacrifice and the practice of humility is salvation. The tradition of connecting Jacob's ladder with humility was not limited to the Benedictines. For example, in the *Specchio di croce* by the Dominican Domenico Cavalca, who wrote in the two or three decades before the Black Death in the mid-fourteenth century, chapter 12 is called "Delli sette gradi dell'odio proprio, e della umiltà," and chapter 13 is entitled "Similitudine delli predetti gradi, e della scala, che vide Giacob."[10]

To some commentators Jacob's ladder connoted the hill of Golgotha or, as Saint Augustine suggested (perhaps inspiring the images cited above), even the Cross itself.[11] This would not invalidate the other interpretations, since the Cross was the focus of all Christian activity, even though the perspective varied in different periods and ambiances. There is also a tradition connecting the Virgin Mary with Jacob's ladder: according to Nicolaus Cusanus, the Virgin is "the ladder by which the Savior descended into human nature and man ascended up to the Savior."[12] It may be relevant to note that Martin Luther repeatedly used a ladder metaphor (not Jacob's but a generic one) in a way that seems to reverse the Catholic metaphorical interpretation of Jacob's ladder. Luther for a while played with the idea, derived from mystic contexts, of climbing a ladder to reach a contact with God, but "he was later to become a staunch opponent of the mystical path as a way to God. None of the traditional soul-cures helped—not even the sacrament of the mass."[13] So Luther came to using the ladder as an illustration of what cannot be done.

The Chosen People were tested, and with them the monks, too, will constantly be put to the test. The stories of the Life of Saint Benedict in Saint Gregory the Great's account in his *Dialogue II* give many examples of temptations. Several figures of the Old Testament that are represented in the Praglia Library are subjected to a testing of their faith, the most dramatic case being when "God put Abraham to the test." Abraham is used in the *Rule* as the model of the monastic virtue of obedience. This testing of faith, and rewarding the virtue of hope, applies to Daniel and his unpleasant stay in the lions' den. Moses' prudent demand for proof to convince his doubting people in the oval with the serpent and the burning bush may be connected with the issue of faith as well. These three stories surround the canvas of *Jerome and Gregory Preaching and Teaching* at the north end of the ceiling (Figs. 66–69). But Christ had started all this, as the paintings of him teaching the Jewish scholars and teaching his followers on the Mount of Olives (on the center of the west wall and the adjacent scene at the north end of the west wall) would clearly set forth (Figs. 28–29, 49, 53, 76–77).

Honesty and chastity are qualities of basic importance in a monastery adhering to the *Rule of Saint Benedict*. The monks and other users of the Library would also have looked up to Judith, above the central wall paintings concerning the Wisdom of Solomon and Christ Teaching (Figs. 47, 49). Judith was praised not only for speaking the truth and for her chastity, having remained true to her husband in widowhood; she was also renowned for her wisdom (Fig. 64).

1.2 Serving the Lord's School

The two images of Christ teaching (in the Temple and on the Mount of Olives), together with the ceiling painting of Gregory and Jerome, and the inclusion of wisdom among Judith's virtues bring to mind Benedict's dictum that the monastery is a school for the Lord's service. The monastery as a whole is a place of learning and the library even more so. The theme of learning is not immediately evident to the twentieth-century visitor to Praglia's Library (Figs. 7, 56, Pl. 1). After reconstructing the wall arrangement it is perceived in the *Pentecost* and *Solomon* and *Christ Teaching in the Temple* (Figs. 29–30, 55), but only after studying the sources and piecing together the complex ambiance in which the program was conceived do we see that this way of showing learning, with both its dangers and its high rewards, is perfectly consistent with the Benedictine tradition, its internal renewal, and its interaction with the Council of Trent. Learning here begins with humility and with the understanding that any human wisdom is a benefice owed to a higher source. We are taught the theology of learning.

Users of the Praglia Library would have beheld great exemplars of wisdom by gazing at the large, centrally placed wall scenes of *Solomon and the Queen of Sheba* and *Jesus Teaching in the Temple* (Figs. 29–30, 46–49). The divine wisdom of the young Jesus in the Temple would have been seen as superior to the flawed human wisdom of Solomon. The choice of Temple settings may well be related to the biblical idea of the seven Pillars of Wisdom, illustrated as a temple in the manuscripts of the *Speculum virginum* (Fig. 74).[14] These paired scenes of stories concerning wisdom are given special

emphasis by their central placement, directly on line, laterally, with the octagonal canvas of *Catholic Religion with the Evangelists* (Fig. 29). The message, for the studious and humble reader, thus concerns the divine source of true wisdom. Reading as they did all the Psalms every week, the Benedictines would have been continually reminded of the many places in which the concept of Wisdom is evoked, including Psalm 110:10: "Initium sapientiae timor Domini." The Holy Spirit itself, on the end wall to which all desks faced (Fig. 76), is a constant inspiration and communicator of Divine Wisdom. In this context we note that all the sessions and every decree of the Council of Trent started with an invocation of the Holy Spirit. Rabanus Maurus developed this theme in another image of ascent: In Greenhill's words: "Fear of the Lord is one of the gifts in Isaiah 11:2–3, and Rabanus constructs on this basis an ascent which is an analogy to the ascent or the relation between the *radix*, the *virga*, and the *flos* of Isaiah 11:1. The first *gradus* in this series, analogous apparently to the *radix*, is *timor Domini*; the last and highest is *Sapientia*."[15] These ideas are elaborated in illustrations from the *Speculum virginum* of the Temple of Wisdom with the seven gifts of the Spirit flowing from the head of Christ (Fig. 74). The basic ideas that the source of wisdom is divine and that true wisdom begins with the fear of God are expressed with eloquence and at length in the Old Testament book of Wisdom and the following book of Ecclesiasticus, in both explicitly linked to seeking salvation.

The monks would have seen their life and work in a universal perspective and would have hoped by their prayer, by their example, and by their scholarly work, which was primarily theological, if not by active missionary works, to further their religion. And so did Daniel, through the intermediary of the reluctant King Darius, who in fact wrote to all peoples in all the languages that everybody should "fear and reverence the God of Daniel." Daniel's enduring hope in his God was justified and he was saved (Fig. 69).

As we review these themes, what emerges is that the eight Old Testament scenes in the ovals and rectangles of the ceiling (Figs. 28–30, 56, Pl. II) are not only connected by their subject matter with the central pictures and the wall paintings, but they seem to be exemplars of virtue for the monks. We know that the key figures, Moses, David, Jacob, Judith, and Daniel, are referred to frequently in the *Rule* and in Barbo's guide to meditation and Saint Gregory's *Dialogue II*, and we know that Old Testament figures are constantly shown as types for New Testament figures and for saints, and generally as models of behavior for the faithful in the liturgy of Mass and Breviary. The connecting of representations of the Virtue of Humility with Judith and Jael in the *Speculum virginum* manuscripts (Fig. 72) suggests the possibility that there may be such an underlying system of associating Old Testament figures with Virtues here too. Not only does it suggest a system, but well-known texts like the *Speculum virginum* and the *Speculum humanae salvationis* also would open up a considerable extension of the classical number of virtues. Representations of the "Tree of Virtues" in the *Speculum virginum* have seven "subvirtues to each of seven canonical ones, and a corresponding number system for the tree of vices."[16] The medieval manuscripts of the two above-mentioned *Specula* were very widely circulated in the monastic world. According to Wilson and Lancaster Wilson:

The text and figures of the *Speculum* [*humanae salvationis*] are devoted to the interpretation of the New Testament through prefigurations in the Old, the so-called typological system, which was the medieval way of relating the Old Testament to the life of Jesus Christ. Originating in Asia Minor with the Greek Fathers, it passed into Western thought and was greatly spread by the influence of St. Augustine.[17]

The *Specula* provided a rich choice of combinations of biblical figures and Virtues. Such combinations also are attested in monumental decorations. The program of the Baroncelli Chapel, Santa Croce, Florence, 1332–38, involves the four Cardinal Virtues in the ceiling of the main vault and the three Theological Virtues plus Humility (making four) in the side vault. In the soffit of the entrance arch, several figures familiar to us at Praglia—Jael, Samson, Moses, Solomon, Judith, and the Queen of Sheba—are portrayed in quatrefoil frames; figures who do not appear at Praglia are Joseph, Joshua, Ruth, Balaam, and Melchizedek. In the soffit of the arch between the vaults are Saint Jerome, two other doctors, Christ, Mary, and the Evangelists.[18]

To see the eight Old Testament figures on the ceiling in Praglia as representations of Virtues is tempting also in view of Trent's accentuation of the Virtues in connection with the "good works" indispensable for Salvation. A hypothetical assignment might be: David (Justice), Samson (Fortitude), Jacob (Humility, Moderation), Judith (Temperance/Chastity), Jael (Charity?!—since she gave milk to Sisera),[19] Moses (with the burning bush, demanding proof from God; Prudence), Abraham (Faith, Obedience), Daniel (Hope, Faith). This very tentative reading uses the standard seven Theological and Cardinal Virtues plus Humility which is used as the base of the Tree of Virtues in the *Speculum virginum* illustrations (Fig. 73). In thinking of the seven Virtues in this context, the seven Pillars of Wisdom from Proverbs 9:1 come to mind. In fact, these concepts are linked in *Speculum virginum* illustrations, for example, Walters Art Gallery MS 72, in which seven gifts of the spirit with subcategories including the four Cardinal and three Theological Virtues flow from a temple in which the seven columns are interspersed with the citation of Proverbs 9:1, "Wisdom has built herself a house, carved out for herself those seven pillars of hers" (Fig. 74).[20] In an earlier manuscript at Arras, the same connection between Wisdom and Virtues is made in an image showing Christ seated before a temple with seven columns surrounded by eight figures, four of whom have been identified as the Cardinal Virtues.[21] The implication is clearly that Wisdom is built upon the practice of Virtues. In our case there are eight virtues (the normal seven plus the "Benedictine" Humility) in the eight Old Testament scenes in the Praglia Library ceiling, precisely the same eight that are illustrated in the Baroncelli Chapel at Santa Croce, Florence, with surrounding personifications.[22] In the context of the Praglia Library the paintings of Old Testament personifications of the Virtues would be intended as models to help the monks approach wisdom, not for its own sake, but to attain salvation. Evidently, the authors of the program were drawing on a long, familiar tradition based in the monastic context, and they may well have known illustrated manuscripts of the *Speculum virginum* which were commonly present in religious houses.

Although the classical canon of Virtues is seven, the number eight is significant in this religious context. There are eight hours for prayer in Saint Benedict's *Rule.* He takes the normal biblical seven (Psalm 118:164) and adds an eighth, saying that "at night, we get up to celebrate God."[23] We have seen Saint Basil and others interpret the Pentecost, a subject dominating the end wall of the Praglia reading room, as representing the eighth day. The Missal refers to the liturgy of the week following a great feast as being within its "Octave." Taking such numbers seriously has a natural place in the Tradition of the Church, and particularly so in monastic life, permanently focused, as it were, on numbered hours and Sundays.

As for Abraham, there is more to say, since he was accorded a very special role in monastic tradition. "St. Benedict . . . seeking solitude in Subiaco [the later Benedictine monastery of Sacro Speco], took after Abraham and the patriarchs of whom the Epistle to the Hebrews 11:38, said that they 'wandered around in solitude'" *(in solitudinibus errantes).* Penco refers to "a monastic tradition lasting for centuries that saw Abraham as model for spiritual pilgrimage and the most complete renunciation [of worldly matters]."[24] The textual bases for this concept, which was applied to monastic community life (as cenobites) as well as to asceticism (as anchorites or eremites), are Genesis 12:1, in which God orders Abraham to emigrate from his land ("Meanwhile the Lord said to Abraham, Leave thy country behind thee, thy kinsfolk and thy father's home . . ."), and Hebrews 11:8–9 and 11:37–38.[25]

Whereas Roman Catholic doctrinal, liturgical, and even iconographic traditions accentuated the obedience manifested through the story of the offering of Isaac,[26] monastic tradition focused on the ascetic "emigration" theme as just outlined. The theme was particularly developed by Saint Bernhard of Clairvaux, in the wake of whose writings on the subject a copious literature dedicated to it was to develop. Pope Eugene III compared the foundation of the monastery of Cîteaux to Abraham's "pilgrimage."

Moses and David, too, played a special role in monastic tradition as exemplars of a concept central to the teaching of monastic virtues: the "man of God" *(vir Dei).* In his *Dialogue II,* Saint Gregory compares Saint Benedict with these two Old Testament persons.[27] Another mingling of nonclassical with classical allegories of Virtues occurs in the pictorial program of the Biblioteca Marciana in Venice (see above, chapter IV). It seems to be characteristic of the Marciana program that, in addition to the canonical Virtues (such as Prudentia with the mirror), there are other figures of nonorthodox design. One group in this category consists of a youth with wings on his lower arms and an old man, which Ivanoff interprets as possibly "l'ingegno povero e il sapere." There are also classical heroes, like Hercules, who in this context possibly designates, like Samson, Fortitude.[28] In this period, a freer and more inventive allegorization was under development that would result, later on, in works like Cesare Ripa's *Iconologia* and Piero Valeriano's *Hieroglyphica,* certainly prepared by such earlier works as the *Hypnerotomachia Poliphili.*[29]

The picture of Daniel in the Praglia ceiling is above the wall where the painting with the Pentecost was placed (Figs. 29, 55, 69, 76). If we follow the biblical account and the Breviary readings (perhaps significantly from Saint Gregory's sermons), Pentecost

gives an even more explicit statement of the spreading of the Word among the peoples, with the same goal as Daniel: to bring humanity to salvation.[30] We repeat the quotation given in chapter IV, and the subsequent verses:

> When the day of Pentecost came round, while they were all gathered together in unity of purpose, all at once a sound came from heaven like that of strong wind blowing, and filled the whole house where they were sitting. Then appeared to them what seemed to be tongues of fire, which parted and came to rest on each of them; and they were filled with Holy Spirit, and began to speak in strange languages, as the Spirit gave utterance to each. Among those who were dwelling in Jerusalem at this time were devout Jews from every country under heaven; so, when noise of this went abroad, the crowd which gathered was in bewilderment; each man severally heard them speak in his own language (Acts 2:1–7). . . . [Then the apostle Peter spoke to the doubters.] These men are not drunk as you suppose; it is only the third hour of the day. This is what was foretold by the prophet Joel: In the last times, God says, I will pour out my spirit upon all mankind, and your sons and daughters will be prophets . . . before the day of the Lord comes, great and glorious. And then everyone who calls on the name of the Lord shall be saved (Acts 2:15–22).

Further readings for the Octave of Pentecost in Missal and Breviary are instructive. The Prophecies for the Vigil of Pentecost refer to Abraham and Moses. The Gospel for Pentecost (John 14:23–31) emphasizes the teaching role of the Holy Spirit: "The Holy Spirit whom the Father will send you in my name, He will teach you all things, and bring all things to your mind, whatsoever I have said to you." The Introit is Wisdom 1:7: "The spirit of the Lord has filled the whole world, Alleluia; and that which containeth all things hath knowledge of the voice, Alleluia. . . ." During the week following Pentecost most of the epistles are from the Acts, showing the effects of the outpouring of the Spirit, and the Gospels tell of Christ teaching and predicting the coming of the Spirit. On the Saturday after Pentecost there are readings from Leviticus and Deuteronomy concerning Moses and his instructions to his people to keep the commandments of the Lord, reminding us of the original Pentecost feast which celebrated Moses' receiving the tablets of the law on Sinai. In the Breviary, there are readings concerning the spreading of the good news.

A close examination of Zelotti's paintings in our Benedictine Library (chapter IV) revealed that the theme of learning is very much present, embedded in the biblical stories and ecclesiastical statements, and in the Sibyls. The Sibylline books of antiquity, in the care of Roman priests, were re-created and often modified after the burning of the Capitol in 83 B.C.; they acquired a Judaeo-Christian bent, making Sibyls in Christian art and literature the female counterparts of the Old Testament prophets, used to show that the Graeco-Roman world too had anticipated the Savior. The Cumaean Sibyl at Praglia holds one book in her lap, while the other, held up and open, displays her inscription; the other

Sibyls' inscriptions are displayed on tablets, in all cases showing that the prophecies were written.[31] Books and other forms of learning are embedded throughout the program. The heretic held down and attacked by Ambrose is holding a book, reminding us not only of early heresies but of the Index. The Evangelists hold their Gospel Books. Saint Jerome holds a large, beautifully bound book, probably his Vulgate. A rabbi in the *Christ Teaching in the Temple* holds a book (probably Scripture), and both here and in the *Solomon and the Queen of Sheba,* learned rhetorical disputes are taking place. The written Tablets of the Law appear at the south end about to be smashed and at the north end received amidst lightning from Heaven. Christ teaches in the Temple at the center of the Library, and on the Mount of Olives the Master coaches his followers in his New Law near the north end. And from the north end come forth all the connotations of languages, spreading the good news, and Wisdom instructing from the celebration of Daniel's salvation by the King of Persia and the tongues of fire and light in the Pentecost (Fig. 76).

1.3 *Benedictine Self-Identification in Times of Challenge*

According to our analysis, the program of the Praglia Library affirmed Benedictine orthodoxy. We emphasize the "Benedictine" nature of the cycle despite the fact that there is no direct reference to anything uniquely Benedictine in the painting program. Its position within a Benedictine monastery ensured this, and it would probably have been supported by the life and miracles of Saint Benedict in the Library anteroom (Figs. 25, 13, 14) postulated in chapter II. All the scenes that are relatively unambiguous point in this direction, above all the octagon with Catholic Religion and the four Evangelists and the adjacent squares with the four Latin Fathers (Pls. I–II, IV). These features show that Religion is founded on the Life of Christ as told in the New Testament and interpreted by the Church Fathers. Christ himself is sacramentally present in the chalice held by Religion (Fig. 63). The more generally christological aspect is taken care of by the Sibylline prophecies (Figs. 58–59, 70–71).

The claim to "orthodoxy," quite apart from all the references to the "indispensable" qualities above (VII.1.1), is apparent in the active figure of Catholic Religion holding the cross and the chalice (Fig. 63, Pl. II). Although it illustrated nothing new, in the sixteenth century it could hardly avoid being read as a reaffirmation of the concepts concerning the Church, the Sacrifice of the Mass, and the sacraments in general that were rejected by the northern reformers, notably Luther. In our reconstruction the entire program is focused on the Holy Spirit and the Virgin Mary (on the north or end wall), thus evoking the traditional but now debated notions of—quite literally—the inspiration of the Church and of the mother and personification of the Church and her main intercessor before God (Fig. 55). A "typological" parallel between the two Testaments is given, and the Church Fathers banishing heresy and teaching make it clear that the Bible is to be understood through the teachings of the Catholic Tradition; this idea is longstanding, as Benedict's own *Rule* shows, but now becomes more pronounced because of its rejection by the northern reformers. It is made even more emphatic by virtue of the accompaniment of the "anti-Philistine" and related scenes on the ceiling. In June 1546 the

Council issued its decree on the reading of Holy Scripture, making it an obligation for the churches to provide instruction in the Bible. This is also required, wherever it is possible, for the monasteries, a provision that, as we have seen in chapter v, was advocated by the abbots representing the Cassinese Congregation at Trent.[32] In April 1546, as noted above, Trent had already reaffirmed the traditional role of the Church in interpreting it in unison with the Fathers.

The *Esau and Jacob* to the left of the entrance and the *Prodigal Son* to the right (Figs. 38–41) make equally significant, though subordinated, statements that extend the ecclesiological perspective in two parallel directions of fundamental importance in the Tradition and its re-actualization in the sixteenth century. The *Esau and Jacob* picture concerns the absolute authority and validity of divinely instituted rules and practice, especially the liturgy and the sacraments, which are valid in the Catholic Church regardless of the human qualities of the priest administering them. The Prodigal Son made penance, and the story evokes the related sacrament which was rejected by Luther.

The concepts just reviewed express a reaffirmation of both Scripture and Tradition, as the foundation of Catholic Religion under the guidance of the Holy Spirit. This was taught by Benedict, revived by Barbo, and reaffirmed at Trent. Our impression is, however, that this attitude and norm system were never abandoned by the Benedictine Order even in times of laxity in the late Middle Ages. Reading the Jesuit scholar Jedin, one might gain the impression that the Benedictines in the "age of Trent" found themselves on rather shaky ground, but later contributions, especially by such authors as Collett, Evennett, and the Benedictine scholars Leccisotti and Trolese, suggest that the Cassinese Congregation, having offered a voice of moderation and theological expertise at Trent, reaffirmed its own tradition in the context of ecclesiastical reforms.

The existence of a special library room must have been felt as a challenge to set forth—in the present case, by pictorial means—the entire meaningful context for the use of that library. The Library at Praglia would have been used by people to whom the pictorial messages would have been accessible; and the decoration of a library in the years following the Council of Trent, at a time when the functions of the written word and of the image were being reevaluated, offered a particularly delicate and important opportunity. In the monastic context the library is important to salvation, since prayer and reading of Scripture and the Fathers (and by implication, scholarship that meditates on such sources and inspires spiritual advancement) are good works or "the work of God," as the *Rule* says.

The relation of the program to the debates at Trent also is relevant to the question of dating the cycle in the Praglia Library. Would the monastery start such a program before seeing the final outcome of the Council debates in terms of decrees? The Council ended in 1563, and we have found that the project of 1562 does *not* involve the series of paintings as we know it today. On stylistic grounds, we placed the painting cycle close to 1570, putting it among the late works of Zelotti, who died in 1578. In reconstructing the program, we see that Zelotti's compositions are sensitive to both the setting and the

meaning of his commission. For example, understanding that the *Pentecost* was placed beneath *Daniel* allows us to see that the compositions were coordinated to denote heavenly light coming from above *Daniel* and radiating forth from *Pentecost* (Figs. 29, 55, 69, 76). In each painting of the cycle Zelotti is faithful to the biblical account and considers the viewpoint of the Library user who enters from the south and studies facing the *Pentecost*. His paired compositions on both ceiling and walls take into account the visual effects of the pairing, in fact, his compositions throughout consider the ensemble (Figs. 76–77). His use of clear, bright color areas in the tradition of painters from Verona and his symbolic use of light to articulate the cause of justice throughout are appropriate to the affirmative subject matter (Pls. I–IV). The Benedictine patrons who provided the program gave him the commission for the Library already knowing his work and, we suppose, having had a good working relationship with him regarding the earlier commissions in their own church. Our dating associates the paintings with the campaign to implement the instructions of the Council of Trent by Bishop Ormaneto of Padua, who served during the years 1570–77. The decrees of Trent specified that there should be episcopal reviews of monasteries, and a visit of Ormaneto to a small sanctuary belonging to Praglia is recorded in 1572.[33]

2 Conclusion

Summing up our findings in this book is risky one way or the other. To create a short and concise synthesis would put us in danger of simplifying unduly a matter that stubbornly defies well-intended formulas. On the other hand, a summary should be short and not require the reader to peruse the whole argumentation once again. For these reasons we have opted for a middle course: offering a short list of the main points as we see them. We are aware of the relativity of any contribution of this kind, however well documented and thoughtfully devised it might be, and in this vein want to stress some of the methodological aspects pertaining to it. We do not want to seem too affirmative even though we, quite obviously, *do* believe in our documentation and argumentation. Our short summary:

First, any Benedictine monastery is a place of study, learning, and meditation, in fact, a "school," and this character is not affected by the presence or absence of specific library quarters. Prayer, meditation, participation in the liturgy and *lectio divina* are all interacting factors in monastic life.

Our second observation agrees with the first. The only case we know that seems encyclopedic in its program is that of San Giovanni Evangelista at Parma, and this program shares with Praglia the placement of imagery of the Holy Spirit at a point of focus; otherwise we see no exclusive features that set monastic library decorations of the Renaissance apart from the cycles for other parts of monasteries, such as the nave of the church or the cloister, in cases like Pomposa, Cesena, or Santa Giustina at Padua. Nonetheless, the evidence we have brought forth with regard to the Praglia Library indi-

cates that the Benedictines of the Cassinese Congregation chose to use this decorative commission to make statements concerning their relationship to recent theological debate, and we have seen the library setting as particularly appropriate to many of those issues. The program incorporates imagery of long-standing use and formulates intended lessons that reassert traditional dogma and address the theology of learning and wisdom; there is a clear accent on "right teaching." The virtues common in library and other decorations are here embodied in biblical models, each an exemplar appropriate to the monk or any serious Christian, and seemingly connected with traditions in imagery and thought about the scriptural Pillars of Wisdom. This looking at Biblical models as exemplars of virtue is precisely what Saint Benedict teaches his monks in his *Rule* (see p. 20, above). The Benedictine Breviary hymn for matins on 21 March, Saint Benedict's Day, envisions Benedict "our patriarch" in the bosom of Isaac, Moses, and Abraham *(sub uno Pectore clausit)*. The lesson that Divine Wisdom, not human learning as such, shows the path to salvation is illustrated in the progression of subjects and in a rich array of teachings along the way. The teachings derive from Scripture, invite meditation on holy writings, and stress the guiding role of the Church and the inspiration of the Holy Spirit.

We might expect to find a distinction between cycles in monasteries that are spatially connected with an altar, and hence directly with the liturgy, and cycles that are not so connected. However, monastic life presupposes that formal liturgy and other forms of devotion and meditation, including reading, are interacting. In the Praglia Library, the issues are interwoven, since the ecclesiological imagery at the center of the ceiling has both theological and liturgical implications. This brings us to our third observation, and it is that very few of the great Italian monastic cycles have been studied carefully enough to be ready for comparative analysis.

This situation as a whole calls for rather cautious conclusions on our part. The need for caution is even more urgent when we try to cope analytically with the theological debates of the sixteenth century. For our fourth consideration is this: there exists no single contemporary witness or more recent scholarly treatment of those debates that can be considered authoritative. The official Council statements are clear but short and generally framed in the negative: who states so and so, is anathema! We have to deal with an enormous complexity of issues and conflicting conceptions of them and interests in them among the protagonists themselves. In consulting modern scholars, it is the complexity rather than a well-defined picture that emerges. If out of this quite intricate general picture we have been able to come up with a meaningful pattern that can assist further research, we shall have achieved something.

Appendix I

Praglia Documents: Excerpts
(Note: Abbreviations in the documents
are disregarded whenever unambiguous.)

DOCUMENT I
A.a. Pr. 8
[index]
1562

Scritura fatta dal Monastero di Praglia con Maestro Battista vicentino del q. [quondam] maestro Guglielmo da Bergamo, e Masestro Zuanne &c. falegnami per le scanzie di nogara nuove per la Libreria, secondo certi 3. dissegni fatti, nel tempo di 14. mesi per . . . [word canceled: per duc<ati> 494 . . . ?].

DOCUMENT 2
A.a. Pr. 8, fol. 4r
1562

Libraria. 1562 adi 8 di Aprile m[esser?] cellerario [manager and accountant of the monastery] di Reverendi padri di Santo Urbano in padoa [heading ends here] Maestro Baptista Vicentino del quondam maestro gulielmo da bergamo et maestro Zuanne del quondam maestro Rodulpho fiorentino per la presente scriptura hano promesso et obligatossi apresso il Reverendo padre Don theodoro da Venecia de cento et primo cellerario Dicti Reverendi monaci et monasterio di praglia di farli la libraria di essi Reverendi monaci in praglia di legnami brancho [= branco] et nogara lauorada iuxta il disegno existente disegnato in tre foglij per essi maestri visto et visti et oportunamente considerato et considerati a li quali foglij per rifar [?] apresso dicti maestri per far dicta opera et libraria et volentesi parermio Io infrascripto nodaro mi li sono sotoscripto facendo il suolo ouero sotopor a dicta libraria di legname brancho [branco] il resto tuto che sarano li corssi doue si riponerano li libri et li frontoni di nogaro bello et apponerano lauoradi de Intagio iuxta el dito disegno Cum le sue teste manufate a Intagio appresso la porta de la libraria iuxta el dito disegno et farli corssi numero vintiotto di longeza de piedi noue in circa [1 piede vicentino = ca. 0.35 m; for comparison, 1 piede veneto is 0.347 m, which amounts to the same; in all: 9 × 35 = 3.15 m] et di alteza di piu di quatro et vna onza [oncia: twelfth of a piede = 2.91666 cm; quattro must refer to piede, not to oncia; "quatro et vna" would be five and would have been written accordingly; thus: 35 × 4 = 140: a little more than 1.40 m; at Cesena the shelves connected with the reading benches are 1.275 m high; see below] o piu o meno como parera a dito Reverendo padre cellerario per vna palla iuxta el disegno che li dara dito Reverendo padre cellerario et fare tuto del legname proprio et particular de dicti maestri et a tuta loro spesa di quanto li andara

per fare dita opera in ordine et compida et sequndo che farano li corssi et banchi meter-
li suso. Et Alincontro Dito Reverendo padre celerario ha promesso et promette di dar a
dicti maestri et pagarli ducati disesete pro bancho et corsso [28 units, see above; 28 × 17 =
476] in ordine et lauorado iuxta el dito disegno et nel precio de tuti dicti banchi et
corssi vintiocto si dechiarati si li include et li riterano [riterranno] il mercede de la pala
predicta et pagarli le teste apresso il muro e porta predicta, ala porcion di un bancho. Et
da poi per il tempo che lauoreranno in dicta opera promette dicto Reverendo padre
cellerario farli alozo [aloggio] et sui lauora<n>ti [*sic?*] in spese di bocha [room and
board], li quali maestri si obligano di dar dicta opera libraria et palla fornita di tuto porto
In tempo quatordesi mesi proximi venturi. Et far in dicto termine di mesi quatordesi li
quali principeranno a scrivo adi primo zugno presente 1562 non haueranno fornita dicta
opera et palla [Boerio, *Lessico del dialetto veneto:* pala, no citation for "palla"], per quela
restanza che gli manchasse a fornire dicti Reverendi padri non siano obligati piu a farli
spese di bocha ne a essi maestri ne a li loro lauoranti [*sic?*] ma debbono continuar a
fornire dicta opera ut supra a sue spese non havendo altro pagamento ne potendo hauer
altro saluo che li ducati disesete per bancho Et in fine di lopera dicto Reverendo padre
celerario li promette di dar per honoranza mozo [= moggio] uno di frumento et carro
uno di vino, ale quale cosse sopra dicti maestri si hanno obligati et si obligano et soli
duj [i.e., the two craftsmen exclusively?] al fare et fornir de dicta opera libraria et pala pre-
dicti obligandossi dicto Reverendo padre cellerario di dar a diti maestri etc. piu questo
podera [poterà] ducati cento et cinquanta in nome di predicti da spendere in prepara-
mento da far dita opera libraria et palla. Promettendo le dicte persone atender et obseru-
ar tute le cosse predite soto obligacion.
[Signatures by notary and contracting partners.]

DOCUMENT 3
A.a. Pr. 8, fol. 4r
1564

Scrittura con li sudetti Maestri Intagliatori per la Costruzione del nuouo Coro [added: et
Sacrestia] per Ducati 494: lire 5. picc. 10 etc. [But document 4 below, to which this refers,
also concerns the library.]

DOCUMENT 4
A.a. Pr. 8, fol. 4r
1564

Libreria e Coro. 1564 Indic . . . [?] in die martij 28 marcij. paduae in celleraria sancti
Vrbani. Supra opera predicta per . . . ? baptista Vicentino del quondam maestro gulielmo
da bergamo Et maestro Zuanne del quondam maestro Rodolpho fiorentino nel far dela
libreria et banchi ali Reverendi Monaci di praglia per . . . ? et vn scrito da loro fato de
man sua/suoi [?] et da loro soto scripto soto di 8 de aprille 1562 [= document 2 above].
Il Reverendo padre Domino Theodoro de cento primo cellerario et dicti Reverendi

monaci da vna banda et li sudeti maestro baptista et maestro zuane daltra sono venuti
In questo di tra loro a qtar [contar ?] insieme sopra tuto quello che hanno havuto dicti
maestri a conto della detta opera, a conto dela quale al presente es<s>o [?]. . . . [??] . . . essi
maestri hauer hauuoto in piu volte da Dicti Reverendi padri tra danari et roba landera-
no [?] de ducati [?] quatro cento e dodese [= dodici] . . . [?] soldi diese et [?] picoli . . .
[indecipherable number] li duj . . . [four to six unreadable, abbreviated words] mozo vno
frumento et carro vno di vino de honoranza iuxta la forma del scrito et per resto dicti
maestri restano hauer dal dicto Reverendo padre cellerario per resto et saldo de ogni
loro mercede de dicta opera ducati ottanta doro in mercede [?] predicta qual danari dicto
Reverendo padre cellerario li promette dar . . . [?] ad ogni loro beneplacito fornito prima
la palla che loro sono obligati a far per virtu del sudeto scritto et adaptati li banchi et
Assetati [= sedie; assettare: locate, place; i.e., books in this case] de la libraria che sarano
bene et [?] che non li resti ne . . . [?] altro et In fede dicio Jo Lodovico giacomo nodaro
di volunta solo et soto scripto alla quale e fu fatto

DOCUMENT 5
A.a. Pr. 3, fol. 253r
1564

[Payment for a little more than lire 417] M. Battista pittor Veronese [presumably Zelotti]
. . . L.<ire> 417.12 [soldi].

DOCUMENT 6
A.a. Pr. 8, fol. 11r
1569

Aadi 17 daprile 1569
Rjceui hio zuane jntaljatore fiorentino dal Reverendo padre don zanbatista celerario
dignissimo deli Reverendi monaci di praglia per chapare di quatro pale delle capele
picole di la jesa [Florentine for "chiesa"] di santa marja di praglia lire hotanta quale palo
semo romasi dacordo jn ducati sedisi luna alire sei et soldi quatro pro ducato per casce-
duna pala a tutta mia ispesa quale pale prometto darle fate jnteramente di due mesi uale
a bon conto—L. 80.
[28 May 1569: further payment for "dite pale"; payments go on until the end of June.]

DOCUMENT 7
A.a. Pr. 7, fols. 242v, 246v.
[a report by Marc Antonio Rottigni of Praglia Monastery]
1753

> Memoria del tempo, e da chi sono stati fatti li Altari della Capella della
> Chiesa [of Praglia] con alcune altre notizie scritta dal Prete Don Marc
> Antonio Rottigni l'anno 1753. . . .

Non parlo io dell'Altare Maggiore posto in questa Città [lapsus calami for Chiesa?] l'anno 1572 . . . ma parlo solamente delle Capelle, li Altari delle quali erano tutte di legno [cf. document 6 above] nel principio di questo secolo, e non essendo stato notato da nessuno li Benefattori di tali Altari di pietra, so stimato bene a farne io memoria. . . . Principio dall'Altare del Crocifisso . . . [mentions privileges for this altar]. . . . L'Altar del pre. S. Benedetto fu fatto tutto intieramente nel principio di questo secolo; e la mensa, e scalini dell'Altare della Sagrestia fu fatta l'anno 1726 . . .

[information concerning the following altars:]

Giulio Colle da Venezia Decano professo di S. Giorgio di Venezia . . . Curato di Carbonara, fece quelle quatro Altari di pietra, cioè quello di S. Giouanni, e l'altro quello delli Apostoli, quello delli Angeli, e quello di SS. Primo, e Feliciano Martiri. . . . L'Altare di S. Maria Madalena fu fatto l'anno 1720 di pietra. . . . Li altri poi sei Altari, cioè S. sebastiano Martire, S. Lorenzo Leuita, et Martire, S. Nicolò da Bari Vescovo, S. Stefano Protomartire, S. Giustina Vergine Martire, S. Antonio Abbate, furono fatte con spesa della Cassa del Monasterio, e così tutti di legno ch'erano furono fatti di Pietra. . . . Passiamo a far memoria delli Pittori, ch'hanno dipinto in questa Chiesa, e da chi sono state ordinate, con altra buona, et utile notizia.

È sempre stata in questo Monasterio tradizione continua esser stata dipinta la Cuba [= cupola], et il uolto della Chiesa dal famoso Pittore Zelotti, che ben piu cose ha dipinto in questo Monasterio, et in tela, e sul muro. L'anno pertanto 1559, era qui Abbate il Pre Placido da Marostica, e tal Pre don Giovan battista da Brescia Cellerario fece dipingere la pala, quella di San Giovanni Battista dal celebre Giovani Badile, che fu il Maestro di Paolo Veronese . . . [etc., on paintings for the church].

DOCUMENT 8
A.a. Pr. 13, fasc. 1, fols. 117r–128r
1768

Fol. 117r and v

[petition for financial aid to finish the library renewal; for the contract see below, fol. 119r and v]

Ritrovandosi nella libreria del Monastero di Praglia varj Codici, e per l'antichità e per la qualità di prezzo considerabile, ne essendo piú capaci li antichi scafali di difendere li codici, ne di contenere per la sua incomoda struttura gli altri libri sopragiunti alla libreria per la morte de' Monaci, specialmente del Reverendissimo Benaglia, Pubblico Professore dell'Università di Padova, venne in deliberazione il Reverendissimo Padre Don Basilio Pellegrini Abbate attuale del sudetto Monastero di convocare al solito li Padri Superiori per esporgli la nota necessità, che aveva il Monastero attualmente in qualche vantaggio di pensare seriamente al sudetto decoro e rimarchevole capitale. Conosciuta pertanto dai sudetti Superiori la necessità stabilirono unanimi, come apparisce dal Foglio dalli stessi sottoscritto d'intraprendere la necessaria, utile, ed onorifica opera de' nuovi scafali, certi che si poteva fare coi soli sivanzi del Monastero. Il Padre Don Francesco Maria Mastini dunque attuale Cellerario del sudetto Monastero col consenso del Reverendissimo Padre

Abbate Don Basilio Pellegrino fece il dì 28. Febbraio dell'Anno 1768. il contratto de' nuovi scafali con Antonio Ratti Marangon per Ducati 1800. da L[ire] 6:4. Stabilito il contratto con prontezza l'artefice diede mano all'opera coll'ajuto del soldo, che anticipatamente il Monastero gli andava somministrando, cosicché agli 18. dello scaduto Luglio aveva riscosso L[ire] 8000:—corrispondendo esso pure coll'avanzamento dell'opera ormai ridotta ad un buono, ma non perfetto stato, e secondo il suo assunto impegno. Prostrato ora apiedi dell'Eccellenza Vostra il sudetto Monastero umilmente implora un benigno assenso per poter fare, che continui il contratto, e dar l'ultima mano all'opera di molto avanzata.

[There follows the document dated 1 February 1768, referred to above, and signed by seven "Superiori."]

Fol. 119r and v
[contract]
Adi 28 Febraio 1768. Praglia.
Poliza di me Maestro Antonio Ratti Marangon di robba e fattura per farsi da nuovo la Libraria del Reverendo Monastero di Santa Maria di Praglia come segue—Dovendo io sottoscritto che per Ducati mille, e ottocento da L 6:4, come acordo stabilito col Padre Reverendissimo Abbate Pellegrini, e dell'A . . . mo Padre Don Francesco Maria Mastini primo cellerario, che io abbia da proveder tutto il bisogno di legname, cola [= colla], chiodaria, e tutta la ferramenta, eccettuato però quello che si aspeta alle ramate [= inferriate, for the windows], cioè materiale, e fattura delle medesime; più che abbia da far quattro scale nelli lati [= corners] della sudetta; più dovendo far la porta con balaustri nel mezo, e di sopra il suo fenestron di lastra con sveza [sverza or vezzo (?), thin ornamental element] d'intorno, più de timpano alla porta far la spaliera con banca da seder, e far una taola [tavola] proporzionata al sito per scrivere, più far la ringhiera con basa, e cornice, e pilastri, e colonelle tornite, in somma tutto eseguito nella forma come il disegno apparisce, piú douendo far la spaliera nell'atrio dauanti alla libreria con bancha, e modiglioni [= modiglioni], e il suo pagiolato [= pagliolato, floor] sotto, douendomene servire però del legname della Libreria vecchia, et di tutte queste fatture, e spese per Ducati come sopra—1800 . . . [confirmation and signatures follow].

Fol. 120r and v
[enactment of the Chapter authorizing the work; dated 30 September (1768)]
. . . Convocati, e capitolarmente congregati al solito suono delle campane tutti di Reverendi Monaci del Monistero di Santa Maria di Praglia. . . .
[Receipts for the works follow; and July 1768, receipt for Antonio Ratti "marangon": carpenter.] Riceuo io sotoscrito dal Illustrissimo padre Don Gaetano Alverri Celerario primo Lire mile e queste sono per Conto di mie Japare [= caparre] cioè della Libraria Dico Lire 1000: più Riceuuto L 5000.

Appendix 2

The Text of Don Vincenzo of Milan: Excerpts

Don Vincenzo di Milano, *De maximis Christi beneficiis pia gratiarum actio. Ex utroque Testamento compendiose collecta, piis & catholicis christianis dedicata, D. Vincentio Monacho Caenobii sancti Severini Casinensis Congregationis autore* [sic] *Napoli . . .* MDLXVIII. Vat. Chigi I IV 148, fols. 66r–86r.

This is a publication bound with other publications and hence page referenced. The biblical references are in the original and remain as given by Don Vincenzo. The text consists of a number of paragraphs, each styled as a thanksgiving addressed to Christ for benefices he has bestowed upon man, such as his Incarnation, Baptism, etc., up through the Passion, Ascension, and Pentecost. A typical paragraph begins: "Proinde laudans benedico tibi pro effusione pretiosissimi sanguinis tui: de quo sanguine in Scripturis sanctis creberri me memoratur. . . ." What is remarkable is that, after Pentecost, the Sacrament of Penance is singled out for special treatment.

Text from beginning of Pentecost paragraph: [fols. 15v–16]
Pro Spiritus sancti paracleti missione quando ascendens in altum, captiuamque ducens captiuitatem, dedisti dona hominibus. Tunc promissum Patris tui ad nos misisti: (Luc. 24) sicut antea spondisti, dicens: (Ioan. 14) Nisi ego abiero, Paracletus non ueniet ad uos: si autem abiero mittam eum ad uos. Tunc Spiritus sanctus repleuit Orbem terrarum, (Sap. 1.6) & loco quod continet omnia, scientiam habuit uocis. Tunc perfectum etiam fuit illud Iohelis uaticinium, dicentis. (Iohe. 2.g) In nouissimis diebus dicit Domiunus, effundam de spiritu meo super omnem carnem: & prophetabunt filii uestri, & filiae uestrae. (Luc. 24.9—Psal. 7 a) quando diuini illi Apostoli induti uirtute ex alto, uariis linguis altissima Dei magnalia loquebantur.

Praeterea gratias tibi ingentes persoluo, ò mundi propitiator, pro Sacramenti poenitentiae: quod tunc instituisti, quando tu clauis (Apoc. 3 . . .) Dauid, claues Regni caelorum Ecclesiae tradidisti, dicens Petro. (Matt. 1 C. c) Tibi dabo claues regni caelorum; et quodcunque ligaueris super terram, erat ligatum et in caelis; et quodcunque solueris super terram, erit solutum et in caelis. De qua potestate iterum dixisti. Amen dico uobis, (Matt. 18 c.) quaecunque alligaueritis super terram, erunt ligata et in caelo: et quaecunque solueritis super terram, erunt soluta et in caelo. Et de qua profecturus ad Patrem rursum dixisti. (Ioan. 2.0.f.) Accipite Spiritum sanctum, quorum remiseritis peccata, remittuntur eis, et quorum retinueritis, retenta sunt. O infinita et incomprehensibilis gratia Dei, qui etiam hominibus potestatem tribuit dimittendi peccata

& qui neminem uult perire, (1 Tim. 2.a—Eze. 18—Eze. 33) sed omnes homines saluos fieri. O certe necessarium poenitentiae sacramentum omni acceptione, & omni laude dignissimum: quo remittuntur peccata, [fol. 17] & reconciliamur Deo. Hoc sacramentum à Doctoribus Orthodoxis, & Catholicis Patribus congrue secunda tabula post naufragium nuncupatur: quod etiam pro gratia recte dici potest. Prima gratia Baptismum est: ubi deponitur homo uetus, & induitur nouus: Secunda gratia est Sacramentum Confessionis: quoniam & si fragilis homo post Baptismum labitur ad peccata; in hoc tamen sacramento omnia peccata diluuntur. Honorifico te etiam pro regimine, & gubernatione Ecclesiae, dilectissiae sponsae tuae, (Act. 20f.) quam tuo acquisisti sanguine. Quoniam, & si tu sponse noster à nobis corporaliter recessisti, nobiscum tamen remansisti: quemadmodum pollicitus es, dicens. (Matt. 28) Ecce ego uobiscum sum omnibus diebus usque ad consummationem seculi. Verè Saluator noster nobiscum remansisti omnibus [fol. 17v] diebus usque ad consummationem seculi. nam licet corporali specie ex hoc mundo ad Patrem remeaueris, pignus tamen Sacramenti Eucharistiae nobis reliquisti. Tunc etiam tanquam sponsus anulum amoris sponsae tuae tribuisti: ac si diceres. Recedens à te, non te relinquam orphanam: sume hunc pro me arrhabonem, negotiareque in eo, dum rediero. Tunc non sacramentaliter, nec accidentibus uelatum, aut per speculum in aenigmate; (1 Cor. 13—2 Cor. 3—Esa. 52) sed reuelata facie, atque oculo ad oculum meam claritatem contemplaberis; meque cum Patre meo, & Spiritu sancto illo intuitu perfrueris, quo me Angeli fruuntur in caelis.

Proinde adorans magnifico te, summisque effero praeconiis ò radix Iesse, ò genus Dauid, pro libro illo sigillis septem signato, intus & foris scripto: (Apoc. 22—Esa. 11—Apoc. 5) foris iuxtà sensum literalem, [fol. 18] intus iuxtà allegoriam, & intelligentiam spiritualem: quem per Spiritum sanctum caeco & tenebroso mundo tribuisti: ut uidelicet per patientiam, & consolationem (Rom. 15) Scripturarum spem haberemus. Hunc librum signatum, intus & foris scriptum tu liber uitae nobis aperuisti, & sanctarum Scripturarum aenigmata reserasti, quam etiam librum te ipsum esse intelligimus: qui rectè intus & foris scriptus diceris: quia Deus es, & homo: Uerbum & caro: secretus & publicus: apertus & opertus [*sic*]. in ueteri lege clausus, & figuris uelatus: in noua uerò manifeste reuelatus. Vel proptereà hic liber intus & foris scriptus dicitur, quoniam Christus superbis incognitus est, & notus humilibus, unde dixisti. Confiteor tibi Pater Domine Caeli, & terrae: (Matt. 11) quia abscondisti haec a sapientibus, & prudentibus, & [fol. 18v] reuelasti ea paruulis. Ceterum hunc librum qui possit aperire, sed nec respicere nemo inuentus est: neque in caelo, ut Angelus: (Apoc. 5) neque in terra, ut homo: neque subter terram, ut spiritus: nisi tu leo de tribu Iuda, radix Dauid; qui aperis, & nemo claudit, & nemo aperit. Cunctis creaturis liber iste inscrutabilis, & tibi soli comprehensibilis.

Insuper agimus tibi gratias pro tuo aduentu in die nouissimo: quando cum potestate magna, & maiestate, & gloria uenies ad iudicandum. Tunc (sicut dicit Scriptura) cuncta quae facta fuerint, (Eccl. 12) adduces in iudicium pro omni errato, siue bona, siue mala sint. (Apoc. 1.b) Tunc uidebit te omnis oculus, & qui te pupugerunt. Tunc inquam in carne nostra uidebimus te Deum nostrum, (Iob. 19—Psal. 61—1 Cor. 3—Gal. 6)

unicuique reddentem iuxtà opera sua, [fol. 19] iustis praemium, reprobis supplicium. Et quis poterit cogitare diem adventus tui? & qui stabit ad uidendum te Deus noster? (Mala. 3—lxx [Septuagint]. 3) à cuius conspectu fugit terra & caelum: (Apoc. 20—ex oratione Manasses) quem omnes pauent ac tremunt à uultu uirtutis tuae.

Demum perennes tibi refero gratias Domine Deus noster, propter illam inaccessibilem, (1 Tim. 6) quam inhabitas lucem, ac propter ingentia & inaestimabilia praemia, quae tuis electis praeparare dignatus es; de quibus scriptum est. (1 Cor. 2—Esa. 64—lxx[Septuagint]. 64) Oculus non uidit, nec auris audiuit, nec in cor hominis ascenderunt quae praeparauit Deus iis, qui diligunt illum. Diligam ergo te Domine Deus meus, ex toto corde meo, & ex tota anima mea, & ex tota uirtute, et ex toto intellectu: (Matt. 22—Mar. 12—Luc. 10—Deut. 8) qui es super omnia, & plusquam omnia diligendus, colendus & adorandus: quemque omnes Angeli, & sancti tui laudant [fol. 19v], colunt, & adorant ut trinum & unum Deum omnipotentem. Cum quibus et ego miser homuncio, et nudus uermiculus laudo, colo, & adoro te Deum plasmatorem meum, & redemptorem meum. Nam non eram, & creasti me, & omnia propter me; me autem propter te, ad imaginem, et similitudinem tuam: (Gen. 1) ad te cognoscendum, ad te amandum, & ad te sine fine fruendum. Timebo te etiam Deus meus timore non illo, (1 Ioh. 4) qui poenam habet, quem perfecta charitas foras mittit: sed illo timore casto, de quo canitur in psalmis: (Psal. 18) Timor Domini sanctus permanens in seculum seculi. Et (ut uniuersam legem impleam & Prophetas) meum quoque proximum, & amicum et inimicum ob tui amorem diligam: iubente diuina Scriptura. (Matt. 22—Mar. 12) Diliges proximum tuum, sicut te ipsum. [fol. 20] Creaturas uerò omnes in te, (Luc. 10—Leui. 19) et propter te diligam: quia per eas te omnium creatorem intelligimus, & fatemur: teste Apostolo. (Rom. 1) Inuisibilia Dei à creatura mundi, per ea, quae facta sunt, intellecta conspiciuntur: sempiterna quoque eius uirtus, & diuinitas.

The text ends with a concluding prayer [fol. 20r and v].

Notes

I
Introduction

1. Translated by the authors in the light of the English version called *The Sinner,* trans. M. Prichard-Agnetti, New York and London, 1907, 88–89, and the Italian from the Milan ed. Hoepli, 83–85. The reference to *Piccolo mondo moderno* was provided by Anthony M. Gisolfi.

2. Sometime between 1080 and 1117. See G. Penco, "Cenni storici dalle origini al 1448," in C. Carpanese and F. G. B. Trolese, eds., *L'Abbazia di Santa Maria di Praglia,* Praglia, 1985, 9–11.

3. The documentation is fragmentary but does include the names of various stonemasons and carpenters working from the 1450s. The rebuilding of the church, begun in 1490, the refectory, and the "chiostro pensile," finished before 1549, have been attributed without documentation to Tullio Lombardo. See G. Bresciani Alvarez, "L'architettura," in Carpanese and Trolese, 1985, 87–112.

4. M. Muraro, *Pitture murali nel Veneto e tecnica dell'affresco,* exh. cat., Venice, 1960, 126.

5. Jacopi Philippi Tomasini, *Bibliotecae Patavinae Manuscriptae publicae e privatae,* Padua, 1639, 48–49, reads: "Bibliotheca D. Mariae Pratalenae. Collibus Euganeis octaano ab urbe loco. . . . Inter extra Occurrit hic Bibliotheca magis Pauli & Baptista Veronensium penicillo quam libris spectanda. . . ." Later sources do not mention Paolo Veronese in connection with the library decorations.

6. Jean Mabillon, *Museum Italicum,* I, *Iter Italicum,* Paris, 1687, 30: "XX Dominica die itum ad monasterium beate Maria de Pratalea Ordinis nostri, situm in collibus Euganeis ad sextum in collibus Euganeis ad sextum milliare extra moenia. Ibi ad triginta monachi: ecclesia elegans in agere sita: domitarii cellae solo ecclesiae aequatae: triplex claustrum: bibliotheca nitidissima libris antiquo ritu dispostis referta, atque picturis ornata est."

7. G. B. Rossetti, *Descrizione delle pitture, sculture, ed architetture di Padova,* Padua, 1776, 355.

8. B. Fiandrini, *Memorie storico cronologiche dell'insigne Monastero di Santa Maria di Praglia Raccolte e Compilate da D. Benedetto Fiandrini di Bologna Decano ed Archivista Pratalese,* 1800, B.P.. 127, MS 93 VI, 47v: "Nel 1765 circa sotto il Governo del Pre D. Basilio Pellegrini di Venezia, furono fatte tutte di nuovo le scanzie della Libreria in nuovo e semplice disegno, di legno Ceresara, per custodir meglio la copiosa raccolta di scelti Libri e Codici." See sections on documents in chapter II and appendix I.

9. D. Alessio Dobrillovich, O.S.B., *Badia Monumentale di Praglia,* Padua, 1923, 26–27, 46–54; *Praglia: Guida storico-artistica dell'abbazia,* Padua, 1953, 42, 60.

10. F. Zava Boccazzi, "Considerazioni sulle tele di Battista Zelotti nel soffitto della libreria di Praglia," *Arte Veneta,* XXIV, 1970, 111–27.

11. F. Zava Boccazzi, "Battista Zelotti a Praglia," in Carpanese and Trolese, 1985, 149–59.

12. Ibid. and 183–88.

13. C. Ridolfi, *Le maraviglie dell'arte* [Venice, 1648], ed. D. von Hadeln, Berlin, 1914–24, II, 363–85. M. Boschini, *La carta del navegar pittoresco* [1660] *con la "Breve Instruzione"* [1674], ed. A. Pallucchini, Venice and Rome, 1966, 667, 736–40. A few of Zelotti's exterior frescoes are recorded in engravings by A. M. Zanetti, *Varie pitture a fresco de' principi maestri veneziani ora la prima volta con le stampe pubblicate,* Venice, 1760. For these and other facade frescoes, see D. Gisolfi, "Tintoretto e le facciate affrescate di Venezia," in *Jacopo Tintoretto nel quarto centenario della morte, Atti del convegno internazionale di studi, Venezia, novembre 1994,* ed. P. Rossi and L. Puppi, Venice, 1996, 111–14, 315–16.

14. Zelotti's *Assumption,* now on the entrance wall of the church, was designed and originally installed as the main altar. His organ shutters, now at the Museo Civico of Padua, with *Moses Receiving the Tablets on Sinai* on the outside and *David and Saul* on the inside, were on the organ at the back of the church. Apparently in the same campaign (ca. 1558–ca. 1562) were his frescoes of *Evangelists with Church Fathers* in the spandrels beneath the dome, drum frescoes with four key scenes from the life of Christ, and a dome fresco glorifying the cross. The damaged, whitewashed, cleaned, and repainted frescoes of the nave vault were again whitewashed in 1963. For bibliography and summaries of opinions, see Zava Boccazzi, 1985, 149–52; K. Brugnolo Meloncelli, *Battista Zelotti,* Milan, 1992, cat. nos. 10, 11, 17, 18; and A. Ballarin and D. Banzano, eds., *Da Bellini a Tintoretto: dipinti dei Musei Civici di Padova dalla metà del Quattrocentro ai primi del Seicento,* Padua, 1991, cat. nos. 123–27 (Vittoria Romani). Much of the scholarship refers to the unpublished thesis of C. Ceschi, "Opere pittoriche del monastero di Santa Maria di Praglia," University of Padua, 1974. There are some variations in dating of the organ shutters within the period 1558–64. Earlier datings—1558 (Romani), 1559–60 (Ceschi)—are convincing in relation to the dated *tondi* of the Marciana Library (1557).

15. For works still at Praglia and those now displaced, see C. Ceschi Sandon, "Pittori attivi a Praglia," in Carpanese and Trolese, 1985, 135–48. Badile's altarpiece was apparently replaced at some point by a 19th-century copy now in situ; see Ballarin and Banzano, 1991, cat. no. 115.

16. Veronese's *Feast in the House of Simon,* now in Turin. Some of the most impressive canvases by Zelotti's contemporary rivals at Praglia are now in the Museo Civico at Padua, including Veronese's *Martyrdom of Saints Primus and Felicianus* and Tintoretto's *Feast in the House of Simon;* these and several other canvases once belonging to Praglia were included in the exhibition *Da Bellini a Tintoretto,* ed. Ballarin and Banzano. Ballarin's assignment of the *Glory of the Angels* (now in the sacristy at Praglia) to Paolo rather than Carletto Caliari, as attested by tradition at Praglia, does not seem acceptable on stylistic grounds. The arch-shaped canvas might have been commissioned along with its pendant, *Saints Primus and Felicianus,* but executed considerably later by Veronese's son.

17. T. E. Cooper, "The History and Decoration of the Church of San Giorgio Maggiore in Venice," Ph.D. diss., Princeton University, 1990, 37–40.

II
The Library Then and Now

1. Bresciani Alvarez, 1985, 112, fig. 85.

2. App. 1, doc. 8.

3. Zava Boccazzi, 1985, 154.

4. James F. O'Gorman, *The Architecture of the Monastic Library in Italy 1300–1600,* College Art Association Monograph on the Fine Arts, New York, 1972; cf. figs. 20 and 22 for the library of ca. 1490 in the Augustine Hermit monastery of San Barnaba, Brescia, where windows and wall frescoes alternate at the same level, or, more relevant, the similar arrangement at the 16th-century library of the Benedictine monastery of San Giovanni Evangelista at Parma, fig. 51.

5. Mabillon, 1687, 1, 30.

6. Zava Boccazzi, 1985, 153.

7. S. Sinding-Larsen, *Christ in the Council Hall: Studies in the Religious Iconography of the Venetian Republic,* 1974, part I, passim.

8. Ibid., 19.

9. Ibid.

10. Ibid., 21.

11. Ibid., 184.

12. For Melk (present-day Austria), see *Breviarium caeremoniarum monasterii Mellicensis, Pars altera = Corpus Consuet. monast.,* XI, 138: "Pallae quoque altarium, vasa et corporalia ac alia ecclesiae ornamenta, prout decet, cum omni diligentia reverenter conserventur et munda, super quo ipse sacrista invigilet et curam habeat diligentem."

13. Zava Boccazzi, 1985, 153–54.

14. Indeed, Roger Rearick, who as a grant recommender in 1989 was familiar with our Praglia project, suggested that drawings in Rome and Florence of a *Madonna Enthroned with Saints* (usually but not always assigned to Zelotti) might be connected with the Praglia Library commission. The basis he gave for the connection, viz., that the figure of Saint Theodore (sometimes called Saint George) identifies the commissioner as "Abbot" Teodoro Pino, does not work, however, since Pino was never abbot but merely *cellerario* at Praglia. See W. R. Rearick, "The Earlier Drawings of Battista Zelotti," in *Nuove ricerche in margine alla mostra Da Leonardo a Rembrandt: Disegni della Biblioteca Reale di Torino,* Turin, 1991, 202–3. See also Meloncelli Brugnolo, cat. nos. D.16, fig. 238, and D.14, fig. 226, and cat. no. D1, fig. 225, for the often-published Chatsworth drawing for the central octagon at the Praglia Library. Gisolfi will address matters regarding Zelotti drawings along with those of close contemporaries in a subsequent publication (see Gisolfi, 1987 and 1990).

15. J. Mabillon, O.S.B., *Annales ordinis S. Benedicti occidentalium monachorum patriarchae,* VI, Lucca, 1745, 99 (ad Annum Chr. 1123): "In Italia condita hoc anno abbatia beatae mariae de Pratalea diocesis Patavinae in montibus Euganeis.... Ecclesia elegans in tumulo posita, cuius solo dormitorii cellae aequatae. Triplex ibidem claustrum, bibliotheca libris antiquo ritu dispositis referta, picturisque ornata."

16. For illustrated surveys, see O'Gorman, 1972; and N. Pevsner, *A History of Building Types,* Princeton, 1976, chap. 7. O'Gorman lists neither Praglia nor San Bernardino at Verona.

17. Zava Boccazzi (1970, 111), as "tempera su tela" (n. 14), refers the restoration by Volpin to the Soprintendenza alle Gallerie di Venezia. Photographs on file at the Soprintendenza del Veneto give the medium of the whole ceiling as "olio e tempera su tela" and list each ceiling painting as oil on canvas except for the two scenes with the Fathers of the Church, which are given as tempera on canvas.

18. G. M. Pivetta, *Notizie sul monastero de' padri benedettini cassinensi di Santa Maria di Praglia,* Padua, 1831, 47–48.

19. F. Cessi, "Riscoperte dopo il restauro, le nove tele pratalensi di Giambattista Zelotti," *Padova,* Sept. 1960, 12–19.

20. See L. Crosato, *Gli affreschi nelle ville venete del Cinquecento,* Treviso, 1962, figs. 49, 64.

21. The negative numbers at the Soprintendenza di Venezia are 6702–6710 for the "striped state" photographs and 7297–7305 for the photographs after restoration.

22. Ceschi Sandon (1985, Scheda 177, Sopr. del Veneto [1976]) sees the wall paintings as inferior in inventiveness to those on the ceiling. Zava Boccazzi (1970, 125) suggested that the wall paintings were earlier than the ceiling paintings.

23. See O'Gorman, 1972, for other examples of earlier frescoed libraries. In several cases O'Gorman's catalogue includes descriptions of lost bench and shelf systems.

24. See O'Gorman, cat. no. 9, figs. 20–23; San Barnaba joined the Observant branch of the Augustinian Order in 1456; the decorations seem to be late 15th century. S. Green, in his dissertation on the Piccolomini Library

(University of California, Los Angeles 1991, 116–19), describes the decoration in the San Barnaba library as didactic. In the contemporary fresco decoration of the "white" Benedictines (not of the Cassinese Congregation) at San Giovanni di Verdara, Padua, the end wall is not original (Green, 119–21).

25. Zava Boccazzi, 1970, 112–25.

26. Zava Boccazzi, 1985, 151–54; Brugnolo Meloncelli, 1992, 100–101, cat. nos. 19–20.

27. R. Pallucchini, "Giambattista Zelotti e Giovanni Antonio Fasolo," *Bollettino del Centro Internazionale di Architettura Andrea Palladio,* x, 1968, 213–24.

28. Zava Boccazzi, 1985, 151, based on Rottigni.

29. See V. Sgarbi, ed., *Palladio e la Maniera, catalogo della mostra,* Venice, 1980, 62–63. Veronese's *Martyrdom of Saints Primus and Felicianus,* once in the church at Praglia, is now also at the Museo Civico, Padua; dated (usually) in the early sixties to (sometimes) in the early seventies, it suggests that Zelotti and Veronese were again working in the same place at the same time. On their earlier collaborations and the distinctions of their hands, see D. Gisolfi Pechukas, "Veronese and His Collaborators at 'La Soranza,'" *Artibus et Historiae,* xv, 1987, 67–108, and eadem, "I primi collaboratori di Paolo Veronese," in *Nuovi studi su Paolo Veronese, Convegno internazionale di studi, 1–4 giugno, 1988,* Venice, 1990, 25–35. Disputed works are also discussed in D. Gisolfi, "'L'Anno Veronesiano' and Some Questions about Early Veronese and His Circle," *Arte Veneta,* XLIII, 1989–90, 30–42, and D. Gisolfi Pechukas, "Two Oil Sketches and the Youth of Veronese," *Art Bulletin,* LXIV, 3, 1982, 388–413. Zelotti's facade frescoes in Venice are discussed in Gisolfi, 1996a, 111–12.

30. Sgarbi, 1980, 55–57; Brugnolo Meloncelli, 1992, cat. nos. 17–18.

31. Sgarbi (1980, 64–65) dates the *Pentecost* in San Rocco between 1568 and 1570, a dating close to that of W. R. Rearick of after 1570 (see Rearick's *Maestri veneti del Cinquecento,* Biblioteca di disegni, VI, 1980, 60), and the *Finding of the True Cross* in the same church, 1565–70. Brugnolo Meloncelli (1992, 116) dates the *Pentecost* now in San Rocco ca. 1566–67 and considers the *Finding of the True Cross* very late, ca. 1577 (p. 124).

32. A drawing for the figure of the Virgin in San Rocco is published in T. Mullaly, *Disegni veronesi del Cinquecento,* Verona, 1971, no. 59, as a "Donna Seduta con Libro"; Rearick (1980, 60) notes its relation to the San Rocco altarpiece.

33. Crosato, 1962, 120–23, as ca. 1557. A mid-sixties dating for Zelotti's frescoes at the Villa Godi is given in Brugnolo Meloncelli, 1992, cat. no. 25.

34. Pallucchini, 1968, 214; Brugnolo Meloncelli (1992, cat. no. 26) gives ca. 1566.

35. J. Ackerman (*Palladio's Villas,* Institute of Fine Arts, New York University, Walter S. Cook Annual Lecture, 1967, 41–42) suggests that the Palladian facade was the last part executed and that the rooms were decorated in the late sixties. Pallucchini (1968, 216) says: "negli anni immediatamente precedenti il 1570."

36. Crosato (1960, 123) suggests 1557 for the Villa Godi decorations; since the villa was built in 1542, a date of ca. 1555 is quite close to that of Zelotti's canvases in the Sala dei Tre Capi in the Ducal Palace, dated 1554. Pallucchini (1968, 214) suggests that the Villa Emo decorations were begun just before the death of the patron, Leonardo Emo, in 1565. Villa Caldogno bears the date 1570, but the villa was already occupied in 1569, and Pallucchini (p. 216) argues that it was decorated by Fasolo and Zelotti "negli anni immediatamente precedenti il 1570." Pallucchini (p. 221) points out that the Cataio decorations are dated between March 1570, when Doge Alvise Mocenigo was elected (portrayed in the frescoes), and the publication of D. B. Betussi's *Ragionamento sopra il Cathajo* (Padua, 1573). M. Binotto ("Un ciclo pittorico di Battista Zelotti nel palazzo palladiano di Montano Barbarano in Vicenza," *Arte Veneta,* XLI, 1987, 63–73) dates this decoration to 1566.

37. *Vita et miracula Sanctissimi Patris Benedicti ex Libro ii Dialogorum Beati Gregori Papae et Monachi collecta: Et ad instantiam Deuotorum Monachorum Congregationis eiusdem Sancti Benedicti Hispaniarum aeneis typis accuratissime delineata,* Rome, 1579.

38. Cooper, 1990, 146–60.

39. ". . . deferri voluit in Ecclesiam: ubi sumpta Eucharistia, sublatis in coelum oculis, orans inter manus discipulorum efflavit animam: quam duo monachi euntem in coelum viderunt pallio ornatam pretiosissimo, circum eam fulgentibus lampadibus, et clarissima et gravissima specie virum stantem supra caput ipsius dicentem audierunt: Haec est via, qua dilectus Domini Benedictus in coelum ascendit."

40. *Codex Benedictus,* Vatican Library: Vat. lat. 1202, available in a facsimile edition with comments in Italian: L. Duval-Arnould and A. Paravicini Bagliani, *Codex Benedictus,* Milan, 1982. For the date and original liturgical use of the codex, see ibid., 25f.; description of the miniatures by B. Brenk, 33–53.

41. Hawkins's translation; P. Hawkins, "'By Gradual Scale Sublimed': Dante's Benedict and Contemplative Ascent," in *Monasticism and the Arts,* ed. T. G. Verdon, Syracuse, 1984, 255ff. Dante, *Paradiso,* 21:28ff.: "di color d'oro in che raggio traluce / vid'io uno scaleo eretto in suso / tanto, che nol seguiva a mia luce. / Vidi anche per li gradi scender giuso / tanti splendor, ch'io pensai ch'ogni lume / che par nel ciel, quindi fosse diffuso."

III
The Benedictine Tradition of Books

1. The *Rule* may have been originally intended for local use only; for a survey of its history within the Benedictine Order, and also for notes on Saint Gregory's *Dialogues,* see J. Richards, *Consul of God: The Life and Times of Gregory the Great,* Cambridge, 1980, chap. 15. On the earliest extant manuscripts of the *Rule* of Benedict, see A. Butler, "The

Cassinese Manuscripts of the Rule," in *Miscellanea di studi cassinensi pubblicati in occasione del XIV centenario della fondazione della Badia di Montecassino,* Montecassino, 1929, 125–27. A new critical edition of the *Rule,* with commentary and numerous references to recent bibliography, is S. Pricoco, ed., *La regola di San Benedetto e le regole dei padri,* Fondazione Lorenzo Valla, Verona, 1995; Pricoco also discusses the relation between Saint Benedict's *Rule* and the *Regula Magistri.* See also G. Penco, O.S.B., *Spiritualità monastica: Aspetti e momenti,* Abbey of Praglia, 1988, chap. 5, 83–95, for background concerning the *Regula Magistri* in relation to Benedict's *Rule* and for the "spirit" of Saint Benedict's *Rule.*

2. Translation by T. Fry, O.S.B., ed., *The Rule of St. Benedict in English,* Collegeville (Minn.), 1982, chap. 73. "Regulam autem hanc descripsimus, ut hanc observantes in monasteriis aliquatenus vel honestatem morum aut initium conversationis nos demonstremus habere. Ceterum ad perfectionem conversationis qui festinat, sunt doctrinae sanctorum Patrum, quarum observatio perducat hominem ad celsitudinem perfectionis. Quae enim pagina, aut qui sermo divinae auctoritatis Veteris ac Novi Testamenti, non est rectissima norma vitae humanae? Aut quis Iiber sanctorum catholicorum Patrum hoc non resonat, ut recto cursu perveniamus ad Creatorem nostrum? Nec non et Collationes Patrum, et Instituta et Vitas eorum, sed et Regula sancti patris nostri Basilii, quid aliud sunt nisi bene viventium et oboedientium monacharum instrumenta virtutum? Nobis autem desidiosis et male viventibus atque neglegentibus, rubor confusionis est. Quisquis ergo ad patriam caelestem festinas, hanc minimam inchoationis Regulam descriptam adiuvante Christo perfice; et tunc demum ad maiora, quae supra commemoravimus, doctrinae virtutumque culmina Deo protegente pervenies. Amen!" (*San Benedetto Abate, Regula monasteriorum,* Italian trans. by the Benedictines of Viboldone, 6th ed., Viboldone [Milan], n.d. [1970s], with the original Latin text; scholarly edition: "Benedicti Regula," *Corpus scriptorum ecclesiaticorum latinorum,* LXXV, Vienna, 1977).

3. For example: *Secundus dyalogorum liber beati Gregorij pape de vita ac miraculis beatissimi Benedicti. Eiusdem Almi patris nostri Benedicti regula. Speculum Bernardi Abbatis casinensis de his in professione obligatur monachus: Venetis Impressum quoque diligentissime per Nobilem virum Lucantonium de giunta florentinum felicibus divi martyris Georgij auspicijs. Anno incarnationis dominice: quingentesimo quinto supra millesium.* An example bound in a 16th-century leather cover exists at the abbey of Santa Giustina in Padua. For this and other early editions, see F. G. B. Trolese, S. Giorato, and L. Prosdocimi, *Edizioni della regola di San Benedetto,* catalogue of exhibition co-sponsored by the libraries of Praglia and Santa Giustina, Padua, Santa Giustina, Oct.–Dec. 1980.

4. *Rule,* 4:55–56. See Pricoco's comments in the above-cited edition (1995) of the *Rule,* 321f., with reference to A. de Vogüé, "Lectiones sanctas libenter audire: Silence, lecture et prière chez saint Benoît," *Benedictina,* XXVII, 1980, 11–26. The emphasis is not only upon the frequency of reading (or listening to readings) but just as much on the

enjoyment of it and active desire for it (according to the cited interpretation of the qualification "libenter").

5. B. Smalley, *The Study of the Bible in the Middle Ages,* 3rd ed., Oxford, 1983, 28–29, citing A. Mundò, "'Bibliotheca,' Bible et lecture du Carême d'après St. Benoît," *Revue Bénédictine,* IX, 1950, 65–94.

6. B. Calati, "Dalla 'lectio' alla 'meditatio': La tradizione benedettina fino a Ludovico Barbo," in Trolese, 1984, 45–57.

7. "Constituenda est ergo nobis dominici scola servitii" (trans. Fry, 1982). For this and the following, see Penco, 1988, chap. 14: "Sul concetto del monastero come 'schola,'" 273–79.

8. Penco (1988, 275) refers to Adam of Perseigne, "Sermo in festivitate sancti Benedicti abbatis," ed. D. Mathieu, *Collectanea Ordinis Cisterciensium Reformatorum,* IV, 1973, 108–9.

9. "Schola celestis disciplin<a>e sanctorum monachorum conventus est" (Penco, 1988, 276).

10. Ibid., 253–54.

11. Ibid., 226–29: "Preghiera, lectio divina, scrittura e vita monastica." This section for the following references.

12. Ibid., 231.

13. Ibid., 199. See also 202–3.

14. St. Augustine: "Hoc versetur in corde quod profertur in voce"; St. Benedict: "mens nostra concordet voci nostrae." Penco, 1988, 208. See Penco's chap. 10, sec. 3: "Disposizioni interiori nella preghiera" (208–18).

15. F. G. B. Trolese, *Ludovico Barbo e S. Giustina: Contributo bibliografico: Problemi attinenti alla riforma monastica del Quattrocento,* Rome, 1983. See also B. Collett, *Italian Benedictine Scholars and the Reformation: The Congregation of Santa Giustina of Padua,* Oxford, 1985, chap. 1, "The Benedictines in Fifteenth-Century Italy."

16. Padua, Biblioteca Civica, B.P. 229, transcribed in G. Cantinoni Alzati, *La Biblioteca di S. Giustina di Padova, libri e cultura presso i benedettini padovani in età umanistica,* Padua, 1982.

17. Extensive bibliography on libraries, including monastic ones, in Pevsner, 1976, chap. 7. Most relevant is O'Gorman, 1972, who does not discuss Praglia. For British Benedictine examples, a starting point is D. H. Turner, R. Stockdale, P. Jebb, and D. Rogers, *The Benedictines in Britain,* London and New York, 1980, esp. 62–81 on libraries and writers. Of interest for its bibliography and information on bookmaking and libraries is J. J. G. Alexander, ed., *The Painted Page: Italian Renaissance Book Illumination, 1450–1550,* exh. cat., Royal Academy, London, and Pierpont Morgan Library, New York, 1994–95, Munich and New York, 1994. In the present chapter, however, we have preferred to base our account on a selection of original documents concerning the Benedictine Order.

18. *Consuetudines monasteriorum Germaniae,* V, ed. B. Albers, Montecassino, 1912, 54f.: "In Capite ieiunorum. [10th century] Secundum consuetudinem universalis ecclesiae fratres nostri cinere et cilicio crucem sequantur. . . . Perlecta hoc capitulo . . . [de Quadragesima . . .], faciat abbas sermonem de eodem <Capitulum> ad fratres et cohortetur

eos. . . . Postea surgant fratres et libros, quos priori anno de biblioteca acceperant, in presenti restituant. Si quis vero per negligenciam librum suum perlegere neglexerit, veniam querat. Deinde armarius brevem prioris anni legat et libros, quos singulis dederat, per nomina recipiat, et iterum legendos aliis fratribus commictat. . . ."

19. *Corpus consuetudinum monasticarum,* XII, I [12th and 13th centuries], ed. L. G. Spätling and P. Dinter, Siegburg, 1985, 136, s.v. *De tempore Quadragesimae:* "In ipso die in capitulo habeat armarius libros collectos super tapetia. Et legatur sententia sancti patris nostri Benedicti *De obseruatione Quadragesimae*." The editors note (xiv): "Die monastische Brauchtexte des Mittelalters—durchweg *consuetudines* genannt—sind uns in der Regel nur dadurch überliefert und bekannt, weil sie in ihrer Gestaltungskraft und Wirksamkeit nicht auf ein Kloster beschränkt bleiben, sondern mit der Ausstrahlung des Reformgedankens auf oftmals verschlungenen Wegen in andere reformwillige Klöster gelangten."

20. *Corpus consuetudinum monasticarum,* II, ed. A. Gransden, Siegburg, 1963, for Eynsham in Oxfordshire [after 1128], 166f.:

VIII. De armarii et eorum custodia. De ceteris quoque ad librorum custodiam necessariis . . . Armarius omnium librorum titulum singillatim annotatum habere debet et libros, qui anno ille prae manibus non habentur, per singulos <annos> semel aut bis exponere aut recensere . . . [instructions for keeping the books in specially fitted cupboards to protect them against humidity] . . .

IX. De libris itinerancium et quod non liceat cantori libros dare vendere vel impignorare sine precio.

Si alicuius iter morosum fuerit, libros bibliothecae quos habuerit ante eius profeccionem armario reconsignabit. . . .

X. De reposicione et emendacione librorum communium et quod nemo aliquid ponat vel demat sine cantore.

Libri communes, qui cotidie ad manum habendi sunt sive ad cantandum sive ad legendum, in loco competenti reponendi sunt, ut competens accessus omnium fratrum esse possit . . . cantor vel armarius diligenter emendare debet et punctare, ne fratribus in cotidiano officio ecclesiae sive in cantando sive in legendo aliquod impedimentum faciant. . . .

XI. Quod praeter libros qui magis necessarii sunt ceteros omnes cantor reponat. Et cui committantur claves librorum si cantor vel armarius in viam diriguntur.

Debet cantor sive armarius inter libros, qui ad cotidianum officium ecclesiae necessarii sunt eciam de aliis, aliquos, quos ad instruccionem vel ad aedificacionem fratrum magis commodos et necessarios esse perspexerit, in commune proponere. Ceteros autem numquam extra armarium ponere debet aut dimittere, nisi specialiter ab aliquo fratre requirantur. . . .

21. *Corpus consuetudinum monasticarum,* XI, 2, ed. J. F. Angerer, Siegburg, 1987 (correct publication year); [1379, with later additions (into the next century)]; *Corpus consuetudinum monasticarum,* II, *Breviarium caeremoniale monasterii Mellicensis,* 138f.: "De conseruacione dominici corporis et reliquiarum . . . Praeterea idem sacrista aut alius frater idoneus bibliothecam librorum in commenda habeat, libros quoque, ne corrumpantur a vermibus aut muribus diligenter custodiat, et nisi accepto alicuius scripti chirographo aut certe competenti vadio libri extra monasterium nullatenus concedantur." At Fruttuaria in Piedmont and Sankt Blasius in Schwarzwald the rule is similar: "De libris, qui in sua [cantoris] potestate sunt, neque extra claustrum neque ulli sine licentia prestat neque uenundat" (*Corpus consuetudinum monasticarum,* XII, 2, ed. L. G. Spätling and P. Dinter, Siegburg, 1987, 142f.).

22. Assessorato alla Cultura della Regione Liguria, *Il processionale benedettino della badia di Sant'Andrea della Castagna,* Milan, 1992, with introductions by P. Rum and B. G. Baroffio. This is a facsimile edition.

23. "Letanie breuiores fiende per claustrum" (unpaginated fol. preceding fol. 1).

24. Examples of (unprinted) book collection preceding the boom in L. Gargan, *Cultura e arte nel Veneto al tempo del Petrarca,* Padua, 1978; for relations between private libraries and monastic libraries, see K. Schneider, "Die Bibliothek des Katharinensklosters in Nürnberg und die städtische Gesellschaft," in *Studien zum städtischen Bildungswesen des späten Mittelalters und der frühen Neuzeit,* Göttingen, 1983, 71–82.

25. *Concilii tridentini tractatuum, pars prima, Complectens tractatus a Leonis X temporibus usque ad translationem concilii conscriptos,* ed. V. Schweitzer, Freiburg, 1930, 119: G. Aleandro, "De convocando concilio sententia (ineunte anno 1537)."

26. E. Aleandri Barletta, "La stamperia romana di Paolo Manuzio dal 1561 al 1563," in *Aspetti della riforma cattolica e del Concilio di Trento: Mostra documentaria,* ed. E. Aleandri Barletta, Rome, 1964, 126.

27. A compendious synopsis on monastic studies by Jean Mabillon (1632–1707), himself a Benedictine monk: a three-volumes-in-one edition: *Tractatus de studiis monasticis in tres partes distributis . . . auctore P. D. Joanne Mabillon. . . ,* editio altera, Venice, 1745. There are various earlier three-part editions, including Paris, 1691, in French, and a Venice edition in Latin of 1705; the first part, concerning his Italian journey, *Iter Italicum,* was first published in 1687. Mabillon also gives some information on library rituals in the Benedictine monasteries.

28. *Corpus consuetudinum monasticarum,* XII, 2, 134: Fruttuaria, Piedmont, and St. Blasius, Schwarzwald: "De oboedientia non mutanda. Obedientiam nullam mutant custodes claustri, si abbas presens est, nisi clauem illam de armario, ubi sunt libri repositi in claustro. . . .[142] De armario cantoris. Habet cantor armarium in ecclesia, ubi sunt libri, qui non uadunt per claustrum sicut ceteri, ubi etiam cartule, ubi omnia instrumenta, que pertinent ad suam obedientiam, sicut est illa de libris ligandis, rasoria,

unde cartule raduntur, et illa talia unde pumigantur et cultelli unde regulantur, tabule paruule, ubi nomina fratrum scribit, quos ipse mittit in breuem ad ebdomadam, siue de missa siue de mense lectore siue de coquina, quia ceteros ebdomadarios scribit puer in fine ispius tabule, que cottidiana dicitur. Facit etiam psalterios et ymnarios de ipsis talibus, quae remanent de magnis cartulis, quando inciduntur. Et facit scribere iuuenes discendi causa et postea uenundat eos cum licentia abbatis uel prioris. . . ."

29. C. Pfaff, *Scriptorium und Bibliothek des Klosters Mondsee im hohen Mittelalter,* Österreichische Akademie der Wissenschaften, Vienna, 1967, 69f., citing, *inter alios,* E. Lehmann, *Die Bibliotheksräume der deutschen Klöster im Mittelalter,* Berlin (East), 1957. The room at Mondsee: "ein langgestreckter, kapellenartiger, mit einem schönen Sterngewölbe überdeckter, einseitig beleuchteter Saal, der im Osten mit den drei Seiten eines Achtecks abgeschlossen wird . . ."; generally: "Zur Ausstattung gehörten Gestelle oder Schränke sowie Pulte zur Aufnahme der frei aufliegenden, aber unausleihbaren 'libri catenati,' und wirklich finden sich noch heute bei einigen Lunacelenses Spuren von Haken, an denen die Ketten angeschlossen wurden."

30. Examples of incunabula printed at Subiaco in 1465 belong to the Pierpont Morgan Library in New York, nos. PML 19376 (Cicero) and PML 239 (Lactantius).

31. So for example at Fruttuaria in Piedmont and St. Blasius in Schwarzwald (*Corpus consuetudinum monasticarum,* XII, 2, 144): "De libris ad mensam uel collationem legendis. Libri, qui in refectorio leguntur uel ad collationem, in sua [cantoris] potestate sunt. Sicut ipse ordinat, ita agimus. Et ille, qui in refectorio siue ad collationem legit, finito libro interrogat eum quid ipse uelit. Ille, qui in festiuitate in refectorio legit, interrogat eum, quales passiones uel sermones debeat legere. Et si ibi fallitur, licentiam habet emendandi nullusque alius nisi prior, qui ad scillam sedet, et cui abbas, et si necesse est, de mensa surgit et ad analogium pergit."

32. Tomasini (1639, 48–49), in his description of the Library at Praglia, lists some thirty manuscripts, apparently selecting from a greater number, since his book concerns manuscripts in private and public libraries of Padua. C. Carpanese ("La biblioteca," in Carpanese and Trolese, 1985, 183–88) summarizes what is known of the history of the Library at Praglia, emphasizing the disruption caused by Napoleon and the difficulty of precisely tracing the books removed from Praglia at the end of the last century. It is clear, however, that many are at the Biblioteca Comunale of Padua. On inventories of other libraries of the Cassinese Congregation, see F. G. B. Trolese, O.S.B. "La congregazione di S. Giustina di Padova (sec. xv)," in *Naissance et fontionnement des réseaux monastiques et canoniaux, Acts du Premier Colloque International du C.E.R.C.O.M., septembre 1985,* Saint-Etienne, 1991, 641–42.

33. G. Ravegnani, *Le biblioteche del monastero di San Giorgio Maggiore con un saggio di Nicola Ivanoff,* Florence, 1976, 16–21.

34. Cantinoni Alzati, 1982, 33–181. On pp. 183–93 are transcribed other lists of books that illustrate usage in the 15th century at Santa Giustina: Breviaries on loan to monks from other monasteries; books to be read in the community (mainly the Fathers of the Church); and books to be read at *mensa.*

35. The dimensions of the 1461 library room at Santa Giustina are 18 m x 6.45 m with a height of 9 m See F. L. Maschietto, *Biblioteca e bibliotecari di S. Giustina di Padova (1697–1827),* Padua, 1981, 1–6, on the Quattrocento library. Compare 16.75 m x 9.33 m with a height of 6.2 m at Praglia; see chap. II above for physical features of the Praglia Library.

36. A. Lenzuni, ed., *All'ombra del Lauro: documenti librari della cultura in età Laurenziana,* exh. cat., Biblioteca Medicea Laurenziana, Florence, May–June 1992, Florence, 1992, 135.

37. Ravegnani, 1976, 11–12.

38. Carpanese, "La biblioteca," 1985, 183; see his nn. 2 and 3, p. 187, for documents concerning the gifts.

IV
The Ceiling and Wall Paintings in the Praglia Library and Other Benedictine Cycles

1. Zava Boccazzi, 1985, 153; her suggestion is based simply on her dating of the cycle. Marostica may have been involved with commissioning Zelotti's work in the church, since he served as abbot for a stretch from 1559 through 1563. See chap. I above, nn. 14–15.

2. Carpanese and Trolese, 1985, 213–14, for a list of the abbots of Praglia. Placido da Marostica was abbot in 1551–53, in 1559–63, and briefly in 1574. Giuliano Carena da Piacenza was abbot in 1569, Eusebio da Brescia in 1570–71, Damiano da Novara in 1572–73.

3. Ravegnani, 1976, 35–43.

4. St. Benedict devoted chapters 8–20 of his *Rule* to the Divine Office and other prayers, such as the weekly complete reading of the Psalms (for the *Rule,* see Pricoco, 1995).

5. *Rule of St. Benedict,* 18:22–26, ending: "We read, after all, that our Holy Fathers, energetic as they were, did all this in a single day. Let us hope that we, lukewarm as we are, can achieve it in a whole week" (Fry, 1982). See also Pricoco, 1995.

6. This information was offered to D. Gisolfi by Giovanna Nepi Sciré, Soprintendente dei Beni Artistici e Storici di Venezia, during a visit to the laboratory in 1989, when the three ceiling paintings by Titian from Santo Spirito were under conservation. The skies of all three pictures had been largely replaced, and so little of the 16th-century pigment remained that it was considered impossible to restore the original intent. See G. Nepi Sciré, "Recenti restauri a Venezia," in *Tiziano,* exh. cat., Venice, 1990, 118–20.

7. Zava Boccazzi, 1985, 156, 159, n. 23. Biblioteca Marciana incunab. 1078 has the date 1481 on the title page;

Marciana Misc. 1188 opuscolo 6 has "IN VINEGIA MDXLVI" on the last page.

8. Barbieri (see below), 1481 version: "Sibylla Samia a Samo insula nudum ense sub pedibus formosum pectus subtileq. velim [velum ?] capiti habens. Sic ait, Ecce veniet dives & nascet<ur> de paupercula: & bestie terrarum adoranbunt eum & dicent, laudate eum in atriis celorum"; Barbieri, 1546 version: "Ecce veniet dives et nascetur de <. . . >." Philippus de Barberiis, *Discordantiae sanctorum doctorum Hieronymi et Augustini,* Venice (1546; a copy in the Bibl. Marc.,Venice, Misc. 1188). More complete texts are in Phil. de Barberiis, *Discordantiae . . . ,* Rome, 1481 (Bibl. Marc. incunab. 1078).

9. Barbieri, 1481 version: "Sibylla nobillissima eritrea in Babilo<n>ia orta: de xpo [Christo] sic ait. In ultima aut<em?> etate humiliabit<ur> deus & sanabit<ur> pres divina<.> iu<n>get<ur> hu<m>anitati divintas. Iacebit in seno agnus & officio puellari educabitur deus & homo. Signa p<re>cedent apud appellas [?]. Mulier vetustissima puerum previum co<n>cipiet. Boetes orbis mirabitur ducatu<m ?> prestabit ad ortum." Barbieri, 1546 version: "In ultima a<etat>e humiliabitur proles divinita<s> vi<?>getur *[sic?]* huma<nitati>."

10. Barbieri, 1481 version: "Sibylla tyburtina: qua<m> Lacta<n>tius tyburté vocat. no<m>i<n>e abunea<m??>: q<uae> tyburi colitur ut dea iuxta ripas amnis: i<n> cuius gurgite simulachr<um> eius i<n>ve<n>tu<m> dicitur: tene<n>s in ma<n>u libr<um>: hoc de xpo [Christo] tal<ite>r prophetavi<t> Nascet<ur> xps [Christus] i<n> bethle<h>e<m>: & a<d>nu<n>ciabit<ur> in Nazareth rex.Tauro pacifico fundatore a'etis [aetatis ?]. O foelix illa mater cuius ubera illu<m> lactabunt. Haec tunica crocea [?] vestietur violaco mantello superposito." Barbieri, 1546 version: "Nascetur Christus in Bethlehem et nuncti."

11. Barbieri, 1481 version: "Sibylla cumana q<uae> fuit tp<or>e Tarq<u>ini prisci scripsit de xpo [Christo] refere<n>te virgilio in lib<ro> buco<lico> i<n> hanc modu Ultima < . . . ?> venit iam carminis aetas Magnus ab integro sedarum nascitur ordo Iam redit & virgo redeunt saturnia regna Iam nova p<ro>genies caelo dimittitur alto Tu modo nascenti puero; quo ferrea primum: Definet: & toto surget gens aurea mundo Casta fave [?] lucina tuus iam regnat appollo *[sic!]*." Barbieri, 1546 version (on scroll, almost unreadable): "DL. tima cumiei be<?> niti<a?>m carminis etab< . . . >. A agnus ab integro."

12. L. D. Ettlinger (*The Sistine Chapel before Michelangelo: Religious Imagery and Papal Primacy,* Oxford 1965, 35f.) notes: "Beginning the narrative at the altar-wall it was customary in the Middle Ages and during the Renaissance either to work round the church and back to the altar, or to proceed in a double stream along each side wall towards the entrance." The following argument is harder to accept: "This system, however, creates one peculiar difficulty. We automatically tend to 'read' pictures from left to right as we do the pages of a book." We would imagine, rather, that the clergy and other educated people would surely have connected the narrative series with the altar and not have read

it "as a book"; while other people didn't read books at all, so probably they also would have taken the series in the correct order. A secular context, in the Doge's Palace, Venice, provides a contemporary example of a painting series with chronological arrangement and shifting vantage points determined by functions and ritual movements (Sinding-Larsen, 1974, 221f., 233f.).

13. Breviary for Augustine, 28 August: "Sed cum vigeret Manichaeorum haeresis, vehementius in illam invehi coepit, Fortunatumque haeresiarcham confutavit." Ambrose for 7 December: "Factus Episcopus, catholicam fidem et disciplinam ecclesiasticam acerrime defendit: multosque Arianos, et alios hæreticos, ad fidei veritatem convertit. . . ."

14. Translation: Missal, *St. Andrew's,* with commentary by Dom Gaspar Lefebvre, O.S.B., 4 vols., Bruges, 1947–51.

15. St. Benedict ("Regula," *Corpus scriptorum ecclesiasticorum latinorum,* LXXV, 1977, Indices, 182) connects Judges 15:11 (about Samson's capture) with his *Rule* 4:64, which says, in a paraphrase of St. Paul, "treasure chastity." Earlier in Judges 15 and in Judges 14 we are told about Samson's wife, who was a Philistine, and about the troubles this caused, of Philistine deceit, and Samson's revenge.

16. The story of Samson and the Philistines occupies Judges 13–16.

17. The Vulgate for the key passage is: "Viditque in somnis scalam stantem super terram et cacumen illus tangens caelum, angelos quoque Dei ascendentes et descendentes per eam, et Dominum innixum scalae dicentem sibi . . ." (Gen. 28:12–13).

18. *Rule of St. Benedict,* 7:67–69 (Fry, 1982).

19. St. Gregory the Great, *Dialogues,* trans. O. J. Zimmerman, O.S.B., New York, 1959 (Fathers of the Church), 89.

20. *Rule of St. Benedict,* 7:1, 3–7 (Fry, 1982).

21. *Rule of St. Benedict,* 64:17–19 (Fry, 1982).

22. Pricoco, 1995, 326.

23. Ibid.: "Pur avendo annunziato all'inizion, con il Maestro, che l'aspirazione del monaco è arrivare velocemente alla gloria celeste e che la scala delle virtù e dell'umiltà conduce al cielo, Benedetto pone al sommo della scala la carità, rifiutando il discorso sui fini ultimi e mostrando di voler mantenere in una prospettiva diversa, terrena e concretamente operabile entro il cenobio, l'itinerario spirituale del monaco."

24. Ibid., 328ff., with bibliography on the subject.

25. Smaragdus, "Smaragdi abbatis expositio in Regulam S. Benedicti," *Corpus consuetudinum monasticarum,* VIII, Siegburg, 1974.

26. E. Martène, *Commentarius in regulam S. P. Benedicti literalis, moralis, historicus, ex variis antiquorum scriptorum commentationibus. Actis sanctorum, monasteriorum ritibus . . . cum editis tum manuscriptis concinnatus. Opera et studio Edmundi Martene Presbyteri et Monachi Benedictini Congregationis Sancti Mauri Parisiensis,* Paris, 1690. The principal commentators are: Smaragdus, O.S.B. (ca. 825), Hildemar, O.S.B. (earlier identified as Paulus Diaconus) (ca. 850), Bernhard of Cassino, O.S.B. = Beatus Aiglerius, abbot of Montecassino

(1263–82), Pierre Bohier, O.S.B., Benedictine abbot, with at least two commentaries on the *Rule,* the last one 1373.

27. "Latera enim eius scalae dicimus nostrum esse corpus et animam" (Martène, 165).

28. "Scala vero ipsa erecta nostra est vita in saeculo, quae humiliato corde a domino erigatur ad caelum" (ibid.).

29. "Ergo his omnibus humilitatis gradibus ascensis, monachus mox ad caritatem dei perveniet illam quae perfecta foras mittit timorem . . ." (ibid., 191).

30. The writings of Bernhard of Montecassino are recorded in the 15th-century inventory as present in the Benedictine library at Santa Giustina. See Cantinoni Alzati, 1982, nos. 51, 317.

31. "Divina vocatio est electio, qua Deus eligit per gratiam, quos per fructum boni operis misericorditer perducit ad gloriam" (Martène, 203).

32. Paulus Warnefred, *Pauli Warnefridi diaconi cassinensis in sanctam regulam commentarium,* Montecassino, 1880, 142ff., ad cap. VII, "De humilitate."

33. J. R. Martin, *The Illustrations of the Heavenly Ladder of John Climacus,* Princeton, 1954. Also see n. 34 below.

34. Walter Cahn discusses examples from Dura Europas to the 13th century in "Ascending and Descending from Heaven: Ladder Themes in Early Medieval Art," in *Santi e demoni nell'alto medioevo occidentale, Atti del convegno di studio, Spoleto, 7–13 aprile 1988,* Spoleto, 1989, II, 697–724, figs. 1–17; fig. 17 from the Walters ArtGallery *Speculum virginum* MS W. 72 is a cross/ladder conflation, while fig. 13 from the same manuscript is a ladder allegory; fig. 12, a frontispiece from the *Rule of St. Benedict* in Stuttgart, shows the saint writing, flanked by Jacob's ladder and an allegorical ladder, thus spelling out the connection.

35. Cf. a similar figure by Veronese in the ceiling of the Sala del Collegio of the Doge's Palace, Venice. Sansovino calls her "la religione," Ridolfi "la Fede," two denominations that converge under the heading "Ecclesia"; see S. Sinding-Larsen, 1974, 256.

36. St. Gregory the Great, *Dialogues,* II, 92, 94.

37. *Rule of St. Benedict,* Prologue, 21.

38. S. Sinding-Larsen, "Paolo Veronese tra rituale e narrativo: Note a proposito di un disegno per il Palazzo ducale," in *Nuovi studi su Paolo Veronese, Atti del convegno internazionale di studi, Venezia, 1–4 giugno 1988,* ed. M. Gemin, Venice, 1990, fig. 30, 36–41.

39. Judith 15:11 ("Thou hast played a man's part, and kept thy courage high. Not unrewarded thy love of chastity, that wouldst never take a second husband in thy widowhood; the Lord gave thee firmness of resolve, and thy name shall be ever blessed") is linked with St. Benedict's *Rule,* 4:64 ("treasure chastity") in the concordance *Corpus scriptorum ecclesiasticorum latinorum,* LXXV, "Benedicti Regula," Vienna, 1977. We note that Samson also is connected with this phrase in the concordance, evidently more in admonishment than as a model; see n. 15 above.

40. "The time came when God put Abraham to the test . . . you shall offer him as a sacrifice; all nations on earth shall pray to be blessed as your descendants are blessed, and

this because you have obeyed me."

41. "Deus meus misit angelum suum et conclusit ora leonum; et non nocuerunt mihi, quia coram eo iustitia inventa est in me" (6:22), a text used as an antiphon and responsorium in the Roman liturgy.

42. For examples, see Centro d'Incontro della Certosa di Firenze [Galluzzo], *Iconografia di San Benedetto nella pittura della Toscana,* Certosa di Firenze, 1982, figs. 188, 190, 191, 193, 194, 196, 197, 199, 204, 205.

43. Philippus de Barbariis, *Discordantiae Sanctorum . . . ,* Rome, 1481 (Libreria Marciana incunab. 1078), woodcut on p. 15; De Barberiis, *Discordantiae . . . ,* Venice, 1546 (Biblioteca Marciana, Misc. 1188.1), cap. XIII, has the engraving of "Eritrea."

44. 1481 version, 17; 1546 version, cap. VIII.

45. St. Gregory the Great, *Dialogues,* II, 93.

46. Ibid.

47. The Hebrew text said 3,000. The Latin Vulgate said 23,000! (Knox, 79, n. 2).

48. The composition suggests a familiarity with Veronese's *Christ Preaching,* now in the Prado but probably then in the Casa Contarini in Padua. If the dating of 1565–66 is correct for the Veronese, it would fit with our dating of ca. 1570 for the Praglia paintings. Specifically, the positioning of Christ, as if enthroned, the placement of the columns behind him, and the use of one of the doctors as a *repoussoir* figure before and to the left of Christ relate to Veronese's version. See Gisolfi Pechukas, 1982, 410–13. Further arguments concerning the Paduan commission and the dating of the Veronese as a mature work were given in a talk by D. Gisolfi, "The School of Verona in America" at Fordham University in November 1993 (in press in *Artibus et Historiae*).

49. Ravegnani, 1976, 42: "L'allegoria è questa volta evidentissima: il palazzo significa l'eterna beatitudine e la sapienza ne e la sola arbitra."

50. O'Gorman (1972) catalogues monastic library rooms, with some omissions, among them Praglia. His no. 42, fig. 50, is the library of San Giovanni di Verdara, another Benedictine site in Padua (though not belonging to the Congregation of Santa Giustina). The extant fresco decorations depict scholars at work in their studies, and in roundels above them female figures that may be personifications of the Liberal Arts and Virtues; on the decorations, see S. Green, "The Piccolomini Library and Its Frescoes," Ph.D. diss., University of California, Berkeley, 1991, 119–21, and notes 57 and 63 below.

51. M. Zorzi, *La Libreria di San Marco: Libri, lettori, società nella Venezia dei Dogi,* Milan, 1987, chap. VI, 2, 139–71, with ample if not complete bibliography. Also relevant is G. Fiaccadori, *Bessarione e l'umanismo, catalogo della mostra, (Biblioteca Marciana, marzo–giugno 1994),* Naples, 1994; the essay by Luca D'Ascia (pp. 67–77) looks at Cardinal Bessarion's role at the Council of Florence.

52. A good summary is given in D. Howard, *Jacopo Sansovino: Architecture and Patronage in Renaissance Venice,* New Haven, 1975, 22–28.

53. Zorzi (1987, 139) correctly refers to the pictorial program as "un complesso disegno iconografico, ancor oggi non decifrato del tutto" and summarizes Ivanoff's preliminary and general interpretation. See N. Ivanoff, "La libreria marciana: arte e iconografia," *Saggi e memorie di storia dell'arte,* VI, 1968, 69–78; for the ceilings exclusively, see also J. Schulz, *Venetian Painted Ceilings of the Renaissance,* Berkeley, 1968, no. 33.

54. Zorzi, 1987, 143: "Tutta la conoscenza trova, anche nella visione rinascimentale, la sua unità nella divinità. Dio è il supremo unificatore del sapere" (citing Ivanoff, 1968, and P. L. Rose, "The Accademia Veneziana: Science and Culture in Renaissance Venice," *Studi veneziani,* XI, 1969, 195. See also Zorzi, 144–45, 148, 152.

55. Ivanoff and Zorzi both summarize the possible identities of the extant "philosophers" and the history of changes and losses. Sylvie Béguin saw the connection of four paintings associated with Veronese in the museum at Chartres with the lost wall paintings of the vestibule (Ivanoff, 1968, 78), and Rearick cites the Chartres series as copies from the library paintings, including two originals, now in the Los Angeles County Museum of Art (W. R. Rearick, *The Art of Paolo Veronese, 1528–1588,* exh. cat., Washington, D.C., 1988, nos. 22–23). See also N. Ivanoff, "Il ciclo dei filosofi della Libreria Marciana," *Emporium,* Nov. 1964, 207–10.

56. Ivanoff, 1968, 74. G. B. Armenini (*De' veri precetti della pittura* [Ravenna, 1587], Hildesheim and New York, 1991, 168) mentions among various ancient examples the library of Tiberius Caesar with "le vere imagini de' poeti antichi con altre effigi di grand'uomini per commuovere con tali esempi e infiammare quegli i quali esercitano l'ingegni loro circa la condizione umane e divine."

57. Green (1991, chap. 3, 115ff.) looks at some earlier monastic library decorations in fresco, including the Augustinian one at San Barnaba, Brescia (1486–90), in which members of the order appear along the walls (not unlike the Franciscan example of San Bernardino illustrated here), and the cycle completed in 1492 by Pietro Antonio degli Abati for the Benedictine monks (who did not join the Cassinese Congregation) of San Giovanni di Verdara, Padua. Here, monk scholars are represented along the walls. Green is not sure of the identity of the female allegorical figures above, but he suggests Virtues and Liberal Arts, and this would fit the total number of 14. The end walls seem to have been remodeled, and the fresco decoration is lacking.

58. Hans Küng, *Justification: The Doctrine of Karl Barth and a Catholic Reflection,* trans. from German, New York, 1964, 102.

59. See N. Ivanoff, "Sculture e pitture dal Quattrocento al Settecento," in *La Basilica di Santa Giustina: Arte e storia,* Castelfranco Veneto, 1970, 167–345, and Cooper, 1990, 146ff.; see also G. Fiocco, "Un affresco di Bernardo Parenzano," *Bollettino d'Arte,* XXV, 1931–32, 433–39.

60. More penetrating studies are available with regard to Giotto's Scrovegni cycle and in such a contribution as J. Baschet, *Lieu sacré, lieu d'images: Les fresques de Bominaco (Abruzzes, 1263): Thèmes, parcours, fonctions,* Paris and Rome, 1991 (with references to other studies).

61. This seems to apply to Hans Belting's book on Assisi: *Die Oberkirche von San Francesco in Assisi: Ihre Dekoration als Aufgabe und die Genese einer neuen Wandmalerei,* Berlin, 1977. The author, as a basis for his interpretations, postulates a "Kontroverstheologie," which must be considered a historical misconstruction, and sees the decorations as a kind of reparative demonstration of loyalty to Rome; for this, see S. Sinding-Larsen, *Iconography and Ritual: A Study in Analytical Perspectives,* Oslo, 1984, 128f.

62. Gargan, 1978, 68, n. 7.

63. O'Gorman (1972, 68) illustrates another case of representing Order members, or at least scholars, in their studies, specifically late-15th-century frescoes along the walls of the library of the "white Benedictines" (not of the Cassinese Congregation whose habits are black) at San Giovanni di Verdara in Padua (fig. 50). Also at San Barnaba, Brescia, an Augustine Hermit monastery, a room that may have served as a library was decorated in fresco in the late 15th century, with portrait tondi (43, figs. 20–23). See also Green, 1991, 116–19.

64. Ibid.; see also Green, n. 57 above.

65. M. Salmi, *L'abbazia di Pomposa,* Rome, 1963.

66. Sinding-Larsen, 1974, 73ff., pls. LXXXIV, LXXXV.

67. C. Hahn, "Picturing the Text: Narrative in the Life of the Saints," *Art History,* XIII, 1, March 1990, 1–33.

68. G. Prevedello, "Cenni sul monacesimo padovano dei secoli XVI–XVIII," in A. de Nicolò Salmazo and F. G. B. Trolese, *I benedettini a Padova e nel territorio padovano attraverso i secoli,* exh. cat., 1980, 121ff., esp. 132f.; and M. P. Billanovich, "Una miniera di epigrafi e di antichità: Il chiostro maggiore di S. Giustina a Padova," *Italia medioevale e umanistica,* XII, 1969, 197–239; cf. also A. de Nicolò Salmazo, "Bernardino Parenzano e le storie di San Benedetto nel Chiostro Maggiore di S. Giustina," in de Nicolò Salmazo and Trolese, 89–120.

69. See the catalogue by A. de Nicolò Salmazo, in de Nicolò Salmazo and Trolese, 1980, nos. 40–59, 272ff. This, however, does not give a complete description, so we follow that of Girolamo da Potenza, in his *Elucidario et vero ritratto . . . ,* written between 1615 and 1619, in the MS B.P. 4898 in the Biblioteca Civica, Padua.

70. See chap. III.2 and nn. 22–23 above.

71. For a list of the 70 monasteries belonging to the Congregation of Santa Giustina in the years 1409–1520, see Trolese, 1991, 643–44.

72. M. L. Madonna, "La biblioteca: Theatrum mundi e theatrum sapientiae," in B. Adorni, ed., *L'Abbazia benedettina di S. Giovanni Evangelista a Parma,* Parma, 1979, 177–94.

73. In a simplified transcription the verb has the form "tserephu," but the rest of the inscription is hard to read (and may have been damaged and incorrectly restored). Careful scanning of the Hebrew Bible with the help of Samuel Bagster's *The Englishman's Hebrew and Chaldee Concordance of the Old Testament* (reprinted in London in the 1970s or 1980s without a date) has not enabled us to locate the reference (if it is biblical at all).

74. For a brief account of Tradition, the significance of

this term, and its role in the Church, with bibliography, see Sinding-Larsen, 1984, 16–19.

75. See de Nicolò Salmazo, 1980, 89–120, for illustrations. A summary of technique, losses, and condition of the cycle is given on pp. 116–20. Often called frescoes, the paintings are described (p. 116) as "pitture a tempera condotte su una leggera preparazione bianca sulla quale i colori sono applicati a velatura nelle prime stesure e a mezzo corpo nelle ombre e nei lumi." Some of the then best-preserved sections were removed in the early 19th century; others were covered in white during the same period.

76. For a penetrating analysis of some of the principles behind hagiographic narratives, see Hahn, 1990, 1–13.

77. This last scene is on the organ shutters by Zelotti, originally in the church at Praglia and now in the Museo Civico, Padua.

V
The Benedictine Order and the Catholic Reform

1. Nevertheless, under the title *The Counter Reformation* (London 1968, repr. New York, 1979), A. Dickens does give an articulate account not only of the combative anti-Protestant Catholic culture, but also of earlier reform efforts within the Roman Church.

2. Küng, 1964.

3. For Cusanus, see R. Haubst, *Die Christologie des Nikolaus von Kues,* Freiburg, 1956, 9 and n. 28. For Pius II, see idem, "Der Reformentwurf Pius' II," *Römische Quartalschrift,* XLIX, 1954.

4. For a full description of the reform of Barbo, see Trolese, 1983, esp. chap. 1, "La riforma Benedettina di S. Giustina nel quattrocento," 139–74.

5. *Paradiso,* 22:74. See P. Hawkins, "'By Gradual Scale Sublimed': Dante's Benedict and Contemplative Ascent," in *Monasticism and the Arts,* ed. T. G. Verdon, Syracuse, 1984, 255–69. The passage pointed out on p. 264 is *Par.* 22:73–96.

6. See G. Penco, O.S.B., *Storia del monachesimo in Italia dalle origini alla fine del Medio Evo,* Rome, 1961, for a description of the decadent state of the Order before the reform (pp. 324–37) and a description of the development of the reform (pp. 337–59). On relations to the University of Padua, see F. L. Maschietto, *Benedettini professori all'Università di Padova (secc. XV–XVIII): Profili biografici,* Cesena and Padua, 1989.

7. T. Leccisotti, "La congregazione benedettina di S. Giustina e la riforma della Chiesa al secolo XV," *Archivio della R. Deputazione Romana di Storia Patria,* LXVII–LXVIII, 1944–45, 453–68: "La congregazione de observantia S. Giustinae era un modello e un mezzo naturale della riforma, intravista ed ideata da Eugenio IV" (462).

8. Pivetta, 1831, 18. See also Trolese, 1983, 150, and n. 10 below.

9. J. Gill, S.J., *The Council of Florence,* Cambridge, 1961, 228f., 238, 243, 253. For example, in his address to the Greek synod in Florence in 1439, Georgios Scholarius,

appointed by the Greek emperor, called the Greek theologians "men of no great capacity to vie with the Latins in theology and philosophy, owing to the sad state of our affairs, because of which those in the highest positions attain to just so much of theology and philosophy as merely not to seem utterly uneducated. . . ."

10. Trolese, 1983, 150. Trolese's book is fundamental to an understanding of the Reform of the Benedictines of the Congregation of Sta. Giustina and its relationship to other developments in the Church. Trolese provides the essential bibliography, bibliography from 1908 through 1982, *fonti,* some documents, and a summary of Barbo's reform (pp. 139–228). Trolese builds on his work of 1983 in his paper of 1985, for which see Trolese, 1991, 626–44 (list of abbeys in the Cassinese Congregation on 643–44). See also C. Carpanese, "Cenni storici dal 1448 al 1980," in Carpanese and Trolese, eds., 1985, 17–28, esp. 17–21.

11. Collett, 1985.

12. Ibid., 77ff.

13. Ibid., 83–86, citing writings of Teofilo Folengo dating from the 1520s. Folengo joined the Cassinese monastery at Brescia in 1509 and left it in 1525, but Collett stresses that the ideas eloquently expressed in Folengo's poetry were common in the Congregation.

14. Ibid., 86f. Collett emphasizes the complexities of the debate of the 1520s in the Congregation: familiarity with St. Paul; stimulus from the writings of Luther, yet reliance, for example, in affirming free will, on writers such as Chrysostom and John Cassian, dear to Benedictines since their beginnings. See also chaps. III and VII here.

15. Collett, 1985, 138ff.

16. Ibid., 157ff.

17. S. Tramontin, "Venezia tra riforma cattolica e riforma protestante," in *Storia religiosa del Veneto,* I, *Patriarcato di Venezia,* ed. S. Tramontin, Padua, 1991, 93–130, 113: *"Il beneficio di Cristo . . .* costituì uno dei *best-sellers* del Cinquecento. Se, come osserva giustamente il Caponetto, ultimo curatore dell'opera, pare esagerata la cifra data dal Vergerio di 40,000 copie stampate e vendute nella sola Venezia in pochi anni, resta il fatto che la sua diffusione è attestata in tutta Italia, dai monasteri e conventi alla corte medicea e alle accademie, dallo scrittoio dei letterati alla casa della gente semplice che sapeva appena leggere e scrivere e fu anche per questo che la Curia romana si affrettò a includerlo nell'Indice dei libri proibiti quando questo nel 1556 fu steso per la prima volta."

18. Jedin, I, 1951, 296.

19. Tramontin, 1991, 113–14.

20. Collett, 1985, 186; chap. 9, "The Crisis at Trent," 186–212.

21. Ibid., 88–94, particularly concerning the role of the Cassinese scholar Isidoro Chiari in relation to Bishop Matteo Giberti of Verona and Gregorio Cortese during the 1520s and 1530s and scholarship focused on the Bible and the Greek Fathers, especially Chrysostom.

22. Ibid., 1985, 119ff.

23. Ibid., 122ff.

24. M. Conti, O.F.M., *La missione degli Apostoli nella regola francescana,* Genoa, 1972, passim.

25. Collett, 1985, 121f. Collett goes on to point out that among the many admirers of Chrysostom in the period only the Benedictines seemed to use him as a theological teacher, a model for arguing the importance of both grace and works.

26. Ibid., 130.

27. Ibid., 128–31.

28. Ibid., 130.

29. D. Cantimori, *Eretici italiani del Cinquecento: Ricerche storiche,* Rome, 1939, repr. Florence, 1967. There are also numerous references to additional sources and literature in Jedin's volumes on the Council of Trent. "Daß Theologen wegen Häresieverdacht belangt wurden, war wenn nicht gerade an der Tagesordnung, so doch keine seltenheit. . . . Der Anstoß kam nicht nur durch Predigten [a subject Jedin treats at some length] . . . sondern auch den Besitz verbotener Bücher . . . Zumal die junge Generation war wie stets für neue Ideenaufnahmen bereit . . ." (Jedin, III, 1970, 8f.).

30. Jedin, I, 1951, 294f.: "In ganz Europa hatten sich während der 1530er Jahre Theologen und Laien in die Heilige Schrift und in die Väter, insbesondere in Paulus und Augustinus vertieft und an sich erlebt, was Sünde und Gnade, Erlösung in Christus und *Rechtfertigung durch den Glauben* an ihn sind [our emphasis]. Alle wollten sie das Wort hören . . . gemeinsam war ihnen die innere Ergriffenheit durch die tiefste Frage ihrer Zeit. Die 'Religion der Rechtfertigung aus dem Glauben' war nicht mehr ein in Deutschland ausgefochtener Kirchenstreit, sondern ein Anliegen des europäischen geistes. . . ."

31. C. de Fede, "Tipografi, editori, librai italiani del Cinquecento coinvolti in processi di eresie," *Rivista di Storia della Chiesa in Italia,* XXIII, 1969; cited by Jedin.

32. F. Lauchert, *Die italienischen literarischen Gegner Luthers,* Freiburg, 1912; cited by Jedin ("behandelt Leben und Schriften von 66 Theologen").

33. Collett, 1985, 87.

34. For Siculo, see Jedin, III, 1970, 9, and Cantimori, 1967, 57ff. and passim. Also Collett, 1985, chap. 10, "Giorgio Siculo: Monastic Doctrine Exaggerated," 213–45.

35. G. Fragnito, "Il Cardinale Gregorio Cortese (1483–1548) nella Crisi religiosa del cinquecento," *Benedictina,* XXXI, fasc. I, 1984, 79–134. Fragnito (pp. 82–83) notes that Cortese's election as Cardinal in 1542 was seen by Cardinal Pole as "la operation del spiritu" *[sic],* and these words (based on a letter dated 1542) suggest the closeness of this group of reform-minded clergy in the Church: "Appena giunse la notizia della promozione del Cortese, da Bologna, dove si trovava come legato, Contarini inviò a San Benedetto a rallegrarsi con l'amico il fratello Tommaso e Galeazzo Fiorimonte, mentre il cardinale Gonzaga visi recava da Mantova, ed il Giberti da Verona."

36. Jedin, I, 1951, 335ff., 339f., 351, 365. Elected Cardinal by Paul III, Cortese also was called to participate in a commission set up to support the pope's policy against the emperor: against "Ein vom Kaiser beherrschtes oder doch ihm willfähiges Konzil" (Jedin, I, 383; see also 398). For Contarini, see G. Fragnito, "Bibliografia contariniana," in F. Cavazzana Romanelli, ed., *Gaspare Contarini e il suo tempo, Atti del convegno di studio, Venezia, 1–3 marzo 1985,* Venice, 1988, 255–66; and E. Gleason, *Gasparo Contarini: Venice, Rome, and Reform,* Berkeley, 1993.

37. Recent studies of this distinguished group are found in the acts of the Contarini congress, ed. Cavazzana Romanelli, 1988. See esp. the contributions of S. Tramontin, "Profilo di Gasparo Contarini," 17–38; G. Fragnito, "Gasparo Contarini tra Venezia e Roma," 93–124; and M. Massa, "Gasparo Contarini e gli amici, fra Venezia e Camaldoli," 39–92.

38. On Benedictine scholarship of the 1520s, see Collett, 1985, 102–11.

39. Gregorio Cortese declared himself "molto affezionato a quell'opera" (Jedin, I, 1951, 566, n. 39). Gropper's *Enchiridion* gained such a popularity that within two years, three editions of it had been published (Jedin, I, 298).

40. Jedin, II, 1957, 141. Contrasted by Caetani's orthodox formula "de fide et operibus": only through "good works," including, necessarily and fundamentally, the sacraments, will "faith" be effective (ibid.).

41. See Jedin, IV, 1975, vol. i, 168 and 334 (n. 34).

42. It is claimed "Mit Recht . . . daß im Enchiridion manche Lehren der Scholastik nicht erwähnt, während manche andere, von den Protestanten verteidigte Sätze stillschweigend herübergenommen würden . . . so verteidigt Gropper wiederholt den katholischen Satz, daß die guten Werke das ewige Leben verdienen können . . . ; aber durch die Annahme des sog. Spezialglaubens stötzt er den ersten satz in gewisser Beziehung wieder um. Ja, sogar der Solafideslehre vermag er eine scheinbar katholische Deutung zu geben . . ." (W. van Gulik, *Johannes Gropper (1503 bis 1559): Ein Beitrag zur Kirchengeschichte Deutschlands, besonders der Rheinlande im 16. Jahrhundert,* Freiburg, 1906, 53).

43. Jedin, I, 1951, 298. Nevertheless, Paul IV called Gropper into the College of Cardinals.

44. Jedin, IV, 1975, vol. i, 18f.: ". . . das Verbot aller von protestantischen Druckern veröffentlichten Bibel- und Väterausgaben beraubte die katholischen Gelehrten ihres wissenschaftlichen Rüstzeugs: Seripando, damals Erzbischof von Salerno, mußte sich eine nichindizierte Bibelausgabe in Rom besorgen lassen, weil alle in seinem Besitz befindlichen Ausgaben unter das Verbot fielen."

45. E. Gleason ("Le idee di riforma della Chiesa in Gasparo Contarini," in Cavazzana Romanelli, 1985, 125–46) stresses Contarini's openness to exchange of ideas and his opposition to the use of force in opposing heresey, citing, for example, letters in which he (writing from Madrid in 1525) speaks against the Spanish Inquisition (129ff.). See also Gleason, 1993, particularly chap. 3, "Venetian Reformer at the Roman Court," 129–85, and bibliography.

46. Jedin, I, 1951, 298.

47. See chap. VI.

48. F. Clark, S.J., *Eucharistic Sacrifice and the Reformation,* 2nd ed., Oxford, 1967, 287.

49. A. Duval, *Des sacrements au Concile de Trente,* Paris, 1985, 118ff. For Eck, see E. Iserloh, *Die Eucharistie in der Darstellung des Johannes Eck. Ein Beitrag zur vortridentinischen Kontroverstheologie über das Messopfer,* Münster, 1950.

50. St. Benedict, *Rule,* 43:1–3: "Ad horam divini Officii, mox auditus fuerit signus . . . summa cum festinatione curratur. . . . Ergo nihil Operi Dei praeponatur."

51. Denzinger-Schönmetzer, *Enchiridion,* nos. 1667ff.; Duval, 1985, 151ff. Connected with this is, of course, confession.

52. See Duval, 1985, chap. 4 on confession.

53. ". . . unde in ipsa justificatione cum remissione peccatorum haec omnia [the gifts of Christ and Holy Spirit] simul infusa accipit homo per Jesum Christum, cui inseritur, fidem, spem, et charitatem: nam fides, nisi ad eam spes accedat et charitas, neque unit perfecte cum Christo, neque corporis ejus vivum membrum efficit: qua ratione verissime dicitur: Fidem sine operibus mortuam et otiosam esse" (Denzinger-Schönmetzer, *Enchiridion,* nos. 1530–31).

54. Duval, 1985, 118ff.; and Iserloh, 1950; references in Sinding-Larsen, 1974, 116; and idem 1990, 38, n. 4. Trent: "Nemo audeat negari missam, quo nomine oblationem hanc exprimere communi consensu consuevit Ecclesia, esse opus bonum"; Duval: "La messe est une oeuvre bonne, *'opus bonum'* . . . parce qu'elle est oeuvre du Christ . . ."(ibid.).

55. Küng, 1964, 8. "Luther and the younger Melanchthon exaggerated when they saw in Paul nothing other than a teacher of justification. And none of the Gospels, not any of the other New Testament writings, are easy to harmonize with Pauline teaching on justification; the problem is not only with the first century, just as later the entire Church and the theology of the East, knew nothing of an explicit theology of justification. Justification became a burning issue only with the Reformation, but even then, for example in Calvin, it was not unqualifiedly central. Side by side with any Protestant theology of justification it had always been customary—and this was true for Luther too—to develop a theology of sanctification. And a third element would have to be added as well—a theology of vocation, the special concern of the Eastern Church."

56. Küng, 1964, 107. Küng also points out that the Council of Trent spent seven months on the doctrine of Justification and notes that Cardinal Pole, who was the papal legate, insisted that the participants read the reformers' writings impartially.

57. Cf. Rahner's warning about the "vicious circle" even in the doctrinal compilation of Denzinger's *Enchiridion:* any specific choice of material from the decrees and the very long-winded and many-leveled debates preceding their promulgation is doomed to be to some extent subjective (Rahner quoted by Küng, ibid., 109). Typically, Karl Barth opens up a major polemic against the Council of Trent's elaboration of the role of "good works" for Justification (ibid., chap. 15).

58. Ibid., 1964, 22.

59. The debates and decree on Justification are treated at length in Jedin, II, 1957, 139–64, 201–20, 238–64.

60. Session VI, January 1547, canon 32: It is anathema to state that a justified person's good works are divine gifts merely and not a result of that man's efforts, or of the good works of whoever is justified: "Si quis dixerit, hominis iustificati bona opera ita esse dona Dei, ut non sint etiam bona ipsius iustificati merita, aut ipsum iustificatum bonis operis, . . . anathema sit" (Denzinger-Schönmetzer, *Enchiridion,* no. 1582).

61. Session VI, January 1547, against the Sola Fide principle, where Justification is connected with the efficacy of the Sacrament: chap. 9: "Contra inanem haereticorum fiduciam" (Denzinger-Schönmetzer, *Enchiridion,* nos. 1533, 1534).

62. Clark, 1967, 103f.

63. Ibid., 105f.

64. References in Sinding-Larsen, 1984, 18f. and 198f. (bibliography on "Tradition"). See also Küng, 1964, esp. 111–16 on the interrelationship of Scripture and Tradition and the role of the Holy Spirit in this.

65. Session XXV of the Council. Denzinger-Schönmetzer, *Enchiridion,* no. 1823, 3 December 1563: "Decretum de invocatione, veneratione et reliquis Sanctorum, et sacris imaginibus: Imagines porro Christi, Deiparae Virginis et aliorum Sanctorum in templis praesertim habendas et retinendas, eiusque debitum honorem et venerationem impertiendam, non quod credatur inesse aliqua in iis divinitas vel virtus, propter quam sint colenda, vel quod ab eis sit aliquid petendum, vel quod fiducia in imaginibus sit figenda, veluti olim fiebat a gentibus, quae in idolis spem suam collocabant: sed quoniam honos, qui eis exhibetur, refertur ad prototypa, quae in illae repraesentant: ita ut per imagines, quas osculamur et coram quibus caput aperimus et procumbimus, Christum adoremus, et Sanctos, quorum illae similitudinem gerunt, veneremur. [Advice to the bishops to use images in their teaching follows, in no. 1824:] Illud vero diligenter doceant Episcopi, per Historias mysteriorum nostrae redemptionis, picturis, vel aliis similitudinibus expressas, erudiri, et confirmari populum in articulis Fidei commemorandis, et assidue recolendis; tum vero ex omnibus sacris imaginibus magnum fructum percipi, non solum quia admonetur populus beneficiorum, et munerum, quae a Christo sibi collata sunt, sed etiam, quia Dei per sanctos miracula, et salutaria exempla oculis fidelium subjiciuntur, ut pro iis Deo gratias agant, ad sanctorumque imitationem vitam, moresque suos componant, excitenturque ad adorandum, ac diligendum Deum, et ad pietatem colendam."

66. *Catechismus ex decreto Concilii Tridentini ad Parochos, Pii V Pont Max. jussu editus,* Rome, 1566; English trans. (595 pages): J. A. McHugh, O.P., and J. C. Callan, O.P., *Catechism of the Council of Trent for Parish Priests Issued by Order of Pope Pius V,* New York, 1923.

67. See *Sacrosanctum Concilium Tridentium cum citationibus ex utroque Testamento, Juris Pontificii Constitutionibus, aliisque S. Rom. Ecc. Conciliis,* Padua, 1753, Session XXV, cap. i–iii, 288–96.

68. See H. O. Evennett, "Three Benedictine Abbots at the Council of Trent, 1545–1547," *Studia Monastica*, 1959, 344–77. Their presence is listed in J. D. Mansi, *Sacrorum conciliorum*, XXXIII, Paris, 1902, Sessions II through VII, for 1546 and 1547, 17–49. At Session XIII, in 1551, another Benedictine abbot was present: Marco of Brescia (Mansi, ibid., 90). For Don Marco's ardent writings, see Collett, 1985, 251–52.

69. Evennett, 1959, 377.

70. Ibid., 347–49.

71. A review of the lists in Mansi, *Sacrorum conciliorum*, XXXIII, confirms this. G. Alberigo, *I vescovi italiani al concilio di Trento (1545–47)*, Florence, 1959, 55: "Tra tutti i vescovi italiani, e non solo veneti, furono rarissimi in quest'epoca i casi di dottori in teologia, o eventualmente in filosofia; la discreta percentuale di graduati era composta, nella quasi totalità, da dottori in diritto canonico o nel classico <utroque jure>."

72. Ibid.: "Le conseguenze di tutto ciò sono ben visibili nell'esame delle discussioni dogmatiche, dove molto spesso i vescovi italiani si espressero con una terminologia canonistica e affrontarono i problemi secondo schemi di natura giuridica, che sorprendono e lasciano perplesso il teologo moderno." We might add the observation that all the conclusive Council decrees are formulated negatively as statements of proscription: whoever says such and such, is anathema.

73. Evennett, 1959, 343ff.

74. Collett, 1985, 187f.

75. Ibid., 201 and n. 67, quoting from Massarelli's diary.

76. Again as inferred from Mansi's lists. Thus, in 1563, the nations were represented as follows: "Itali 187, Galli 26, Hispani 31, Germani 2" (*Sacrorum conciliorum*, XXXIII, col. 214).

77. J. D. Mansi, *Concilium Tridentinum*, Pars Sexta . . . 1562–1563, ed. S. Ehses, Freiburg, 1924, 925.

78. Evennett, 1959, 353–54. On the issues related to translations of Scripture, Chiari argued against exclusive authority for St. Jerome's Vulgate, pointing out that Jerome himself denies that any interpreter of the Bible had spoken with the Holy Spirit! The Cassinese abbots also voted for Pole's unsuccessful proposal for three authoritative translations of the Bible (in Hebrew and Greek as well as Latin). Chiari's support for requiring biblical lectureships in all cathedrals and monasteries was quite warm, as was the Dominican Fra Domingo de Soto's opposition. See also Collett, 1985, 194–95.

79. Evennett (1959, 357–58) refers to Isidoro's publication in 1548 of the text of his remarks, with which Massarelli's briefer notes are consistent. Despite calls for simple language and criticism of Scholastic elaboration, Chiari's view is consonant with traditional Catholic theology, stressing the need for continuing human effort, and repentance (not a second baptism) after a fall from grace.

80. Ibid., 360–66.

81. Mansi, *Sacrorum Conciliorum*, XXXIII, col. 208 (Session XXV, 3–4 December 1563).

82. Jedin, III, 1970, 8f.; see also Cantimori, 1964, passim.

83. Jedin (II, 1957, 22) discusses his position under the heading: "Gab es also auf dem Konzil eine Gruppe von Kryptolutheranern?" He points out that the term "Lutheran" was used in a rather loosely defined manner; nevertheless, general experience should teach us that religious, social, and political attitudes are not consistently determined by the quality of semantics but by "marketing" values. See also Luciano degli Ottoni's role in the debate on "Faith" as recorded by Jedin, II, 211, 243 (cited along with another Benedictine abbot: "Nach Luciano ist der Gerechte sogar verpflichtet, zu glauben, daß das ewige Leben erlangen werde"). Bishop Angelo Massarelli, Secretary of the Council in the first Trento period, accused Luciano degli Ottoni of explaining the doctrine of Faith with the help of "the arguments of the Lutherans" (Jedin, II, 245f.).

84. Collett, 1985, 186.

85. Ibid., 189–91.

86. Leccisotti, 1944–45, 458–62, 467–68.

87. "Jn die Ascensionis Domini nostri jesu christi. . . . [omissis] Non cantatur etiam Missa in nostra Ecclesia propter indulgentiam plenariam, ne jmpediatur pia mens populorum confluentium ad Altare maius, in quo creditus esse corpus beatj Marcj Euangelistae, licet olim multo plures confluerent ad indulgentiam consequendam, etiam ex remotioribus locis et prouincijs, sed hodie rapuerunt corda fidelium et ardor jlle spiritus ellanguit, ut uix pauci credant indulgentijs, propter errorem lutheranorum hereticorum, qui uigent in presens, propter peccata nostra, sed Deus ex alto respiciens oues suas dissipatas, miserebitur eis, purgens Ecclesiam suam et jlluminans, et auferens omnes errores à cordibus eorum qui minime resistere uolent spiritui sancto" (Biblioteca Marciana, Venice, Bibl. Marc., Cod. lat. III, 172, Coll. 2276, Rituum caeremoniale, fol. 15).

S. Sinding-Larsen is preparing a publication of the Latin part of this document (in a forthcoming volume of Institutum Romanum Norvegiae, Acta: *The Burden of the Ceremony Master: Image and Action in San Marco, Venice, and in an Islamic Mosque*).

88. L. Tacchella, "Il processo agli eretici veronesi Matteo e Alessandro degli Avogari nell'anno 1567," *Studi storici veronesi Luigi Simeoni*, XXX–XXXI, Verona, 1980–81, 308.

89. Alberigo (1959, 83) indicates that the documents are in the Archivio Vescovile of Padua and cites other sources (n. 2). Documents from 1560 onward attest to "considerable disagreement among Jesuits, both in theology and philosophy, about what was safe and what wasn't," and a book, *Ratio studiorum*, of 1586—years after the close of the Council of Trent—tried to "settle . . . the difficult question of the choice of opinions" (M. Sharratt, *Galileo: Decisive Innovator*, Cambridge, 1996, 39, with Jesuit bibliographical references). For the Jesuits as one element among many, see E. Aleandri Barletta, "La Campagnia di Gesù," in *Aspetti della riforma cattolica e del Concilio di Trento*, 1964, 74: "La Compagnia di Gesù non fu, come alcuni sostengono 'organo principale della Chesa della controriforma' . . . ma, soprattutto nel '500, essa rappresentò, insieme con tutti gli altri ordini religiosi nuovi e rinnovati, il lievito gettato in una pasta divenuta inerte."

90. R. Bellarmini, *De controversiis christianae fidei,* 4 vols., Milan, 1721, I, cols. 776f.

91. Ibid., II, col. 554.

92. Ibid., IV, passim.

93. Ibid.

94. Collett, 1985, 249–50.

95. Ibid., 246–50 on the codex. Collett (250–60) comments on other examples of writings in the Congregation during the 1550s and 1560s that exemplify the shift toward an emphasis on piety, although he also offers examples of continuity of the traditional Cassinese teachings.

96. Leccisotti, 1944–45, 458–59.

97. Ibid., 466–68: "per opporsi agli sforzi dei protestanti che cercavano di svisare il testo dei Padri."

VI
The Texts of the Fathers

1. Gill, 1961, 312.

2. Ettlinger, 1965, 32ff.

3. For the reference to the choir stalls, see Cooper, 1990, 146f.

4. For his presence at Trent: Mansi, *Sacrorum conciliorum,* XXXIII, col. 208 under Session XXV, December 1563. For his service in the commission: Leccisotti, 1944–45, 467.

5. Penco, 1988, 326: "nel quale [quadro] vi sia dipinto a tutta perfezione l'arbore del patriarca san Benedetto giusta il dessegno così compilato dal Rev. P. Don Arnaldo monaco di questa Congregazione, al presente nel monastero di San Zorzi Maggiore di Venezia, con tutte quelle figure per ordine come vanno."

6. S. Sinding-Larsen, "Paolo Veronese a Palazzo Ducale," one of three introductory articles for *Paolo Veronese: Disegni e dipinti,* exh. cat., ed. A. Bettagno, Venice, 1988, 23–29; and idem, 1990, 36–41. See also n. 34 below.

7. Y. Congar, "Langage des spirituels et langage des théologiens," in *La mystique rhénane, Colloque de Strasbourg, 16–19 mai 1961,* ed. J. Dagens, Paris, 1963, 16.

8. M. Grabmann, *Die Geschichte der katholischen Theologie seit Ausgang der Väterzeit,* Freiburg, 1933, repr. Darmstadt, 1961, 123. Anselm's writings apparently were well known in the Congregation of Santa Giustina, since there are several entries under his name in the 15th-century inventory. See Cantinoni Alzati, 1982, nos. 192, 326, 347, 569, 874, 1329, and addenda.

9. Peter the Chanter, *De oratione et speciebus illius* (introduction, comments, and critical text publication: R. C. Trexler, *The Christian at Prayer: An Illustrated Prayer Manual Attributed to Peter the Chanter [d. 1197],* Binghamton, N.Y., 1987). Peter also has interesting comments on the use of images (see esp. 50f.). Nine medieval MS copies are extant, two of them in the Veneto (Padua and Venice): Trexler, 68f., for Padua and Venice.

10. For the *devotio moderna* and the *imitatio Christi* in the context of the Congregation of Santa Giustina, see Trolese, 1991, 640f. Nine copies are listed in the 15th-century

inventory of the Santa Giustina library; see Cantinoni Alzati, 1982, nos. 116, 410, 622, 1051, 1066, 1138, 1264. The term *imitatio Christi* also was in traditional use within the Roman Church in the sense of a sacramentally informed and sustained effort at following Christ's example.

11. S. Benko, *The Meaning of Sanctorum Communio,* Studies in Historical Theology, III, London, 1964, 112.

12. See also Calati, 1984.

13. Lodovico Barbo, *Ad monachos S. Iustinae de Padua modus meditandi et orandi per Reverendum Dominum Lodovicum [Barbo] Episcopum Tarvisinum compositus,* ed. with parallel text in Lodovico Barbo, O.S.B., "Metodo di pregare e di meditare," *Scritti monastici editi dai Monaci Benedettini di Praglia,* IV (ital.-lat.), serie ascetico-mistica III, Treviso, n.d. (but imprimatur of 1924). Our references are to this parallel edition.

14. Barbo, 68: "Post quem ad secundum ascendetis gradum orationis scilicet meditationis. Meditatio hoc modo itaque fit non verbis, sed corde, intellectu et affectu oratur. Cum enim ante intellectum repraesententur opera Dei et ordo creaturarum et pulcritudo earum, intellectus perconctatur [percunctatur?], gaudet et rapitur in amore Dei. . . ."

15. Ibid., 70: "coelum ita stellis sole et lunam decoratum, terram floribus fructibus bestiisque innumerarum specierum. . . ." For other religions, the Quran may be cited as relying extensively on nature's beauty for depicting the glory of God. Trolese (1991, 641) notes: "La spiritualità del Barbo, alla quale si nutrono poi i suoi seguaci, è tributaria oltre che dei classici autori monastici, quali s. Gregorio Magno, s. Bernardo, anche del francescanesimo, dei circoli domenicani veneziani seguaci di s. Caterina da Siena, con un influsso anche dal mondo orientale [Trolese gives references here], nei cui riti si riavvisava un riverbero della chiesa antica [reference in Trolese]."

16. Barbo, 100: "Die autem Sabbato meditare, et finge te cum tuo gloriosissimo Jesu descendere ad infernum, et finge te videre maximam splendorem procedentem ex gloriosissimo Jesu et vide Adam, Evam, Abraham, Isaac et Jacob, Moysem, David. . . ."

17. Ibid., 90: "Post haec finge te videre ipsum Dominum Jesum duci ligatum. . . ."

18. A very useful reevaluation of recent scholarship related to religious imagery in "devotional" contexts is J. Hamburger, "The Visual and the Visionary: The Image in Late Medieval Monastic Devotions," in *Viator: Medieval and Renaissance Studies,* XX, 1989, 161–82; also especially on the later fate of the Gregorian tradition concerning the use of images. See also K.-A. Wirth, "Von mittelalterlichem Bildern und Lehrfiguren im Dienste der Schule und des Unterrichts," in *Studien zum städtischen Bildungswesen des späten Mittelalters und der frühen Neuzeit,* ed. L. Grenzmann, Göttingen, 1983, 256–370.

19. As reviewed in chap. V. Earlier reform movements such as the *devotio moderna* had reacted against what they considered an exaggerated assembly of images verging on luxury and distracting from spiritual meditation; a typical case is the movement's action against the art collection at the female Cistercian convent of Wienhausen (north

Germany) in 1469: H. Appuhn, *Kloster Wienhausen,* Wienhausen, 1986, 46ff.

20. See chap. v.3, n. 65. We repeat the key lines and complete the quote: "Illud vero diligenter doceant Episcopi, per historias mysteriorum nostrae redemptionis, picturis, vel aliis similitudinibus expressas, erudiri et confirmari populum in articulis fidei commemorandis et assidue recolendis; tum vero ex omnibus sacris imaginibus magnum fructum percipi, non solum quia admonetur populus beneficiorum et munerum, quae a Christo sibi collata sunt, sed etiam, quia Dei per sanctos miracula et salutaria exempla oculis fidelium subiciuntur, ut pro iis Deo gratias agant, ad sanctorumque imitationem vitam moresque suos componant, excitenturque ad adorandum ac diligendum Deum, et ad pietatem colendam. Si quis autem his decretis contraria docuerit, aut senserit; anathema sit . . ." (Denzinger-Schönmetzer, *Enchiridion,* no. 1824).

21. For this, see S. Sinding-Larsen, *The Burden of the Ceremony Master: Image and Action in San Marco, Venice, and in an Islamic Mosque,* forthcoming in *Institutum Romanum Norvegiae, Acta.*

22. C. Hahn, "Icon and Narrative in the Berlin Life of St. Lucy (Kupferstichkabinett MS 78 A 4)," in R. Ousterhout and L. Brubaker, eds., *The Sacred Image: East and West,* Urbana (Ill.), 1995, 72–90, 178.

23. A very articulated and instructive account is found in J. Hamburger, "The *Liber miraculorum* of Unterlinden: An Icon in Its Convent Setting," in Ousterhout and Brubaker, 1995, 147–90. See also idem, "The Use of Images in the Pastoral Care of Nuns: The Case of Heinrich Suso and the Dominicans," *Art Bulletin,* LXXI, 1, 1989, 20–46.

24. A. D. Hedeman, "Roger van der Weyden's Escorial *Crucifixion* and Carthusian Devotional Practices," in Ousterhout and Brubaker, 1995, 194.

25. Hoffman cites some images in prints that are "examples of the type of popular devotional images in use as early as the 13th century and especially in vogue in the 15th-century centers of woodcut and engraving production. It is now clear that the Madonnas were commissioned directly by the monastery at Einsiedeln and that they were certainly original creations"; E. Warren Hoffman, "Some Engravings Executed by the Master E. S. for the Benedictine Monastery at Einsiedeln," *Art Bulletin,* XLIII, 3, 1961, 231–37.

26. For relations between images and texts, the literature is today almost unsurveyable; some observations in S. Sinding-Larsen, "Categorization of Images in Ritual and Liturgical Contexts," Ettore Majorana Centre for Scientific Culture, Erice, and Ecole des Hautes Etudes, Paris (in press in Italian and French versions); and idem, "Créer des images: remarques pour une théorie de l'image," in *L'image et la production du sacré,* ed. F. Dunand, J.-M. Spieser, and J. Wirth, Paris, 1991, 35–76.

27. "pingi solent absentia, quia non videntur: Deus autem licet sit praesens, tamen non videtur, ideo pingi potest, ac si abesset. . . . At imago Dei, et Trinitatis, ut a nobis pingitur . . . neque habetur pro Deo a nobis . . . sed ad per-

ducendum homines in aliquam Dei notitiam per analogicas similtudines" (Bellarmini, *De controversiis,* II, cols. 703 E–704 A). To St. Ambrose, for example, Christ is the image of God: "solus enim Christus est plena imago dei propter expressam in se paternae claretudinis unitatem." (See G. Francesconi, *Storia e simbolo: "Mysterium in figura": la simbolica storico-sacramentale nel linguaggio e nella teologia di Ambrogio di Milano,* Pubblicazioni del Pontificio Seminario Lombardo in Roma, Ricerche di Scienze Teologiche, XVIII, Brescia, 1981, 117. This monograph dedicates a chapter to each of the following terms: *mysterium, sacramentum, imago, similitudo, species, umbra, typus,* and *figura.*

28. Cantinoni Alzati, 1982; items by St. Ambrose listed in the 15th-century inventory of the library of Santa Giustina are nos. 2, 83, 380. Also see list on p. 189 showing that no. 2 was among the books read at mensa; pp. 192–93, reproducing a list including books of Ambrose then at the monastery of San Benedetto Po and being considered for transfer to Padua; appendix of manuscripts from Santa Giustina not included in the inventory.

29. J. F. Sowa, "Relating Diagrams to Logic," in *Conceptual Graphs for Knowledge Representation, Lecture Notes in Artificial Intelligence,* ed. G. W. Mineau, G. B. Moulin, and J. F. Sowa, Berlin, 1991, 1f.

30. For the visual factor in devotion and learning, see Hamburger, 1989a, 161–82; various contributions in H. van Os, ed., *The Art of Devotion in the Late Middle Ages in Europe 1300–1500,* Amsterdam, 1994; and, most especially, Wirth, 1983, 256–370.

31. Council of Trent, Session XIII, October 1551, cap. 4, "De Transubstantiatione" (Denzinger-Schönmetzer, *Enchiridion,* no. 1642).

32. Same session, Canon 11: "Si quis dixerit, solam fidem esse sufficientem praeparationem ad sumendum sanctissimae Eucharistiae sacramentum: anathema sit . . ." (Denzinger-Schönmetzer, *Enchiridion,* no. 1661).

33. Trent (Session VII, March 1547, Canon 4) stressed that the Eucharistic sacrament ranged over the others and that the sacraments are necessary for salvation: "Si quid dixerit, Sacramenta novae Legis non esse ad salutem necessaria, sed superflua, et sine eis aut eorum voto per solam fidem homines a Deo gratiam iustificationis adipisci, licet omnia singulis necessaria non sint; anathema sit" (Denzinger-Schönmetzer, *Enchiridion,* no. 1604).

34. Duval, Paris, 1985, 118ff.: "C'était bien, dans ce schéma, revendiquer face à Luther la légitimité de l'expression *opus bonum,* mais pour refuser en même temps de réduire cette oeuvre bonne à une activité propre des hommes, en quelque sorte étrangère au Christ. La messe est une oeuvre bonne, 'opus bonum,' . . . parce qu'elle est une oeuvre du Christ" (p. 199). For a contemporary case of an "opus bonum" reference in a non-liturgical context (Veronese's ceiling decoration of the 1570s in the Sala del Collegio), see Sinding-Larsen, 1990, 37–41. Hans Aurenhammer's misunderstanding of the issue (review in *Zeitschrift für Kunstgeschichte,* 2, 1992, 289f.) is of some relevance to the methodological problems concerning the general concep-

tion of the period, and so also the background for Praglia; his review may be summarily discussed here. Aurenhammer rejects without an argument the interpretation of the exact wording of the "mottos" on the Kassel drawing (partly quoted in the present book, p. 36) and the conclusions that (a) they reflect—also by choice of terminology—central themes that had been debated at the Council of Trent; and (b) they must have been formulated by an expert in theology (and not by Veronese; this was a main point of disussion). In order to underpin the idea that Veronese himself "invented" the inscriptions, Aurenhammer rejects, again without argumentation or references, the conclusion that "Beispiele der 'guten Werke' . . ." are involved in the inscriptions. His contribution is noteworthy and should be examined because he repeats the now old-fashioned view that the reinforcement of Catholic Tradition against the northern reformers is conceived historically merely as an "*einseitig anti-lutheranisch*-eucharistische Interpretation" (our emphasis). He seems to believe that the modern studies of the Catholic Reform take Luther and the reactions against his teachings as a starting point of the Catholic Reform movement, which in fact started in the 15th century.

35. J. A. Jungmann, "Die Kirche in der lateinischen Liturgie," in J. Daniélou and H. Vorgrimler, eds., *Sentire Ecclesiam: Das Bewusstsein von der Kirche als gestaltende Kraft der Frömmigkeit,* Freiburg, 1961, 185ff. The relevant Offertory text reads: "Suscipiat Dominus sacrificium de manibus tuis, ad laudem, et gloriam nominis sui, ad utilitatem quoquoe nostram, totiusque Ecclesiae suae sanctae."

36. See Duval, 1985, 45, with reference to the following Council teaching: "Declarat, hanc potestatem perpetuo in Ecclesia fuisse, ut in sacramentorum dispensatione, salva illorum substantia, ea statueret vel mutaret, quae suscipientium utilitati seu ipsorum sacramentorum venerationi, pro rerum, temporum et locorum varietate, magis expedire judicaret" (Denzinger-Schönmetzer, *Enchiridion,* no. 1728, Session XXI, 16 July 1562).

37. Duval, 1985, 53; Denzinger-Schönmetzer, *Enchiridion,* no. 1747.

38. The literature on this subject is enormous; an excellent summary in Jedin's section "[Die] Religiöse Bedeutung der Lehre vom Meßopfer," 1975, IV, i, 176f. Against the "autonomous" power of faith: "die Messe [war] nicht ein neues Opfer neben dem Kreuze, sondern dessen sakramentale Gegenwärtigsetzung . . . , daß sie in erster Linie das Werk Cristi ist, *unser* Werk nur, insofern wir 'durch, mit und in Christus als unserem Haupt tätig sind'" [Jedin quoting Erwin Iserloh].

39. Sinding-Larsen, 1984, 18f.; bibliography on "Tradition," 198f.

40. *Rule of St. Benedict,* 42:1–2. See also chap. II.

41. Ibid., 9:8.

42. E. M. Heufelder, O.S.B., "St. Benedikt von Nursia und die Kirche," in Daniélou and Vorgrimler, 1961, 176ff.

43. The decree on Penance was issued at Session XIV, November 1551 (Denzinger-Schönmetzer, *Enchiridion,* nos. 1667–93).

44. St. Gregory the Great, *Dialogues,* II, 92–94.

45. This text requires further study.

46. Vincenzo da Milano, *De maximis Christi beneficiis pia gratiarum actio,* Bibliotheca Apostolica Vaticana, MS Chigi I IV 148, fols. 66–86 (see app. 2). See also Collett, 1988, 255–59, for his discussion of this as a carefully written orthodox tract timed to address a crisis in the Congregation involving the brief presidency in 1567 of Don Andrea da Asolo, a sympathizer of Siculo.

47. "Si quis dixerit, sine praeveniente Spiritus Sancti inspiratione atque ejus adjutorio hominem credere, sperare et diligere aut paenitere posse, sicut oportet, ut ei iustificationis gratia conferatur, anathema sit" (Canon 3; Denzinger-Schönmetzer, *Enchiridion,* no. 1553).

48. The following editions are used: *Missale romanum,* Rome, 1949; *Beviarium romanum,* Malines, 1876.

49. "Patrata sunt haec mystice, / Paschae peracto tempore, / Sacro dierum circulo, / *Quo lege fit remissio"* [our emphasis] (J. Pascher, *Das liturgische Jahr,* Munich, 1963, 235).

50. "Ex omni gente cigitur / Graecus, Latinus, Barbarus, / Cunctisque admirantibus / Linguis loquuntur omnium. . . ."

51. "Iudea tunc incredula . . ." (Pascher, 1963, 241).

52. "Sed editis miraculis [or: Sed signis et virtutibus] / Occurrit, et docet Petrus, / Falsum profari perfidos/ Ioele teste comprobans."

53. "Deficiant peccatores a terra, et iniqui ita ut non sint. . . ."

54. Such as: "Iudaeei quoque, et proselyti, Cretes et Arabes: audivimus eos loquentes nostris linguis magnalia Dei" (repeatedly in the Breviary for the Pentecost period). The Missal for Pentecost Sunday has Acts 2:1–11, with conversion of peoples, for which see below.

55. Missal, Monday of the Pentecost Octave: "Spiritus Sanctus docebit vos, alleluja." Missal, Thursday of the Pentecost Octave: "Spiritu Domini replevit orbem terrarum, alleluja: et hoc continet omnia, scientiam habet vocis. . . ; Deus, qui hodierna die corda fidelium Sanctis Spiritus illustratione docuisti. . . ; Munera quaesumus, Domine, oblata sanctifica: et corda nostra Sancti Spiritus illustratione emunda."

56. E.g., "Opportet ut oderis in te opus tuum, et ames in te opus Dei."

57. "Fuerunt ergo quidam philosophi de virtutibus et vitiis subtilia multa tractantes, dividentes, definientes, ratiocinationes acutissimas concludentes, libros implentes, suam sapientiam buccis crepantibus ventilantes, qui etiam dicere auderent hominibus. . . ."

58. For this and the following, see J. Daniélou, S.J., *Bible et liturgie: La théologie biblique des Sacrements et des fêtes d'après les Pères de l'Eglise,* 2nd rev. ed., Paris, 1958, chap. 17, "Le huitième jour," 355–87, and chap. 19, "La Pentecôte," 429–48.

59. R. Haubst, *Die Christologie des Nikolaus von Kues,* Freiburg, 1956, 96ff. (section: "Christus die Fülle der Zeit"); 102, with n. 54: that with Cusanus "mitunter der 'achte Tag' die Vollendung oder vielmehr den Anbruch des neuen, ewigen Lebens in Gott nach dem Ablauf des irdisch-

zeitlichen Geschehens bezeichnet," with reference to St. Augustine: "Octava dies est dies nova et renovationis"; "Haec tamen septima erit sabbatum nostrum, cuius finis non erit vespera, sed dominicus dies velut octavus aeternus, qui Christi resurrectione sacratus est, aeternam non solum spiritus, verum etiam corporis requiem praefigurans." For Christ and "time," see also Haubst, 119.

60. For such two-way readings, see J. Baschet, "Logique narrative, noeuds thématiques et localisation des peintures murales: Remarques sur un livre récent et sur un cas célèbre de boustrophédon," in *L'emplacement et la fonction des images dans la peinture murale du Moyen-Age,* Saint-Savin, 1993; for a comparable case of two-way reading in the axis mosaics in San Marco, Venice, see S. Sinding-Larsen, "A Walk with Otto Demus: The Mosaics of San Marco, Venice, and Art-Historical Analysis," *Institutum Romanum Norvegiae, Acta,* series altera, VIII, 1992, 145–205.

61. "Si igitur audieris omnia quae prae praecepero tibi, et ambulaveris in viis meis et feceris quod rectum est coram me custodiens mandata mea et praercepta mea, sicut fecit David servus meus, ego tecum et aedificabo tibi domum fidelem, quomodo aedificavi David domum. . . ."

62. Bellarmini, *De controversiis,* IV, cols. 133 and 90, respectively.

63. *Concilii tridentini,* 119: Aleandro, "De convocando concilio sententia (ineunte anno 1537)."

64. They appear together at the side of Humilitas who kills Pride in manuscripts of the *Speculum virginum* from the 12th to the 14th century, including: Baltimore, Walters Art Gallery, MS 72, fol. 31r; London, British Library, Arundel MS 44, fol. 34r; Leipzig, University Library, MS 665, fol. 49r. See J. Seyfarth, ed., *Speculum virginum (Corpus Christianorum, Continuatio Mediaeualis,* V), Turnhout, 1990, fig. 5; see also Seyfarth's chart of subjects in extant MS versions on p. 134. An example of their appearance in conjunction with Virtues in wall decoration exists in the Baroncelli Chapel, Santa Croce, Florence, 1332–38 (see p. 93): Julian Gardner, "The Decoration of the Baroncelli Chapel in Santa Croce," *Zeitschrift für Kunstgeschichte,* XXXIV, 2, 1971, 89–113. In the *Speculum virginum,* IV, 151ff., we hear: "An ignoras, ut omittam milia feminarum sub lege uel sub gratia uires hosticas eneruantium, quid Iudith in Oloferne, quem dicere possumus totum infernum quasi qui nihil supernum habeat, quid Iahel in Sisara, Madianitarum principe fecerint, quae ualentia sexus infirmioris nihil aliud est, nisi quod humilitas semper preualet superbiae in quacumque sanctorum professione?" (Seyfarth, *Speculum virginum,* 103). We are grateful to Dr. Dorothy M. Shepard for her help with this material.

65. See Cooper, 1990, 142–44.

66. J. Lutz and P. Perdrizet, *Speculum humanae salvationis,* 2 vols., Mulhausen, Meininger, 1907–9, chap. XXX, verses 17ff., 75ff., respectively.

67. A. Wilson and J. Lancaster Wilson, eds., *A Medieval Mirror: Speculum humanae salvationis, 1324–1500,* Berkeley, 1984, 29.

68. St. Benedict's *Rule* (4:73) paraphrases the Bible: "If you have a dispute with someone, make peace with him before the sun goes down."

69. Judith and Jael also appear together in some prints of the Renaissance period. For example, they are grouped with Esther in a woodcut series by Hans Burgkmair of *Eighteen Worthies* (nine men and nine women) dated 1519. Judith appears alone as a heroine in many other prints. Jael is sometimes included in print series of the 16th century illustrating the "power of women" that include such figures as Delilah and Solomon's wives who trick men for less positive purposes. Lucas van Leyden's small woodcut series *Power of Women* of 1516/19 includes her. See H. D. Russell with B. Barnes, *Eva/Ave: Women in Renaissance and Baroque Prints,* exh. cat., National Gallery of Art, Washington, D.C., 1990), New York, 1990, 36–39, 155. See text and n. 64 above on manuscript illustrations of Judith and Jael as personifications of Humility.

70. One wonders if readings from the Book of Wisdom may have led to the convention of the Mary-centered image of Pentecost, for Wisdom is spoken of in the feminine and conflated with light, as is the Holy Spirit, for example, Wis. 7:7–14 (used for Robert Bellarmini's feast of May 13 in the Missal): "I called, and the spirit of wisdom came upon me, and I preferred her before kingdoms and thrones, and esteemed riches nothing in comparison of her. Neither did I compare unto her any precious stone, for all gold in comparison of her is as little sand, and silver in respect to her shall be counted as clay. I loved her above health and beauty, and chose to have her instead of light, for her light cannot be put out. Now all good things came to me together with her, and innumerable riches through her hands. And I rejoiced in them all; for this wisdom went before me, and I knew not that she was the mother of them all: which I have learned without guile, and communicate without envy and her riches I hide not . . ." (Missal, *St. Andrew's,* 1950 [pre-Vatican II], III, 281).

71. "Decretum de vulgata editione Bibliorum et de modo interpretandi s. Scripturam . . . ut nemo suae prudentiae innixus, in rebus fidei et morum, ad aedificationem doctrinae Christianae pertinentium, sacram Scripturam ad suos sensus contorquens, contra eum sensum, quem tenuit et tenet sancta mater Ecclesia, cuius est iudicare de vero sensu et interpretatione Scripturarum sanctarum, aut etiam contra unanimem consensum Patrum ipsam Scripturam sacram interpretari audeat, etiamsi huiusmodi interpretationes nullo umquam tempore in lucem edendae forent . . ." (Denzinger-Schönmetzer, *Enchiridion,* nos. 1506ff).

72. The introduction to Pentecost in the Missal, *St. Andrew's,* 1950, III, 149: "after Easter Pentecost is the greatest feast of the whole year, having an equally privileged vigil and octave. . . . the book of the Acts of the Apostles is read, for this is the season which commemorates the foundation of the Church, of whose beginnings this sacred book gives an account. . . . The New Testament puts the Old in its true light by showing that everything that it contained was only in the nature of a type. So in the mass for Pentecost and throughout the octave, the Old and the New Law, Holy

Scriptures and Tradition, the Prophets, the Church Fathers and the Apostles echo the Master's words. Like the different pieces of a mosaic, all these parts group themselves in such a way as to bring before the mind a wonderful picture portraying the action of the Holy Ghost. . . ."

VII
Benedictine Self-Identification in Times of Challenge

1. An example is at Praglia (Albareda 116). See F. G. B. Trolese, O.S.B., S. Giorato, and L. Prosdocimi, *Edizioni della regola di San Benedetto (sec. XVI–XX),* exh. cat., Padua, 1980, 21.

2. This was established in the papal bull of Martin V dated 1 January 1419, "Ineffabile summi providentia," which founded the Congregation first called "de unitate"; Martin's formula of two-thirds of the professed monks in the monastery continued as two-thirds of the participants at the "capitolo conventuale" under the constitution established for the Congregation by the Condulmer pope in 1423. See Trolese, 1991, 630, 634–35. Today, a novice prepares for nine years before his profession (oral communication at Praglia).

3. E. S. Greenhill, "The Child in the Tree," *Traditio,* X, 1954, 344–47 (the text is now attributed to Quodvultdeus (ca. 390–ca. 453); a possible association between this sermon and illustrations in the *Speculum virginum* is discussed.

4. Penco, 1988, 27: "la preghiera contemplativa adombrata dalla mistica scala di Giacobbe." "La vita monastica è un'ascesa verso il cielo, una 'scala Dei'" (ibid., 122).

5. St. Benedict, *Rule,* 64:18.

6. See chap. IV, nn. 28, 29; and Cahn, 1989, 722–23, figs. 16–17.

7. Cantinoni Alzati, 1982, nos. 220, 291.

8. Collett, 1985, 15ff., writing of the "theologies of the *Scala perfectionis,*" some of which were connected with the *devotio moderna.*

9. C. Ripa, *Iconologia,* ed. C. Tomasini, Venice, 1645, 207. For medieval illustrations of Philosopy in terms of ladders, based on Boethius, see Wirth, 1983, 332ff., ills. 35 and 36.

10. D. Cavalca, *Specchio di croce,* ed. G. Bottari, Rome, 1738 (citing numerous editions previous to this), 51ff., 57ff.

11. A. Derbes, "Images East and West: The Ascent of the Cross," in Ousterhout and Brubaker, 1995, 122, n. 12; and Cahn, 1989, figs. 15–17. Greenhill (1954, 347–49) cites a 12th-century sermon by Alanus of Lille which gives Jacob's Ladder as a type of the Cross.

12. Haubst, 1956, 102.

13. J. Atkinson, *Martin Luther and the Birth of Protestantism,* Harmondsworth, 1968, 43, 47, 72. Luther "was later to dismiss mysticism as a technique to know God. He described it, with rationalism and moralism, as one of the ladders men erect to reach heaven, contrasting these 'heavenly ladders' with the ladder God had lowered in Christ" (p. 43). By construing such ladders, men tried to create their own image of God—a blame that applied also to Catholicism, since here a man-conceived (in Luther's conception) technique, the sacraments, provided such an image.

14. Baltimore, Walters Art Gallery MS 72, fol. 104r; Berlin, Staatsbibliothek MS 1701, fol. 126r; Troyes, Bibl. Mun. MS 252, 2r, 113v. The image comes from Proverbs 9:1.

15. Greenhill, 1954, 351.

16. Seyfarth (1990) gives the list, 135f., with reference to her Abb. 4 (Tree of Virtues). Repetitions of the illustrations in ten different manuscripts are given on p. 134. In the Arundel MS 44 in the British Museum (fol. 34v and r), standard Trees of Virtues and Vices are illustrated (Seyfarth, Abb. 4 and 3). Both types are in the Walters Art Gallery MS 72 as well (our Fig. 73).

17. Wilson and Lancaster Wilson, 1984, 9, 24–26 (the quotation is on p. 24).

18. Gardner, 1971, 89–113.

19. The Index of Christian Art at Princeton University lists illustrations of Jael giving milk to Sisera in ten manuscripts from the 12th to the 14th century.

20. See nn. 14, 16, and 18 above. For background, A. Katzenellenbogen, *Allegories of the Virtues and Vices in Medieval Art,* London, 1939. The rest of Proverbs 9 is also relevant in our context, since it seems to predict Eucharistic sacrifice in its references to wine at table (2–65); 9:6 says, "follow all of you the path that leads to discernment"; 9:10 reiterates Isaiah's "True wisdom begins with the fear of the Lord." See also A. Watson, "The *Speculum virginum* with Special Reference to the Tree of Jesse," *Speculum,* III, 447–69, esp. 455–60.

21. On the MS at Arras, no. 559, see A. Boutremy, "Bible illuminé de St. Vaast à Arras," *Scriptoria,* IV, 1950, 67–81.

22. See n. 18 above.

23. *Rule,* chap. 16: after Complines: "et nocte surgamus ad confitendum ei [Deo]."

24. For this and the following notes on Abraham, see Penco, 1988, chap. 9, "La vocazione di Abramo nella spiritualità monastica," 176–90.

25. Hebrews 11:8–9; 11:37–38. Penco here refers to Guibert of Gembloux, "Sermo de laudibus Sancti Benedicti," in *Analecta sacra,* VIII, ed. J. B. Pitra, Montecassino, 1882, 593–97.

26. For the iconography, Penco refers to S. van Woerden, "The Iconography of the Sacrifice of Abraham," *Vigiliae Christianae,* XV, 1961, 214–55.

27. *Dialogues,* II, ed. Zimmermann, 68–72. Penco, 1988, 148; Penco dedicated a section of his book (chap. 8, sec. 3) to "Le virtù del monaco. Il 'vir Dei'" (145–51).

28. Zorzi, 1987, 144f.

29. For an example of allegorical reference in the *Hypnerotomachia,* see app. 5 (218f.) to W. Stedman Sheard, "The Widener *Orpheus:* Attribution, Type, Invention," in J. T. Paoletti and W. Stedman Sheard, *Collaboration in Italian Renaissance Art,* New Haven, 1978, 189–219. The modern bibliography on this "symbolic" literature is enormous and cannot be included here.

30. The Pentecost account is in the Acts: 1:13–14,

2:1–21. Examples from the relevant liturgy follow. Missal, Prayer for Pentecost Sunday: "Deus, qui hodierna die corda fidelium Sancti Spiritus illustratione docuisti. . . ." Missal, reading: Acts 1–11. Breviary, Lectures from St. Gregory's 30th homily: "In ipso autem lectionis exordio audistis quid Veritas dicit: Si quis diliget me, sermonem meum servabit. Probatio ergo dilectionis, exhibitio est operis. . . ; Ad magnificat, Antiphone: . . . hodie Spiritus sanctus in igne discipulis apparuit, et tribuit eis charismatum dona: misit eos in universum mundum praedicare, et testificari: Qui crediderit, et baptizati fuerit, salvus erit, alleluya."

31. *Oxford Classical Dictionary,* ed. N. G. L. Hammond and H. H. Scullard, 2nd ed., Oxford, 1976, 906, 984. The priest custodians of the Sibylline Books were called Quindecimviri from 51 B.C. Earlier, from 367 B.C., there were ten, and even earlier only two. Of the post–83 B.C. collection of books subject to later influences, fourteen remain and are published in various editions. The prophecy of the Cumaean Sibyl in Virgil's *Fourth Ecologue,* saying "the Virgin returns" and "the serpent shall perish and the false poison plant shall perish," and speaking of the "reign of Saturn" (part of her inscription at Praglia), is a Roman source for associating the Sibyls with the Messaiah. This may explain the Cumaean Sibyl's distinction in the program at Praglia as the only one who holds a book (*Virgil* [Publius Vergilius Maro], *with an English translation,* ed. H. R. Fairclough, 1, rev. ed., Cambridge, Mass., n.d., 28f.: "Ultima Cumei venit iam carminis aetas; / magnus ab integro saeculorum nascitur ordo, / iam redit et Virgo, redeunt Saturnia regna; iam nova progenies caelo demittitur alto./ tu modo nascenti puero, quo ferres primum / desinet ac toto surget gens aurea mundo, casta fave Lucina . . ."). We thank our colleague Dr. Dimitri Hazzikostas for help in tracking down these references.

32. Quoted in *Sacrosanctum Concilium Tridentium,* 16ff. See the discussion on three Benedictine abbots at Trent in chap. v.4 above.

33. C. Carpanese, O.S.B., *Il santuario del Monte della Madonna nei colli euganei,* Praglia, 1987, 47.

Bibliography

Archival Material and Manuscripts

PADUA, BIBLIOTECA CIVICA

Fiandrini, B., *Memorie storico cronologiche dell'insigne Monastero di Santa Maria di Praglia Raccolte e Compilate da D. Benedetto Fiandrini di Bologna Decano ed Archivista Pratalese,* B.P. 127, MS 93 VI (1800).

Girolamo da Potenza, *Elucidario et vero ritratto . . . ,* MS B.P. 4898.

PRAGLIA

A.a. Pr. 8, 1562 [index].
A.a. Pr. 8, fol. 4r, 1562, Libraria.
A.a. Pr. 8, fol. 4r, 1564, Scrittura.
A.a. Pr. 8, fol. 4r, 1564, Libreria e Coro.
A.a. Pr. 3, fol. 253r, 1564 [payment].
A.a. Pr. 8, fol. 11r, Aadi 17 daprile 1569, Rjceui hio zuane.
A.a. Pr. 7, fols. 242v, 246v. ff., 1753 [report by Marc Antonio Rottigni of Praglia Monastery].
A.a. Pr. 13, fasc. I, fols. 117r–128r, February 1768 [petition for financial support].

ROME, VATICAN

Vat. Chig: IIV, 148, fols. 66r–86r (1568).

VENICE, BIBLIOTECA MARCIANA

Cod. lat. III, 172, Coll. 2276, Rituum caeremoniale (1567).

Published Sources

Ackerman, J., *Palladio's Villas,* Institute of Fine Arts, New York University, Walter S. Cook Annual Lecture, 1967.

Adam of Perseigne, "Sermo in festivitate sancti Benedicti abbatis," ed. D. Mathieu, *Collectanea Ordinis Cisterciensium Reformatorum,* IV, 1973, 108–9.

Adorni, B., ed., *L'Abbazia benedettina di S. Giovanni Evangelista a Parma,* Parma, 1979.

Alberigo, G., *I vescovi italiani al concilio di Trento (1545–47),* Florence, 1959.

Aleandri Barletta, E., "La stamperia romana di Paolo Manuzio dal 1561 al 1563," in *Aspetti della riforma cattolica e del Concilio di Trento: Mostra documentaria,* exh. cat., ed. E. Aleandri Barletta, Rome, 1964, 126–36.

Aleandro, G., "De convocando concilio sententia (ineunte anno 1537)," in *Concilii tridentini tractatuum, pars prima, Complectens tractatus a Leonis X temporibus usque ad translationem concilii conscriptos,* ed. V. Schweitzer, Freiburg, 1930.

Alexander, J. J. G., ed., *The Painted Page: Italian Renaissance Book Illumination, 1450–1550,* exh. cat., Royal Academy, London, and Pierpont Morgan Library, New York, 1994–95, Munich and New York, 1994.

Alvarez, see Bresciani Alvarez.

Alzati, see Cantinoni Alzati.

Appuhn, H., *Kloster Wienhausen,* Wienhausen, 1986.

Armenini, G. B., *De' veri precetti della pittura* [Ravenna, 1587], Hildesheim and New York, 1991.

Assessorato alla Cultura della Regione Liguria, *Il processionale benedettino della badia di Sant'Andrea della Castagna,* with introductions by P. Rum and B. G. Baroffio, Milan, 1992.

Atkinson, J., *Martin Luther and the Birth of Protestantism,* Harmondsworth, 1968.

Aurenhammer, H., Review of *Nuovi studi su Paolo Veronese, Convegno internazionale di studi, Venezia, 1–4 giugno 1988,* ed. M. Gemin, Venice, 1990, in *Zeitschrift für Kunstgeschichte,* II, 1992.

Bagster, S., *The Englishman's Hebrew and Chaldee Concordance of the Old Testament,* reprinted in London without a date (1970s/1980s).

Ballarin, A., and D. Banzano, eds., *Da Bellini a Tintoretto: dipinti dei Musei Civici di Padova dalla metà del Quattrocento ai primi del Seicento,* exh. cat., Padua, 1991.

Barberiis, Philippus de, *Discordantiae sanctorum doctorum Hieronymi et Augustini,* Venice (1546) (a copy in the Bibl. Marc., Venice, Misc. 1188).

———, *Discordantiae . . . ,* Rome, 1481 (Bibl. Marc. incunab. 1078).

Barbieri, see Barberiis.

Barbo, Lodovico, O.S.B., *Ad monachos S. Iustinae de Padua modus meditandi et orandi per Reverendum Dominum Lodovicum [Barbo] Episcopum Tarvisinum compositus,* ed. with parallel text in Lodovico Barbo, "Metodo di pregare e di meditare," *Scritti monastici editi dai monaci benedettini di Praglia,* IV (ital.-lat.), serie ascetico-mistica III, Treviso, n.d. (imprimatur 1924).

Barletta, see Aleandri Barletta.

Baschet, J., 1991, *Lieu sacré, lieu d'images: Les fresques de Bominaco (Abruzzes, 1263): Thèmes, parcours, fonctions,* Paris and Rome.

———, 1993, "Logique narrative, noeuds thématiques et localisation des peintures murales: Remarques sur un livre récent et sur un cas célèbre de boustrophé-

don," in *L'emplacement et la fonction des images dans la peinture murale du Moyen-Age,* Saint-Savin.

Bellarmini, Roberto, *Disputationum Roberti Bellarmini . . . De controversiis christianae fidei,* 4 vols. (folio), Milan, 1721.

Belting, H., *Die Oberkirche von San Francesco in Assisi: Ihre Dekoration als Aufgabe und die Genese einer neuen Wandmalerei,* Berlin, 1977.

Benedict, St., "Benedicti Regula," *Corpus scriptorum ecclesiasticorum latinorum,* vol. LXXV, Vienna, 1977.

———, *San Benedetto Abate, Regula monasteriorum,* traduzione italiana a cura delle Benedettine di Viboldone, 6th ed., Viboldone (Milan), n.d. (1970s).

———, *The Rule of St. Benedict in English,* ed. and trans. T. Fry, O.S.B., Collegeville, Minn., 1982.

Benedict's *Rule,* see *Regola.*

Benko, S., *The Meaning of Sanctorum Communio,* Studies in Historical Theology, III, London, 1964.

Betussi, D. B., *Ragionamento sopra il Cathajo,* Padua, 1573.

Bible: *Edizio Clementina Bibliorum sacrorum iuxta vulgatum,* Vatican, 1959.

Bible: *The Holy Bible, a Translation from the Latin Vulgate in the Light of the Hebrew and Greek Originals Authorized by the Hierarchy of England and Wales and the Hierarchy of Scotland,* trans. Monsignor Knox, New York, 1956.

Billanovich, M. P., "Una miniera di epigrafi e di antichità: Il chiostro maggiore di S. Giustina a Padova," *Italia medioevale e umanistica,* XII, 1969, 197–239.

Binotto, M., "Un ciclo pittorico di Battista Zelotti nel palazzo palladiano di Montano Barbarano in Vicenza," *Arte Veneta,* XLI, 1987, 63–73.

Boschini, M., *La carta del navegar pitoresco [1660] con la "Breve Istruzione" premessa alle "Ricche Minere della Pittura Veneziana"* [1674], critical edition of A. Pallucchini, Civiltà Veneziana Fonti e Testi, VII, Venice and Rome, 1966.

Boutremy, A., "Bible illuminé de St. Vaast à Arras," *Scriptoria,* IV, 1950, 67–81.

Bresciani Alvarez, G., "L'architettura," in Carpanese and Trolese, 1985, 87–112.

Breviarium monasticum pro omnibus sub regula S. Patris Benedicti militantibus, Brussels, 1941.

Breviarium romanum, Mechelen, Belgium, 1876.

Brugnolo Meloncelli, K., *Battista Zelotti,* Milan, 1992.

Butler, A., "The Cassinese Manuscripts of the Rule," in *Miscellanea di studi cassinensi pubblicati in occasione del XIV centenario della fondazione della Badia di Montecassino,* Montecassino, 1929, 125–27.

Cahn, W., "Ascending and Descending from Heaven: Ladder Themes in Early Medieval Art," in *Santi e demoni nell'alto medioevo occidentale, Atti del convegno di studio, Spoleto, 7–13 aprile 1988,* Spoleto, 1989, II, 697–724.

Calati, B., "Dalla 'lectio' alla 'meditatio': La tradizione benedettina fino a Ludovico Barbo," in Trolese, 1984.

Cantimori, D., *Eretici italiani del Cinquecento: Ricerche storiche,* Rome, 1939, repr. Florence, 1967.

Cantinoni Alzati, G., *La Biblioteca di S. Giustina di Padova, libri e cultura presso i benedettini padovani in età umanistica,* with transcription of 15th-century inventory of library at Santa Giustina, Padua, Biblioteca Civica, B.P.. 229, Padua, 1982.

Carpanese, C., O.S.B., 1985a, "La biblioteca," in Carpanese and Trolese, 183–88.

———, 1985b, "Cenni storici dal 1448 al 1980," in Carpanese and Trolese, 17–28.

———, 1987, *Il santuario del Monte della Madonna nei colli euganei,* Praglia.

Carpanese, C., O.S.B., and F. G. B. Trolese, O.S.B., eds., *L'Abbazia di Santa Maria di Praglia,* Milan, 1985.

Catechismus ex decreto Concilii Tridentini ad Parochos, Pii V Pont. Max. jussu editus, Rome, 1566 (for English translation, see McHugh and Callan).

Cavalca, D., O.P., *Specchio di croce,* ed. G. Bottari, Rome, 1738.

Cavazzana Romanelli, F., ed., *Gaspare Contarini e il suo tempo,* Atti del convegno di studio, Venezia, 1–3 marzo 1985, Venice, 1988.

Centro d'Incontro della Certosa di Firenze [Galluzzo], *Iconografia di San Benedetto nella pittura della Toscana,* Certosa di Firenze, 1982.

Ceschi Sandon, C., "Pittori attivi a Praglia," in Carpanese and Trolese, 1985, 135–48.

Cessi, F., "Riscoperte dopo il restauro, le nove tele pratalensi di Giambattista Zelotti," *Padova,* Sept. 1960, 12–19.

Clark, F., S.J., *Eucharistic Sacrifice and the Reformation,* 2nd ed., Oxford, 1967.

Collett, B., *Italian Benedictine Scholars and the Reformation: The Congregation of Santa Giustina of Padua,* Oxford, 1985.

Concilii tridentini tractatuum, pars prima, Complectens tractatus a Leonis X temporibus usque ad translationem concilii conscriptos, ed. V. Schweitzer, Freiburg, 1930.

Congar, Y., "Langage des spirituels et langage des théologiens," in Dagens, 1963, 16–34.

Consuetudines monasteriorum Germaniae, V, ed. B. Albers, Montecassino, 1912.

Conti, M., O.F.M., *La missione degli Apostoli nella regola francescana,* Genoa, 1972.

Cooper, T. E., "The History and Decoration of the Church of San Giorgio Maggiore in Venice," Ph.D. diss., Princeton University, 1990.

Corpus consuetudinum monasticarum, II, ed. A. Gransden, Siegburg, 1963.

Corpus consuetudinum monasticarum, XI, 2, ed. J. F. Angerer, Siegburg, 1987.

Corpus consuetudinum monasticarum, XII, 1, ed. L. G. Spätling and P. Dinter, Siegburg, 1985.

Corpus consuetudinum monasticarum, XII, 2, ed. L. G. Spätling and P. Dinter, Siegburg, 1987.

Crosato, L., *Gli affreschi nelle ville venete del Cinquecento,* Treviso, 1962.

Dagens, J., ed., *La mystique rhénane, Colloque de Strasbourg, 16–19 mai 1961*, Paris, 1963.

Daniélou, J., S.J., *Bible et liturgie: La théologie biblique des Sacrements et des fêtes d'après les Pères de l'Eglise*, 2nd rev. ed., Paris, 1958.

Daniélou, J., S.J., and H. Vorgrimler, S.J., eds., *Sentire Ecclesiam: Das Bewusstsein von der Kirche als gestaltende Kraft der Frömmigkeit*, Freiburg, 1961.

Denzinger-Schönmetzer, *Enchiridion*: H. Denzinger and A. Schönmetzer, S.J., *Enchiridion symbolorum, definitionum et declarationum de rebus fidei et morum*, 33rd ed., Freiburg, 1965.

Derbes, A., "Images East and West: The Ascent of the Cross," in Ousterhout and Brubaker, 1995, 110–32.

Dickens, A., *The Counter Reformation*, London, 1968, repr. New York, 1979.

Dobrillovich, D. Alessio, O.S.B., *Badia Monumentale di Praglia*, Padua, 1923.

Duval, A., *Des sacrements au Concile de Trente*, Paris, 1985.

Duval-Arnould, L., and A. Paravicini Bagliani, *Codex Benedictus*, Milan, 1982 (facsimile of MS in the Vatican Library).

Ettlinger, L. D., *The Sistine Chapel before Michelangelo: Religious Imagery and Papal Primacy*, Oxford, 1965.

Evennett, H. O., "Three Benedictine Abbots at the Council of Trent, 1545–1547," *Studia monastica*, I, 1959, 344–77.

Fede, C. de, "Tipografi, editori, librai italiani del Cinquecento coinvolti in processi di eresie," *Rivista di Storia della Chiesa in Italia*, XXIII, 1969.

Fiaccadori, G., ed., *Bessarione e l'umanismo, catalogo della mostra, Biblioteca Marciana, marzo–giugno 1994*, Naples, 1994.

Fiocco, G., "Un affresco di Bernardo Parenzano," *Bollettino d'Arte*, XXV, 1931–32, 433–39.

Fragnito, G., 1984, "Il Cardinale Gregorio Cortese (1483–1548) nella crisi religiosa del Cinquecento," *Benedictina*, XXXI, 79–134.

———, 1988a, "Bibliografia contariniana," in Cavazzana Romanelli, 255–66.

———, 1988b, "Gasparo Contarini tra Venezia e Roma," in Cavazzana Romanelli, 93–124.

Francesconi, G., *Storia e simbolo: "Mysterium in figura": la simbolica storico-sacramentale nel linguaggio e nella teologia di Ambrogio di Milano*, Pubblicazioni del Pontificio Seminario Lombardo in Roma, Ricerche di Scienze Teologiche, XVIII, Brescia, 1981.

Fry, T., see Benedict, St.

Gardner, J., "The Decoration of the Baroncelli Chapel in Santa Croce," *Zeitschrift für Kunstgeschichte*, XXXIV, 2, 1971, 89–113.

Gargan, L., *Cultura e arte nel Veneto al tempo del Petrarca*, Padua, 1978.

Gill, J., S.J., *The Council of Florence*, Cambridge, 1961.

Gisolfi, D., 1989–90, "'L'Anno Veronesiano' and Some Questions about Early Veronese and His Circle," *Arte Veneta*, XLIII, 30–42.

———, [1993], "The School of Verona in America," Fordham University lecture, in press, in *Artibus et Historiae*.

———, 1996a, "Tintoretto e le facciate affrescate di Venezia," in *Jacopo Tintoretto nel quarto centenario della morte, Atti del convegno internazionale di studi, Venezia, novembre 1994*, ed. P. Rossi and L. Puppi, Venice, 111–14, 315–16.

———, 1996b, "Veronese," in *The Dictionary of Art.*, vol. 32, 345–58.

———, 1996c, "Zelotti," in *The Dictionary of Art.*, vol. 33, 631–32.

Gisolfi Pechukas, D., 1982, "Two Oil Sketches and the Youth of Veronese," *Art Bulletin*, LXIV, 3, 388–413.

———, 1987, "Veronese and His Collaborators at 'La Soranza,'" *Artibus et Historiae*, XV, 67–108.

———, 1990, "I primi collaboratori di Paolo Veronese," in *Nuovi studi su Paolo Veronese, Convegno internazionale di studi, Venezia, 1–4 giugno 1988*, ed. M. Gemin, Venice, 25–35.

Gleason, E., 1988, "Le idee di riforma della Chiesa in Gasparo Contarini," in Cavazzana Romanelli, 125–46.

———, 1993, *Gasparo Contarini: Venice, Rome, and Reform*, Berkeley.

Grabmann, M., *Die Geschichte der katholischen Theologie seit dem Ausgang der Väterzeit*, Freiburg, 1933, repr. Darmstadt, 1961.

Green, S., "The Piccolomini Library and Its Frescoes," Ph.D. diss., University of California, Berkeley, 1991.

Greenhill, E. S., "The Child in the Tree," *Traditio*, X, 1954, 322–71.

Gregory the Great, St., *Dialogues*, trans. O. J. Zimmerman, O.S.B., Fathers of the Church, New York, 1959.

Gregory the Great, St., see also *Vita*.

Guibert of Gembloux, "Sermo de laudibus Sancti Benedicti," in *Analecta sacra*, VIII, ed. J. B. Pitra, Montecassino, 1882, 593–97.

Gulik, W. van, *Johannes Gropper (1503 bis 1559): Ein Beitrag zur Kirchengeschichte Deutschlands, besonders der Rheinlande im 16. Jahrhundert*, Freiburg, 1906.

Hahn, C., 1990, "Picturing the Text: Narrative in the Life of the Saints," *Art History*, XIII, 1–13.

———, 1995, "Icon and Narrative in the Berlin Life of St. Lucy (Kupferstichkabinett MS 78 A 4)," in Ousterhout and Brubaker, 72–90.

Hamburger, J., 1989a, "The Visual and the Visionary: The Image in Late Medieval Monastic Devotions," *Viator: Medieval and Renaissance Studies*, XX, 161–82.

———, 1989b, "The Use of Images in the Pastoral Care of Nuns: The Case of Heinrich Suso and the Dominicans," *Art Bulletin*, LXXI, 1, 1989, 20–46.

———, 1995, "The *Liber miraculorum* of Unterlinden: An Icon in Its Convent Setting," in Ousterhout and Brubaker, 147–90.

Haubst, R., 1954, "Der Reformentwurf Pius' II," *Römische Quartalschrift*, XLIX.

———, 1956, *Die Christologie des Nikolaus von Kues,* Freiburg.

Hawkins, P., " 'By Gradual Scale Sublimed': Dante's Benedict and Contemplative Ascent," in Verdon, 1984, 255–69.

Hedeman, A. D., "Roger van der Weyden's Escorial *Crucifixion* and Carthusian Devotional Practices," in Ousterhout and Brubaker, 1995, 191–203.

Heufelder, E. M., O.S.B., "St. Benedikt von Nursia und die Kirche," in Daniélou and Vorgrimler, 1961, 176–84.

Hoffman, see Warren Hoffman.

Howard, D., *Jacopo Sansovino: Architecture and Patronage in Renaissance Venice,* New Haven, 1975.

Iserloh, E., *Die Eucharistie in der Darstellung des Johannes Eck: Ein Beitrag zur vortridentinischen Kontroverstheologie über das Messopfer,* Münster, 1950.

Ivanoff, N., 1961, "Il ciclo allegorico della Libreria sansoviniana," in *Arte antica e moderna,* Florence.

———, 1964, "Il ciclo dei filosofi della Libreria Marciana," *Emporium,* November, 207–10.

———, 1968, "La libreria marciana: arte e iconografia," *Saggi e memorie di storia dell'arte,* VI, 1968, 69–78.

———, 1970, "Sculture e pitture dal Quattrocento al Settecento," in *La Basilica di Santa Giustina: Arte e storia,* Castelfranco Veneto, 1970, 167–345.

Jedin, H., S.J., *Geschichte des Konzils von Trient,* 4 vols., Freiburg, I, 1951; II, 1957; III, 1970; IV, 1975.

Jungmann, J. A., S.J., "Die Kirche in der lateinischen Liturgie," in Daniélou and Vorgrimler, 1961, 185–95.

Katzenellenbogen, A., *Allegories of the Virtues and Vices in Medieval Art,* London, 1939.

Knox, see Bible.

Küng, H., *Justification: The Doctrine of Karl Barth and a Catholic Reflection* (trans. from German by T. Collins, E. E. Tolk, and D. Granskou), New York, 1964.

Lauchert, F., *Die italienischen literarischen Gegner Luthers,* Freiburg, 1912.

Leccisotti, D. T., "La congregazione benedettina di S. Giustina e la riforma della Chiesa al secolo XV," *Archivio della R. Deputazione Romana di Storia Patria,* LXVII–XVIII, 1944–45, 451–68.

Lehmann, E., *Die Bibliotheksräume der deutschen Klöster im Mittelalter,* Berlin (East), 1957.

Lenzuni, A., ed., *All'ombra del Lauro: documenti librari della cultura in età Laurenziana,* exh. cat., Florence, Biblioteca Medicea Laurenziana, May–June 1992, Florence, 1992.

Lutz, J., and P. Perdrizet, *Speculum humanae salvationis,* 2 vols., Mülhausen, 1907–9.

Mabillon, J., O.S.B., 1687, *Museum Italicum,* I, *Iter Italicum,* Paris.

———, 1745a, *Tractatus de studiis monasticis in tres partes distributis . . . auctore P. D. Joanne Mabillon . . . ,* editio altera, Venice.

———, 1745b, *Annales ordinis S. Benedicti occidentalium monachorum patriarchae,* VI, Lucca.

Madonna, M. L., "La biblioteca: Theatrum mundi e theatrum sapientiae," in Adorni, 1979, 177–94.

Mansi, J. D., 1901–27, *Sacrorum conciliorum nova collectio,* Florence, 1759–98; Paris and Leipzig.

———, 1924, *Concilium Tridentinum,* Pars Sexta . . . 1562–1563, ed. S. Ehses, Freiburg, 1924.

Martène, E., *Commentarius in regulam S. P. Benedicti literalis, moralis, historicus, ex variis antiquorum scriptorum commentationibus. Actis sanctorum, monasteriorum ritibus . . . cum editis tum manuscriptis concinnatus. Opera et studio Edmundi Martene Presbyteri et Monachi Benedictini Congregationis Sancti Mauri Parisiensis,* Paris, 1690.

Martin, J. R., *The Illustrations of the Heavenly Ladder of John Climacus,* Princeton, 1954.

Maschietto, F. L., 1981, *Biblioteca e bibliotecari di S. Giustina di Padova (1697–1827),* Padua.

———, 1989, *Benedettini professori all'Università di Padova (secc. XV–XVIII): Profili biografici,* Cesena and Padua.

Massa, M., "Gasparo Contarini e gli amici, fra Venezia e Camaldoli," in Cavazzana Romanelli, 1988, 39–92.

McHugh, J. A., O.P., and C. J. Callan, O.P., *Catechism of the Council of Trent for Parish Priests Issued by Order of Pope Pius V,* New York, 1923.

Meloncelli, see Brugnolo Meloncelli.

Missal, *St. Andrew's,* with commentary by Dom Gaspar Lefebvre, O.S.B., 4 vols., Bruges, 1947–51.

Mullaly, T., *Disegni veronesi del Cinquecento,* Verona, 1971.

Mundò, A., " 'Bibliotheca,' Bible et lecture du Carême d'après St. Benoît," *Revue Bénédictine,* IX, 1950, 65–94.

Muraro, M., *Pitture murali nel Veneto e tecnica dell'affresco,* exh. cat., Venice, 1960.

Nepi Sciré, G., "Recenti restauri a Venezia," in *Tiziano,* exh. cat., Venice, 1990, 109–31.

Nicolò Salmazo, A. de, "Bernardino Parenzano e le storie di San Benedetto nel Chiostro Maggiore di S. Giustina," in de Nicolò Salmazo and Trolese, 1980, 89–120.

Nicolò Salmazo, A. de, and F. G. B. Trolese, *I benedettini a Padova e nel territorio padovano attraverso i secoli,* exh. cat., Padua, 1980.

Oberman, H. A., *The Harvest of Medieval Theology: Gabriel Biel and Late Medieval Nominalism,* Cambridge, Mass., 1963.

O'Gorman, J. F., *The Architecture of the Monastic Library in Italy 1300–1600, Catalogue with Introductory Essay,* College Art Association Monograph on the Fine Arts, New York, 1972.

Os, H. van, ed., *The Art of Devotion in the Late Middle Ages in Europe 1300–1500,* Amsterdam, 1994.

Ousterhout, R., and L. Brubaker, eds., *The Sacred Image: East and West,* Urbana, 1995.

Oxford Classical Dictionary, ed. N. L. G. Hammond and H. H. Scullard, 2nd ed., Oxford, 1976.

Pallucchini, R., 1968, "Giambattista Zelotti e Giovanni Antonio Fasolo," *Bollettino del Centro Internazionale di Architettura Andrea Palladio,* X, 213–24.

———, ed., 1981, *Da Tiziano a El Greco: per la storia del manierismo a Venezia,* exh. cat.,Venice.

Paoletti, J.T., and W. Stedman Sheard, *Collaboration in Italian Renaissance Art,* New Haven, 1978.

Pascher, J., *Das liturgische Jahr,* Munich, 1963.

Pechukas, see Gisolfi Pechukas and Gisolfi.

Penco, G., O.S.B., 1961, *Storia del monachesimo in Italia dalle origini alla fine del Medio Evo,* Rome.

———, 1985, "Cenni storici dalle origini al 1448," in Carpanese and Trolese, 9–11.

———, 1988, *Spiritualità monastica: Aspetti e momenti,* Abbey of Praglia.

Peter the Chanter, see Trexler.

Pevsner, N., *A History of Building Types,* Princeton, 1976.

Pfaff, C., *Scriptorium und Bibliothek des Klosters Mondsee im hohen Mittelalter,* Österreichische Akademie der Wissenschaften,Vienna, 1967.

Pivetta, G. M., *Notizie sul monastero de' padri benedettini cassinensi di Santa Maria di Praglia,* Padua, 1831.

Praglia, Guida storico-artistica dell'abbazia, Padua, 1953.

Prevedello, G., "Cenni sul monacesimo padovano dei secoli xvi–xviii," in de Nicolò Salmazo and Trolese, 1980.

Pricoco, S., ed., *La regola di San Benedetto e le regole dei padri,* Fondazione Lorenzo Valla,Verona, 1995.

Ravegnani, G., *Le biblioteche del monastero di San Giorgio Maggiore con un saggio di Nicola Ivanoff,* Florence, 1976.

Rearick,W. R., 1980, *Maestri veneti del Cinquecento,* Biblioteca di disegni, vi.

———, 1988, *The Art of Paolo Veronese, 1528–1588,* exh. cat.,Washington, D.C.

Regola in italiano per le monache con aggionta delli Decreti del Sacro Concilio di Trento, Et di alcune Bolle Ponteficie spettanti à Monache, Venice, 1594.

Richards, J., 1980, *Consul of God: The Life and Times of Gregory the Great,* Cambridge.

Ridolfi, C., *Le maraviglie dell'arte* [Venice, 1648], ed. D. von Hadeln, 2 vols., Berlin, 1914–24.

Ripa, C., *Iconologia,* ed. C.Tomasini,Venice, 1645.

Romanelli, see Cavazzana Romanelli.

Rose, P. L., "The Accademia Veneziana: Science and Culture in Renaissance Venice," *Studi veneziani,* xi, 1969, 191–242.

Rossetti, G. B., *Descrizione delle pitture, sculture, ed architetture di Padova,* Padua, 1776.

Rule, see Benedict, St. Also see *Regola.*

Russell, H. D., with B. Barnes, *Eva/Ave: Women in Renaissance and Baroque Prints,* exh. cat., National Gallery of Art,Washington, D.C., 1990, New York, 1990.

Sacrosanctum Concilium Tridentium cum citationibus ex utroque Testamento, Juris Pontificci Constitutionibus, aliisque S. Rom. Ecc. Conciliis, Padua, 1753.

Salmi, M., *L'Abbazia di Pomposa,* Rome, 1963.

Sandon, see Ceschi Sandon.

Schneider, K., "Die Bibliothek des Katharinenklosters in Nürnberg und die städtische Gesellschaft," in *Studien zum städtischen Bildungswesen des späten Mittelalters und der frühen Neuzeit,* Göttingen, 1983, 71–82.

Schulz, J., *Venetian Painted Ceilings of the Renaissance,* Berkeley, 1968.

Seyfarth, J., ed., *Speculum virginum, Corpus Christianorum, Continuatio Mediaevalis,* v,Turnhout, 1990.

Sgarbi,V., ed., *Palladio e la Maniera, catalogo della mostra,* Venice, 1980.

Sharratt, M., *Galileo: Decisive Innovator,* Oxford, 1994; repr. Cambridge, 1996.

Sinding-Larsen, S., 1974, *Christ in the Council Hall: Studies in the Religious Iconography of the Venetian Republic, Institutum Romanum Norvegiae, Acta,* v, Rome.

———, 1984, *Iconography and Ritual: A Study in Analytical Perspectives,* Oslo.

———, 1988, "Paolo Veronese a Palazzo Ducale," one of three introductory articles for *Paolo Veronese: Disegni e dipinti,* exh. cat., ed. A. Bettagno, with entries by W. R. Rearick,Venice, 23–29.

———, 1990, "Paolo Veronese tra rituale e narrativo: Note a proposito di un disegno per il Palazzo Ducale," in *Nuovi studi su Paolo Veronese, Atti del convegno internazionale di studi, Venezia, 1–4 giugno 1988,* ed. M. Gemin,Venice, 36–41.

———, 1991, "Créer des images: remarques pour une théorie de l'image," in *L'image et la production du sacré,* ed. F. Dunand, J.-M. Spieser, and J.Wirth, Paris, 35–76.

———, 1992, "A Walk with Otto Demus: The Mosaics of San Marco,Venice, and Art-Historical Analysis," *Institutum Romanum Norvegiae, Acta,* series altera, viii, 145–205.

———, 1997, "Categorization of Images in Ritual and Liturgical Contexts," Ettore Majorana Centre for Scientific Culture, Erice (Sicily) and Ecole des Hautes Etudes, Paris, *Cahiers du Léopard d'Or,* 5.

———, forthcoming, *The Burden of the Ceremony Master: Image and Action in San Marco, Venice, and in an Islamic Mosque,* forthcoming in *Institutum Romanum Norvegiae, Acta.*

Smalley, B., *The Study of the Bible in the Middle Ages,* 3rd ed., Oxford, 1983.

Smaragdus, "Smaragdi abbatis expositio in Regulam S. Benedicti," *Corpus consuetudinum monasticarum,* viii, Siegburg, 1974.

Sowa, J. F., "Relating Diagrams to Logic," in *Conceptual Graphs for Knowledge Representation, Lecture Notes in Artificial Intelligence,* ed. G. W. Mineau, B. Moulin, and J. F. Sowa, Berlin, 1991, 1–63.

Stedman Sheard,W., "The Widener *Orpheus:* Attribution, Type, Invention," in Paoletti and Stedman Sheard, 1978, 189–219.

Tacchella, L., "Il processo agli eretici veronesi Matteo e Alessandro degli Avogari nell'anno 1567," *Studi storici veronesi Luigi Simeoni,* xxx–xxxi,Verona, 1980–81.

Tomasini, Jacopo Filippo, *Bibliotecae Patavinae Manuscriptae publicae e privatae,* Padua, 1639.

Tramontin, S., 1988, "Profilo di Gasparo Contarini," in Cavazzana Romanelli, 17–38.

———, 1991, "Venezia tra riforma cattolica e riforma protestante," in *Storia religiosa del Veneto,* I, *Patriarcato di Venezia,* Padua, 93–130.

Trexler, R. C., *The Christian at Prayer: An Illustrated Prayer Manual Attributed to Peter the Chanter (d. 1197),* Binghamton, 1987.

Trolese, F. G. B., O.S.B., 1983, *Lodovico Barbo e S. Giustina: Contributo bibliografico: Problemi attinenti alla riforma monastica del Quattrocento,* Rome.

———, 1991, "La congregazione di S. Giustina di Padova (sec. xv)," in *Naissance et fonctionnement des réseaux monastiques e canoniaux, Acts du Premier Colloque International du C.E.R.C.O.M., septembre 1985,* Centre Européen de Recherches sur les Congrégations et Ordres Religieux, Travaux et Recherches, Saint-Etienne.

———, ed., 1984, *Convegno per il VI centenario della nascita di Ludovico Barbo, Padova 1982,* Cesena.

Trolese, F. G. B., S. Giorato, and L. Prosdocimi, *Edizioni della regola di San Benedetto,* cat. of exhibition cosponsored by the libraries of Praglia and Sta. Giustina, Padua, Santa Giustina, October–December 1980.

Turner, D. H., R. Stockdale, P. Jebb, and D. Rogers, *The Benedictines in Britain,* London and New York, 1980.

Verdon, T. G., ed., *Monasticism and the Arts,* Syracuse, 1984.

Vincenzo of Milan, O.S.B., *De maximis Christi beneficiis pia gratiarum actio,* Naples, 1568 (printed but difficult to find; copy in the Bibliotheca Apostolica Vaticana, Chigi I IV 148, fols. 66–86).

Virgil [Publius Vergilius Maro], *with an English Translation,* ed. H. R. Fairclough, I, rev. ed., Cambridge, Mass., n.d.

Vita et miracula Sanctissimi Patris Benedicti ex Libro ii Dialogorum Beati Gregori Papae et Monachi collecta. Et ad instantiam Deuotorum Monachorum Congregationis eiusdem Sancti Benedicti Hispaniarum aeneis typis accuratissime delineata, Rome, 1579.

Vogüé, A. de, "Lectiones sanctas libenter audire: Silence, lecture et prière chez saint Benoît," *Benedictina,* XXVII, 1980.

Vulgate, see Bible.

Warnefred, Paulus, *Pauli Warnefridi diaconi cassinensis in sanctam regulam commentarium,* Montecassino, 1880.

Warren Hoffman, E., "Some Engravings Executed by the Master E. S. for the Benedictine Monastery of Einsiedeln," *Art Bulletin,* XLIII, 3, 1961, 231–37.

Watson, A., "The *Speculum virginum* with Special Reference to the Tree of Jesse," *Speculum,* III, 1928, 445–69.

Wilson, A., and J. Lancaster Wilson, eds., *A Medieval Mirror: Speculum humanae salvationis, 1324–1500,* Berkeley, 1984.

Wirth, K.-A., "Von mittelalterlichem Bildern und Lehrfiguren im Dienste der Schule und des Unterrichts," in *Studien zum städtischen Bildungswesen des späten Mittelalters und der frühen Neuzeit,* ed. L. Grenzmann, Göttingen, 1983, 256–370.

Woerden, S. van, "The Iconography of the Sacrifice of Abraham," *Vigiliae Christianae,* XV, 1961, 214–55.

Zanetti, A. M., *Varie pitture a fresco de' principi maestri veneziani ora la prima volta con le stampe pubblicate,* Venice, 1760.

Zava Boccazzi, F., 1970, "Considerazioni sulle tele di Battista Zelotti nel soffitto della libreria di Praglia," *Arte Veneta,* XXIV, 1970, 111–27.

———, 1985, "Battista Zelotti a Praglia," in Carpanese and Trolese, 149–59.

Zorzi, M., *La Libreria di San Marco: Libri, lettori, società nella Venezia dei Dogi,* Milan, 1987.

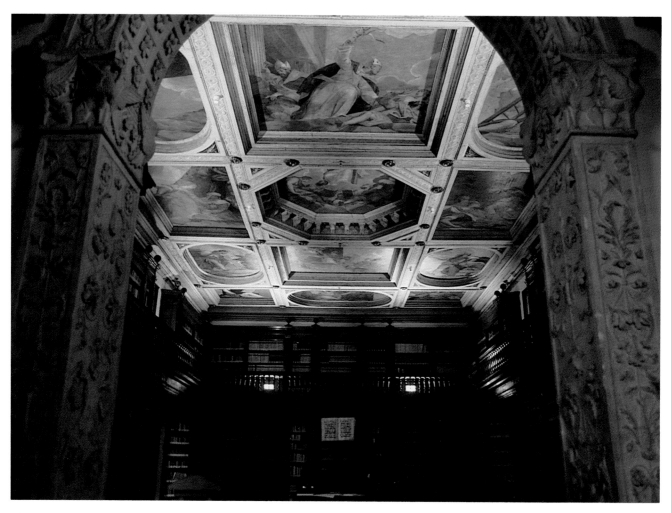

Plate 1 Present-day view of the Library Room at Praglia, from the anteroom

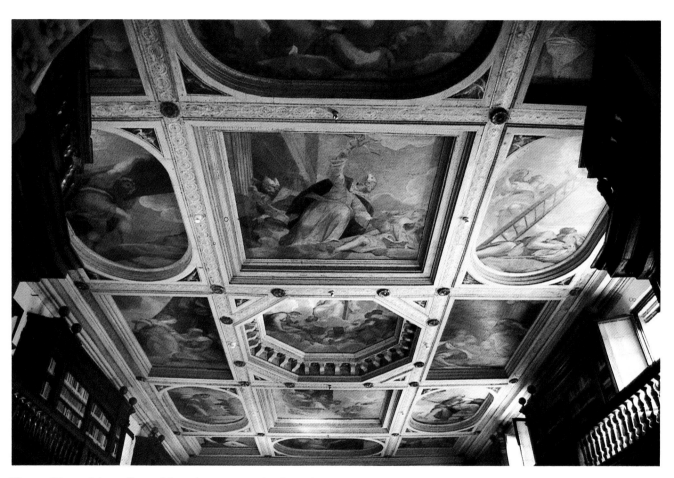

Plate II View of the ceiling of the Library at Praglia, from the entrance

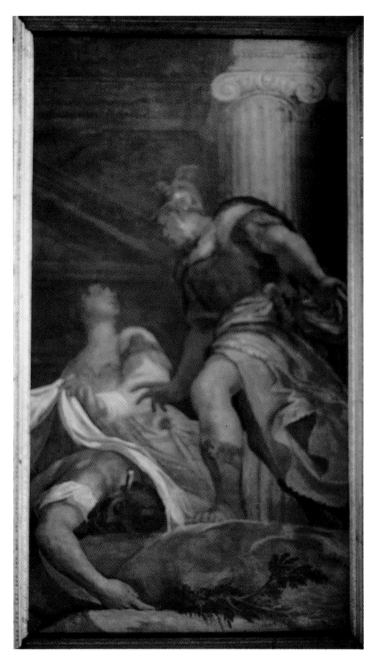

Plate III *Jael and Sisera,* tempera on canvas, 320 × 180 cm. Ceiling of
the Library at Praglia

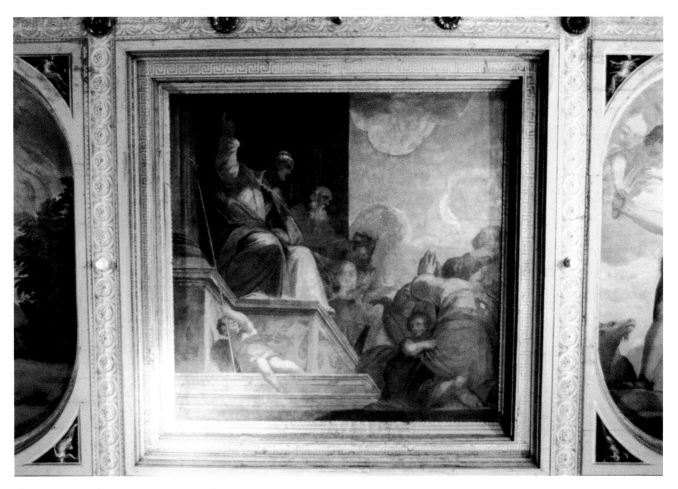

Plate IV *Saints Gregory and Jerome Preaching and Teaching,* tempera on canvas, 320 × 320 cm. Ceiling of the Library at Praglia

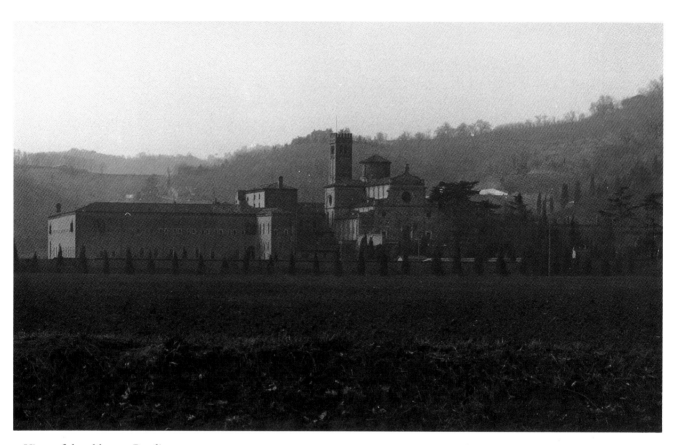

1 View of the abbey at Praglia

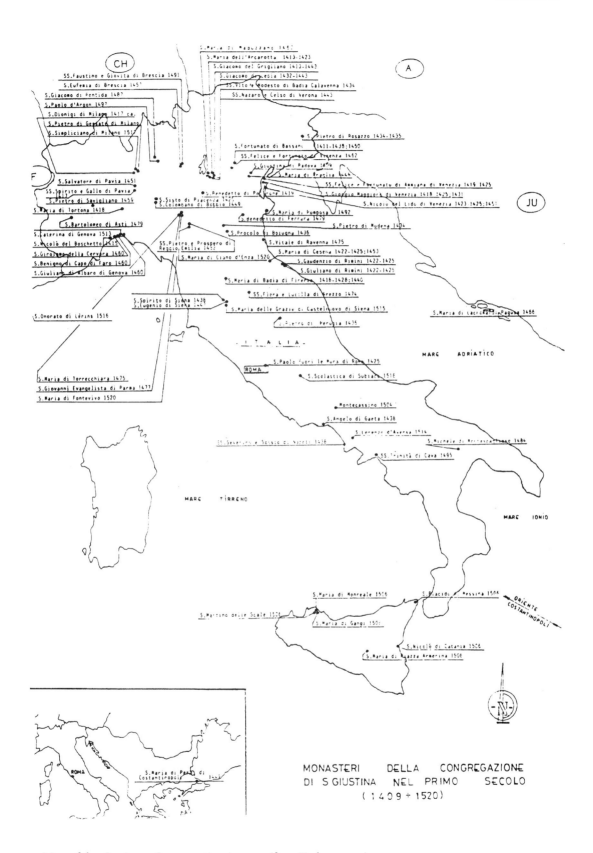

2 Map of the Cassinese Congregation in 1520 (from Trolese, 1991)

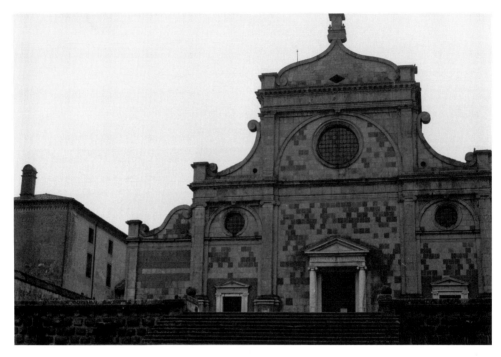

3 Library and church at Praglia, from the north

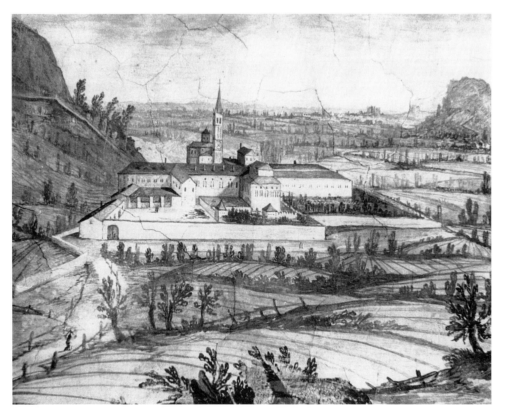

4 Pozzoserrato, detail of fresco: view of Praglia from the south, ca. 1575. Anteroom of the
sacristy, Sta. Giustina, Padua

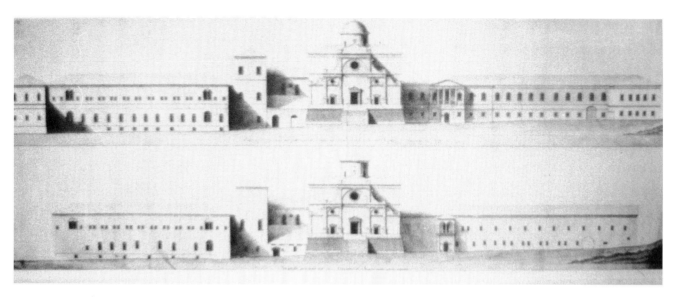

5 Vincenzo Zabeo-Giovanni Battista Meduna, proposed reconstruction of the monastery showing north Library windows restored, ca. 1824

6 Exterior north wall of the Library at Praglia

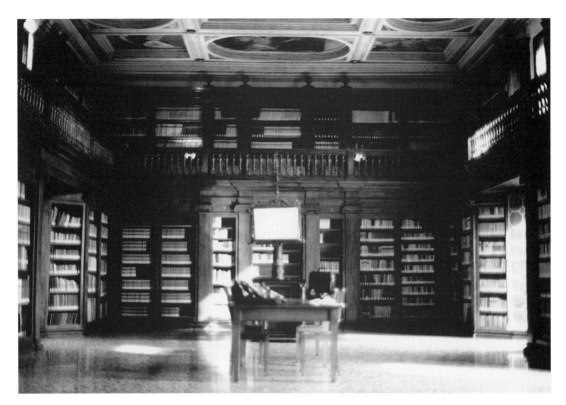

7 Interior of the Library at Praglia (see Plate 1)

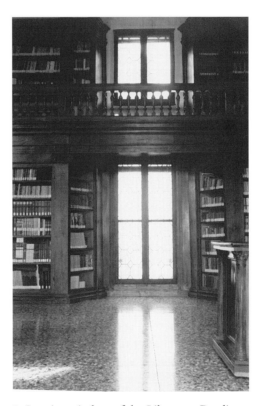

8 Interior window of the Library at Praglia

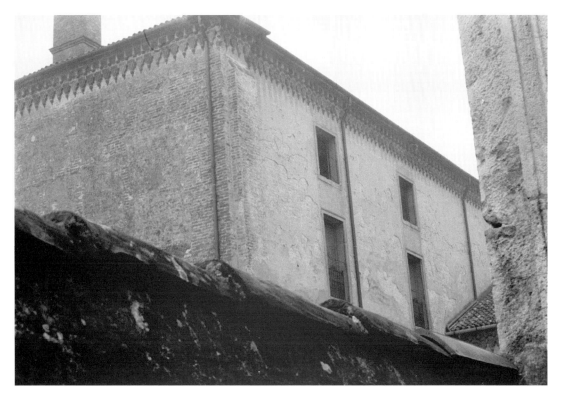

9 Exterior of the west wall of the Library at Praglia

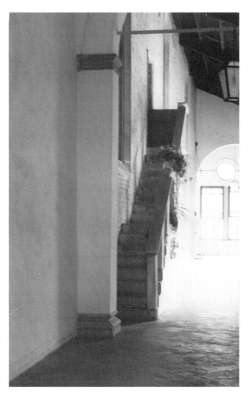

10 Staircase in the room below the Library
at Praglia

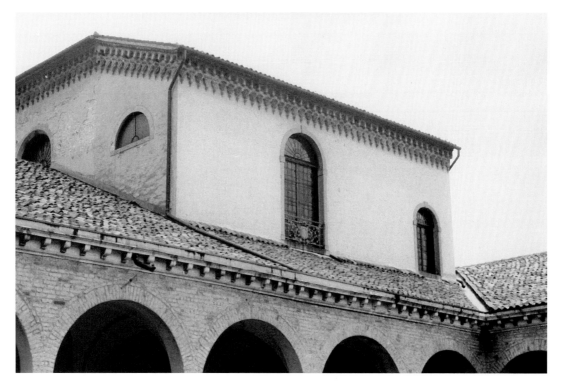

11 Exterior of the anteroom of the Library at Praglia, from the upper cloister

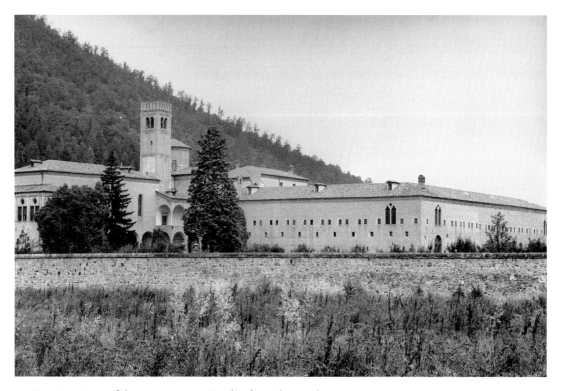

12 Exterior view of the monastery at Praglia, from the southeast

13 Ceiling of the anteroom at Praglia, from the Library

14 Ceiling of the anteroom at Praglia

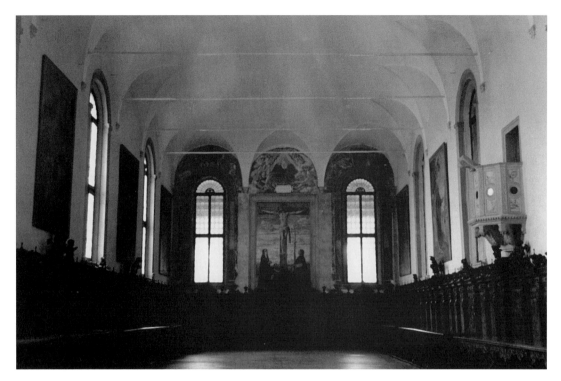

15 Interior view of the Refectory at Praglia, with Zelotti's wall paintings from the Library on the side walls

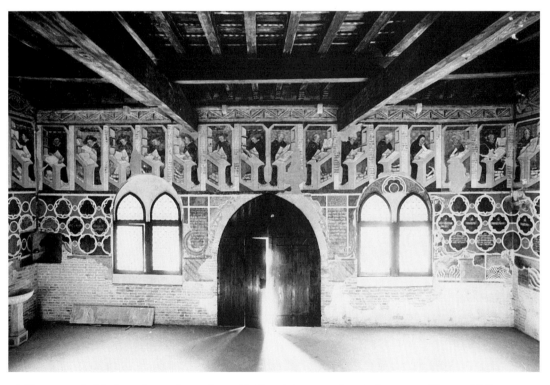

16 Tommaso da Modena, fresco decoration with Dominican monk-scholars, 1352. Chapter Hall, S. Nicolò, Treviso

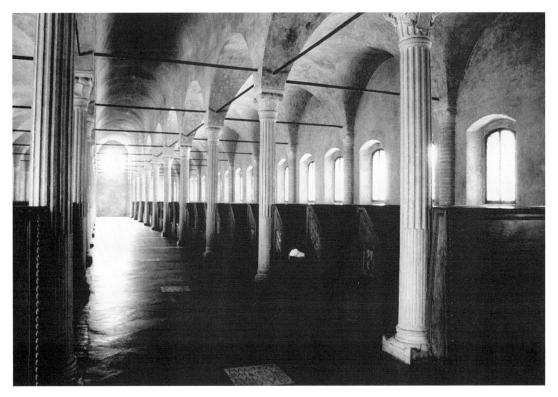

17 View of the library at Cesena

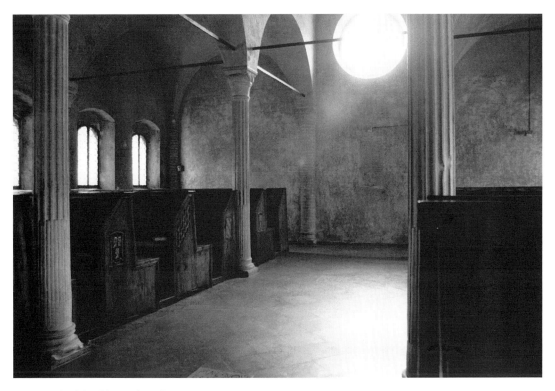

18 Detail of the library benches, Cesena

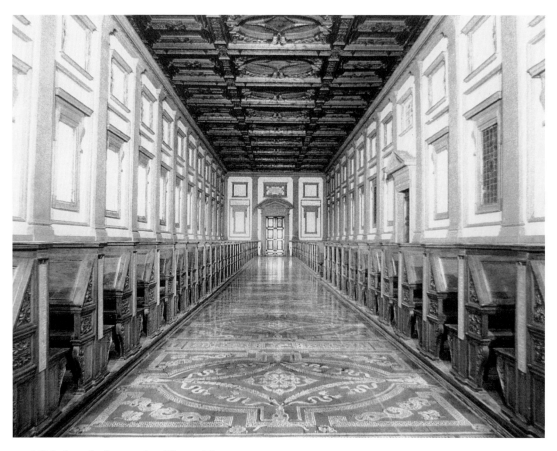

19 Michelangelo, Laurentian Library, Florence, 1524–34

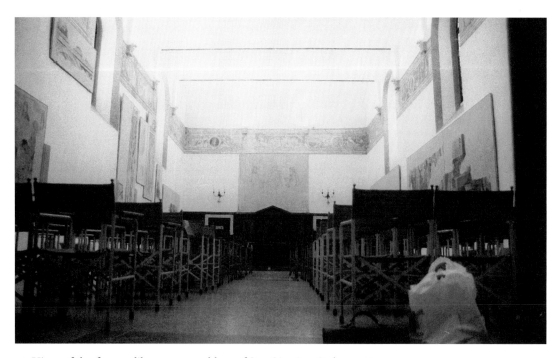

20 View of the former library room, abbey of Sta. Giustina, Padua, 1461

21 Detail of Figure 20: wall opposite entrance with sinopia of *Madonna and Child with Saints Justine and Benedict*

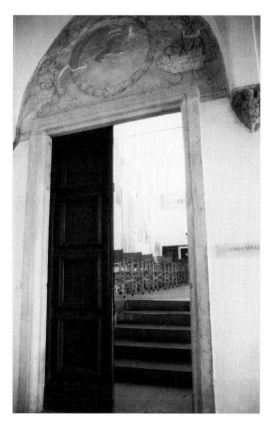

22 *St. Gregory,* fresco. Entrance to the library room, Sta. Giustina, Padua

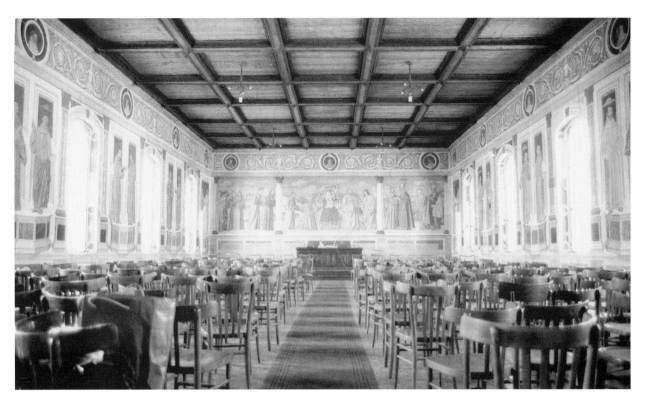

23 View of the former library room, S. Bernardino, Verona

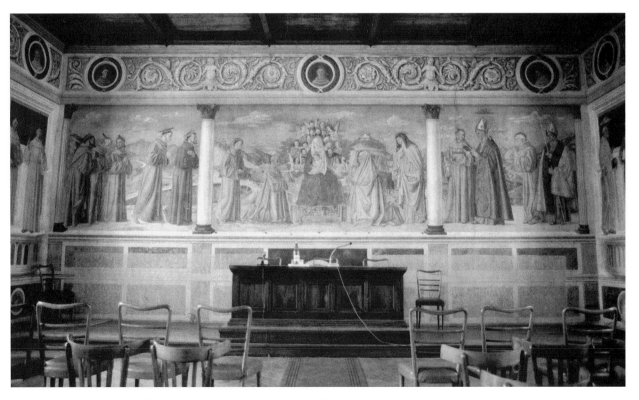

24 Detail of Figure 23: wall opposite entrance with fresco by Domenico Morone, *Madonna with Saints and Donors,* ca. 1500

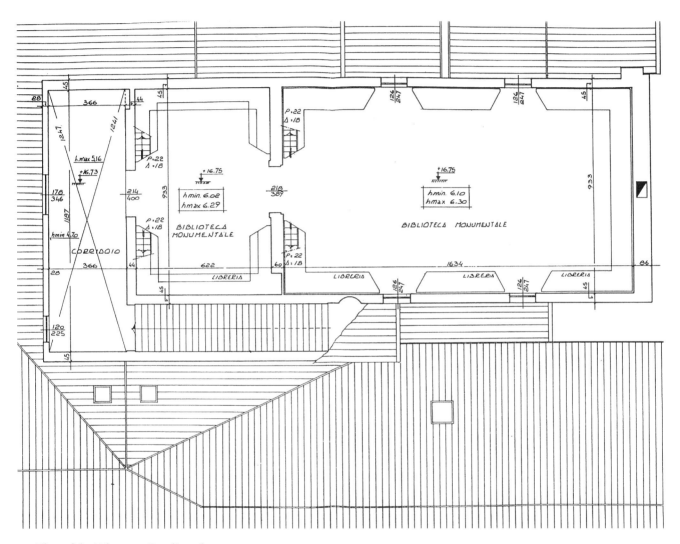

25 Plan of the Library at Praglia today

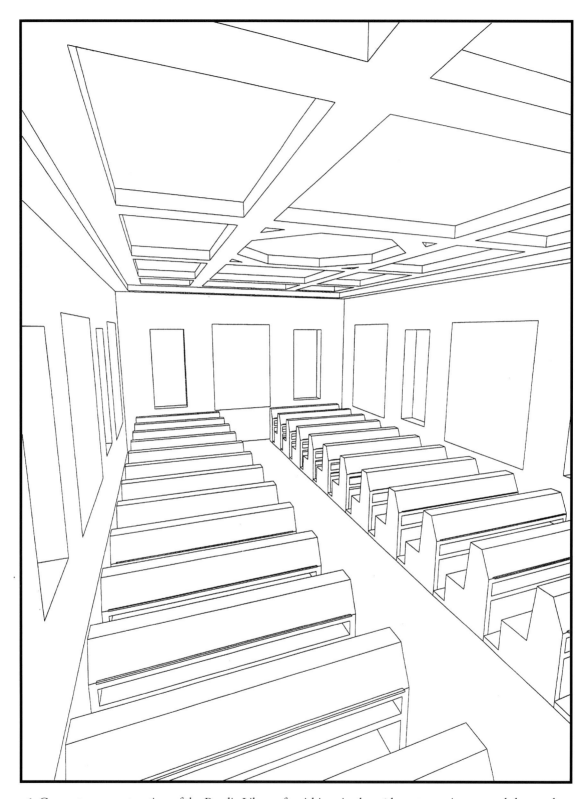

26 Computer reconstruction of the Praglia Library furnishings in the 16th century, view toward the north

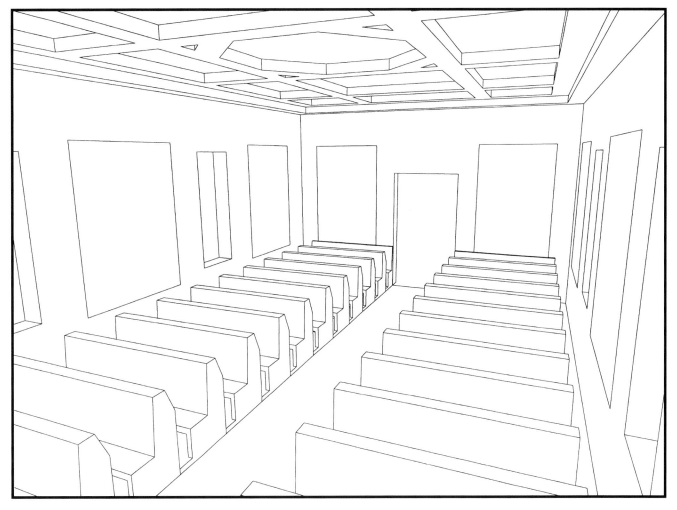

27 Computer reconstruction of the Praglia Library furnishings in the 16th century, view toward the south

END WALL

		Pentecost with Mary 240 cm		
	Erythraean Sibyl	Daniel in the Lions' Den	Cumaean Sibyl	
Moses Receiving Tablets 252 cm	Moses and the Burning Bush and Serpent	Gregory and Jerome Preaching and Teaching	Abraham Sacrifices Isaac	*Sermon on the Mount* 250 cm
Solomon and the Queen of Sheba 269 cm	Judith and Holophernes	Catholic Church and Evangelists	Jael and Sisera	*Christ Teaching in the Temple* 268 cm
Moses Breaking Tablets 242 cm	Samson with the Gates of Gaza	Augustine and Ambrose Subduing Heretics	Jacob's Ladder	*Christ and the Money Changers* 245 cm
	Samian Sibyl	David and Goliath	Tiburtine Sibyl	
	Jacob and Esau 234 cm	ENTRANCE	*Prodigal Son* 229.5 cm	

Painting titles in italic type = wall paintings in reconstructed positions.
Painting titles in Roman type = ceiling paintings in actual positions.
Height of wall paintings ± 340 cm; width dimensions in the respective boxes.

28 Chart showing the reconstructed relationship of subjects of the ceiling paintings and the wall paintings in the Library at Praglia

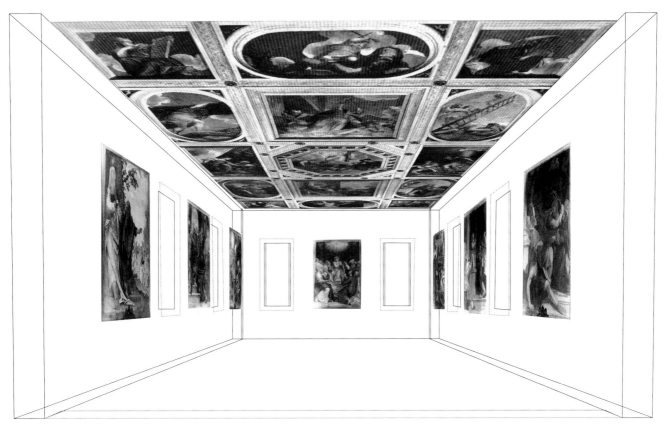

29 Computer reconstruction of the Library at Praglia with paintings scanned in, view toward the north

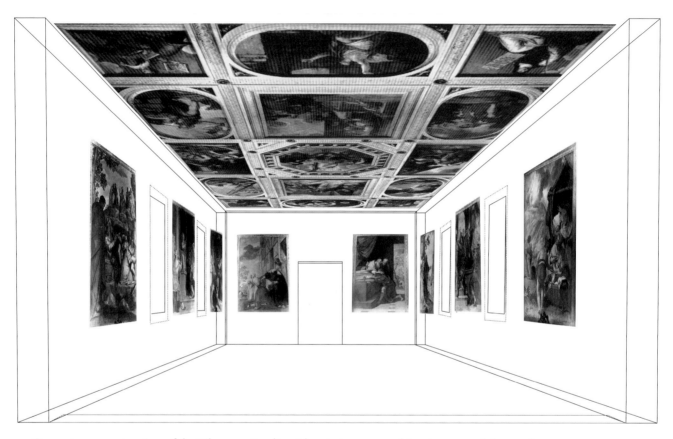

30 Computer reconstruction of the Library at Praglia with paintings scanned in, view toward the south

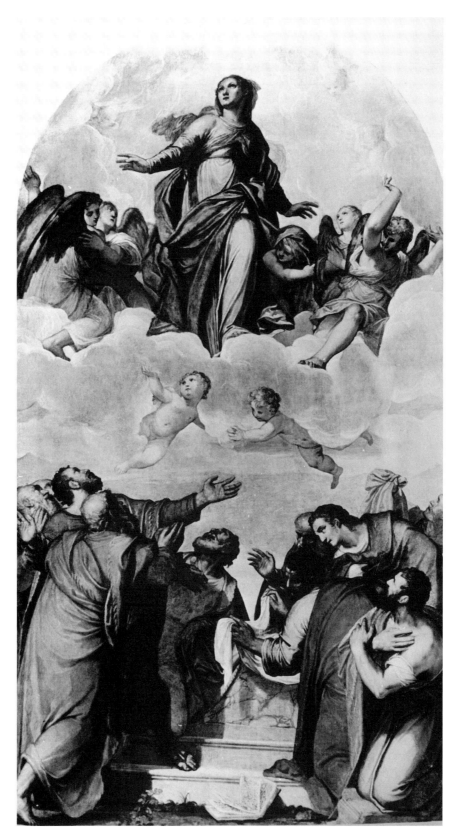

31 Battista Zelotti, *Assumption,* ca. 1559, oil on canvas, arched, 450 × 241 cm.
Church of Sta. Maria di Praglia

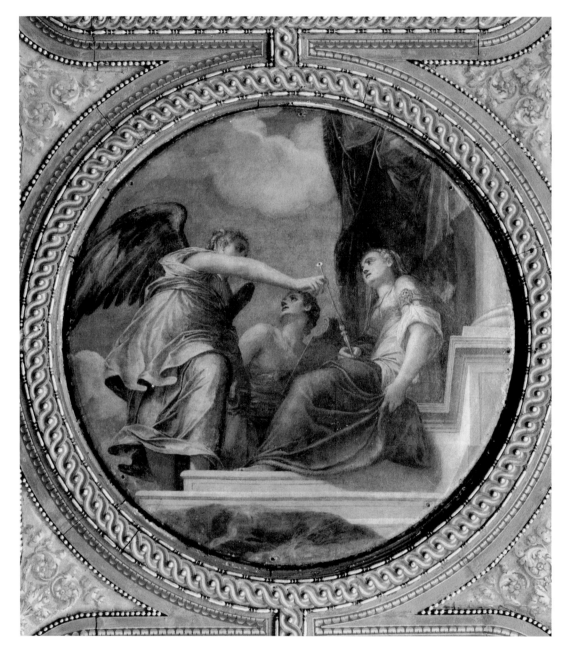

32 Battista Zelotti, *Allegory of Modesty,* 1557, oil on canvas, diam. 230 cm. Marciana Library, Venice

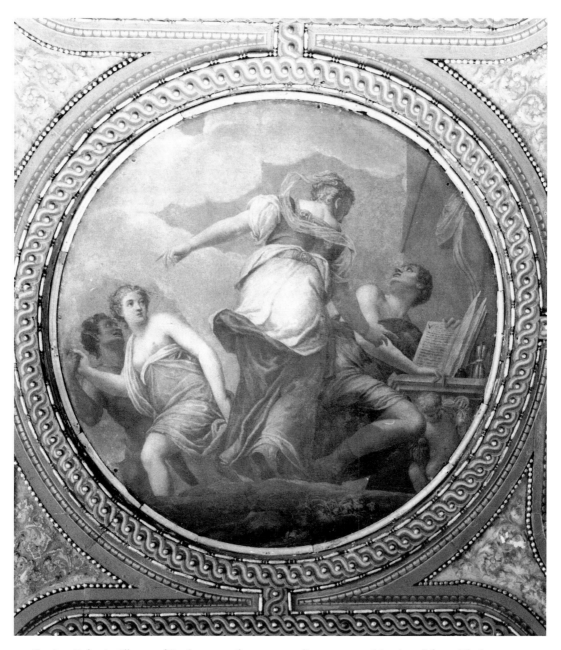

33 Battista Zelotti, *Allegory of Study,* 1557, oil on canvas, diam. 230 cm. Marciana Library, Venice

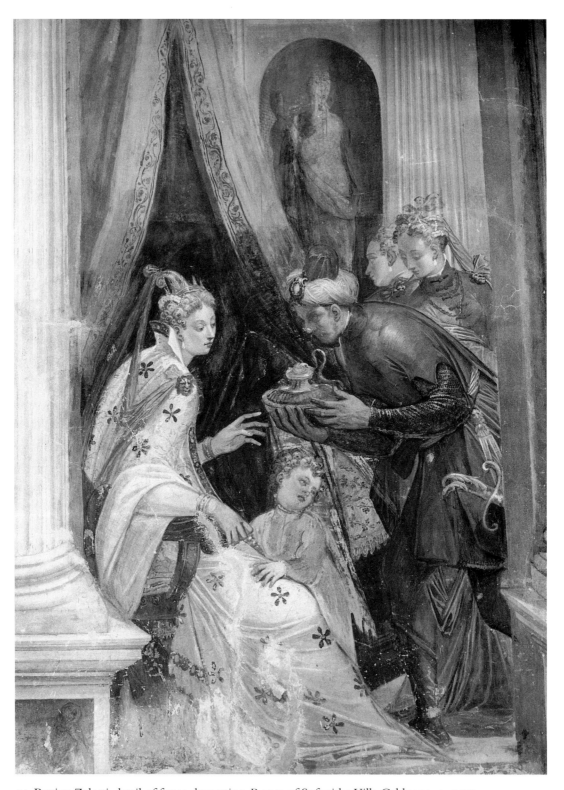

34 Battista Zelotti, detail of fresco decoration, Room of Sofonisba, Villa Caldogno, ca. 1570

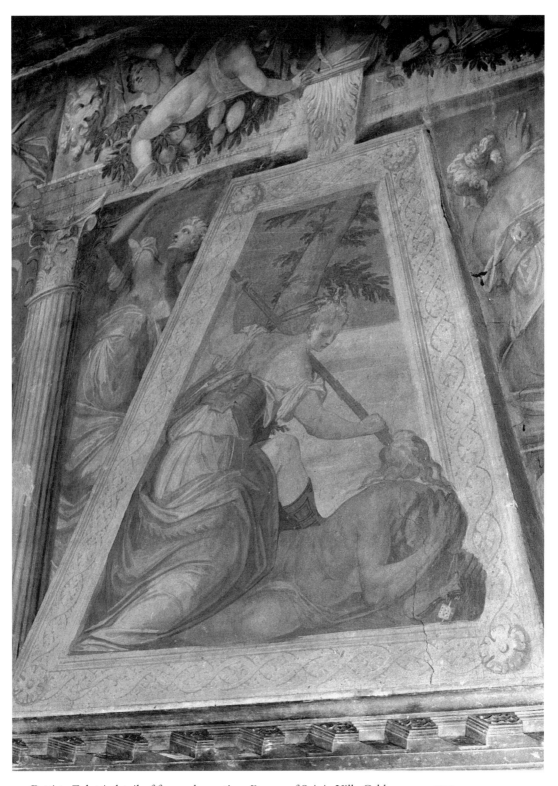

35 Battista Zelotti, detail of fresco decoration, Room of Scipio, Villa Caldogno, ca. 1570

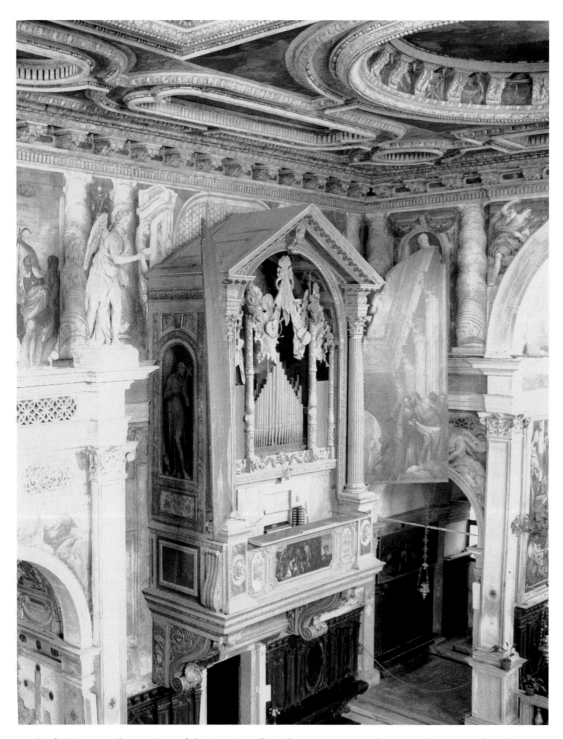

36 Paolo Veronese, decorations of the interior of S. Sebastiano, Venice, showing placement of *Erythraean Sibyl* (hidden by organ shutter) and *Samian Sibyl* below Archangel Gabriel at the entrance to the sanctuary, ca. 1560

37 Paolo Veronese, *Cumaean and Tiburtine Sibyls* below *Virgin Annunciate and Prophet*, ca. 1560.
S. Sebastiano, Venice

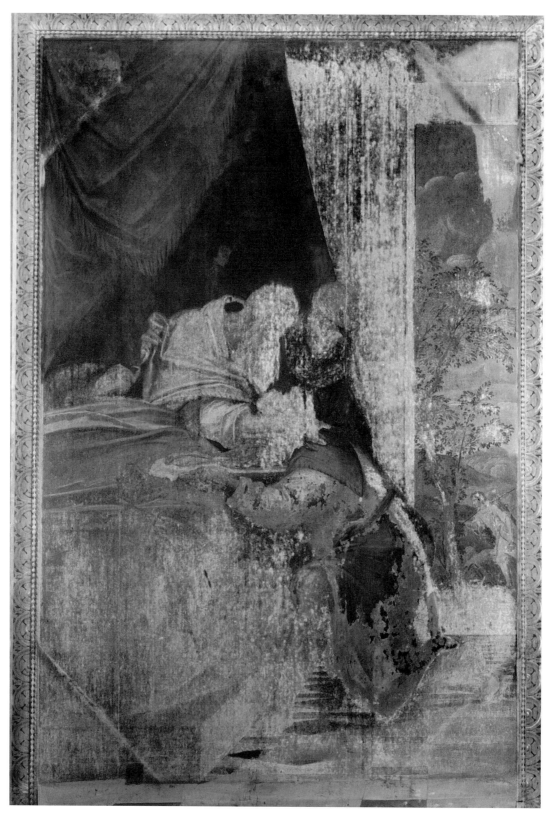

38 Battista Zelotti, *Jacob and Esau*, tempera on canvas (before 1960 conservation). Refectory, Praglia

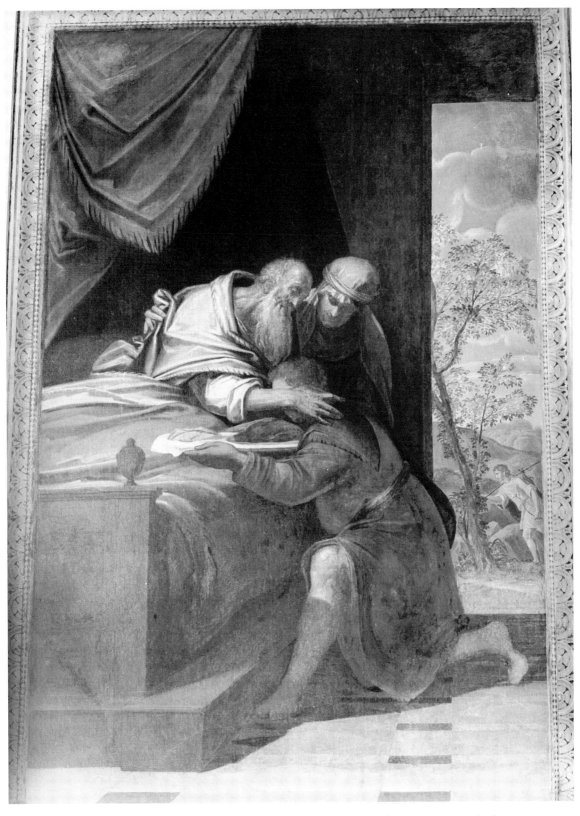

39 Battista Zelotti, *Jacob and Esau,* tempera on canvas, ca. 340 × 234 cm (after 1960 conservation). Refectory, Praglia

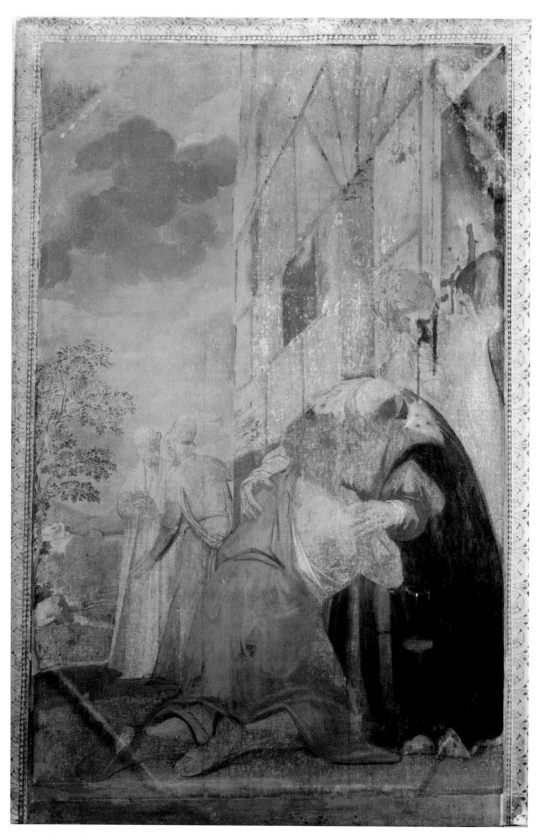

40 Battista Zelotti, *Prodigal Son,* tempera on canvas (before 1960 conservation). Refectory, Praglia

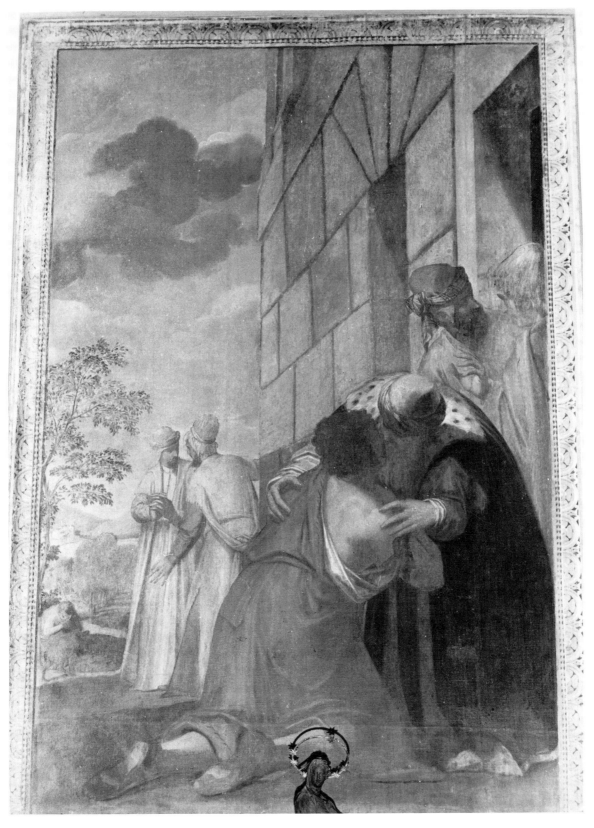

41 Battista Zelotti, *Prodigal Son,* tempera on canvas, ca. 340 × 229.5 cm (after 1960 conservation). Refectory, Praglia

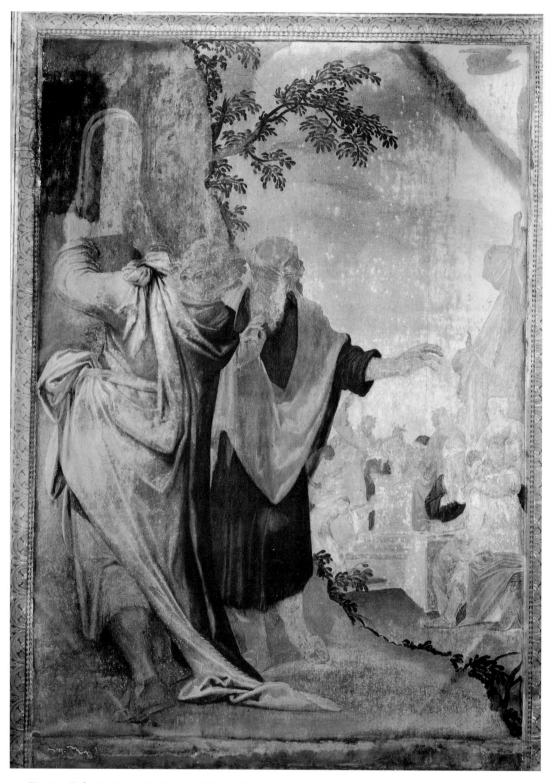

42 Battista Zelotti, *Moses Breaking the Tablets of the Law,* tempera on canvas (before 1960 conservation). Refectory, Praglia

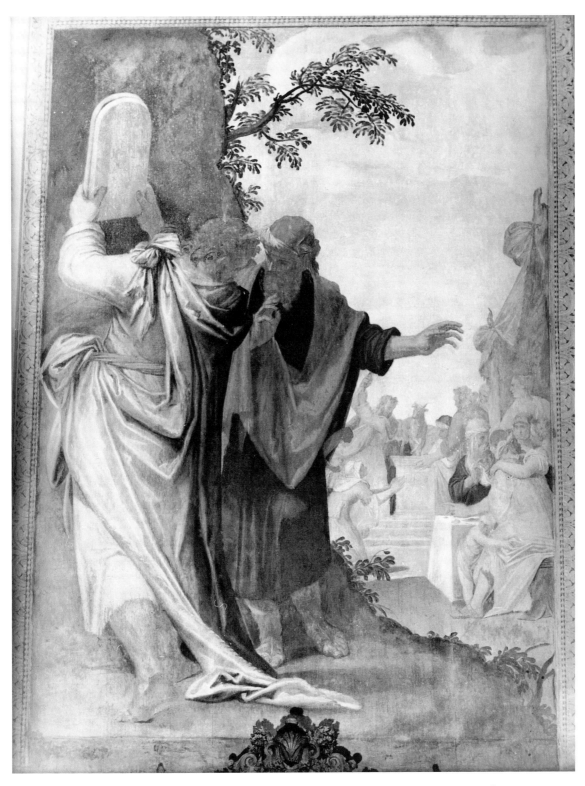

43 Battista Zelotti, *Moses Breaking the Tablets of the Law,* tempera on canvas, ca. 340 × 242 cm (after 1960 conservation). Refectory, Praglia

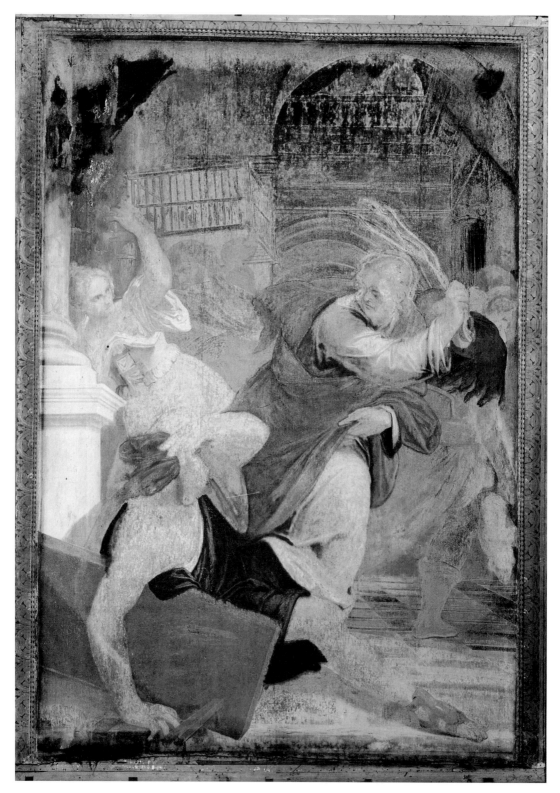

44 Battista Zelotti, *Christ Chasing the Money Changers from the Temple,* tempera on canvas (before 1960 conservation). Refectory, Praglia

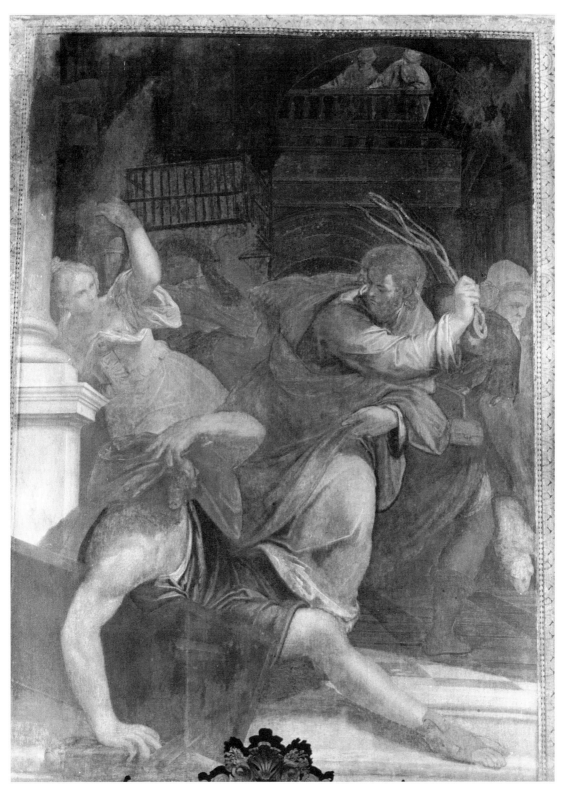

45 Battista Zelotti, *Christ Chasing the Money Changers from the Temple,* tempera on canvas, ca. 340 × 245 cm (after 1960 conservation). Refectory, Praglia

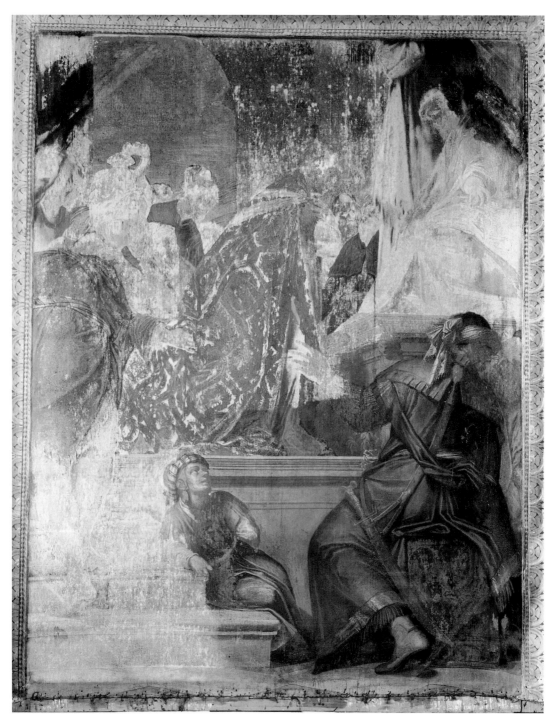

46 Battista Zelotti, *Solomon and the Queen of Sheba,* tempera on canvas (before 1960 conservation).
Refectory, Praglia

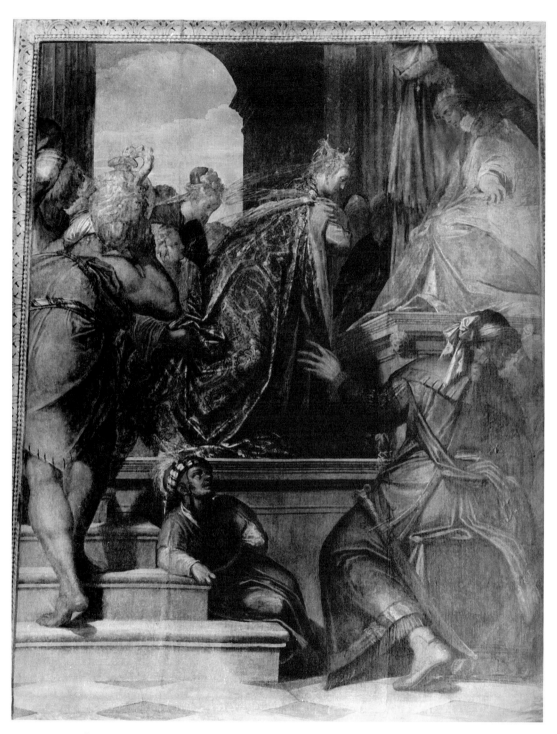

47 Battista Zelotti, *Solomon and the Queen of Sheba,* tempera on canvas, ca. 340 × 269 cm (after 1960 conservation). Refectory, Praglia

48 Battista Zelotti, *Jesus Teaching in the Temple,* tempera on canvas (before 1960 conservation). Refectory, Praglia

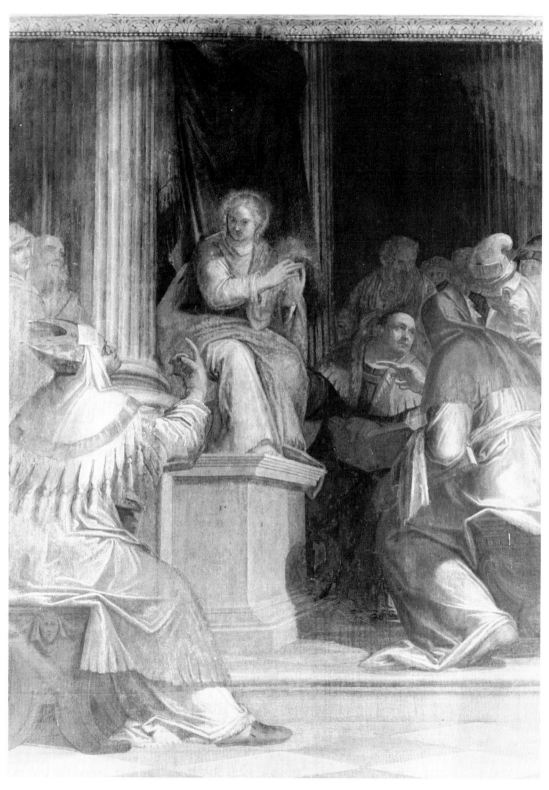

49 Battista Zelotti, *Jesus Teaching in the Temple,* tempera on canvas, ca. 340 × 268 cm (after 1960 conservation). Refectory, Praglia

50 Battista Zelotti, *Moses on Mount Sinai Receiving the Tablets and the Baby Moses Saved,* tempera on canvas (before 1960 conservation). Refectory, Praglia

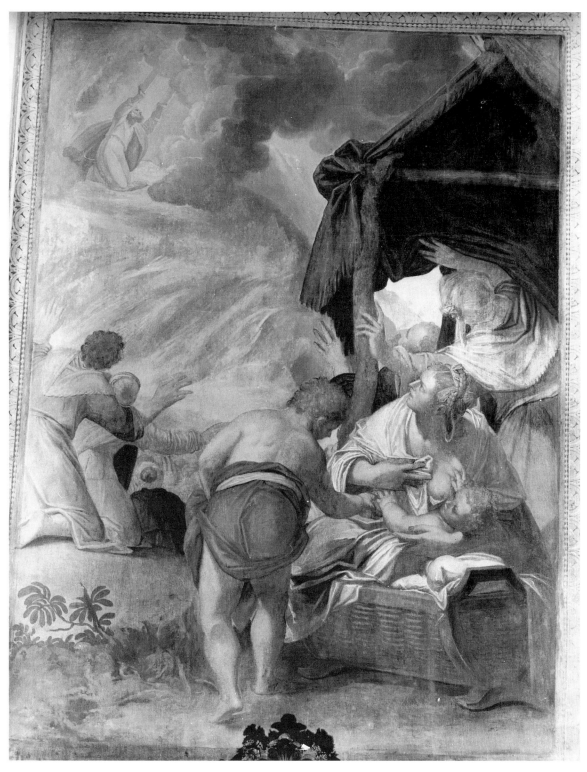

51 Battista Zelotti, *Moses on Mount Sinai Receiving the Tablets and the Baby Moses Saved,* tempera on canvas, ca. 340 × 252 cm (after 1960 conservation). Refectory, Praglia

52 Battista Zelotti, *Sermon on the Mount,* tempera on canvas (before 1960 conservation). Refectory, Praglia

53 Battista Zelotti, *Sermon on the Mount*, tempera on canvas, ca. 340 × 250 cm (after 1960 conservation).
Refectory, Praglia

54 Battista Zelotti, *Pentecost,* tempera on canvas (before 1960 conservation). Refectory, Praglia

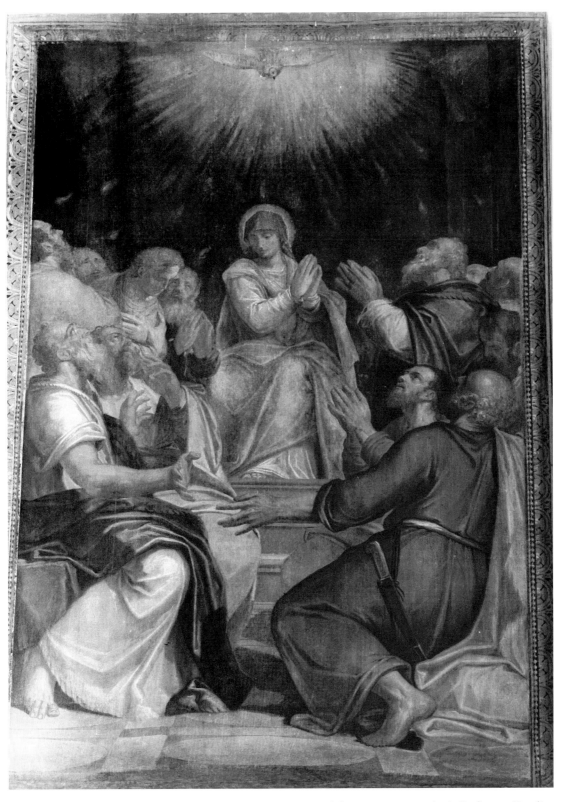

55 Battista Zelotti, *Pentecost*, tempera on canvas, 340 × 240 cm (after 1960 conservation). Refectory, Praglia

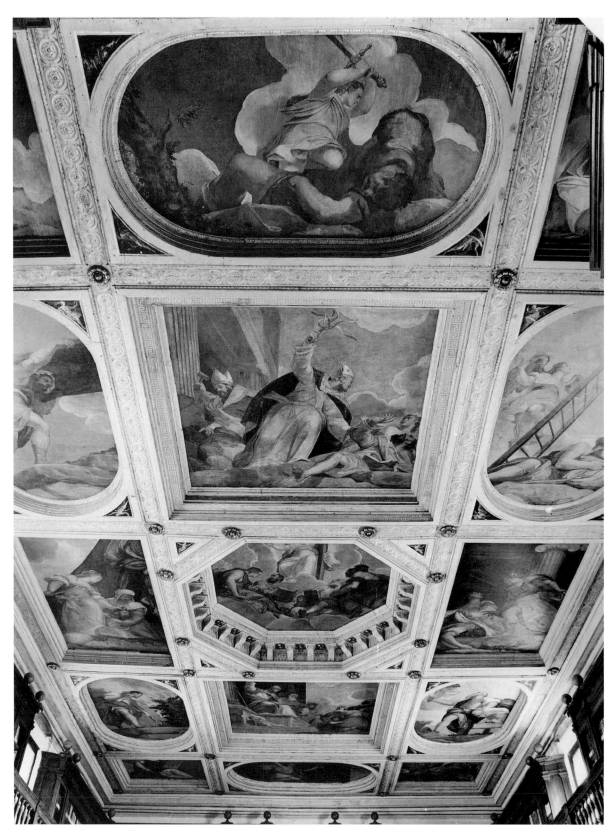

56 Battista Zelotti, ceiling of the Library at Praglia (see Plate II)

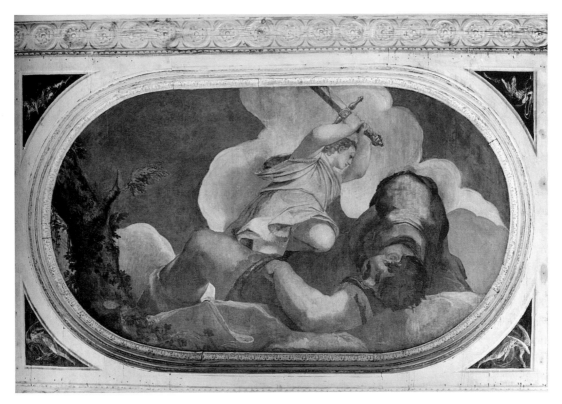

57 Battista Zelotti, *David and Goliath,* tempera on canvas, oval, 180 × 320 cm. Library at Praglia

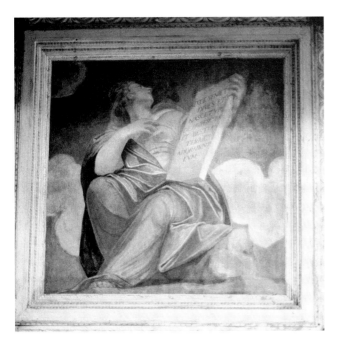

58 Battista Zelotti, *Samian Sibyl,* tempera on canvas, 180 × 180 cm. Library at Praglia

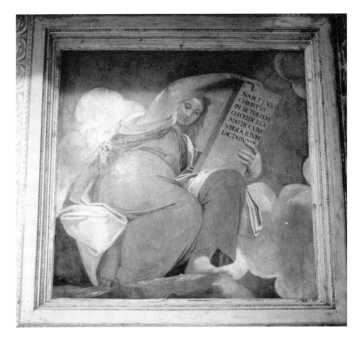

59 Battista Zelotti, *Tiburtine Sibyl,* tempera on canvas, 180 × 180 cm. Library at Praglia

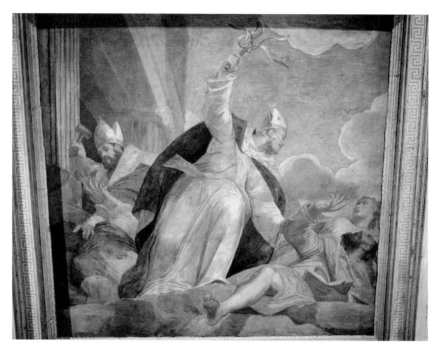

60 Battista Zelotti, *Saints Augustine and Ambrose Attacking Heretics,* tempera on canvas, 320 × 320 cm. Library at Praglia (see Plates i and ii)

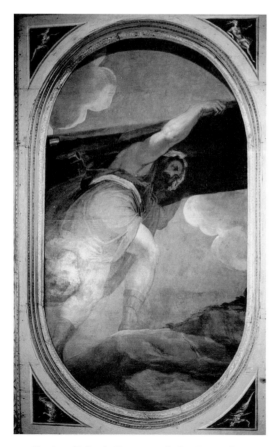

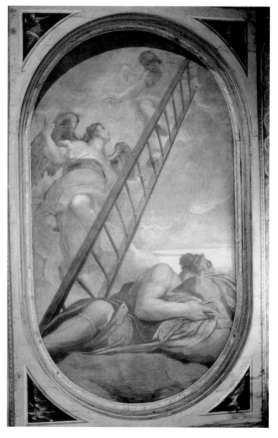

61 Battista Zelotti, *Samson with the Gates of Gaza,* tempera on canvas, oval, 320 × 180 cm. Library at

62 Battista Zelotti, *Jacob's Ladder,* tempera on canvas, oval, 320 × 180 cm. Library at Praglia

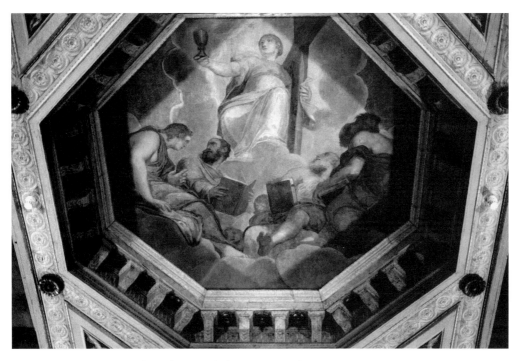

63 Battista Zelotti, *Catholic Religion with the Four Evangelists,* tempera on canvas, octagon, 320 × 320 cm. Library at Praglia

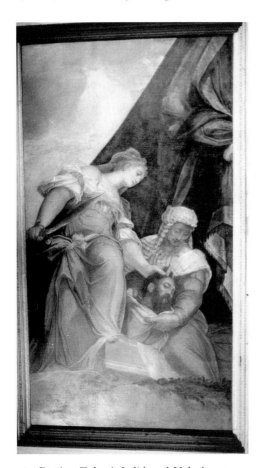

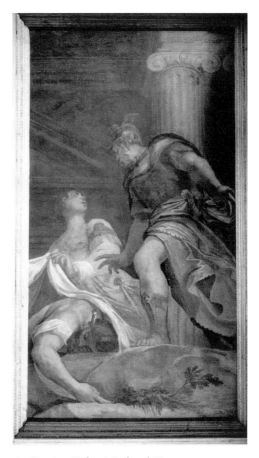

64 Battista Zelotti, *Judith and Holophernes,* tempera on canvas, 320 × 180 cm. Library at Praglia

65 Battista Zelotti, *Jael and Sisera,* tempera on canvas, 320 × 180 cm. Library at Praglia (see Plate III)

185

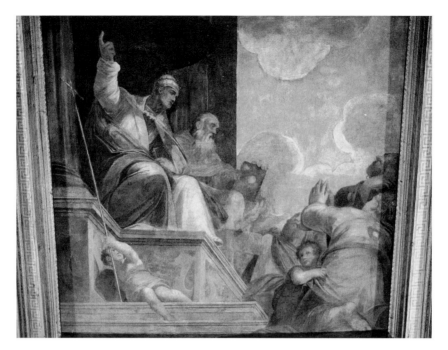

66 Battista Zelotti, *Saints Gregory and Jerome Preaching and Teaching,* tempera on
canvas, 320 × 320 cm. Library at Praglia

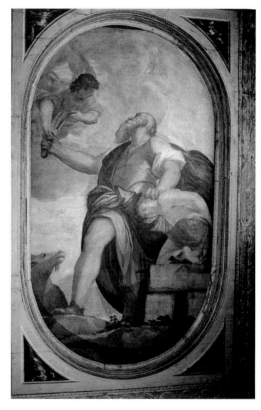

67 Battista Zelotti, *Moses with the Burning
Bush and Serpent,* tempera on canvas, oval,
320 × 180 cm. Library at Praglia

68 Battista Zelotti, *Abraham and Isaac,*
tempera on canvas, oval, 320 × 180 cm.
Library at Praglia

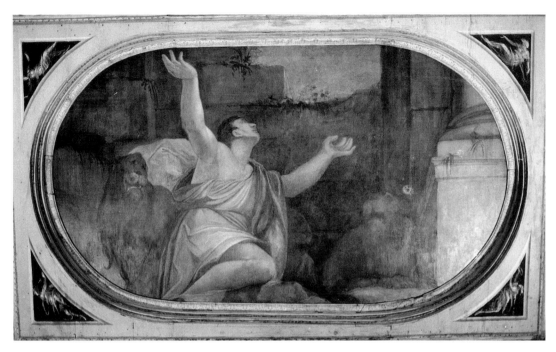

69 Battista Zelotti, *Daniel in the Lions' Den,* tempera on canvas, oval, 180 × 320 cm. Library at Praglia

70 Battista Zelotti, *Erythraean Sibyl,* tempera on canvas, 180 × 180 cm. Library at Praglia

71 Battista Zelotti, *Cumaean Sibyl,* tempera on canvas, 180 × 180 cm. Library at Praglia

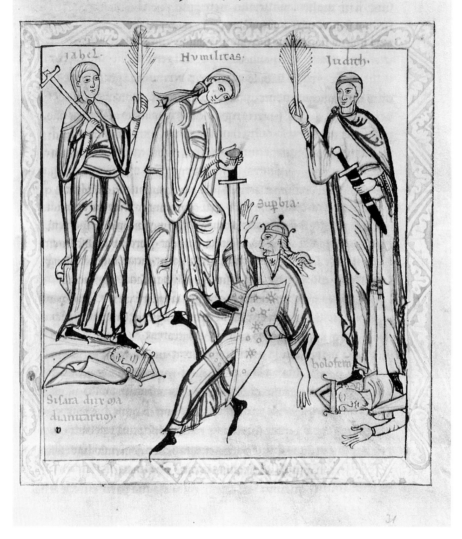

72 *Humility Killing Pride, Flanked by Jael and Judith,* from the *Speculum virginum,* MS
72, fol. 31, illumination 20 × 18.4 cm. Walters Art Gallery, Baltimore, Maryland

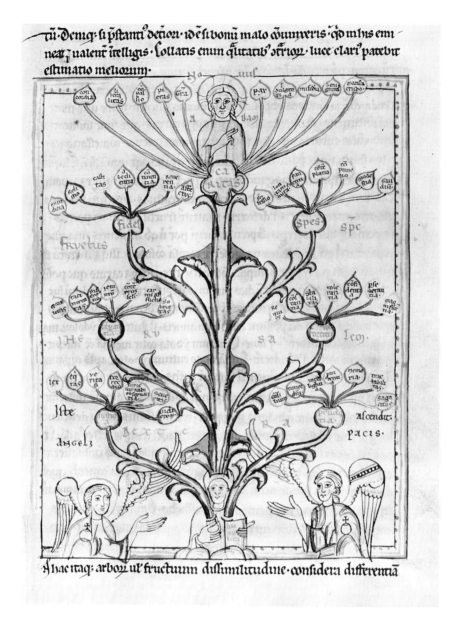

73 *Tree of Virtues,* from the *Speculum virginum,* MS 72, fol. 26, illumination 21 × 16.2 cm. Walters Art Gallery, Baltimore, Maryland

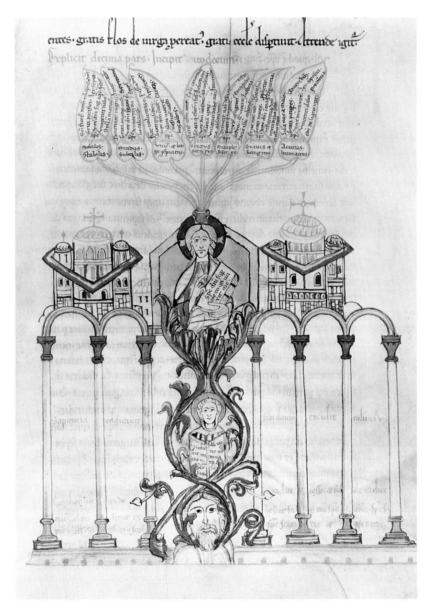

74 *Temple of Wisdom, with Seven Gifts of the Spirit Collated with Virtues,*
Beatitudes, the Lord's Prayer, Apostle's Creed, with Inscriptions from Proverbs 9:1 and
Isaiah 11:1–3, from the *Speculum virginum,* MS 72, fol. 104r, illumination 25.4 ×
20.4 cm. Walters Art Gallery, Baltimore, Maryland

Representing Logic in Graphs

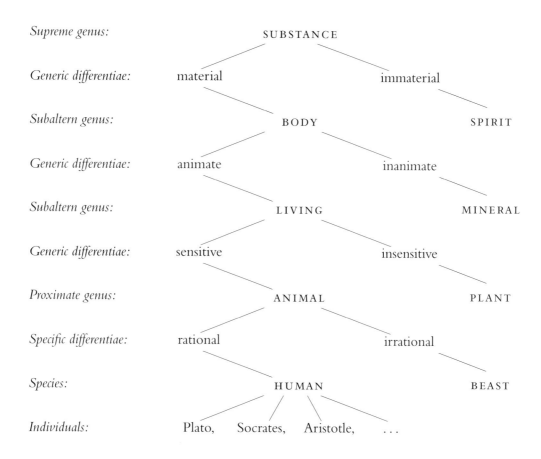

Supreme genus:	SUBSTANCE
Generic differentiae:	material · · · immaterial
Subaltern genus:	BODY · · · SPIRIT
Generic differentiae:	animate · · · inanimate
Subaltern genus:	LIVING · · · MINERAL
Generic differentiae:	sensitive · · · insensitive
Proximate genus:	ANIMAL · · · PLANT
Specific differentiae:	rational · · · irrational
Species:	HUMAN · · · BEAST
Individuals:	Plato, Socrates, Aristotle, . . .

75 "Tree of Porphyry" (after Sowa)

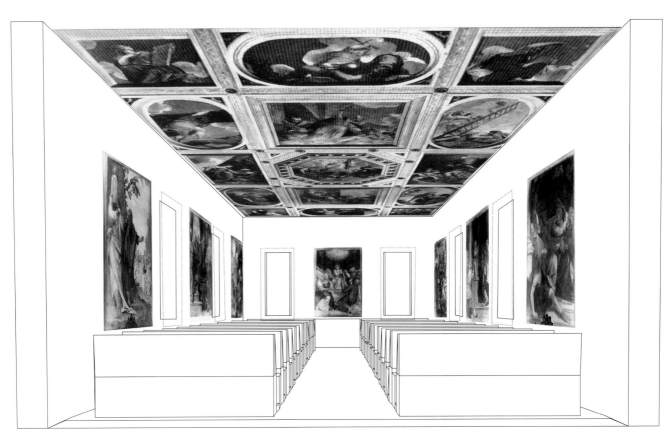

76 Integrated reconstruction of the 16th-century Library Room at Praglia with furnishings and Zelotti's paintings, view toward the north

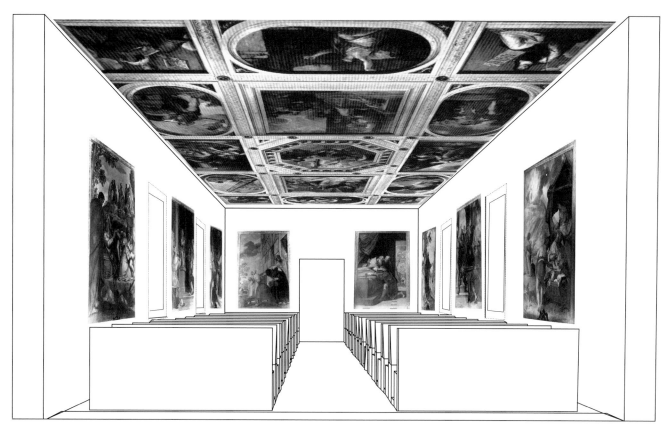

77 Integrated reconstruction of the 16th-century Library Room at Praglia with furnishings and Zelotti's paintings, view toward the south

Index

Biblical names, and pictures representing corresponding scenes, appearing almost on every page, are given only summarily, mainly under the respective pictorial programs listed under locations; *see* Bible for text references. Artists' names are given mainly under the respective locations. References to the notes have been avoided in order not to extend the Index beyond acceptable limits; the notes mainly concern support and extension of subjects treated in the text.

Abbots of the Santa Giustina/Cassinese Congregation, rotation, knowing each other 53, 60, series of abbots around 1570, *see* Congregation, Damiano da Novara, Eusebio da Brescia, Placido da Marostica, Stefano Cataneo da Novara

Abraham 38, and Obedience 39, and Good Works 39, 71, special role in monastic tradition 94, model for St. Benedict 94, *see* Works, and Isaac (the sacrifice), 39, *see* Praglia, Library, *Pentecost*

Alighieri, Dante, *Paradise*, St. Benedict 17, crisis reflected in 60

Ambrose, St. 14, 31ff., Breviary readings on 31, with Augustine, *see* Praglia, Library

Anselm, St., of Canterbury 75

Antiochene Fathers 62

Assisi, San Francesco, arrangement of scenes 31, Santa Maria degli Angeli Processionals 23f.

Augustine, St. 14, 31ff., Breviary readings on 31, Mass readings for 32, theology, important in Benedictine tradition 64, with Ambrose, *see* Praglia, Library

Badile, Antonio 2f.

Baltimore (Md.), Walters Art Gallery, *Speculum virginum* 35, combining figures of Jael and Judith with Humility 92, *see* Praglia, Library, *Scala Paradisi* 90, seven pillars of Wisdom 91f., tree of virtues 92f., *see Speculum humanae salvationis*

Barak, *see* Jael

Barbieri, Filippo, O.P., author of book on the sibyls 30

Barbo, Ludovico, and tradition, reforms 2, 60, reemphasized Benedictine traditions 4, 22, 60, 64, *Metodo di pregare e di meditare* 21, 76f., *see* Congregation, Padua (Santa Giustina), Praglia, Reading, crisis after the Black Death 60, reflected in Alighieri's *Paradise* 60

Basil, St., on Pentecost and the "eighth day" 82, 94

Basle, Council of 73

Beata nobis gaudia 81

Bellarmini, Roberto 71, on Good Works 71, on images 78

Benedetto da Mantova, *Beneficio di Cristo* 61f.

Benedict, St., readings on, in the Breviary 17, life according to St. Gregory 4, 16f., 20, 80, depiction series of life 55ff., *see* Padua, Santa Giustina, like Abraham, David, and Moses 94, *Rule* 4, 19ff., *see also* Divine Office, Humility, Learning, Moderation, Obedience, Reading, Repentance, Teaching, Virtues, Work, on Divine Office 80, *see* Divine Office, relation to ideas taken up at Trent 67, focusing on reading, studies 19, on reading, learning, meditation, prayer, and contemplation 22f., 80, on Penance 80, *Rule* printed with Trent instructions 88, honesty and chastity 91, Old Testament figures, models for the faithful 92

Benedictine Order, *see also* Cassinese Congregation, life with liturgy, prayer, and reading 76, monastery as a sacred site 35, 38, 89, hardly "laxity" attributed to them 97

Library and book usage, *see also* Benedict, Books, Library, monastery as a place of reading, study 49, distribution at Lent 23f., readings in the refectory 25, processionals used in cloister 23f., external loan 23, library pictorial programs 47ff., relevance of nonlibrary cycles 50

Pictorial cycles 51, ordering pictures for distribution 78, Bible reading 69, 97, and interpretation 87, on Penance 86, *see* Library, nonlibrary cycles 49f., *see* Cesena, Padua, Pomposa

Theological traditions 70, St. Paul, Greek Fathers, St. Augustine 62, 64, 72, mistaken for "Lutheran" 64, "theoretical mysticism" 75, *see also* Barbo, Book, Fathers, Heresy, Orthodoxy, Trent, Tradition, and the Catholic Reform 3, at Trent, *see* Ottoni, Trent, scriptural and patristic scholarship 72

Bernhard of Clairvaux 75, on ascetic tradition 94

Bernhard of Montecassino, on Good Works 34, *see* Work

Bible, Old and New Testaments 6, *see also*, Trent, Testaments, Paul, Bible problematic as a source 28, 41, translation version used here 28, as a source for dogmatics 49, Trent obligation of reading 68f., 97, Church authority on 87, Vulgate 69, 96, texts referred to in this book: Vulgate 28

Cited texts [pages in brackets]:
1 John 4:18 [33]
1 Samuel [1 Kings] 16 [56], 17:4ff. [29, 56]
2 Timothy 4:1–8 [32]
3 Kings [1 Kings] 10:1–13 [43, 57], 11:1–13 [43], 11:38 [84], 14:8 [84]
Acts 1–2, 1:24–26 [46f., 57], 2:1–7, 2:15–22 [95],

5:29 [84]

Daniel 6:16 [40, 57], 6:23 [39], 6:25–26, 6:26–27 [40]

Exodus 2:1–10 [44, 57], 2:7–9 [45], 3–4 [38, 57], 3:5–6, 3:7–13, 4:2–5 [38], 14 [82], 19:9–15, 20–25, 20:1–17, 18–21 [45], 32:1–35 [42, 57], 32:17–20, 32:26 [42]

Genesis 12:1 [94], 22 [39, 57], 22:1–19 [82], 26:34f. [41], 27 [41, 56], 27:29 [41], 28:12–20 [32, 33, 57], 33:13 [34]

Hebrews 11:8–9, 37–38 [94]

Isaiah 11:2–3 [92]

Joel 2:28–32 [81]

John 14:23–31 [95]

Judges 4–5 [36f., 57], 13:1–5 [32], 16:1–3 [32], 16:3ff. [57]

Judith 8:29 [36], 13 [36, 57], 16:3 [36]

Luke 2:41–52, 46–49 [44, 57], 14:11 [33], 15:11–32, 18–19 [42, 56], 18:14 [33]

Mark 11:15–17 [43, 57]

Matthew 5, 5:11–12 [45, 57], 16:19 [42], 21 [84]

Proverbs 9:1 [93]

Psalms 88:21 [32], 47(48) [81f.], 67(68) [81], 84, 98 [82], 103 (104) [81], 110:10 [92], 118:164 [94]

Romans 2:4 [42], 4 [71]

Wisdom 1:7 [95]

Subjects represented, *see* Cesena, Padua, Pomposa, Praglia, grouping of Old and New Testament scenes along two walls 30f.

Bologna, Pinacoteca civica, Zelotti painting 31

Book(s) 95f., *see* Benedict, St., *Rule,* Benedictine Order, Bible, Breviary, Learning, Library, Reading, Teaching, postmedieval "Book culture" and market 24, monastic distribution at Lent 23f., Christ as the exemplary "book" 22, Paul IV's *Index* 61, 64, unlawful printing and distribution 63

Boschini, Marco 2

Brescia, San Barnaba library, *Allegory of the Teachings of St. Augustine* 14, 17

Breviary, revised by Pius V 28, *see also* Divine Office 28

Bruno, St. 17

Caldogno, Villa (Vicenza), Battista Zelotti, decorative cycle 15f., Battista Zelotti, Room of Scipio, Room of Sofonisba, frescoes 16

Calvini, Chrysostomo 68f.

Carthusian Order, private devotion and public celebration 77

Cassian, St. 21

Cassinese Congregation, *see* Benedictine Order, Congregation

Cataio, Castello del (Rome), Battista Zelotti, decorative cycle 13, 15f.

Catechism of the Council of Trent 68, sought spread by the Jesuits 71

Catholic Reform 3, 59, *see* Crisis, *Reformatio generalis* of 1459 (Nicolaus Cusanus), internal contradictions, "Protestant-like" appeal to Paul and Greek Fathers

59, *see* Fathers, Paul

Catholic Religion, *see* Religion

Cavalca, Domenico, *Specchio di croce,* Jacob's ladder and humility 90

Cesena, Biblioteca Malatestiana 11f., 50, Madonna del Monte, arrangement of scenes 31

Charity, ladder figure as 34

Chiari, Isidoro 62, at Trent 68f.

Christ 7, life of 35, as teacher, as "book" 22, *see* Praglia, Refectory, Cesena, Madonna del Monte, *Sermon on the Mount* 7, 12f., 45f., used in St. Benedict's *Rule* 46, *Teaching in the Temple* 7, 44, *Expelling the Money Changers* 7, 13, 43f., christology 96

Chrysostom, St. John, obeying from faith and love 87, importance for Benedictine and Franciscan tradition 62, possibly reflected in St. Benedict's *Rule* 62

Church, and Tradition, Holy Spirit, Mary 78ff., *see* Crisis, Cusanus, Learning, Mary, Mass, Reform, Religion, Spirit, Teaching, Tradition, Trent, Trent on traditions 97, mystical traditions within 75, represented as *Religio Catholica, see* Religion, Vincenzo of Milan on 80f.

Cîteaux, foundation of as Abraham's pilgrimage 94

Codex Benedictus (Vatican Library) 17, 77

Cognition, from God 48, *see* Wisdom

Confession 86, *see* Penance, Trent

Congregation Cassinese/of Santa Giustina 2, 4, 22f., 52, 60f., Barbo's reformed Congregation 60f., *see* Abbots, the Barbo Reform 1f, connected with general efforts 60, *see* Barbo, connected with University of Padua 60, Cassinese tradition focusing on Bible, Pauline Epistles, Fathers, esp. the Greek, love and related benefits from Christ 61, *see* Benedetto da Mantova, Contarini

Contarini, Gasparo, his theological ideas 61, 64, 68

Contemplation, *see* Reading

Councils, *see* Basle, Florence, Trent, and Wisdom of Holy Spirit 54

Counter Reformation, misleading term 59, *see* Catholic Reform

Crisis in the Church 59f., *see* Church, Florence (Council of), Heresy, Indulgences, Reform, Trent

Cusanus, Niocalus, Church reform projects 59, on Jacob's ladder 90

D'este, Cipriano Rinaldini 60

Damiano da Novara, abbot of Praglia 28, 53

Daniel in the Lions' Den 39f., *see* Praglia, Library, picture connected with Pentecost, spreading the Word 94f.

Dante, *see* Alighieri

David and Goliath 29, *see* Praglia, Library, David, role in monastic tradition 94, *see* Gregory, *Dialogue II*

Deborah, Song of (Judith 8:29) 36

Devotio moderna 75

Diodorus of Tarsus 62

Divine Office, *see also* Breviary 22, in Benedict's *Rule* 28f., 80, here called work of God 29

Dominican Order, learning, library 50, *see* Treviso

Emo, Villa (VI) Battista Zelotti, decorative cycle 13, 15f.

Esau and Jacob 7, 41

Eucharist, *see* Mass, Religion

Eugene IV, Pope, and the Congregation of Santa Giustina and Praglia 60, and the Council of Florence 60, on Cîteaux and Abraham 94

Eusebio da Brescia, abbot of Praglia at the probable date of the library program, around 1570 28

"Evangelism" in Jedin, 63

Faith, *see also* Religion, Works, effective dependent on Good Works 35, on operative religion 79, 80, 87, 93, *see* Virtues

Fathers, efforts to restore their texts 72, represented for Church Militant 84

 Greek, use of in the Catholic Reform 59, role for Ottoni's theology 62, for Benedictine tradition 19–20, 79–80

 Latin 89, combating heresy, teaching 89, *see* Ambrose, Augustine, Benedictine Order, Gregory, Jerome

Fiandrini, Benedeto 2

Florence

 Council of Florence, crisis after 60

 Laurentian Library (Michelangelo) 11f., furnishing, user capacity 26

 Santa Croce, Baroncelli Chapel, Old Testament and Virtue figures combined 93

Franciscan Order, theological tradition 62, library, *see* Verona

Fruttuaria, monastery 25

Galluzzo (Florence), Certosa, St. Bruno paintings 17

Giberti, Matteo 68

Girolamo da Potenza, his *Elucidario* 52f., 55ff., 84f., *see* Padua, Santa Giustina

God, presence 35, 38

Godi, Villa Zelotti, Decorative cycle frescoes 15

Good Friday 24

Gregory the Great, St. 14, 37f., *Dialogue II* on life and miracles of St. Benedict 4, 16f., 20, 37f., 55ff., on Divine authority, delegated power from God 41f., on temptations 91, on Old Testament figures 92, St. Benedict compared to David and Moses 94, with St. Jerome, *see* Praglia, Library

Gregory XII 60

Hagiography, nonliterary sources for 51

Heresy 63f., Mass and procession against 70, trial for 70f., *see* Books, Church, Crisis, Sts. Ambrose and Augustine attacking 31f., *see also* Philistine, St. Augustine

Humility, in St. Benedict's *Rule* 33f., in St. Gregory's *Dialogue II* 33, *see also* Ladder, Benedict, St., *Rule,* and Praglia, Library, *Jacob's Ladder,* literary traditions on humility and connecting figure of ladder 33ff., 90, connected with Jael and Judith 92

Hypnerotomachia Poliphili 94

Iam Christus astra ascenderat 81

Imagery at Trent 67f., Bellarmine on 78

Indulgences, disbelief in at Venice 70

Isaac 38, *see also* Abraham

Jacob and Esau 7, 31ff., 34, 38, *see* Praglia

Jacob's Ladder, see Ladder, Humility, Praglia

Jael, Sisera, and Barak 36f., *see* Praglia, Library Jael, *see* Baltimore, Judith, Mary, Praglia, *Speculum* Jael paired with Judith 85, both connected with Humility 92

Jerome, St., 14, 37f., with St. Gregory, *see* Praglia, Library

Jesuits and the Catechism 71

Jesus, *see* Christ

John Cassian on *Jacob's Dream* 35

John Climacus on the *Scala Paradisi (see Scala Paradisi)* 35, 90

Judith and Holophernes 36, *see* Praglia, Library, Judith, *see* Baltimore, Jael, Mary, Praglia, *Speculum,* Judith figure of honesty and chastity 91, paired with Jael 85, both connected with Humility 92

Justification, at Trent 65ff., requires Holy Spirit 81, *see* related to Mass Sacrifice 35f., 79, and theological virtues 65, and Good Works 65f., *see* Work

Ladder, St. Benedict's soul ascending 17f., figure in the *Rule* 18, literary interpretations of figures of ladder 34f., 90, Jacob's, *see* Praglia, Library, *see also* Charity, Humility, Moderation, *Scala Paradisi,* Work, vices and virtues battling 35

Law, New 45, Old and New 87

Learning 95f., *see* Books, Reading, Teaching, Sibyls, Wisdom, monastery as school 22, *magisterium, disciplina* 22, and the Holy Spirit 46

Lectio divina, see Reading

Lent, distribution of books 23f.

Library, no liturgy (but *see* Books), *see* Liturgy, pictorial programs 47ff., 50f., Armenini's prescriptions 49, *see* Marciana, Parma, Praglia, San Giovanni di Verdara, Venice, Verona, Vicenza, *see* Benedictine Order (pictorial cycles), Monastic traditions, *see* Benedict, St., *Rule,* Benedictine Order, Padua, Santa Giustina, Parma, San Giovanni Evangelista Monastic library functions 24f., Praglia, early collections 25f., pictorial programs 47f.

Liturgy, no such for libraries 3, 46, general familiarity with liturgical concepts, and "Faith" 35, *see* Mass, Religion

Luther/an ideas (real or assumed) 63f., 70, 97, heresy 79

Mabillon, Jean, description of original Praglia library 2, 8, 11

Marciana Library 48–49

Martène, E. 34

Mary, Virgin, associated with the Church, present at Pentecost 47, central role at Praglia 47, 81, Marian context determinant 53, *see* Cesena, Madonna del Monte, prefigured by Jael and Judith 85

Mass, Holy (Eucharist), at Trent 64 ff., 66f., 86, and other sacraments 79, penance 86, and power of Eucharist, in St. Gregory 35, *see also* Eucharist, Justification, Religion, Sacrifice, Work 22, Mass as Sacrifice and Good Work 35f., 64f., and

Justification 35, Offertory 79

Massarelli, Angelo, against Ottoni 68ff., *see* Ottoni

Mauro, St., feast 17

Meditatio, see Barbo, Contemplation, Reading

Melk, Stift, "pallae" 10, library 23

Moderation, Jacob as model of in St. Benedict 34

Monastery traditions, *see also* Benedict, Monastic rule, Benedictine Order, Dominican Order, Franciscan Order, Reading, Learning, Library, Processionals, Teaching, Virtues, difficulties of setting up typologies for monastic picture series 53, Trent decree on apostolic visits 98

Montecassino, Abbey of 22

Moses on Sinai, Breaking tablets, Burning bush 7, 13, 38f., 42f., 44f., *see* Praglia, role in monastic tradition 94, *see* Gregory, *Dialogue II,* Pentecost

Obedience 84, 87, 89, in Benedictine tradition and Rule 62, Abraham type of 39

Octave, *see* Pentecost

Opus bonum, see Work, further Spirit, Holy, Bellarmini

Oratio, see Reading, Prayer

Order, *see* Benedictine, Carthusian, Dominican, Franciscan

Ormaneto, Bishop, visit 98

Orthodoxy, in Benedictine tradition 59, 96

Ottoni, Luciano degli, Benedictine abbot at Trent, with books on Index 61, his theology 62, 68f., 87, his "errors" 68f.

Padua

Cloister, readings in 23f., 52, former paintings 51f., according to Girolamo da Potenza 55ff., 84f.

Library 11, *Madonna and Child with Sts. Justine and Benedict* and *Madonna and Child with Saints and a Donor* 14, collection and size 25f.

Museo Civico, Zelotti organ shutters, originally in the Praglia church 15

Santa Giustina, seat of Cassinese Congregation, and Barbo Reform 22 (*see* Barbo), administrative closeness to Praglia 55, book collection 23, 26, Paolo Veronese 3

University, and Aristotelian tradition 78

Palla/pala, discussion of term 8ff., 15

Palladio, Andrea, reflected in painting by Zelotti (?) 42

Palm Sunday 24

Parma, San Giovanni Evangelista Processional 24, Library, learned picture and inscription program 22, 48f., 53f., dominance of the figure of the Holy Spirit, *see* Learning, Spirit, Wisdom

Paul IV, his *Index librorum prohibitorum* 61, 64

Paul, St., use of in the Catholic Reform, *see* Catholic Reform, used in support of Catholic orthodoxy 71, in Benedictine tradition 64, in Ottoni's theology 62

Penance 65, and the Prodigal Son 86, *see* Prodigal Son and Good Works, *see* Work, Trent on, preparatory to Eucharist 86

Pentecost 6, 13, 46f., 81ff., 87, 95, Breviary and Missal for 81f., Abraham, Moses 95, "eighth day," Octave, and number allegories 82f., St. Augustine on 82f., St. Basil on 82, 94, *see* Praglia, Spirit, and Daniel 40, and conversion 81f., and good works 82

Perugia, San Pietro, planning of pictorial cycle 74

Peter the Chanter 75

Peter, St., and divine authority 41f.

Philistine, enemies of God's people 29f., 32, 84, 96f., *see also* Heresy 29f., 32, term used against opponents at Trent 69, the Protestants 84

Picture(s), *see* Imagery, arrangements of 74, *see* Assisi, Cesena, Pomposa, Porphyry, Praglia, Rome (Santa Prassede), Vatican, Venice (Madonna dei Miracoli), programming by Church/State authorities/experts 74f., depicted events and abstract issues 75, rites concerning 77, Trent and 77, Barbo on vision and images 76ff., Benedictines ordering pictures for distribution 78, Bellarmine and earlier traditions on understanding/learning by images 78

Pius II, reform program 59

Placido da Marostica, abbot of Praglia 27

Pole, Reginald 61

Pomposa, Abbey of, Church fresco series 51

Porphyry, Tree of 78, and Aristotelian tradition, *see* Padua, university

Pozzoserato 2f.

Praglia, belonging to the Congregation of Santa Giustina (Padua)/Cassinese Congregation 22, 52, 60, this effected by Eugene IV 60, series of abbots around 1570, problems in studying 3, 75, *see* Pictures, location 1f., and the Barbo Reform 1f., *see* Congregation (Cassinese tradition), Antonio Badile, Jacopo Tintoretto, Pozzoserrato, Paolo Veronese, Carletto Caliari 3

Church, Battista Zelotti 10, *Assumption* 15

Praglia, Library (for the anteroom, *see* below), location 2, earliest sources 2f., earliest (?) catalogue 25, probable capacity 26, Zelotti 3, 6, payments to him 14f., other painters 3, condition of paintings 13f., program interpretation generally 27f., no "typical" background 53 (*see* Typology), program authorship 27f., dating 98

Ceiling pictures:

Abraham and Isaac (The Sacrifice), subject: 39, significance: 39, 87, 89, 91, style (Zelotti) 39

Catholic Religion or *Church with the Four Evangelists,* subject: 35f., significance: 35f., 83, 85f., 87, 89, 91, "Faith" an insufficient label 35, *see* Church, Mass, Religion, Sacraments, Work, style (Zelotti) 36, 79f., evangelists with books 96

Cumaean Sibyl, subject: 30, 40, significance: 30, 40, 87

Daniel in the Lions' Den 13, subject: 39f., significance: 39f., 83, 87, 94f., 98, relation to *Pentecost* 40, style (Zelotti) 40

David and Goliath, subject: 29, significance: 29, 83f., 85f., 87, style (Zelotti) 29f.

Erythraean Sibyl, dressed as Santa Scholastica 40, subject: 30, 40, significance: 30, 40, 87

Jacob's Ladder, subject: 32f., significance: 32ff., 84, 89, 90, and St. Benedict's *Rule* 17f., 33f., *see* Humility, Ladder, Moderation, style (Zelotti) 35

Jael with Sisera, subject: 36f., significance: 37, 84f., 86f., style (Zelotti) 37, *see Speculum virginum*

Judith and Holophernes, subject: 36, significance: 36, 85ff., 91, style (Zelotti) 36, *see Speculum virginum*

Moses with the Burning Bush and Serpent, subject: 38, significance: 38, 87, 89, style (Zelotti) 38f.

Saints Ambrose and Augustine Attacking Heretics 14, subject: 31, significance: 31f., 83f., 85f., 96, style (Zelotti) 31f.

Saints Jerome and Gregory Preaching and Teaching 14, subject: 37f., significance: 37f., 83, 87, 91, 96, style (Zelotti) 38

Samian Sibyl, subject: 30, significance: 30, 86

Samson with the Gates of Gaza, subject: 32, significance: 32, 84f.

Sibyls: literary background 30, 40, *see* Sibyls, style (Zelotti) 31, 40, 85, 95f., and learning 95f.

Tiburtine Sibyl, subject: 30, significance: 30, 86

General significance: interpretative overview 78ff., doctrinal program 58, affirmative, positive 88, Old and New Law 87, submission to God's law 45, practice of Virtues, *see* Virtues, related to the religious crisis 59, *see* Crisis, Reform, in the wake of the Council of Trent 58, 88, 91, 97f. (no "Counter Reformation," 59), importance of Trent notion of Penance 65, stressing Benedictine tradition 59f., 91, orthodoxy in theology and ecclesiology 59, 96, accent on Chosen People 36, 37f., 58, 83ff., 85, 87ff., 89f., 91, combative themes 58, 86, 88, Catholic Tradition on learning 59, Church's control of learning and Scripture interpretation 87, and Divine Wisdom 58, 91f., teaching 37f., 96, wisdom, learning, meditation 46, 86, 91f., spreading the Word 94f., Divine authority 41, delegated power from God 41, New Law 45, moral set down in *Rule* 88, humility 33ff., 89, obedience 39, 84, 89, Catholic Religion 35f., faith 39, overcoming heresies 87 (*see* Heresy), overcoming the enemies of God's people 37, the Philistine 29f., 32, 88 (*see* Philistine), not going astray 42, 44, 89f., repentance and punishment/forgiveness 42f., 86, 90, keeping God's house uncorrupted 43, Temple for display of God's wisdom 44, monastery sacred site 35, 38, 89, central role of the Virgin Mary (Praglia dedication) 47, implied criticism of the Protestants 80

Library anteroom 16ff., only place for a story of St. Benedict 56, 96

Present condition: Ceiling and wall paintings (Battista Zelotti) style 15f., 40f., *see* Pictures, arrangements, Pentecost theme set apart, focal 82f., *see* Pentecost

Present condition: Room furnishing 5f., decoration subjects 3

Reconstruction: Furnishing 8ff., 11ff., the "pala/palla" 9, 14f., *see* Palla, Wall paintings 6ff., 1562–64 decoration campaign 14, chronology 14f., grouping of Old and New Testament scenes along two walls 30f.

Refectory (Battista Zelotti): condition of paintings 13f., 41

 Christ Expelling the Money Changers 7, 13, 16, subject: 43f., significance: 43f., 84, and Trent reforms 85, style (Zelotti) 43

 Christ Teaching in the Temple 7, subject: 44, significance: 44, 87, 89, 91, 96, relation to Solomon 44, style (Zelotti) 44

 Jacob and Esau 7, subject: 41, significance: 41f., 84, 85f., 97, style (Zelotti) 41

 Moses Breaking the Tablets 7, 13, subject: 42f., significance: 42f., 84f., 87, 89f.

 Moses on Sinai Receiving the Tablets 7, subject: 44f., significance: 44f., 87, style (Zelotti) 45

 Pentecost 7, 13, 15, subject: 46f., significance: 46f., 81f., 83, 87, 91, 94, 98, indirect reference in the *Rule* 46, Virgin Mary 81, 86, style (Zelotti) 46f.

 Prodigal Son 7, 13, subject: 41f., significance: 41f., 84, 86, 90, 97, style (Zelotti) 42, and Palladio 42

 Sermon on the Mount 7, 13, subject: 45f., significance: 45f., 87, 91, 96, style (Zelotti) 46

 Solomon and the Queen of Sheba 7, 13, 16, subject: 43f., significance: 43f., 87, 89, 91, 96, style (Zelotti) 44

Wall paintings: reconstructed placement of present refectory paintings 6ff., 41, general style (Zelotti) 47, for contents, *see* above: Refectory.

Prayer and *lectio divina* 22

Processionals 23f., 52

Prodigal Son 7, 13, 42, figure of repentance 86, 97, *see* Praglia, and Penance, *see* Penance, in St. Benedict's *Rule* 86

Programming, *see* Pictures

Prudence 87, *see* Virtue

Psalter, reading 22

Reading, *see also* Books, Learning, Teaching, Benedict, *Rule,* emphasis on by St. Benedict 21f., *lectio divina, lectio sacra* 21, and *meditatio, oratio, contemplatio* 22, and preparation for Mass, liturgy 22, Psalter reading 22, Barbo on 76f.

Rebecca 41

Reform, Catholic, *see* Benedictine Order, Catholic Reform, Cusanus

Regola in italiano per le monache con aggionte delli Decreti del Sacro Concilio di Trento . . . 88

Regula Magistri 19, 22, 34

Religion, Catholic, Scripture basis 79, guided by the Holy Spirit 97, *see* Spirit, and power of Eucharist, in St. Gregory 35, represented as Church 35, 79, and sacraments 79, *see* Praglia, Library, Justification, Mass, Tradition, Works, religion from good works,

from active liturgy 35, tradition 96, reaction to Northern Reformers 96
Repentance 42, *see* Penance
Ridolfi, Carlo 2
Ripa, Cesare 94
Rome, Santa Prassede, Zeno Chapel, arrangement of scenes 31, Vatican City, Sistine Chapel, arrangement of scenes 31, 74
Rossetti, Giovanbattista 2
Rule, see Benedict, St., *Rule, Regula Magistri*
Ruppert von Deutz 75
Sacraments, *see* Church, Mass, Penance, Religion, Trent
Sadoleto 68
Saint Blasius (Schwarzwald), monastery library 25
Samson with the Gates of Gaza, in St. Benedict's *Rule* 32, *see* Praglia, Library
San Benedetto del Po, Paolo Veronese 3
San Giovanni di Verdara, library 51
Sant'Andrea della Castagna (Genoa), processional 24
Sapientia, see Spirit, Wisdom
Scala Paradisi, see Ladder 35, 90
Scala perfectionis 90
Scholastica, Saint 40, Erythraean sibyl dressed as 40
School, *see* Learning, Teaching
Sheba, *see* Solomon
Sibyls 2, 7, 30f., 95f., and learning, *see* Learning, Praglia, Library, at Cesena 52f.
Siculo, Giorgio, Benedictine "heretic" 63, 72, executed for heresy 70
Sisera, *see* Jael, *see* Praglia, Library
Smaragdus, *Commentary on the Rule* 34
Solomon and the Queen of Sheba 7, 12f., 43f., *see* Praglia
Soto, Domingo de, inquisitor 69
Speculum humanae salvationis 50, 85, Judith and Jael prefigurations of Virgin Mary 85, wisdom imagery, Tree of Virtues, 92f.
Speculum virginum 92f, *see* Baltimore, Walters Art Gallery
Spirit, Holy, guiding Church 97, necessary for Justification 81, *see* Baltimore, Councils, Learning, Universities, Wisdom, *also* Parma (San Giovanni Evangelista), Praglia, Refectory, spiritus -> inspiratio 54, and wisdom 46, 54, 92, normal focus for churches and libraries 54
Stefano Cataneo da Novara, abbot of San Giovanni Evangelista at Parma and at Praglia, also at Trent 53
Subiaco (Rome), St. Benedict at, like Abraham 94, Benedictine monasteries, first printing press in Italy 25
Teaching, *see also* Benedict, St., Monastic rule, *Catechism,* Learning, Reading, Trent, Christ as teacher 22, 37f.
Testaments, Old and New 6f., parallelism 96, Old Testament figures models for monks 92, *see* Abraham, David, Moses, and virtues 93, *see* Bible, Florence, Santa Croce (Baroncelli Chapel)
Theodore of Mopsuestia 62
Theodorete of Cyprus 62

Thomas à Kempis 75
Tintoretto, Jacopo 3, *see* Venice, San Giorgio Maggiore
Titian 29
Tomasini, J. F. 2
Tradition of the Church 67, embracing liturgical practice 79, 97, *see* Religion
Trent, Council of, apostolic visits 98, theological and liturgical issues 64ff., *see also* Bible, Church, Justification, Mass, Penance, *Catechism,* Pictures, Tradition, Virtues, Works, other main issues, Bible (Scripture) 64, Church and Mass and other sacraments 79, and mariology 64, Tradition 64, implementation of decrees 71, Benedictine presence at 68ff., these "bypassing" Scholasticism 68f., disciplinary reforms systematization of archives, libraries 24, Benedictine presence Stefano Cataneo da Novara, abbot of San Giovanni Evangelista, Parma, and of Praglia 53
Treviso, San Nicolò, chapter hall, Tommaso da Modena, fresco decoration 50, 55
Typologies, difficulties in setting up for monastic picture programs 53
Universities and wisdom of Holy Spirit 54, *see* Spirit
Valeriano, Piero 94
Vatican Library, *see Codex Benedictus,* Vincenzo of Milan
Venice
 Biblioteca Marciana, pictorial program 48, progression from divinely inspired virtues 48, combination of classical and Christian themes 94, Zelotti 15, 48, Zelotti, *Allegory of Modesty, Allegory of Study* 15, figs. 32–33
 Doge's Palace, cycle programming by experts 74f., *see* Pictures, technical terms 9, Sala dell'anticollegio, Veronese's allegory, religion from works 35f., Veronese and Zelotti paintings in the Sala dei Tre Capi 31
 Madonna dei Miracoli, arrangement of scenes 31
 San Giorgio Maggiore, programming of cycles by experts 74, choir stalls with Story of St. Benedict 16, Tintoretto 3, *Manna* and *Last Supper* 30, Veronese 3, library collection 25f., Longhena's Library, execution period 28, Valle's comment on placement of paintings 46
 San Marco, "palla/pala," Pala d'oro 10, processional 24, *Salve Regina* rite 77
 San Sebastiano, Paolo Veronese 2, 32, placement of four sibyls 30
 Santa Maria della Salute, *David and Goliath,* by Titian (formerly Santo Spirito) 29
Verona, San Bernardino, former library 11, 14, 17, 50f., 55, Santi Nazaro e Celso, Antonio Badile, Paolo Veronese 3
Veronese, Carletto Caliari 3
Veronese, Paolo 2f., *see* locations
Vicenza
 Cathedral, Battista Zelotti, *Miraculous Draught of Fishes* and *Conversion of St. Paul* 15

Monte di Pietà, Battista Zelotti 15

San Rocco, Battista Zelotti 15, 46

Vincenzo of Milan, *De maximis . . .* 80, partially quoted in
app. 2

Virtues 49, 83, 91, 93ff., 99, theological virtues and
Justification 65, Faith, Obedience, Prudence 87,
cardinal and theological virtues 93, hope, honesty,
and chastity 91, and Old Testament figures 93, 99,
Trent connection with Works, *see* Benedict,
Charity, Florence, Santa Croce (Baroncelli
Chapel), Humility, Ladder, Moderation,
Obedience, Religion, *Speculum humanae salvationis,
Speculum virginum,* Trent, Venice (Marciana),
Wisdom, Work

Vision, *see* Pictures

Wisdom, see *also* Baltimore, Learning, Parma (San
Giovanni Evangelista), Reading, Spirit, Teaching,
display of God's wisdom 44, 91, and the Holy
Spirit 46, all cognition from God 48, seven pillars
of 91

Work(s), Good *(opus bonum), see* Justification, Mass,
Penance, Repentance, Religion, Virtues, Breviary
82, Bernhard of Montecassino on 34, Benedict's
Rule on 20, 35, 62, 97, 99, in Benedictine tradition
62, Abraham 39, defined by Bellarmini 71, at Trent
79, Trent connection with Virtues 93

Zelotti, Battista 2f., 6, 10, 15f., 31, 97f., and passim, *see*
Praglia

SOURCES OF ILLUSTRATIONS

Figures 1, 3, 6–15, 17, 18, 20–24, 32, 33, 36, 37, 56–69;
 Plates I–IV: authors' photographs

Figure 2: from F. G. B. Trolese, "La congregazione di S.
 Giustina di Padova (sec. XV)," in *Naissance et fonction-*
 nement des réseaux monastiques e canoniaux, Actes du
 Premier Colloque International du C.E.R.C.O.M., sep-
 tembre 1985, Centre Européen de Recherches sur les
 Congrégations et Ordres Religieux, Travaux et
 Recherches, Saint-Etienne, 1991

Figures 4, 5: from C. Carpanese and F. G. B. Trolese, eds.,
 L'Abbazia di Santa Maria di Praglia, Milan, 1985,
 cover and fig. 85

Figure 16: courtesy of M. Muraro

Figure 19: from M. I. Catalano, *Il pavimento della biblioteca*
 mediceo laurenziana, Florence, 1992, pl. X

Figure 25: courtesy of the abbey at Praglia

Figures 26, 27: computer reconstructions with the techni-
 cal assistance of Kjetil Hoel and Terje Moe

Figure 28: authors' chart

Figures 29, 30, 76, 77: computer reconstructions with the
 technical assistance of Rachel Moog and Catherine
 Vardon

Figures 31, 34, 35, 39, 41, 43, 45, 47, 49, 51, 53, 55, 70, 71:
 courtesy of the Soprintendenza per i Beni Artistici
 e Storici del Veneto

Figures 38, 40, 42, 44, 46, 48, 50, 52, 54: courtesy of the
 Soprintendenza ai Beni Artistici e Storici di Venezia

Figures 72–74: courtesy of the Walters Art Gallery,
 Baltimore, Maryland

Figure 75: after J. F. Sowa, "Relating Diagrams to Logic,"
 in *Conceptual Graphs for Knowledge Representation,*
 Lecture Notes in Artificial Intelligence, ed. G. W.
 Mineau, B. Moulin, and J. F. Sowa, Berlin, 1991,
 fig. 1

CAA Monographs on the Fine Arts

Order the following from University of Washington Press, P.O. Box 50096, Seattle, Washington 98145-5096, 800/441-4115. For CAA members' discount, cite membership number with your order.

JOAN A. HOLLADAY, *Illuminating the Epic: The Kassel* Willehalm *Codex and the Landgraves of Hesse in the Early Fourteenth Century.* 1997. CAA Monograph LIV. ISBN 0-295-97591-1. $50.00 (members $37.50)

BRIGITTE BUETTNER, *Boccaccio's* Des cleres et nobles femmes: *Systems of Signification in an Illuminated Manuscript,* 1996. CAA Monograph LIII. ISBN 0-295-97520-2. $45.00 (members $33.75)

CLIFFORD M. BROWN and GUY DELMARCEL, with the collaboration of Anna Maria Lorenzoni, *Tapestries for the Courts of Federico II, Ercole, and Ferrante Gonzaga, 1522–63.* 1996. CAA Monograph LII. ISBN 0-295-97513-X. $50.00 (members $37.50)

BACKLIST

The following monographs are available from Penn State Press, Suite C, Barbara Building, 820 North University Drive, University Park, Pennsylvania 16802, 814/865-1327. For CAA members' discount, cite membership number with your order.

MARILYN R. BROWN, *Degas and the Business of Art: "A Cotton Office in New Orleans."* 1994. CAA Monograph LI. $57.50 (members $43.25)

ANITA FIDERER MOSKOWITZ, *Nicola Pisano's Arca di San Domenico and Its Legacy.* 1994. CAA Monograph L. $55.00 (members $41.25)

CAROL RADCLIFFE BOLON, *Forms of the Goddess Lajja Gauri in Indian Art.* 1992. CAA Monograph XLIX. $47.50 (members $35.75)

JEFFREY C. ANDERSON, *The New York Cruciform Lectionary.* 1992. CAA Monograph XLVIII. $42.50 (members $31.75)

MEREDITH PARSONS LILLICH, *Rainbow Like an Emerald: Stained Glass in Lorraine in the Thirteenth and Early Fourteenth Centuries.* 1991. CAA Monograph XLVII $49.50 (members $37.25)

EDITH W. KIRSCH, *Five Illuminated Manuscripts of Giangaleazzo Visconti.* 1991. CAA Monograph XLVI. $39.50 (members $26.50)

ALEX SCOBIE, *Hitler's State Architecture: The Impact of Classical Antiquity.* 1990. CAA Monograph XLV. $35.00 (members $26.25)

PRISCILLA P. SOUCEK, *Content and Context of the Visual Arts in the Islamic World.* 1988. CAA Monograph XLIV. $42.50 (members $31.75)

HENRY MAGUIRE, *Earth and Ocean: The Terrestrial World in Early Byzantine Art.* 1987. CAA Monograph XLIII. $35.00 (members $26.25)

JAROSLAV FOLDA, *The Nazareth Capitals and the Crusader Shrine of the Anunciation.* 1986. CAA Monograph XLII. $35.00 (members $26.25)

LIONEL BIER, *Sarvistan: A Study in Early Iranian Architecture.* 1986. CAA Monograph XLI. $35.00 (members $26.25)

BERNICE F. DAVIDSON, *Raphael's Bible: A Study of the Vatican Logge.* 1985. CAA Monograph XXXIX. $35.00 (members $26.25)

WILLIAM TRONZO, *The Via Latina Catacomb: Imitation and Discontinuity in Fourth-Century Roman Painting.* 1986. CAA Monograph XXXVIII. $35.00 (members $26.25)

IRVING LAVIN, ed., *Gianlorenzo Bernini: New Aspects of His Art and Thought.* 1985. CAA Monograph XXXVII. $39.50 (members $29.50)

ROBERT S. NELSON, *The Iconography of Preface and Miniature in the Byzantine Gospel Book.* 1980. CAA Monograph XXXVI. $35.00 (members $26.25)

JOHN R. CLARKE, *Roman Black-and-White Figural Mosaics.* 1979. CAA Monograph XXXV. $35.00 (members $26.25)

HENRY-RUSSELL HITCHCOCK, *Netherlandish Scrolled Gables of the Sixteenth and Early Seventeenth Centuries.* 1978. CAA Monograph XXXIV. $35.00 (members $26.25)

MILLARD MEISS and ELIZABETH H. BEATSON, *La Vie de Nostre Benoit Sauveur Ihesuscrits and La Saincte Vie de Nostre Dame.* 1977. CAA Monograph XXXII. $35.00 (members $26.25)

WALTER CAHN, *Romanesque Wooden Doors of Auvergne.* 1975. CAA Monograph XXX. $35.00 (members $26.25)

CLAIRE RICHTER SHERMAN, *The Portraits of Charles V of France.* 1969. CAA Monograph XX. $35.00 (members $26.25)

HOWARD SAALMAN, *The Bigallo: The Oratory and Residence of the Compagnia del Bigallo e della Misericordia in Florence.* 1969. CAA Monograph XIX. $35.00 (members $26.25)

JACK J. SPECTOR, *The Murals of Eugène Delacroix at Saint-Sulpice.* 1968. CAA Monograph XVI. $35.00